11 February 2015
from Killarney, Éire

D0745802

REVOLUTIONARY IRELAND

A Photographic Record

REVOLUTIONARY IRELAND
A Photographic Record

George Morrison

Gill & Macmillan

Gill & Macmillan
Hume Avenue, Park West, Dublin 12
with associated companies throughout the world
www.gillmacmillanbooks.ie

© George Morrison 2013
978 07171 5709 9

Index compiled by Róisín Nic Cóil
Design and print origination by www.slickfish.ie
Printed by BZGraf. S.A., Poland

This book is typeset in DIN 13pt on 20pt leading.

The paper used in this book comes from the wood pulp of managed forests. For
every tree felled, at least one tree is planted, thereby renewing natural resources.

All rights reserved. No part of this publication may be copied, reproduced or
transmitted in any form or by any means, without permission of the publishers.

A CIP catalogue record for this book is available from the British Library.

5 4 3 2 1

CONTENTS

INTRODUCTION

'Long threatening comes at last.' The Easter Rising had its roots firmly established in nineteenth-century Ireland, America and even England itself, not to mention the importance of the French revolutionary influences and their direct bearing on Wolfe Tone and Robert Emmet.

Revolutionary traditions have never fallen on deaf ears in Ireland. The Great Famine transformed the Irish countryside, just as the Industrial Revolution transformed Ulster. The Famine, and the consequent deaths by starvation and forced emigration, left a legacy of bitterness against Britain that nothing could assuage. Heavy industry, concentrated in largely Protestant east Ulster, marked off that province ever more from the rest of the island. As east Ulster became part of the British regional economy, the rest of Ireland was beginning to slough off as much of English culture as it could. Towards the end of the nineteenth century the revival of interest in Irish studies was a powerful cultural preparation for what was to come.

From the very beginning of the twentieth century the ground was well prepared for the efforts of the Irish Republican Brotherhood. Radical nationalist groups of all sorts proliferated. Opponents of the Boer War; Sinn Féin; the Gaelic League; the Irish literary revival—all these and others like them met with success, notably among young intellectuals of both sexes. Beneath the seemingly calm surface of colonial Ireland, currents of opposition were already forming, especially among the new educated nationalist elite, which were to find their fullest expression in 1916.

The First World War—or the Great War, as it was known to contemporaries—provided the indispensable context for the Irish Revolution. It was really a European rather than a world war. It involved every major European power and accomplished the destruction of three empires: Russian, German and Austro-Hungarian.

For all combatants, Britain included, it was a life-or-death struggle. At the beginning of the war Britain could provide only a paltry army for the British Expeditionary Force that crossed to Belgium, numbering fewer than 200,000 men. The other combatant powers, unlike Britain, maintained standing armies made up of conscripts and mobilised an astonishing 7 million men between them.

Kitchener's New Army, comprising both volunteers and conscripts, eventually brought the British army's numbers up to nearly 5 million. But the casualties were horrific and the war itself was touch and go for a long time. If ever the old Fenian cry of 'England's difficulty is Ireland's opportunity' rang true, surely it was now. That was what drove Tom Clarke and Seán Mac Diarmada—the crucial figures behind the revival of the IRB—to lay their plans for an insurrection while Britain was locked in its desperate struggle for survival. They formed a Military Council, a minority of trusted conspirators within the IRB.

The IRB itself was a minority within the Irish Volunteers. The plans for the Rising were therefore laid by a secret group that concealed its intentions from the leadership of both the IRB and the Volunteers. They took James Connolly and his tiny Irish Citizen Army into their confidence, lest the Citizen Army trip off its own rebellion, which it was threatening to do. As it transpired, Connolly was to prove the most forceful and most competent military leader among the leaders of the Rising.

The Rising was the seminal event. There can be no doubt that the British response to it was crucial in determining and defining the subsequent relations of our two peoples. General Maxwell's grave for a hundred bodies, dug at Arbour Hill, foreshadowing his intentions, was to remain largely unfilled, thanks to public feeling in England. As for Irish opinion, much of it was hostile at first, but sentiment quickly changed. All those political forces that approved of the Rising coalesced in a reconstituted Sinn Féin, which proceeded to win a series of by-elections before sweeping the country, except for Unionist seats in Ulster, in the general election of December 1918 that marked the close of the Great War.

During the war, conscription had been introduced in Britain but not in Ireland. It was a telling omission: the British government had good reason to believe that the introduction of conscription in Ireland would have resulted in severe social and political unrest; but by 1917 the military situation in Europe was so desperate that it felt impelled to grasp the nettle. The result was exactly as predicted. The mere threat of conscription—it was never introduced—hugely raised the stakes. It united every shade of nationalist opinion in opposition. John Redmond withdrew his party from the House of Commons in protest, implicitly granting Sinn Féin's point that attendance there was a waste of time for Irishmen.

This united nationalist coalition against conscription, which significantly included the higher clergy of the Catholic Church, was implicitly separatist. A once-in-a-generation shift in national sentiment was taking place. First the Rising, then the by-elections and finally the anti-conscription campaign destroyed the home-rule cause. The demand was now more radical: separation. Home rule or devolution was no longer sufficient and that new demand in its turn gave new energy to the Volunteers, by now known as the IRA. They reopened the fight with the Empire in January 1919, on the same day that Sinn Féin—the victors of the December election—declined to take their seats in the British Parliament and instead constituted themselves as Dáil Éireann, the Irish assembly, in Dublin.

The military campaign was met with what was euphemistically called a 'police action', to be endured by nationalist Ireland as the Black and Tans and the Auxiliaries were unleashed on the civilian population.

In the middle of the War of Independence in the south there occurred the tragic partition of Ireland. Did the British will it, in order to get shot of the 'Irish problem'? Or was it the product of a fatally divided Ulster and a fatally divided Ireland? Historians differ on this, but all acknowledge the sadness of sundering what had traditionally been a unity.

The new Northern Ireland, comprising six of Ireland's counties, was meanwhile to be born to the accompaniment of the most horrific inter-communal violence, directed mainly against the Catholic minority now trapped within the new Protestant statelet—and directed moreover by the official forces of that statelet in a vicious campaign of lawlessness and vengeance.

The Anglo-Irish truce, which ended the war in the south, was to be used for the regrouping and extending of forces on both sides. But here there was to be a very salient distinction. As that master of intelligence Michael Collins knew, the mismatch of forces left the IRA in a position of greater weakness than their opponents. His inability to communicate this to Republicans remains the most tragic feature of his career, leading ultimately to his death. The imperialist extremists in the English Tory party proved too powerful to allow any compromise. Although Lloyd George—no saint he—was a Liberal, the Tories were a majority in his coalition government.

All this bore on the Irish response to the Agreement signed at Downing Street in December 1921. It established the Irish Free State and provided what Collins called 'the freedom to achieve

freedom.' But it fell short of the full republican demand and was therefore regarded by a large minority of nationalists as a violation and betrayal, not only of the martyrs of 1916, but of the oath of allegiance to the Republic that all members of Sinn Féin had taken. This was the basis of the Civil War split.

The internal pressures that caused this split were matched by external pressures exerted by London on the nascent Free State to ensure internal security in its territory. This British pressure on Collins was an important trigger in setting off the Civil War. All nationalist factions were desperate to avoid a civil conflict. It might not have been possible to do so, given the hot passions of the time, but the clumsy threats from the British government did not help. Specifically, the threat to redeploy British troops—which had been withdrawn or confined to barracks since the truce—was recklessly provocative.

Cogadh na gCarad—the War of the Friends—should never have been allowed to happen; but happen it did, and this in spite of the many attempts made to prevent it. Not least of these was the proposed meeting in the vicinity of Skibbereen between Collins and de Valera that never happened. One thing we have to be grateful for is the undoubted fact that there was overwhelming external intervention on one side only. That saved us from experiencing the horrors of Spain, and consequently we were enabled to take recuperative action sooner.

The border that was drawn in 1920 is still there. A provision in the Anglo-Irish Treaty allowed for the establishment of a Boundary Commission to review its details. This raised hopes in the Free State that the commission would so alter the border as to render Northern Ireland an enfeebled and unsustainable rump. The same thought struck fear in Unionist hearts. In the event, the commission proposed only minor transfers of territory, and even these were regarded as too politically explosive to justify such modest adjustments. Its report was quietly shelved and suppressed.

After the years of revolution came the decades of quiet as the two Irish states subsided into an existence of mutual distrust and suspicion. What had happened in the first quarter of the twentieth century had been transformative. It had made Ireland anew—the only Ireland that we now know.

PROLOGUE

The Ancient Greeks put it succinctly in two short words: *Panta rei*—'All flows.' So it ever is with human affairs: constant change and renewal. Those who would wish to nail the hands of the clock to its face are up against a very serious problem indeed! The inexorable pressure exerted by time obliges the restrained hands eventually to move forward with disruptive violence.

This book attempts to deal with just such a period of recent Irish history, when these conditions prevailed, and to give a coherent account of them through surviving photographs.

In order to arrive, with due understanding, we may begin at a time only a few short years from when permanent photography was invented. Let us start in 1845, when the first photographs of Irish interest are to be had.

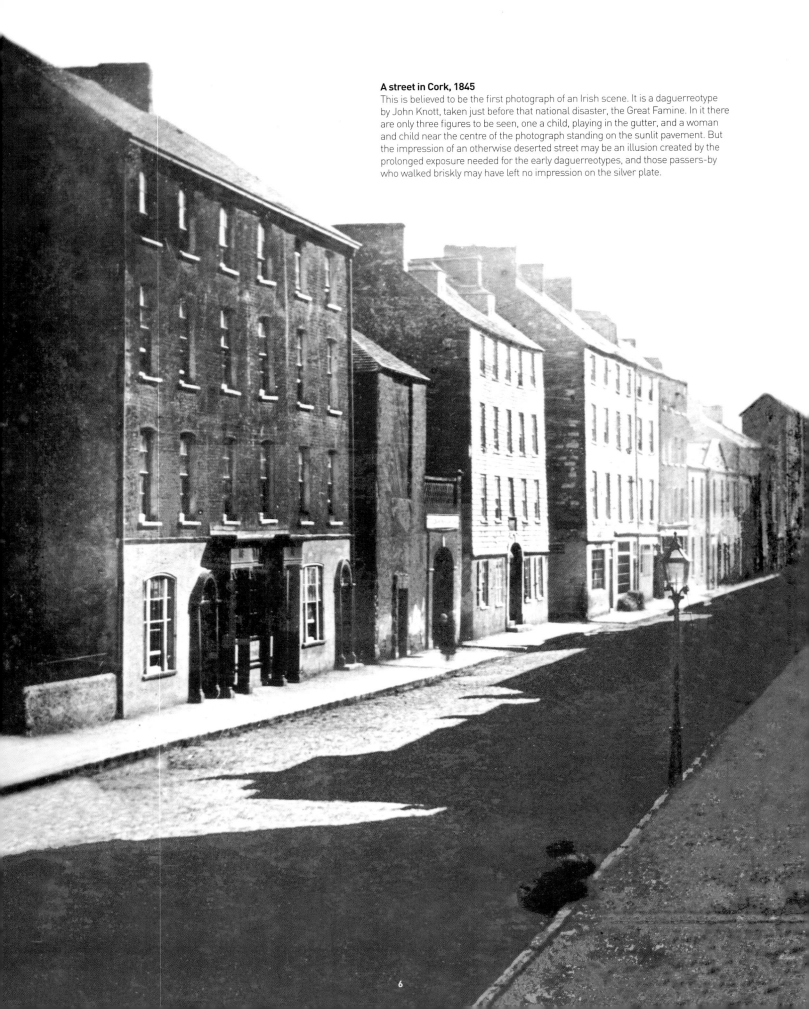

A street in Cork, 1845
This is believed to be the first photograph of an Irish scene. It is a daguerreotype by John Knott, taken just before that national disaster, the Great Famine. In it there are only three figures to be seen, one a child, playing in the gutter, and a woman and child near the centre of the photograph standing on the sunlit pavement. But the impression of an otherwise deserted street may be an illusion created by the prolonged exposure needed for the early daguerreotypes, and those passers-by who walked briskly may have left no impression on the silver plate.

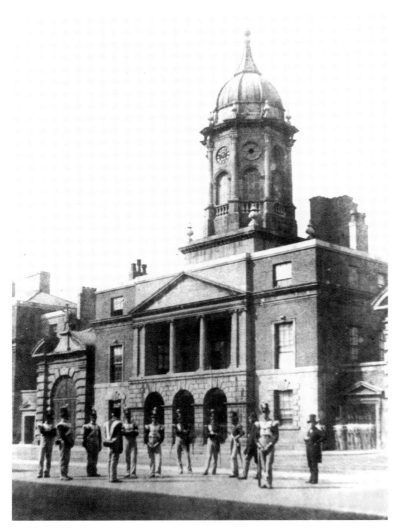

Soldiers on guard duty at Dublin Castle, 1845
Also thought to be pre-Famine photographs are the series of
excellent calotypes taken by the English pioneer of photography
William Henry Fox Talbot, the inventor of the process. Here he
shows the changing of the guard at Dublin Castle. Almost since
its construction began in 1204 Dublin Castle had been the chief
centre of English administration in Ireland. The guard going
off duty can just be seen, a little blurred from their movement,
at the bottom right. Fox Talbot, being a relation of the Talbots
of Malahide, was a frequent visitor to Ireland, and many fine
calotypes of his are preserved in collections both here and abroad.

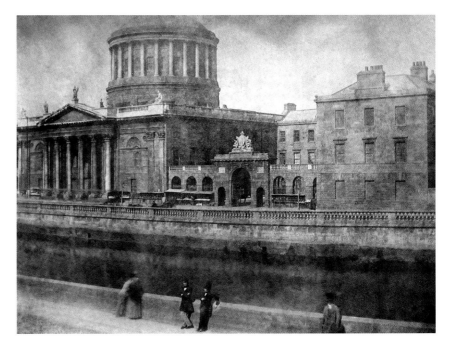

The Four Courts, Dublin, with bookstalls in front, 1845
As Dublin Castle was the chief seat of English power, so
the Four Courts at Inns Quay were the main centre for
administering English law in Ireland. Begun in 1785, one of the
many fine works by the architect James Gandon, the building
was completed in 1801. Fox Talbot's photograph shows the
building slightly disfigured by the many bookstalls, containing
mainly law books, along quite a stretch of its river elevation.
In the immediate foreground are several citizens enjoying the
sunshine, without the diesel fumes that would be an inevitable
accompaniment today.

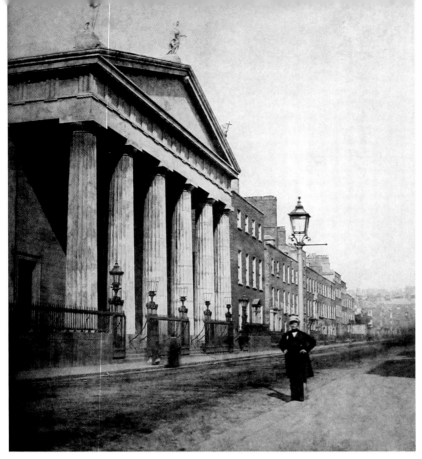

The Pro-Cathedral, Marlborough Street, Dublin, 1845
Owing to the unfortunate vicissitudes of Irish history, the reformed churches were in possession of all the ancient cathedral churches in Dublin, and consequently the Catholics were deprived of a cathedral of their own. As a partial remedy, this fine building with the severely Ionic style of portico was completed by the architect Sir Richard Morrison from the original design of John Sweetman, with alterations, just about the time this photograph was taken. Clearly seen is one of Dublin's original gas lamps, with a support for the lamplighter's ladder at the right-hand side only. Only two of the six lamps designed to light the entrance to the Pro-Cathedral appear to be functioning.

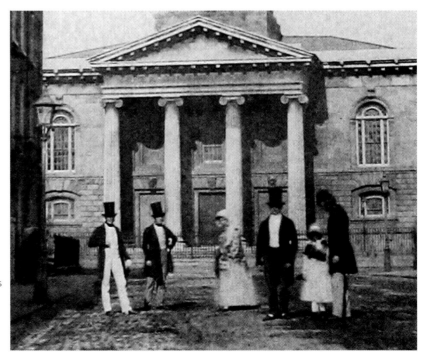

Hardwicke Place and St George's Church, Dublin, 1845
In this detail from Fox Talbot's pre-Famine series of calotypes of Dublin, a family party is seen assembling at the head of Hardwicke Street. The building in the background is St George's Church, built by the architect Francis Johnston in 1802 and one of the loveliest churches in Ireland, said to resemble in its spire St Martin in the Fields, London.

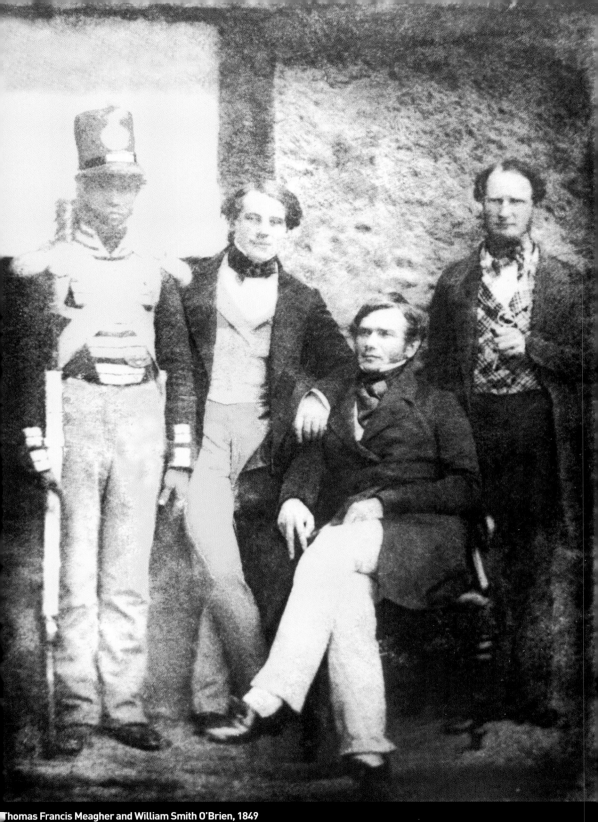

Thomas Francis Meagher and William Smith O'Brien, 1849

This, a calotype taken by an unknown photographer, is the only authentic photograph to show the leaders of 'Young Ireland' during their imprisonment in Tasmania. On the left is seen a British soldier armed with a musket. Next comes Thomas Francis Meagher (standing) and William Smith O'Brien (seated), and then their jailer, carrying a large key as a symbol of his office. There was such a demand for copies of this photograph that it led to several faked versions being made with actors. The author has seen two of these productions

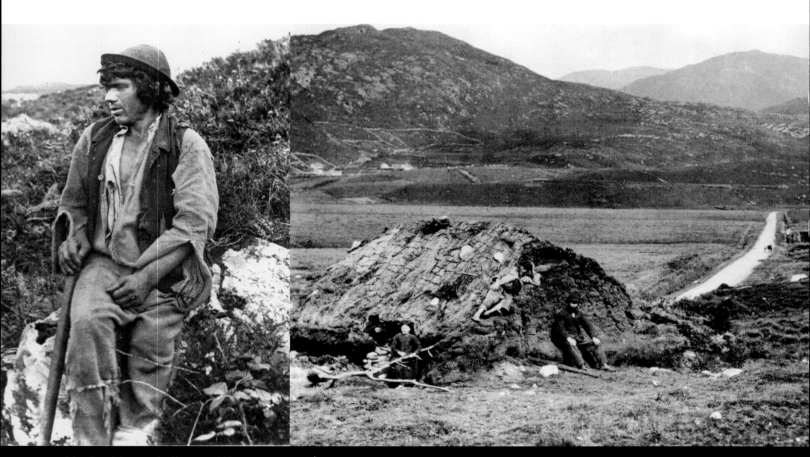

A landless labourer, Co. Kerry, c. 1860
A labourer is seen here, in an early wet-collodion-process photograph, with his most treasured possession: his spade. This unfortunate man, almost the poorest of the poor, typifies the condition to which many Irish people of both sexes were reduced by the Famine and for many years after it. Many more had left Ireland permanently in the vast wave of emigration that ensued, which was to set the pattern for many years to come.

A 'black-house', Co. Mayo, c. 1860
The tenacity with which Irish people clung to the land is very well exemplified by this picture of a 'black-house' in Co. Mayo in the 1860s. An evicted tenant and his family have built themselves a traditional black-house by excavating the ground in a rectangular area and surrounding the area with a pile of turf cut from an adjacent bog and dried in the sun. The roof is supported on the forked branches of trees, upon which have been laid strips of turf, and these in their turn have been covered with rushes fastened to light battens of wood. The whole is overlaid with strategically placed large stones as a precaution against prevailing gales.

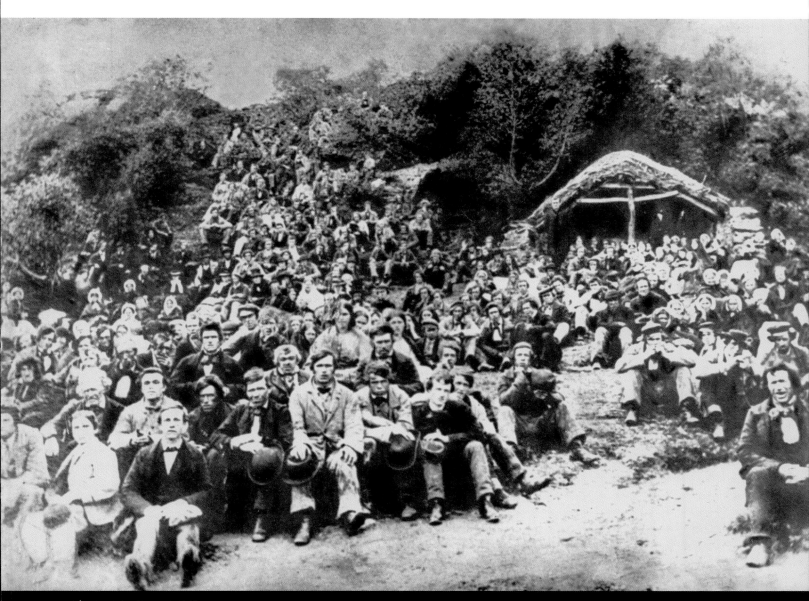

A 'scallon', Co. Donegal, 1867
The tenacity with which people clung to the land was matched only by that which they showed in remaining attached to their religious faith. The 'Mass rock' and 'scallon' were both products of the seventeenth-century Cromwellian persecution, affecting all Catholics and thus the majority of the Irish people. The Mass rock was any flat-topped rock that lent itself to use as an altar; the scallon was a temporary shelter built above such a rock to afford some protection for the officiating priest and his assistants. When Catholics were forbidden to worship in churches, open-air gatherings of this kind were commonplace throughout Ireland.

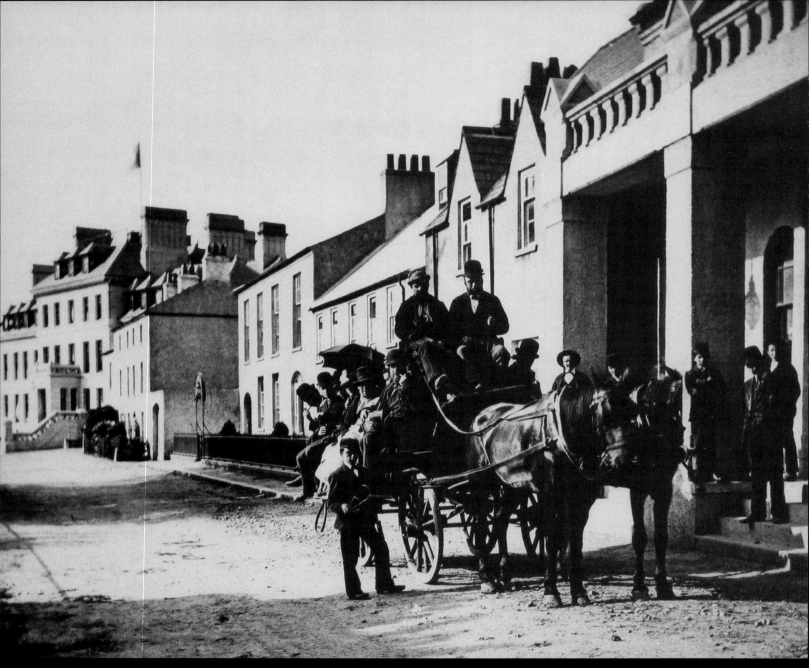

A Bianconi car at Clifden, Co. Galway, 1865
The first railway in Ireland was built in 1834, and although this was to be quickly followed by other lines they at first served only the chief trunk routes. An enterprising Italian immigrant, Charles Bianconi, seized his chance and launched a service operated with large four-wheeled side-cars, running at first between Clonmel and Cahir, Co. Tipperary. Its social usefulness was such that it quickly spread to all parts of Ireland. This is a Bianconi car that connected Galway with Clifden—a service that was to remain longer than any of the other routes. Although one might suppose this car to be fully loaded, it is not. Bianconi had secured a contract for delivering the mails to many parts of Ireland, and all his cars carried a special strong-box devoted to this purpose. It had a flat top that could accommodate, in an emergency, five or even, it is said, six more passengers. But spare a thought for the poor horses shown in the photograph!

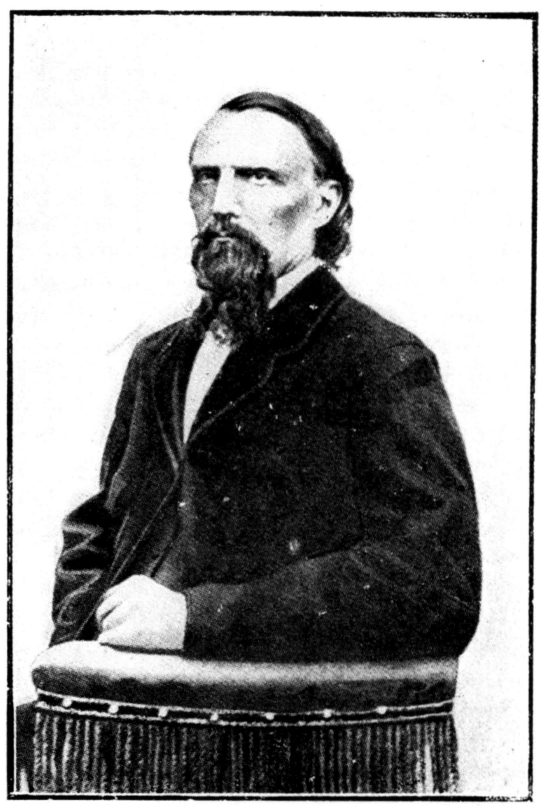

John O'Mahony
Ever since the accomplishment of the American and French Revolutions the republican ideal had been proposed as more appropriate than any other for Ireland. In 1858 an American of Irish descent, John O'Mahony, gathering together those who survived from the Rising of 1848, founded a new grouping, the Irish Republican Brotherhood. It was to be a secret, oath-bound society, devoted to the establishment of a sovereign and independent republic in Ireland and having the support of a newly founded political body in the United States, Clan na Gael.

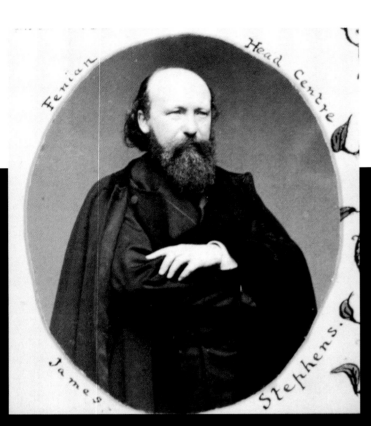

James Stephens, Head Centre for Ireland

James Stephens, who had taken part in the 1848 Rising, was appointed Head Centre for Ireland, with full organising powers. He at once set about work, travelling the length and breadth of the country, holding secret meetings and getting much support. Those who followed him at this time came to be called Fenians. Stephens was not careful enough, however, to avoid his new recruits being infiltrated by British agents, the consequence of which was that in 1865 the principal leaders in Ireland were arrested and given long terms of penal servitude; and when, in 1867, the uprising took place it was a disaster. For this turn of events the credit must rest largely with a body of men first established in 1822 and reformed in 1836: the Royal Irish Constabulary. This armed paramilitary force, with barracks in all the principal towns and even villages, was instrumental in feeding information to Dublin Castle about all that was going on in the entire country.

Prison photograph of a Fenian

Here is a prison photograph of one of the rank-and-file members of the Fenians, Edward O'Madeoig.

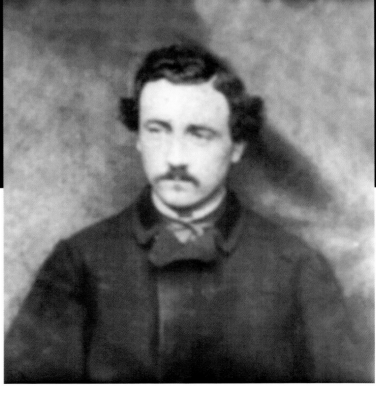

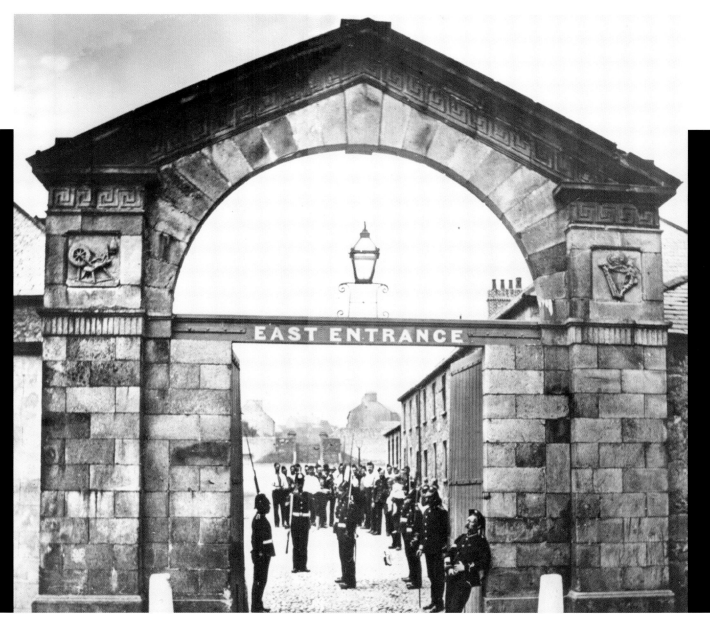

A British army barracks in Ireland, 1870
Ireland's continuing colonial status is made plain in this wet-collodion-process photograph of one of the British army barracks scattered throughout the country. While the Royal Irish Constabulary continued to be the chief source of intelligence, the British army in Ireland and the Royal Navy had their own intelligence services too, though these did not co-operate as closely with cne another as might have been expected, and this gap tended to widen as the years went on.

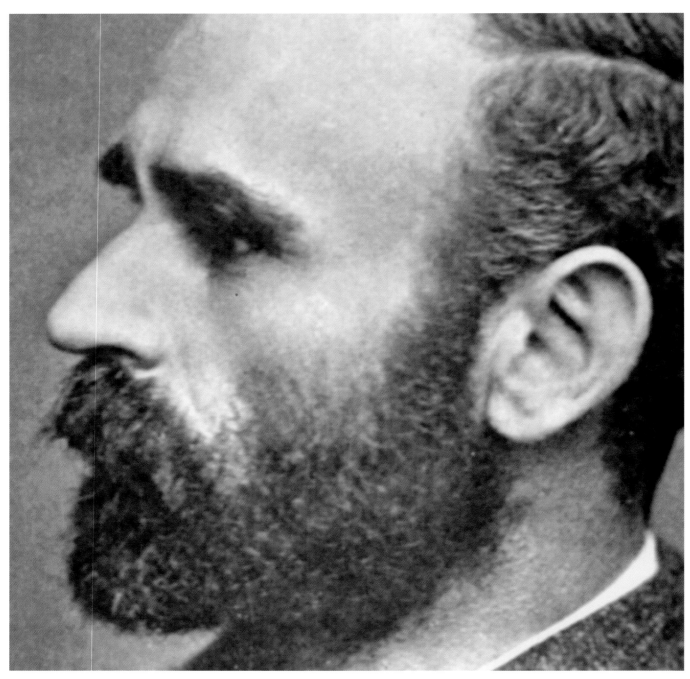

Michael Davitt, c. 1880

This remarkable man, born to a small-holding family at Straide, Co. Mayo, at the very height of the Great Famine, was to experience at the tender age of four-and-a-half a most painful event: being evicted from his home. After a brief stay in the local workhouse the family moved to England in 1850. Here, in 1857, as a child labourer in a spinning-mill, Davitt suffered an industrial accident that caused him to lose his right arm. In spite of this appalling experience, with the help of patrons he gained access to a Wesleyan Methodist school and, thus prepared, to a job with a printer, where he learnt to set type. But the real purpose of his life was made clear to him when, by attending night school at the local Mechanics' Institute, he developed an interest in Irish social history and at the same time was influenced by the great Chartist leader Ernest Charles Jones, who became his friend and supporter.

In 1865 Davitt joined the IRB, becoming organising secretary for northern England and Scotland in 1867. In 1870, while awaiting a delivery of arms destined for Ireland, he was arrested and charged with treason-felony. He received such harsh treatment in prison that his case, among those of other prisoners who were serving similar sentences, became the subject of a public outcry, leading to their release in 1877.

Davitt was in the United States in 1878, giving lectures on Irish affairs, but returned to Co. Mayo in 1879, where, with the support of Charles Stewart Parnell and others, he founded the Land League and took a prominent part in its activities against evicting landlords. In 1891 he joined the anti-Parnell faction and in the same year founded the Irish Democratic Labour Federation, subsequently giving lectures in many parts of the world. Few people can have survived such a traumatic childhood and gone on to become such conspicuous ornaments to the cause of social progress.

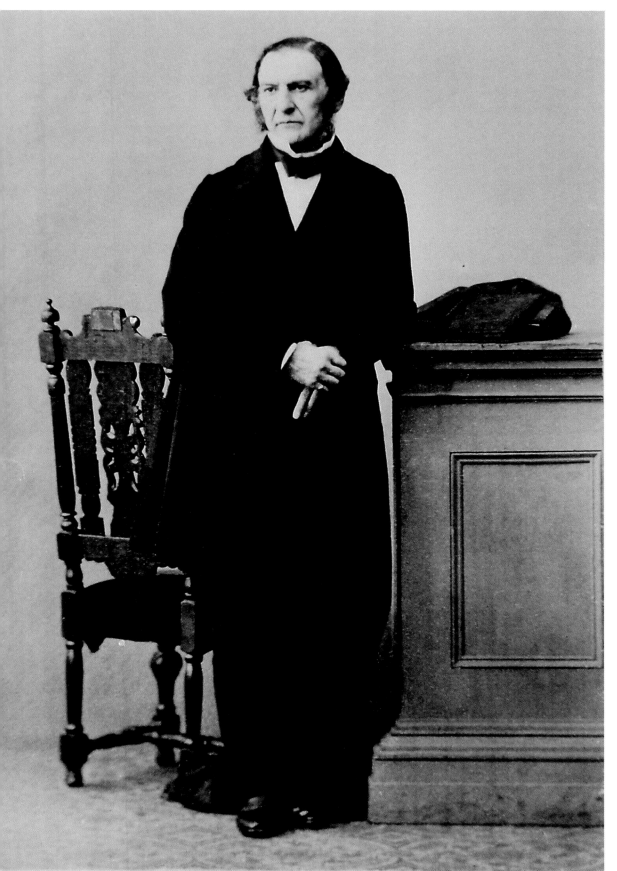

William Ewart Gladstone, c. 1870
This astonishingly able politician, whose active political life spans more years than that of almost any other British political figure, was first elected to Parliament as a member of the Tory party in 1832. The Tories split over Sir Robert Peel's repeal of the Corn Laws in 1846. Gladstone became a Peelite and a strong supporter of free trade. In 1859, the Peelites were one of the constituent elements of the new Liberal party, which he led from 1867. On becoming Prime Minster for the first time, in 1868, he is said to have exclaimed, 'My mission is to pacify Ireland.' In 1870 his government introduced the Landlord and Tenant (Ireland) Bill, as well as legislation that ensured the secrecy of the ballot. But Gladstone's hopes of bringing peace to Ireland were to remain unfulfilled, in spite of his sincere wish to do so, by the continuing opposition of the Tories and Liberal Unionists, who united to bring about the fall of his government in 1886. After six years in opposition he was returned to power in 1892 and the following year succeeded in getting his second Government of Ireland Bill passed by the House of Commons, only to see it defeated in the House of Lords. His eyesight beginning to fail, in 1894 he resigned as Prime Minister and in 1898 died at his wife's home, Hawarden Castle, in Wales.

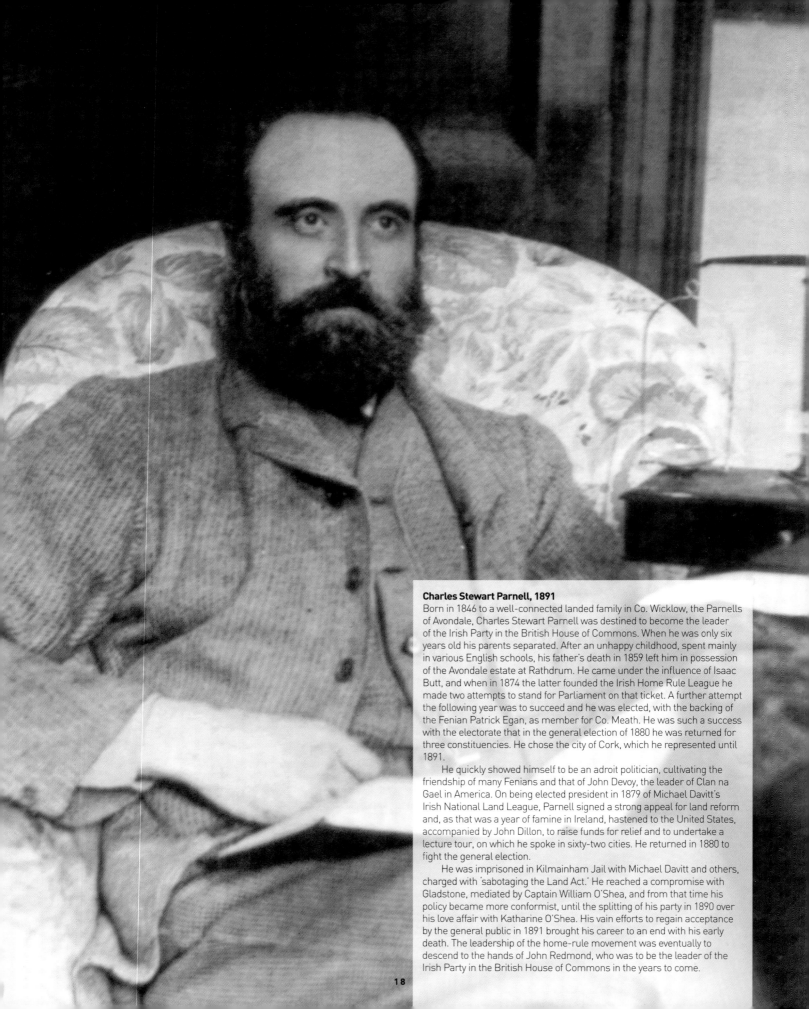

Charles Stewart Parnell, 1891

Born in 1846 to a well-connected landed family in Co. Wicklow, the Parnells of Avondale, Charles Stewart Parnell was destined to become the leader of the Irish Party in the British House of Commons. When he was only six years old his parents separated. After an unhappy childhood, spent mainly in various English schools, his father's death in 1859 left him in possession of the Avondale estate at Rathdrum. He came under the influence of Isaac Butt, and when in 1874 the latter founded the Irish Home Rule League he made two attempts to stand for Parliament on that ticket. A further attempt the following year was to succeed and he was elected, with the backing of the Fenian Patrick Egan, as member for Co. Meath. He was such a success with the electorate that in the general election of 1880 he was returned for three constituencies. He chose the city of Cork, which he represented until 1891.

He quickly showed himself to be an adroit politician, cultivating the friendship of many Fenians and that of John Devoy, the leader of Clan na Gael in America. On being elected president in 1879 of Michael Davitt's Irish National Land League, Parnell signed a strong appeal for land reform and, as that was a year of famine in Ireland, hastened to the United States, accompanied by John Dillon, to raise funds for relief and to undertake a lecture tour, on which he spoke in sixty-two cities. He returned in 1880 to fight the general election.

He was imprisoned in Kilmainham Jail with Michael Davitt and others, charged with 'sabotaging the Land Act.' He reached a compromise with Gladstone, mediated by Captain William O'Shea, and from that time his policy became more conformist, until the splitting of his party in 1890 over his love affair with Katharine O'Shea. His vain efforts to regain acceptance by the general public in 1891 brought his career to an end with his early death. The leadership of the home-rule movement was eventually to descend to the hands of John Redmond, who was to be the leader of the Irish Party in the British House of Commons in the years to come.

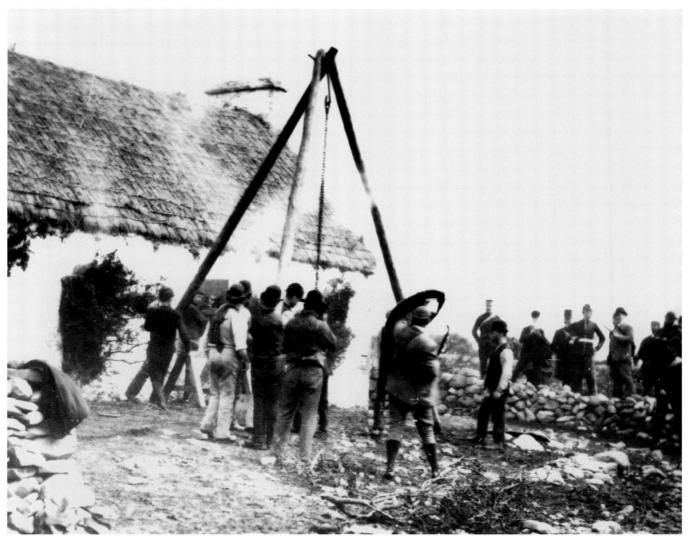

An eviction in Co. Donegal, 1899
In spite of the efforts of Gladstone and Parnell, evictions continued to prevail, as this photograph of one taking place in Co. Donegal shows. Indeed one may say that, because of Gladstone's policy of breaking the Land League, they became more frequent as the league declined in strength. A tripod has been set up to allow the dreaded battering-ram to be swung against the door or the wall. Furze bushes have been thrust through windows by the besieged inhabitants to provide an improvised screen for the throwing out of boiling water, the steam from which is visible. A well-dressed man in the foreground uses a shield to protect his head, while further in the background, to the right, soldiers and police consult the bailiff and others. Note too that the battering-ram team is composed of ordinary labourers.

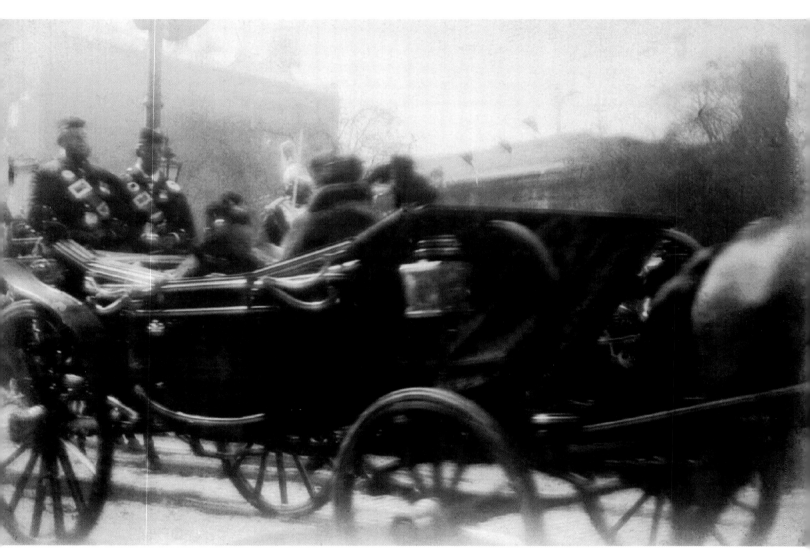

Queen Victoria in Dublin, 1900
At the climax of the British victory over the Boers in 1900, it was decided that the Sovereign should pay a state visit to Dublin. Seated behind her in the open landau at the extreme left is the bearded figure of John Brown, her favourite Scotsman, without whose presence she was not accustomed in the later years of her reign to make any considerable journey. This rare photograph, published here for the first time, was taken by a young man who was later to become a distinguished scientist, author and playwright, Prof. William Robert Fearon.

PART 1

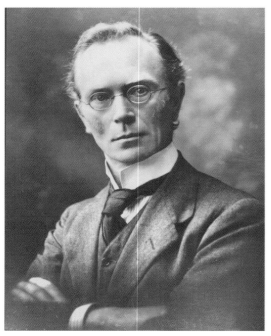

Prof. Eoin MacNeill, c. 1893
Eoin MacNeill held the chair of early Irish history at the
National University of Ireland. With Dr Douglas Hyde, a scholar
and poet from Co. Roscommon, he jointly founded the Gaelic
League (Conradh na Gaeilge) in Dublin in 1893. Both were men
of distinction; MacNeill went on to be chief of staff of the Irish
Volunteers, and Hyde became first President of Ireland in 1937.
Conradh na Gaeilge is still flourishing, being concerned in the
teaching of Irish and the promotion of cultural events.

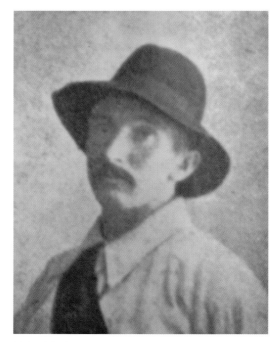

Major John MacBride
MacBride was born in Westport, Co. Mayo, in 1868, son of
the owner of a small general business. A member of the
IRB, he went on a visit to the United States in 1896 and
after his return he emigrated to South Africa and settled
there. He helped the Boers to organise the Irish Transvaal
Brigade under its first commanding officer, Colonel John
Blake, and when the latter stepped down he took command
himself. In 1903 he was in Paris, where he met and married
Maud Gonne. After the failure of the marriage he returned
to Ireland but, being in British eyes a marked man, was
excluded from the councils of those planning the 1916
Rising. It was only on the very morning of the Rising that he
learnt what was going on and volunteered to take his part.

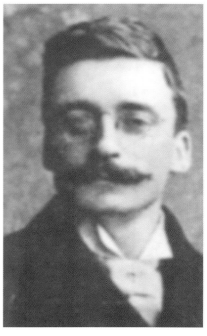

Arthur Griffith, c. 1901
The young journalist Arthur Griffith, who had
just returned from the Boer Republics, had
very trenchant views about Queen Victoria's
visit to air in his newspaper, *the United
Irishman,* of which he was also the proprietor.
'The Queen of England, guarded by the
remains of her army, her sailors and police
has entered Dublin. In order to ensure her a
welcome in the city which for forty years she
has, happily, kept away from, it was placed
under military law.'

Maud Gonne, c. 1901
Edith Maud Gonne, only child of Captain (later Major) Thomas Gonne of the 17th Lancers, was born at Tongham,
Surrey, in 1866. After her mother's death when she was only a young child her father sent her to a boarding-
school in France. Posted to Ireland in 1882, Major Gonne began a career as a minor diplomat, taking his
daughter abroad with him, and in Paris in 1889 she met for the first time William Butler Yeats, after which she
played an active role in the Land League. Revisiting France in 1890, she renewed her relationship with Lucien
Millevoye, a politician of right-wing views. In 1891 she was in London, where, under Yeats's influence, she joined
the Hermetic Society of the Golden Dawn. In 1892 she returned to Paris and to Millevoye, with whom she had
two children, of whom only the younger, a daughter born in 1894, survived.

 After several years of travel, during which she visited England, Wales, Scotland and America, her political
life may be said to have begun with a protest against the celebration of Queen Victoria's Diamond Jubilee, and
two years later her relationship with Millevoye ceased. In 1900 she founded a national organisation for Irish
women, Inghinidhe na hÉireann, in 1902 she became a Catholic, and the following year, in Paris, she married
Major John MacBride. Henceforth her life was to be devoted to furthering the cause of Irish republicanism.

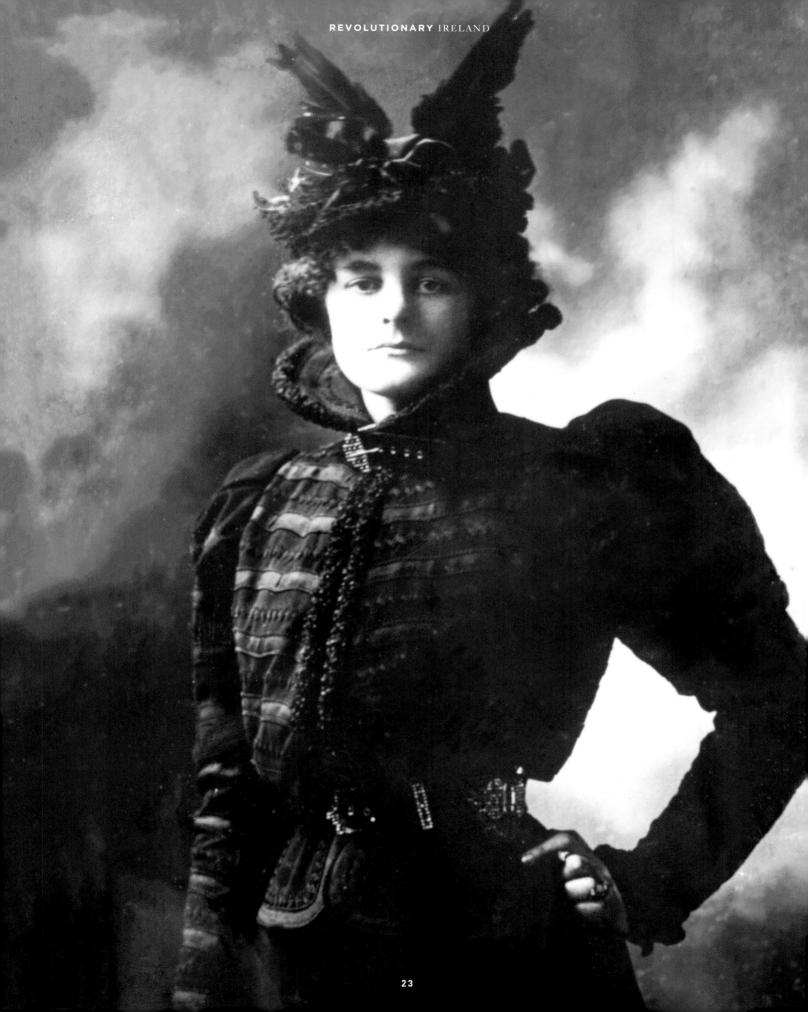

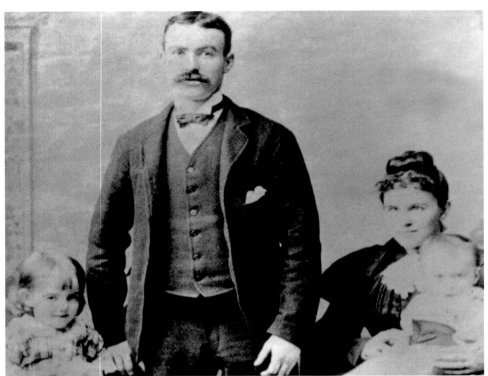

James Connolly and family, 1901
Born to Irish parents in Edinburgh in 1868, James Connolly had an early experience of life not unlike that of Michael Davitt. Like Davitt he was a child labourer, and like Davitt also, being of a studious nature, he educated himself by much reading. He was from the start a young man of great character and a committed socialist. After his marriage he returned to Ireland in 1896 as a socialist organiser and founded the Irish Socialist Republican Party and edited Ireland's first socialist newspaper, the *Workers' Republic*, from 1898.

Patrick Pearse, 1903
This altogether remarkable young man, seen here after taking his degree as a barrister in 1903, went on to edit the Gaelic League's newspaper and to become one of the leading figures in the republican movement. He became interested in education; his book *The Murder Machine* is an open criticism of English educational methods, which in his view were intended to further imperial designs. He founded St Enda's School, first at Cullenswood House in Ranelagh, later at Rathfarnham. After visiting America, where he became a member of the IRB, Pearse was further drawn into the cause of Irish nationalism and in 1913 joined the Irish Volunteers, where a career of the utmost distinction awaited him. Pearse was also a poet. It is a really surprising thing that so many of those executed for their part in the Easter Rising were to be so described, among them Roger Casement, Thomas MacDonagh and Joseph Plunkett.

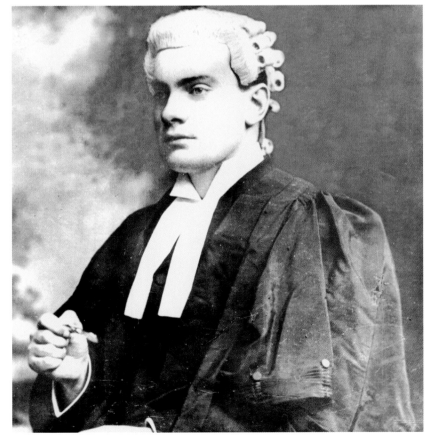

Sir Roger Casement, 1903

Roger Casement, born in Co. Dublin and reared in Co. Antrim, began h s diplomatic career by serving in the British Consular Service in Africa. While there he was appointed to inquire into the atrocities committed against the people of the Congo Free State, a vast territory then the private property of King Leopold II of Belçium. The result of his conscientious and perilous investigation was to confirm and augment to the fullest extent the accounts of the many unspeakable depredations and cruelties taking place there. His report was published in 1903, when this photograph was taken.

Some years later Casement was asked to make a report on conditions in the Putumayo region of Peru. This time it was a British company that was involved in the exploitation and expropriation of the Amazonian Indians. The account of conditions that Casement gave was equally devastating. He returned to London, where his second report was published by order of Parliament in 1912, and for his work he was knighted.

Feeling more and more alienated from imperialism, Casement threw himself wholeheartedly into the Irish republican cause. He accepted the position of treasurer of the Irish Volunteers and, together with Molly Childers and Alice Stopford Green, began fund-raising to buy arms. In 1914 he was in New York, meeting members of the IRB, who sent him on a secret mission to Germany, where he founded an Irish Brigade among prisoners of war in the internment camps there. In 1916 he returned to Ireland by German submarine, just in time for the Rising, but was captured by the RIC. Sent to London, he was first imprisoned in the Tower, later transferred to Pentonville Prison, where he was hanged, a victim of the imperialism he had come to detest. His remains were repatriated to Ireland in 1965 and given a state funeral and are now interred in Glasnevin Cemetery, Dublin.

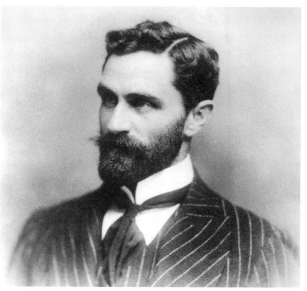

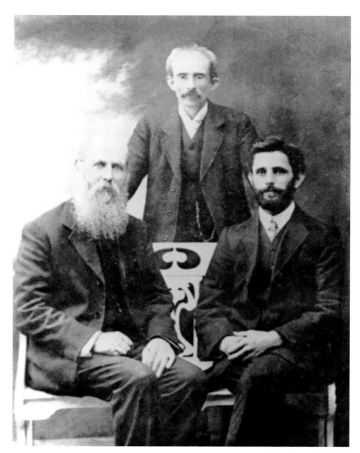

O'Leary, Clarke and Mac Diarmada

This unique photograph summarises the position of the revived Irish Republican Brotherhood in Ireland at the turn of the century: the two old Fenians Clarke and O'Leary, ever patiently waiting for the time when 'England's difficulty would be Ireland's opportunity,' with the young IRB member Seán Mac Diarmada.

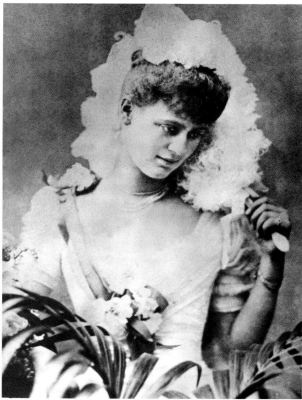

Constance Gore-Booth

Born in 1868 into a well-known landed family at their home, Lissadell, near Cloghboley, Co. Sligo, Constance Gore-Booth and her younger sister, Eva, were brought up with the greatest care and were accustomed to every privilege usually accorded to members of their class at the time. Here we see Constance in the ball dress she wore when being presented to Queen Victoria as a débutante. After 'coming out' she attended many of the levées and receptions given by the Lord Lieutenant at Dublin Castle. Being of a serious turn of mind, however, she became disappointed with the superficialities of court life. She made up her mind to study painting and for this purpose went to Paris, where she met her future husband, Count Casimir Markiewicz. The marriage, though it produced two children, did not prove to be a happy one, and she decided to devote the remaining part her life to the cause of Irish republicanism.

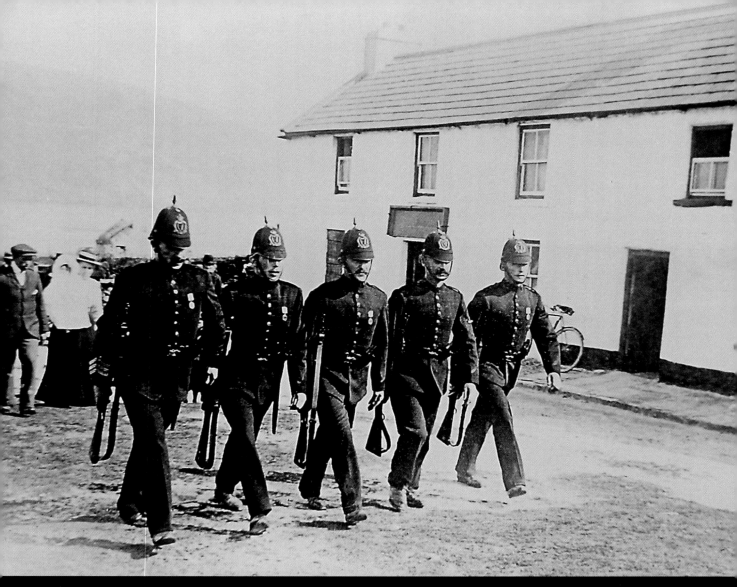

Royal Irish Constabulary at Annamoe, Co. Wicklow
The RIC remained the chief source that Dublin Castle was to rely upon for early warnings of unrest in the country, as witness this photograph of a sergeant and his platoon marching up the main street of Annamoe, a village in Co. Wicklow. That county, being mountainous, always had a reputation for insurgency, the O'Byrnes, O'Tooles and O'Dwyers making frequent raids on the city and its outskirts. After the rebellion of 1798 the British built a military road into the heart of Co. Wicklow, from Rathfarnham to Aghavanna, passing near to Annamoe, so that troops could be deployed with the utmost speed.

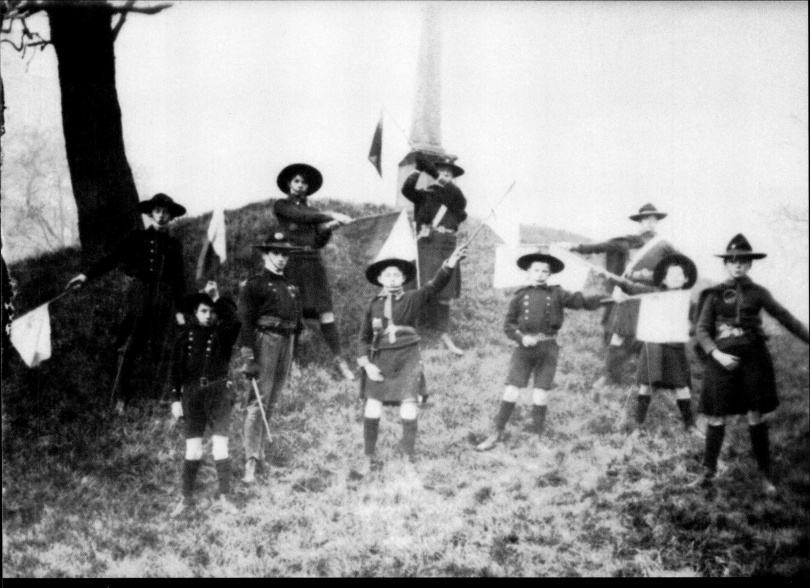

Fianna Éireann boys at the Rotunda Gardens, Dublin, 1909
As Maud Gonne had worked to organise Irish women in Inghinidhe na hÉireann, so Constance Markievicz in 1909 began to form a truly national scouting movement, Fianna Éireann. Sir Robert Baden-Powell's Boy Scouts Association had been founded less than a year earlier. In the beginning she concentrated her efforts on boys with a Dublin city background, as this rather posed photograph of them practising flag-signalling shows. Among one of the first members was the youthful Liam Mellows (third from left with drawn sword), who was to do so much in later years to promote the spreading of the movement throughout the country.

Unionist meeting at Balmoral, outside Belfast, 1912

'All flows,' as the Ancient Greeks said; and the world of politics is no exception to this rule. The 'Liberal Unionists' (so they called themselves) who, with the Tory party, brought about the fall of Gladstone's government in 1886 by opposing his first Government of Ireland Bill, were to join forces officially with the Conservative Party a little later, forming a united bloc in the House of Commons called the Conservative and Unionist Party, which remained opposed to this legislation in any shape or form. In 1911, when the Prime Minister Herbert Asquith succeeded, with the help of the Irish Party, in passing a bill that abolished the veto power of the House of Lords, which had thus far blocked home rule for Ireland, this powerful group was up in arms.

Immediately a monster meeting was planned for Balmoral, outside Belfast, to take place on 9 April 1912, to which the leader of the Conservative and Unionist Party, Andrew Bonar Law, was invited. Sir Edward Carson, a Dublin barrister who had fully espoused the Irish Unionist cause and become widely recognised for so doing, was there with Lord Londonderry and many other distinguished Unionists to greet him. It was a measure of the insecurity felt by almost the whole of the Protestant community in the north at this time that more than 80,000 people attended the meeting. Bonar Law's message to the vast assembly was in essence a simple one. He told them: 'You hold the pass, the pass for the Empire!'

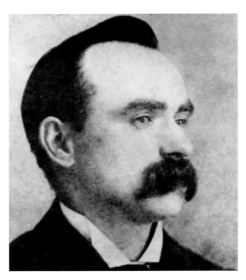

James Connolly, 1910

From 1903 to 1910 James Connolly was in America, working for the Industrial Workers of the World, editing the *Harp* and founding an Irish Socialist Federation. On his return to Ireland he formed a close association with James Larkin, co-operating with him in his efforts to unionise Irish workers and accepting the position of organiser for Ulster in Larkin's ITGWU. He was thus in the right place to observe what may be called the outbreak of proto-fascism in that province.

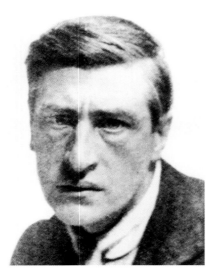

James Larkin

'Big Jim Larkin', as he was later to be called on account of his tall stature, was a true giant of the Irish labour movement. In 1909 he founded the Irish Transport and General Workers' Union (its first letter-heading depicted a Blériot monoplane) and he set himself the task of inviting into the membership as many of the dock workers and transport workers as he could get. Very soon, however, he encountered opposition to his efforts from shipping interests, coal merchants, tramway owners and newspaper proprietors, which was to culminate in the great strikes and lock-out of 1913.

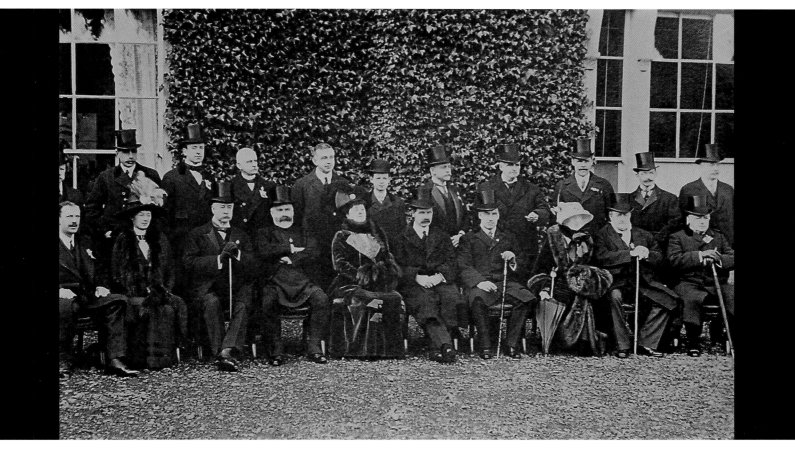

The Londonderrys' house party at Mountstewart, 1912
To make their support more evident still, Lord and Lady Londonderry assembled the upper crust of Unionism, together with Bonar Law and his son, at a house party at Mountstewart on Strangford Lough. Here we see them all gathered for the solemn occasion. The Marquis of Londonderry is seated, third from the left; next on the right comes the Church of Ireland Primate, Dr John Crozier; next Lady Londonderry, seated beside Mr Bonar Law, whose son stands behind them wearing a bowler hat (not being yet privileged to wear a top hat); then Sir Edward Carson. Seated on the extreme right with neatly rolled umbrella is Admiral Lord Charles Beresford of the well-known Co. Waterford family.

But it is well to remember that there was at this time a far rougher side to life. On the anniversary of the Battle of the Boyne, 12 July, a pogrom took place in Belfast that resulted in approximately two thousand Catholics being forced to leave their jobs in the Harland and Wolff shipyards. James Connolly, who had worked so hard and consistently to avoid the horrors of sectarianism, must have been devastated. He returned to Dublin to give help to his friend Jim Larkin.

The Ulster Volunteer Force drills, Belfast, 1912

Two months later the Ulster Volunteer Force was already drilling. The speed with which this operation was got under way was astonishing and argues long and efficient preparation. Their military training was undertaken by serving officers of the British army as well as by many ex-servicemen of all ranks. This amateur photograph shows something else besides: the militarisation of the bowler hat! At first their drill was performed with wooden staffs the approximate length of rifles; later these were to be replaced when licences to bear arms were obtained from local magistrates.

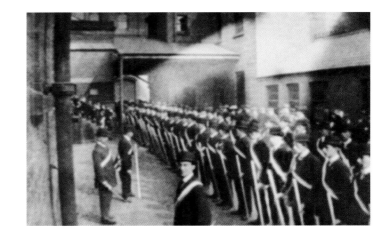

Carson signs the Ulster Covenant, 28 September 1912

The British government was so taken aback by these developments that it was almost powerless to take any action against them. Carson quickly followed up his advantage and a little over six months later was the first to sign his name to the Ulster Covenant, a document threatening in the clearest terms to oppose home rule for Ireland. The venue chosen was Belfast City Hall, and special lighting equipment was installed to ensure that the event would be suitably recorded for posterity. But 'the best-laid schemes o' mice an' men gang aft agley.' When Carson tried to place his signature on the document it was discovered that the special pen provided would not work. Quick as a flash, the young telegraph boy seen at the extreme right of the photograph whipped out his own pen, and with this Carson signed. Behind Carson's left shoulder stands Sir James Craig, and Admiral Beresford is seen, standing, the third figure from the right.

More than 237,000 male signatures were added to this document and almost as many female signatures to a similar pledge. Some enthusiasts, in a gesture more romantic than practical, are said to have signed in their own blood. All those signing were to be asked later for their services to oppose home rule.

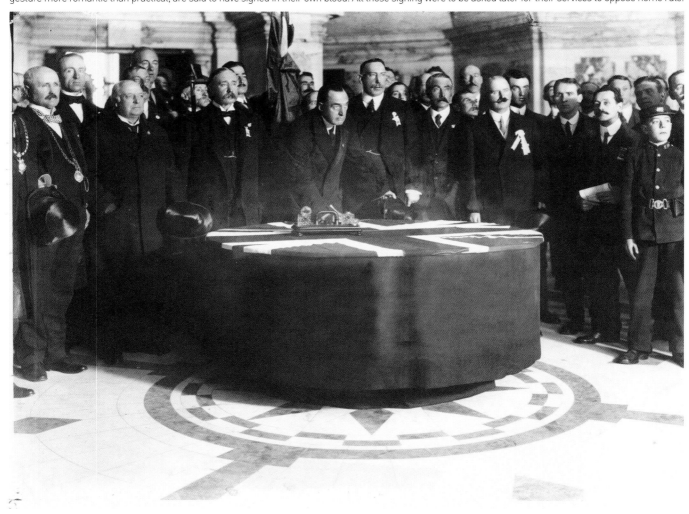

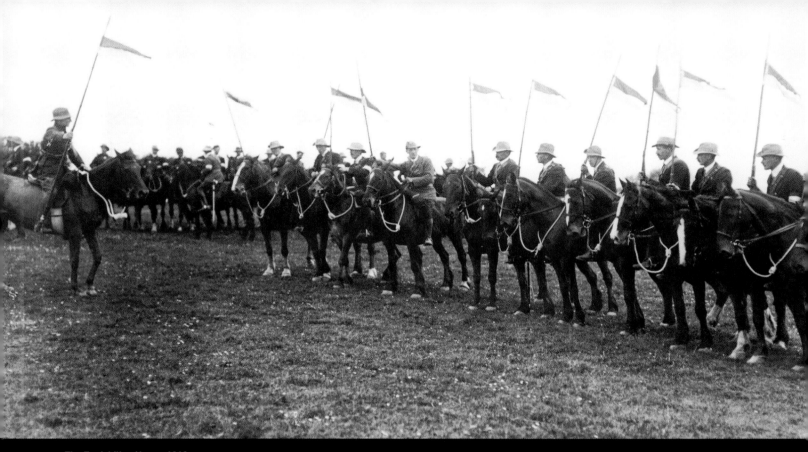

The Enniskillen Horse, 1913

It was like the legendary sowing of the dragons' teeth: armed men sprang up everywhere. Here are shown the Enniskillen Horse, a lancers regiment, drilling in 1913. This could never be attributed to accident: long-considered plans were coming to fruition. The organisation involved to bring all this about simply has to be admired. The smallest details were attended to. And all those very sharp-looking lances—where did they suddenly spring from? Money was involved, a great deal of money, even if the men themselves were volunteers. But what of the lessons learnt from the Battle of Colenso?

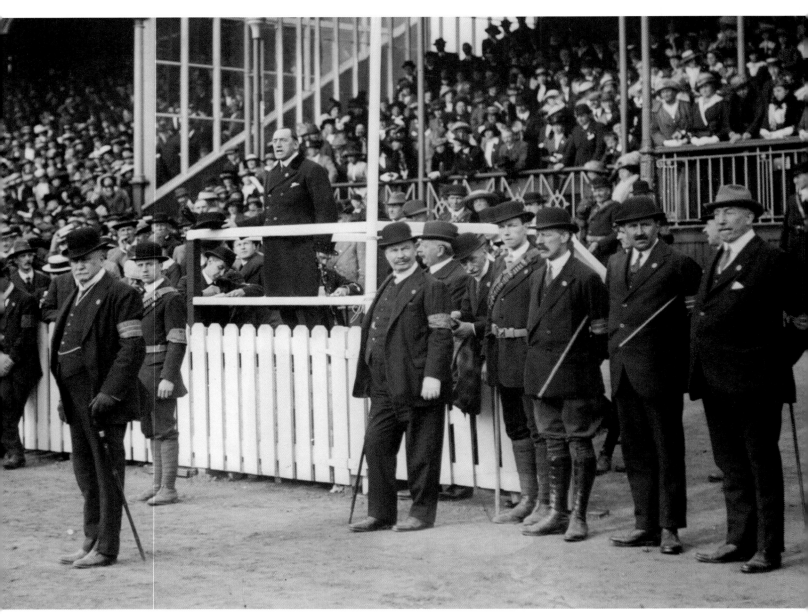

Carson speaks at Balmoral, 1913

Sir Edward Carson addressed a parade of the Ulster Volunteer Force at Balmoral in July 1913, when he expressed in the most vehement terms his opposition to home rule and the determination of the unionist community to fight, if necessary, against it. Immediately to the right is Captain Sir James Craig (later Lord Craigavon). The armbands worn by the majority of military gentlemen who form the foreground should be noted as evidence of the excellent organisation shown by the Unionists, as each designated their rank in the newly formed Ulster Volunteer Force, of which force no less a person than General Sir George Richardson consented to become Commander-in-Chief. He is seen in the immediate foreground, on the left, with a walking-stick.

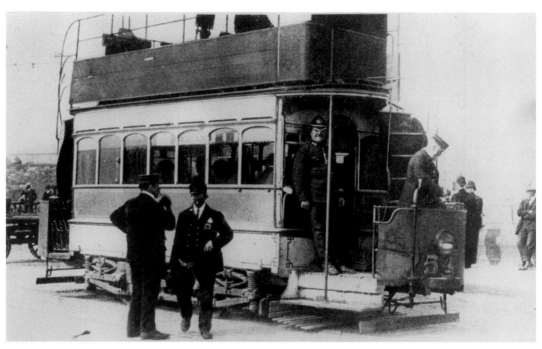

The Dublin tram strike, 1913

Dublin was one of the first cities to enjoy an electric tram service. At first it was provided by several rival private companies, but these were amalgamated into one when the Dublin United Tramways Company was formed in 1904, thus establishing a monopoly that was owned eventually by William Martin Murphy. Mr Murphy had other interests too, and was prominent in the Dublin Employers' Federation. He owned the *Irish Independent* and was not without many other resources. Trouble arose when he refused to allow any tramway workers to join Larkin's ITGWU, with threats of instant dismissal for those who did so.

The strike spread rapidly to involve also typesetters, compositors and other staff at the *Independent*. Then the lock-outs began. It was not long before they spread to such an extent that four hundred employers locked out their workers, and prevailed upon local magistrates to prohibit public meetings. It is estimated that a third of Dublin's labour force was locked out. Many incidents occurred in an attempt to disrupt the tram services, and Mr Murphy called for police protection. It was instantly given. The photograph shows a DMP constable travelling on the footplate of one of the trams. Soldiers and police were employed to guard the tram depots.

On 31 August, in spite of the prohibition, Larkin called for a mass meeting in O'Connell Street. There was a warrant out for his arrest but that did not stop him from turning up and attempting to address the vast crowd from a window of the Imperial Hotel (above Clery's department store). He was arrested and the police baton-charged the crowd, causing at least one fatality and a number of serious injuries. As the strikes continued, the police became more and more brutal, causing more deaths.

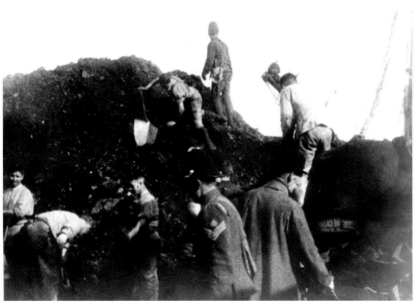

British soldiers shovelling coal at Dublin docks, 1913

It was to be a fight with no holds barred. Soon the coal merchants, such as Tedcastles, were involved too. They complained that striking workers refused to handle coal at the docks. Straight away the British army was ordered to do so, as this photograph shows, and they got down to performing their strike-breaking task under military compulsion. But matters continued to get worse and worse. The army and police were involved in the protection of convoys of lorries going to all parts, and still the strike continued to spread—and the lock-outs too.

So brutal had the actions of the police and military become that James Larkin called for volunteers for a new body to protect the interests of the workers: the Irish Citizen Army. The call was answered by many, including the young Seán O'Casey.

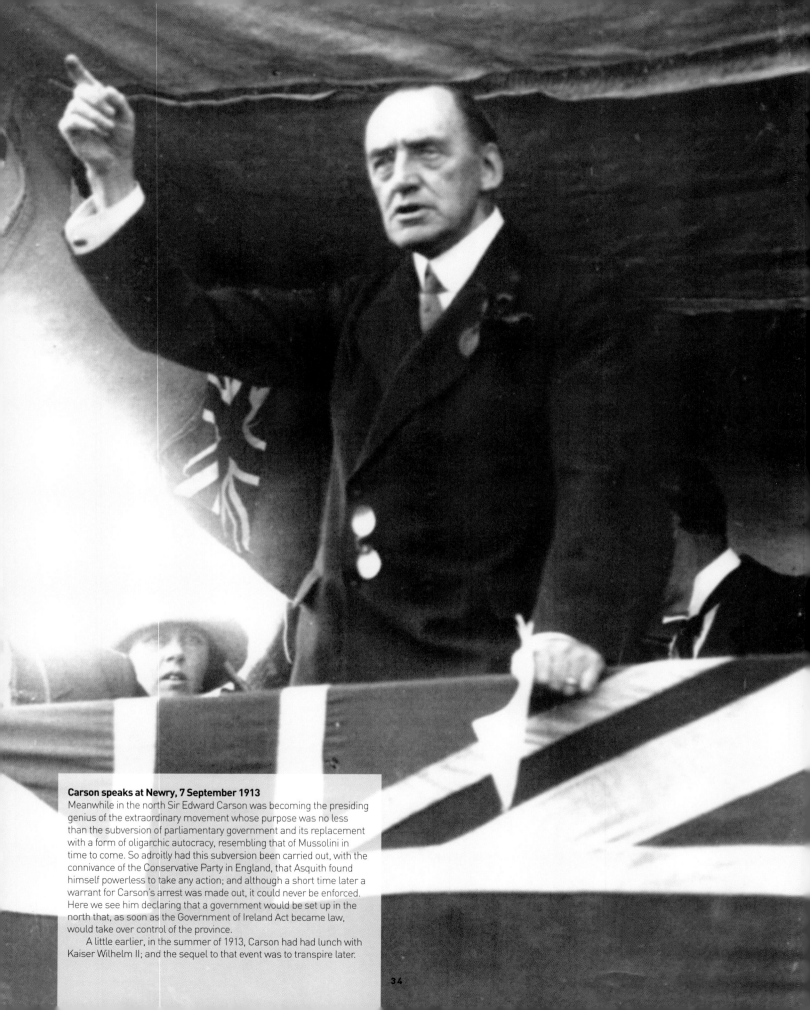

Carson speaks at Newry, 7 September 1913
Meanwhile in the north Sir Edward Carson was becoming the presiding genius of the extraordinary movement whose purpose was no less than the subversion of parliamentary government and its replacement with a form of oligarchic autocracy, resembling that of Mussolini in time to come. So adroitly had this subversion been carried out, with the connivance of the Conservative Party in England, that Asquith found himself powerless to take any action; and although a short time later a warrant for Carson's arrest was made out, it could never be enforced. Here we see him declaring that a government would be set up in the north that, as soon as the Government of Ireland Act became law, would take over control of the province.

A little earlier, in the summer of 1913, Carson had had lunch with Kaiser Wilhelm II; and the sequel to that event was to transpire later.

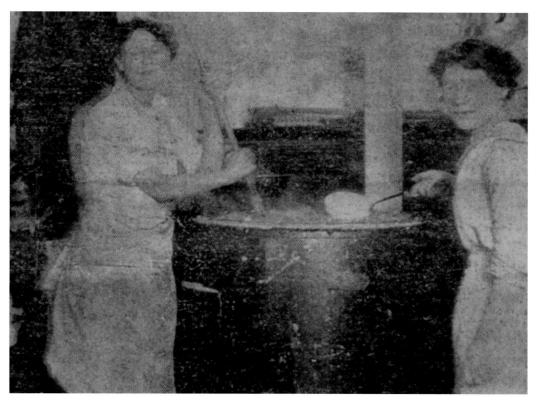

A soup kitchen at Liberty Hall, Dublin, 1913
As the strikes and lock-outs wore on, ITGWU strike funds were rapidly depleted, and Larkin, with the help of Maud Gonne MacBride and Constance Markievicz, opened a soup kitchen at Liberty Hall to help feed the locked-out workers. So desperate had their situation become that Larkin was glad to receive financial assistance from other unions in England and even from the Continent, sedulously subscribed from out of their weekly wages by the workers themselves.

Food from the food ships, Dublin, 1913
So great was the distress among the Dublin working class that unions throughout Europe and the United States, as well as in England, opened special accounts to facilitate their members contributing to funds to enable food to be bought. Special ships were chartered to bring this food to Dublin, which quickly became known as the 'food ships'. Here we see children and locked-out workers with food provided by the food ships.

Nor was this mighty show of solidarity all that was done. Many families in England volunteered to throw open their doors to receive child refugees from this artificially induced famine. As this was done in a strictly non-denominational way, a number of sermons were immediately preached by Catholic priests claiming that the children were in danger of 'losing their Faith.' This was seized upon by some elements in the press and used as a stick with which to beat trade unions in general and the ITGWU in particular.

Meanwhile a Commission of Inquiry was established with a view to laying bare the causes of the strikes and lock-outs. Murphy and Larkin, somewhat reluctantly, made their peace, and the strike came to an end. The employers of Dublin had learnt their lesson: 'The game is not worth the candle.' A lock-out on this scale was never to be repeated.

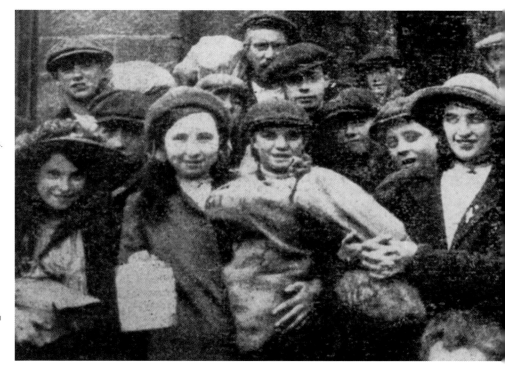

The Rt Hon. F. E. Smith MP speaking at Ballyclare, 1913

Meanwhile Unionists in the north were ablaze, and fanning the flames further came the Rt Hon. F. E. Smith, Conservative and Unionist MP for a division of Liverpool. Addressing a large gathering at Ballyclare, Co. Antrim, on 20 October he told them that as soon as the Government of Ireland Bill became law 'we will say to our followers in England, "To your tents, O Israel".' He further promised that the Conservatives would be willing to risk the collapse of the whole body politic to prevent 'this monstrous crime.'

Smith's inflammatory speech was followed only four days later by an exceedingly grave development. The Ulster Unionist Council declared itself to be 'the Central Authority of the Provisional Government of Ulster.' Carson was appointed chairman of that body, and among its other members were such personages as the Duke of Abercorn, the Marquis of Londonderry and Captain James Craig, while its Legal Assessor was to be the Hon. James Campbell KC MP, later Lord Glenavy, a prominent banker.

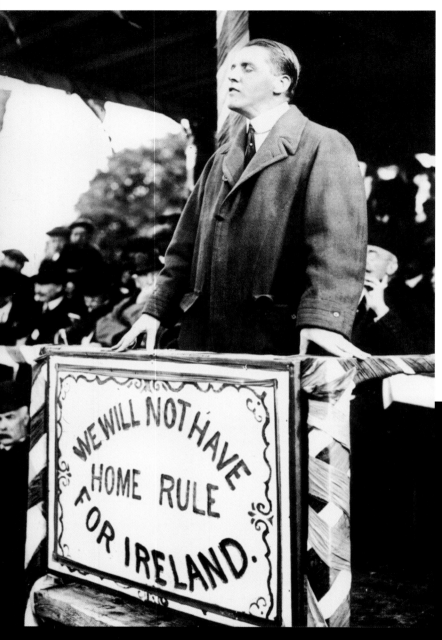

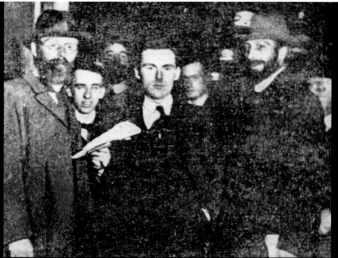

Founding of the Irish Volunteers, Dublin, 25 November 1913

Hardly surprisingly with these threatening moves taking place in the north, in Dublin at the Rotunda Rooms another body was being founded: the Irish Volunteers—a similar body of men but with a totally different and distinct purpose. The Unionists in the north had taken up arms to resist home rule and to fight on behalf of British imperialism; the volunteer force founded in Dublin was to be dedicated to the service of Ireland. The three figures seen in the foreground are symbolic of the different nuances assumed by this body of men in the course of time. To the right, Seán Mac Diarmada, with his IRB links symbolising the militant republican separatist view, Tom Kettle the Redmondite position, and on the left Prof. Eoin MacNeill, who was to be appointed chief of staff. At the inaugural meeting 4,000 men are said to have enrolled, among them Éamon de Valera. By the year's end they are said to have numbered 10,000.

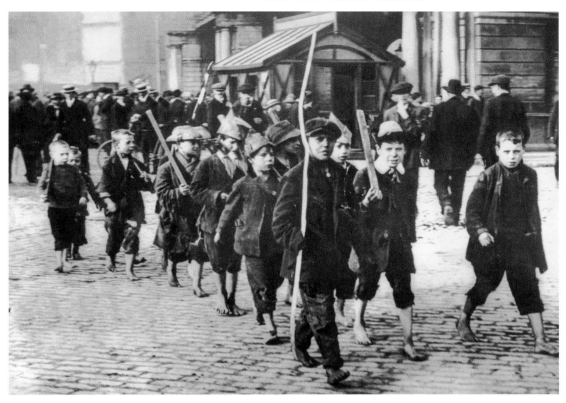

Barefoot boys march, Dublin, 1913
Little wonder, with so much militarism in the air in 1913, that the barefoot boys of Dublin were marching and drilling too.

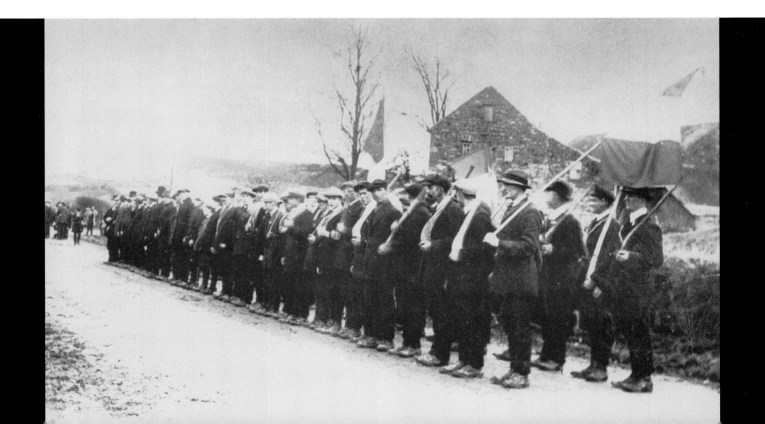

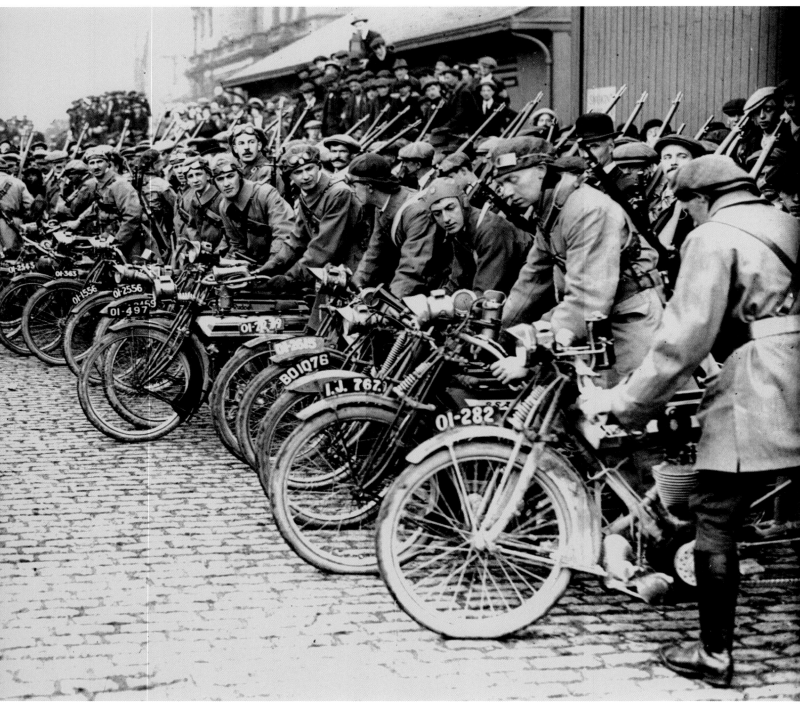

Motor-Cycle Corps of the UVF distribute arms, 1914

Suddenly it was all too late. Lunch with the Kaiser had paid off handsomely. Early in April, Major Fred Crawford of the UVF and his associates had chartered a steamer, the *Mountjoy*. Money being no object, they had bought in Germany 35,000 second-hand Mauser rifles and 2½ million rounds of ammunition. With Crawford himself aboard to act as supercargo, and proceeding through the Kiel Canal, these munitions were destined to be landed at Larne, Bangor and Donaghadee in an operation as remarkable for its secrecy as for its boldness. The password used by the gun-runners was 'Gough'!

So great was the silence surrounding these events that no photographers were permitted to be present, and so we have no actuality photographs; thus the participants were to be denied their place in the visual history of Ireland. What is seen here is the subsequent and highly efficient distribution of these arms.

Sir Roger Casement, 1914

Sir Roger Casement had accepted the position of treasurer to the Irish Volunteers. He was a man with a wide knowledge of the nuances and vicissitudes of empires and their practical political consequences; he knew what was going on at Westminster. At that seat of government a weakened Asquith was being pushed further and further to the right. General Sir Hubert Gough, officer commanding the 3rd Cavalry Brigade at the Curragh Camp, had flagrantly refused to serve against the Ulster Volunteer Force, and many other officers of King George V's army, both in Ireland and England, were voicing similar sentiments. The open rebellion was spreading; it was assuming the dimensions of a putsch. The warrants for the arrest of Sir Edward Carson and other leaders of the Unionists had been signed, but could not be enforced!

Amidst all this confusion Casement made a momentous decision, a decision that was to affect the whole course of his life: the Irish Volunteers must be armed. This was a decision that agreed perfectly with the feelings of the IRB. In London he took part in the formation of a fund-raising committee, chaired by the historian Alice Stopford Green, and the money began to come in. He then handed over his position as treasurer of the Irish Volunteers to Michael O'Rahilly and left London, bound for America to visit the leaders of the IRB, who sent him in October on a secret mission to Germany.

The Rt Hon. John Redmond MP, 1914

John Redmond MP, leader of the Irish Party in the British House of Commons, was being steadily forced by Asquith's vacillations to defer his hopes of securing home rule to some time in the very indefinite future. At the same time he was endeavouring to get into his own hands the control of the Irish Volunteers. In this he failed, but he split the Volunteer movement in the process. Those who remained in the Redmondite camp came to call themselves the National Volunteers, while the Irish Volunteers came more and more under the influence of the IRB. When, a little over a month later, a European war broke out Redmond advised his section of the Volunteers to join the British army, in the hope of securing home rule.

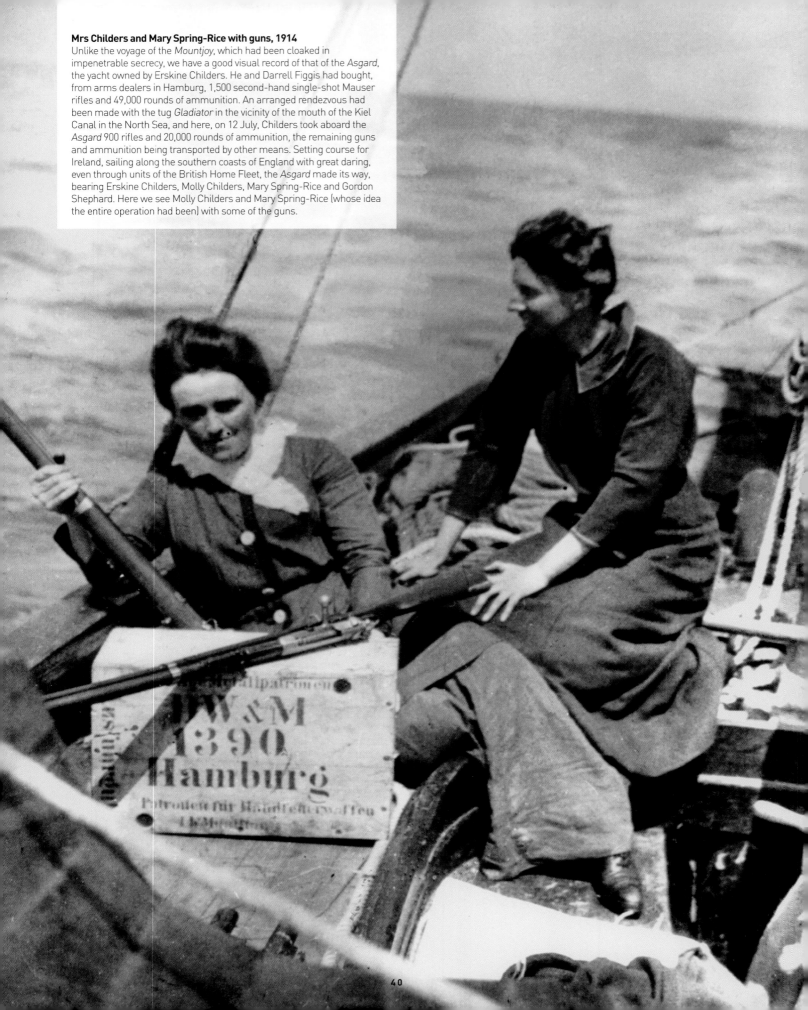

Mrs Childers and Mary Spring-Rice with guns, 1914

Unlike the voyage of the *Mountjoy*, which had been cloaked in impenetrable secrecy, we have a good visual record of that of the *Asgard*, the yacht owned by Erskine Childers. He and Darrell Figgis had bought, from arms dealers in Hamburg, 1,500 second-hand single-shot Mauser rifles and 49,000 rounds of ammunition. An arranged rendezvous had been made with the tug *Gladiator* in the vicinity of the mouth of the Kiel Canal in the North Sea, and here, on 12 July, Childers took aboard the *Asgard* 900 rifles and 20,000 rounds of ammunition, the remaining guns and ammunition being transported by other means. Setting course for Ireland, sailing along the southern coasts of England with great daring, even through units of the British Home Fleet, the *Asgard* made its way, bearing Erskine Childers, Molly Childers, Mary Spring-Rice and Gordon Shephard. Here we see Molly Childers and Mary Spring-Rice (whose idea the entire operation had been) with some of the guns.

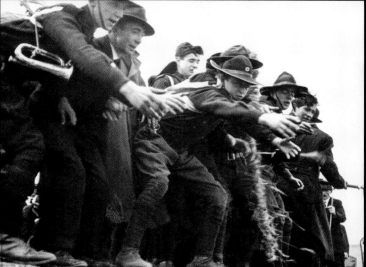

Boys of Fianna Éireann reach for the rifles, 1914

When Erskine Childers arrived at the small port of Howth, Co. Dublin, exactly on time, at 12:46 on Sunday 26 July, he failed to receive the agreed signal that all was ready for the guns to be landed. With extreme caution he approached the pier and was delighted to see that all the preparations had in fact been made, and within minutes he was alongside, and unloading had begun.

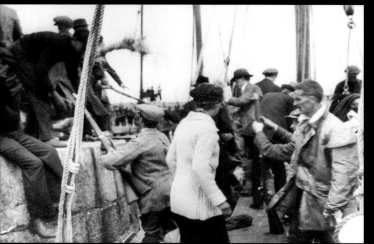

Mary Spring-Rice and Erskine Childers aboard the *Asgard*, 1914

Unloading the *Asgard*'s cargo was only the first step; getting the rifles safely into Dublin was the next. For this was not an operation like that of the *Mountjoy*. A fleet of cars had been arranged to bring the ammunition to special hiding-places where it could be stored in safety, but the rifles themselves were another matter. It had been arranged that these should be carried by the Volunteers themselves.

In spite of the cutting of the telegraph lines to Howth, the news of the landing had reached Dublin Castle, and the authorities there immediately ordered a force of the Dublin Metropolitan Police and a detachment of the King's Own Scottish Borderers to intercept. This they attempted to do at Clontarf but they succeeded only in capturing nineteen rifles. It seemed as though the day would end without bloodshed; sad to say, this was not to be. The King's Own Scottish Borderers, under an inexperienced officer, were met at Bachelor's Walk with taunts and jeers, stones were thrown, and the officer ordered his men to fire into the crowd. Three civilian lives were lost and thirty-two other people were injured, some seriously. One of these, Sylvester Pidgeon, died some days later.

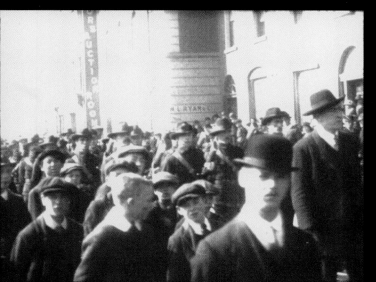

Larkin leads the Citizen Army at the funeral of Sylvester Pidgeon, 1914

The victims of the Bachelor's Walk incident received magnificent funerals. Here Jim Larkin, seen on the extreme right, leads the Irish Citizen Army contingent, marching with reversed arms as a sign of mourning, in the funeral procession of the last of the victims to die, Sylvester Pidgeon. The authorities were being very cautious and thought better of interfering with the obsequies in any way, not even intervening when both the Irish Volunteers and the Citizen Army marched with their newly acquired arms. But tensions were increasing rapidly to breaking-point as the British Empire was already at war with the Central Powers of Europe.

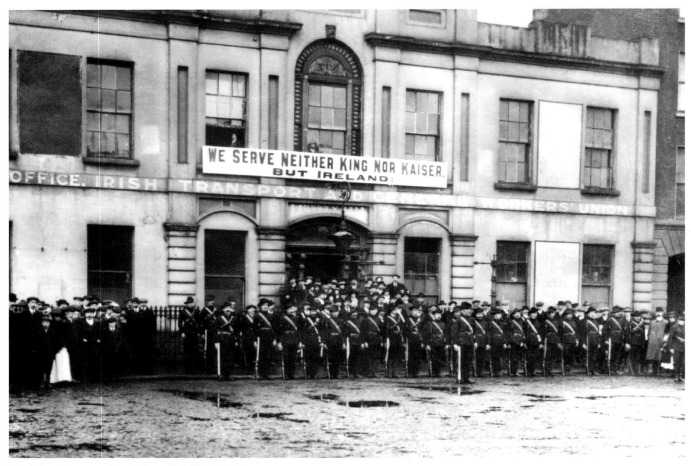

The Citizen Army parades at Liberty Hall, Dublin, 1915
Both the Irish Volunteers and the Irish Citizen Army were now armed, if inadequately in comparison with the Ulster Volunteer Force. The Citizen Army received its military training from Captain Jack White, son of the 'Hero of Ladysmith', as General Sir George White was known at that time. White is the tall man seen foremost in the ranks of the Citizen Army, who are shown parading in 1915 outside Liberty Hall under the watchful eye of James Connolly.

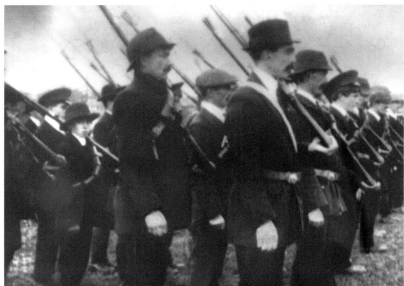

The Irish Volunteers drilling, 1915
The Irish Volunteers also were parading, marching and drilling and collecting all the arms they could obtain, as this photograph taken in 1915 shows. A fund to enable them to purchase arms had been set up in the United States, the Defence of Ireland Fund, which was sending the money raised to Michael O'Rahilly.

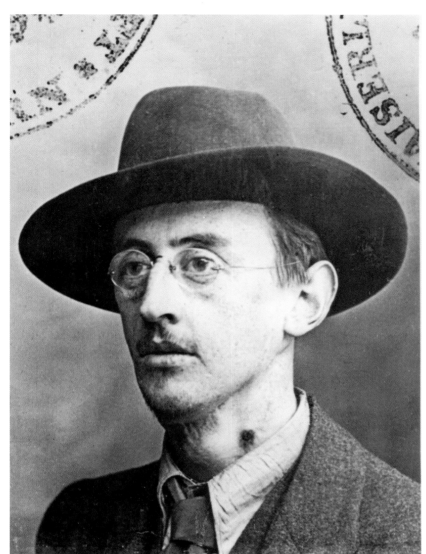

Joseph Plunkett

As he was himself, all the children of Count Plunkett were dedicated to the cause of Irish republicanism, and no-one more so than his eldest son, Joseph, who would be the author of the master plan of the Easter Rising. He was from the first a member of the Irish Volunteers. Being also a member of the Supreme Council of the IRB, he was fully informed of all their plans. He had the great misfortune to suffer for almost all his life from chronic ill-health, having contracted glandular tuberculosis in infancy, but in spite of this disability he worked tirelessly for the republican ideal.

In April 1915 Plunkett undertook a mission to Germany on behalf of the IRB to arrange with the Chancellor, Theobald von Bethmann-Hollweg, for a shipment of arms to be sent to Ireland. Travelling first to Spain and from there to Italy, in Florence he selected a change of name, calling himself James Malcolm. From there he went on to Bern, crossed into Germany and attained Berlin. His business with Bethmann-Hollweg completed, he visited Casement, who was feeling more and more isolated and restless. Plunkett returned to Ireland in the early autumn and gave himself to another mission, this time to tell the leaders of the IRB in America of his progress with Bethmann-Hollweg and how things were shaping in Ireland. Home again in October, he joined the Military Council that the IRB had established to plan the Rising.

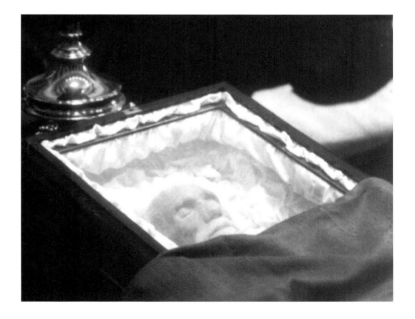

Jeremiah O'Donovan Rossa in his coffin, 1915

In July one of the greatest figures of the Fenian movement died in America, Jeremiah O'Donovan Rossa. His body was at once brought to Ireland and is here seen lying in state in City Hall, Dublin. O'Donovan Rossa had been a man of the utmost tenacity and steadfastness all his life and had endured the most cruel punishments during his confinement in English prisons.

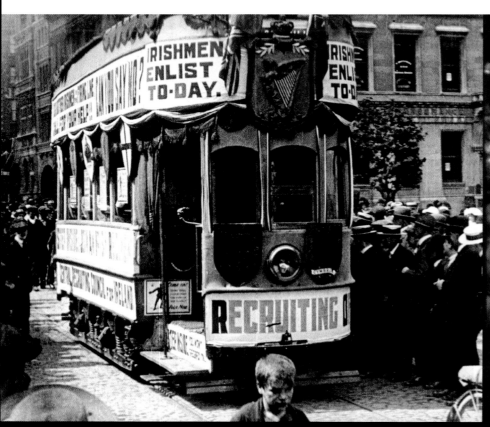

British mobile recruiting office, Dublin, 1915
The war was going badly for the British. The number of British army dead was increasingly rapidly as a consequence of the campaigns in the Dardanelles and particularly also in France. Redmond's National Volunteers and those of the UVF who enlisted in the British army, together with those from all parts of the British Empire, were not nearly sufficient to make up the appalling losses. Something had to be done, in England and in Ireland too. A great recruiting drive was held in Dublin, comprising a succession of motor vehicles and marching British regiments, among which was displayed this mobile recruiting office—one of William Martin Murphy's trams!

Pearse speaks at the grave of O'Donovan Rossa
In Glasnevin Cemetery, Dublin, when O'Donovan Rossa was laid to rest Patrick Pearse delivered his funeral oration. It was to be the finest speech of his short life, concluding with the words 'The Defenders of this Realm have worked well in secret and in the open. They think they have pacified Ireland. They think that they have purchased half of us and intimidated the other half. They think that they have foreseen everything, think that they have provided against everything; but the fools, the fools, the fools! They have left us our Fenian dead, and while Ireland holds these graves, Ireland unfree shall never be at peace.'

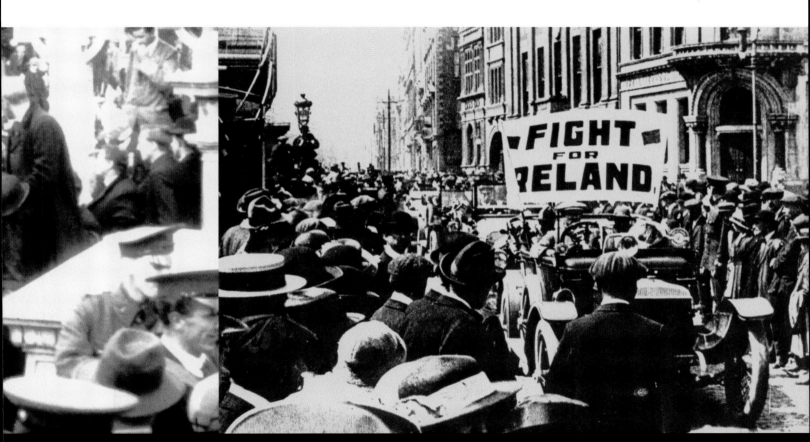

'Fight for Ireland,' Dublin, 1915
By this time Redmond's efforts to obtain home rule had virtually
come to nothing, but the British still continued to use the slogan
'Fight for Ireland' in their propaganda. And as though this
were not enough, William Martin Murphy had entered into an
agreement with a number of Dublin's principal employers that
they would summarily dismiss able-bodied male workers in
order to force them to join the British army.

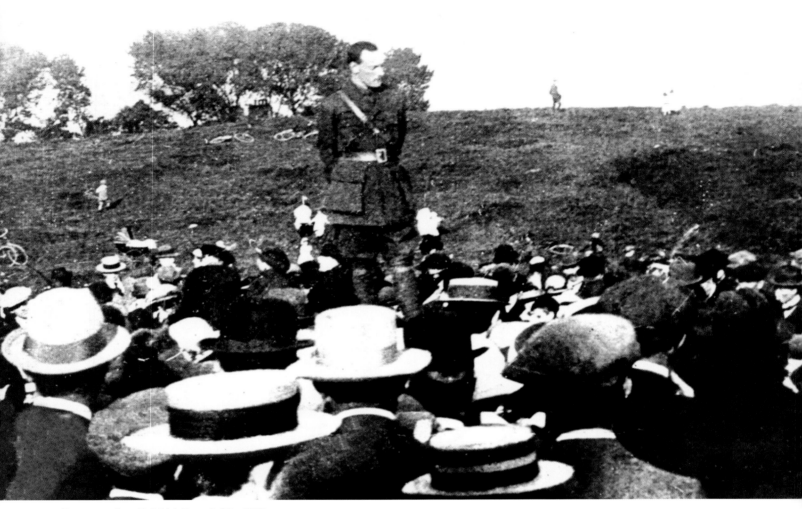

Pearse speaks at Dolphin's Barn, Dublin, 1915
It has not proved possible to recover what he said on this occasion, although Pearse was accustomed to record his important speeches on an Edison Phonograph. These priceless records were to survive for a time, kept by his mother at St Enda's in Rathfarnham. They have now disappeared.

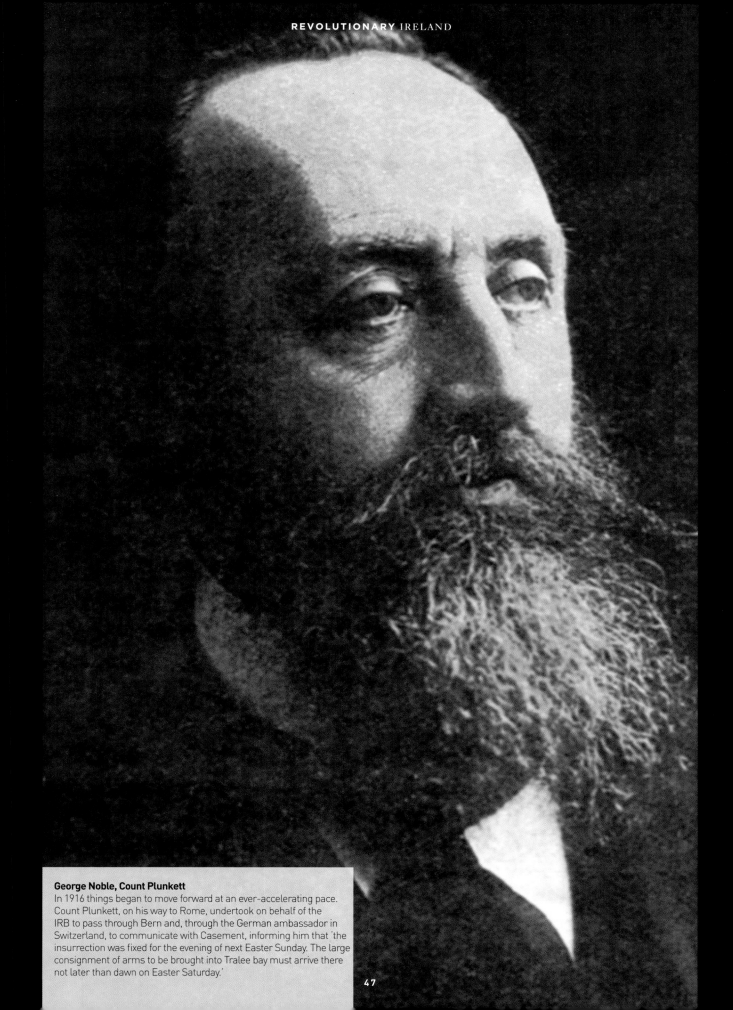

George Noble, Count Plunkett
In 1916 things began to move forward at an ever-accelerating pace.
Count Plunkett, on his way to Rome, undertook on behalf of the
IRB to pass through Bern and, through the German ambassador in
Switzerland, to communicate with Casement, informing him that 'the
insurrection was fixed for the evening of next Easter Sunday. The large
consignment of arms to be brought into Tralee bay must arrive there
not later than dawn on Easter Saturday.'

47

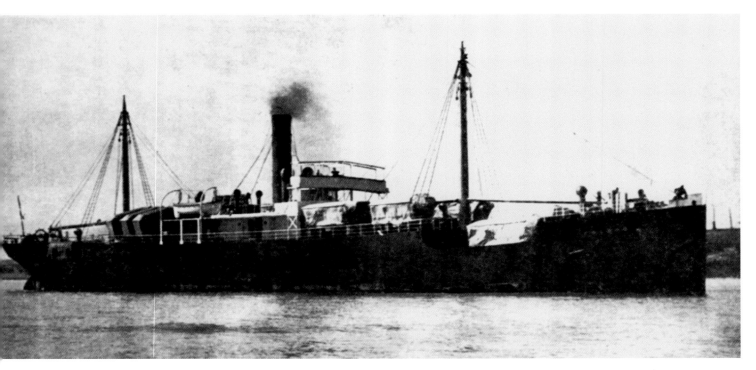

The *Castro/Libau/Aud*

The ship chosen by the Germans to carry arms to Ireland had originally been British, captured as a prize of war when it was named the *Castro* and had belonged to a firm of ship-owners from the port of Hull. In an attempt to keep its voyage secret it was twice renamed, once as the *Libau*, on the second occasion as the *Aud*. To fit it for its gun-running operation it was furnished with a number of secret compartments and heavily disguised to make it resemble a Norwegian tramp steamer. Incredible though it may seem, it was not fitted with wireless telegraphy.

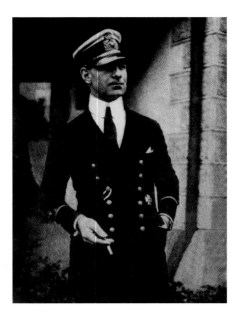

Captain Karl Spindler

Karl Spindler was a reserve officer of the Imperial German Navy specially selected to perform the operation. On the *Aud* he carried with him to Ireland 20,000 captured Russian rifles, 10 German machine-guns, 4 million rounds of ammunition for the rifles, a million rounds for the machine-guns and 400 kilograms of explosives. The *Libau/Aud* began its journey from the port of Lübeck on 9 April 1916.

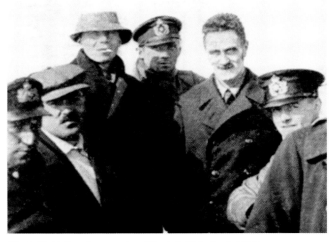

Monteith, Bailey, Casement and Captain Weissbach, 1916

This photograph, taken on top of the *U19*'s conning-tower, shows (left to right) Captain Robert Monteith (wearing a cap), Bailey (in a shapeless hat), a crew member, Sir Roger Casement and Captain Weissbach (commander of the submarine). Casement went ashore at Banna Strand with his two companions. Shortly after this photograph was taken all was ruin: Casement captured, the *Aud* apprehended and scuttled with all its arms; but Monteith, who had not been captured, succeeded in getting a message through to Dublin, where it was delivered to James Connolly at Liberty Hall, telling of Casement's capture.

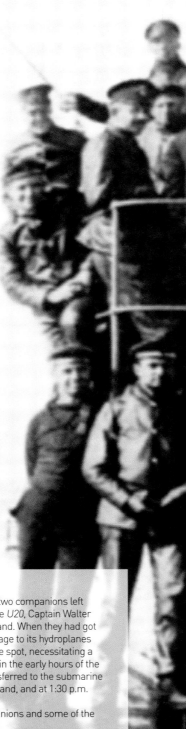

The *U19* with Casement aboard, 1916

On Wednesday 12 April, Casement and his two companions left Heligoland and embarked on the submarine *U20*, Captain Walter Schweiger in command, setting out for Ireland. When they had got nearly half way there the *U20* suffered damage to its hydroplanes that was more than could be repaired on the spot, necessitating a return to Heligoland. They were back there in the early hours of the morning of Friday 15 April, where they transferred to the submarine *U19*, Captain Raimund Weissbach in command, and at 1:30 p.m. resumed their interrupted journey.

Here we see Casement, his two companions and some of the crew of the *U19*.

Casement had been disappointed with the amount of aid he had been able to get from Germany and was coming back to Ireland with the secret intention of trying his best to call off the Rising. His health was broken, and this most charming man was a wreck of his former self, but he nonetheless wrote to thank his contact on the German Admiralty Staff, Captain Heydel, as follows:

Nearing Shannon Mouth,
20th., April, 1916 6 p.m.

Dear Captain Heydel,
A few lines to thank you and your chief for the kindly hospitality of the 'U 19'. We were very sorry to lose 'U 20'—and her charming Captain and officers—but Oberleut. Walter has been very kind and helpful on board this boat. I am hopeful of landing tonight in darkness near Ardfert and meeting friends in Tralee in the morning.

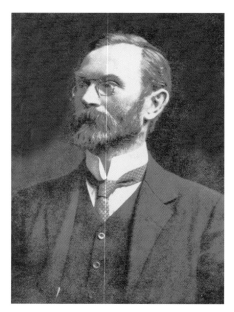

Prof. Eoin MacNeill, 1916

Eoin MacNeill had remained in his position as chief of staff of the Irish Volunteers. He believed that his force should be employed only for the defence of Ireland. The IRB, which had a radically different view and which controlled practically all the officers of the Dublin battalions, as well as others throughout the country, was intent on employing the Volunteers for insurrectionary purposes, and it had come to a decision on the date on which this should take place: Easter Sunday evening, 23 April.

A couple of days before this date MacNeill became anxious and, summoning Pearse to his home, asked him straight out whether this was so or not. Pearse declared that it was, and MacNeill then replied that he would do everything in his power, short of betraying Pearse to the British, to prevent it. Pearse had issued a general mobilisation order, and this MacNeill now countermanded, making it clear that all parades and marches of the Volunteers were cancelled.

Meanwhile that Saturday the Revolutionary Council of the IRB was meeting and was in receipt of Monteith's message. They reached the conclusion that a pre-emptive strike by Crown forces was about to take place and succeeded in persuading MacNeill to rescind his cancellation. But later that day MacNeill changed his mind again, this time communicating to the press a letter forbidding the proposed manoeuvres.

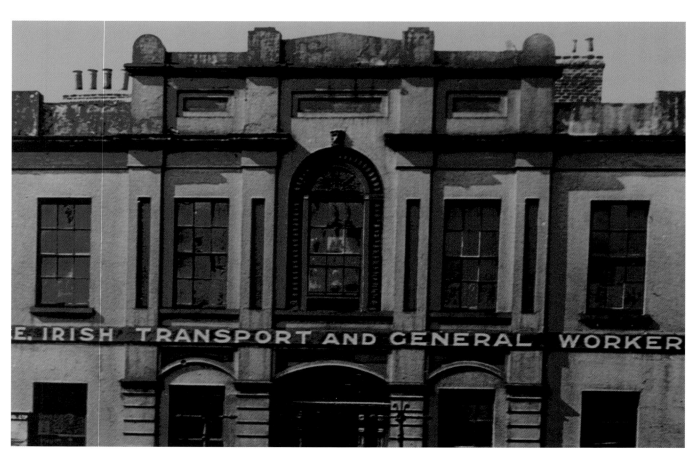

Liberty Hall, evening

Early on Sunday the Military Council, to which James Connolly had recently been admitted, met at Liberty Hall. They were fully aware now of the capture and scuttling of the *Aud* and had made a decision to go ahead with the Rising with the Dublin battalions of the Irish Volunteers and the Irish Citizen Army. Tom Clarke took the chair and pressed his case vigorously, supported by Pearse, Mac Diarmada and Connolly. Noon on Easter Monday was the time now agreed by all; but to prevent premature action Pearse signed an order confirming MacNeill's prohibition. The one person who was absent was Joseph Plunkett, who was undergoing medical treatment at a nursing-home; but when he was informed of developments he hastened to take his appointed place.

PART 2

In 1914, a few hours before the British Empire's ultimatum to the German Empire was due to expire, a small flotilla of British trawlers, under the command of the British Navy and carrying on board special equipment, might have been seen making its way to a certain point of rendezvous in the North Sea. When they reached that point, a few minutes after the ultimatum expired and under cover of night, they proceeded to grapple and hook the German undersea cable to New York, raise it to the surface and, by the careful matching of impedances, connect it to New York via the Admiralty in London, without the Germans being aware of anything amiss.

As a consequence of this remarkable coup all cables sent in both directions were compromised. Both the German diplomatic and consular services in New York and Washington were involved and all the cables sent to Germany by Franz von Papen, then military attaché in Washington. This simple circumstance explains why, in spite of their attempts at secrecy, the IRB and Joseph Plunkett met with such little success and why the British Admiralty were so well informed about the sailing of the *Libau/Aud* and Sir Roger Casement's plans. The Easter Rising must, at all times, be seen in this context.

DUBLIN BRIGADE ORDERS.

H.Q.

24th April, 1916.

1. The four city battalions will parade for inspection and route march at 10 a.m. to-day. Commandants will arrange centres.

2. Full arms and equipment n one day's rations.

Thomas Macdonagh.

Commandant.

Coy E 3 will
Parade at Beresford Place at
10 a.m.

P. H. Pearse
Comdt.

Mobilisation Order, 1916
Early on Easter Monday morning Commandant Thomas MacDonagh signed the order that brought out the Dublin battalions of the Irish Volunteers as well as the Irish Citizen Army and another small body of men, the Hibernian Rifles. This order was countersigned by Commandant Patrick Pearse. In all about 1,500 men responded to this summons, but this was only about half the number called for in the plans for the Rising, so the confusion caused by MacNeill's countermanding order was proving disastrous even at this stage.

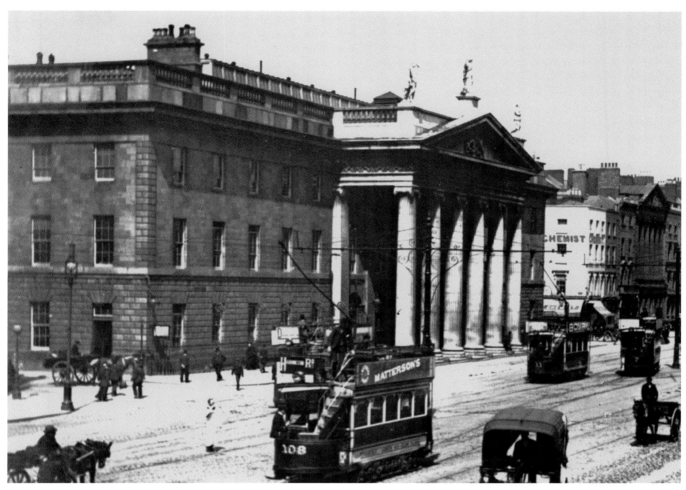

General Post Office (1)

The General Post Office in O'Connell Street was chosen for the seat of
what was to be the Provisional Government of the Irish Republic. Francis
Johnston's beautiful building, which opened its doors to the public in
1818, had stood for ninety-eight years, virtually unchanged in outward
appearance with the exception of a new storey that had been added
to it, as is to be seen in the photograph. The roof, and in particular the
roof of the additional structure, had great quantities of lead used in its
construction. When Crown forces made use of incendiary shells to set
fire to the upper floors of the building the molten lead caused a number
of casualties among the garrison.

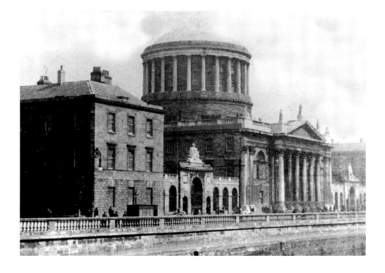

The Four Courts (2)

As the principal centre for the administration of British law in Ireland,
the Four Courts came well to the fore as a target for occupation by the
republican forces. Tables and chairs and moveable furniture in general
were used to block windows.

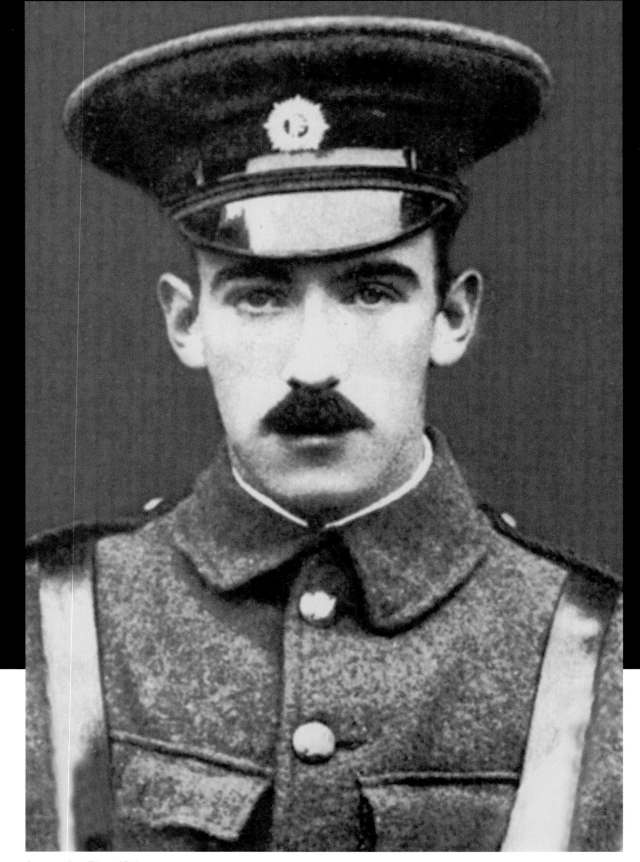

Commandant Edward Daly
To Commandant Edward Daly was assigned the task of occupying the Four Courts as his headquarters, but under his command stretched a large part of the north city, and this was to be a source of weakness. Deprived of a proper turn-out by MacNeill's countermanding order, his forces were too thinly spread to enable him to occupy Broadstone railway station before British forces took possession of it.

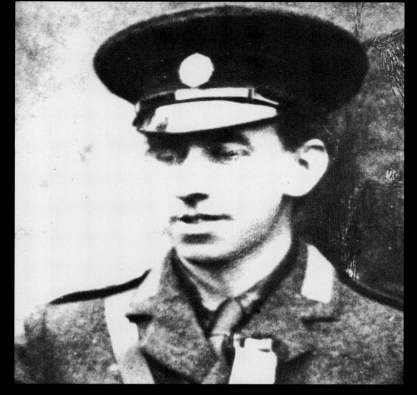

Commandant Thomas MacDonagh
Born at Cloghjordan, Co. Tipperary, in 1878, MacDonagh was
educated at Rockwell College, Cashel. Developing an interest in
Anglo-Irish literature, he became a lecturer in that field in the
National University of Ireland and also a teacher at St Enda's
School. He published several volumes of poetry and together
with Joseph Plunkett edited the *Irish Review*. He joined the Irish
Volunteers in 1913 and became Director of Training, being later
appointed to the command of the Dublin Brigade.

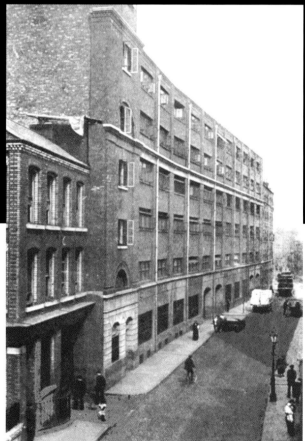

Jacobs' Biscuit Factory
One of the strongest buildings to be held by the republican forces
during the Rising was Jacob's biscuit factory in Bishop Street (now the
site of the National Archives), because of its steel-girder construction.
But it was not very strategically placed, being in what was virtually a
side street. Here Thomas MacDonagh, Commandant of the Dublin
Brigade, established his headquarters.

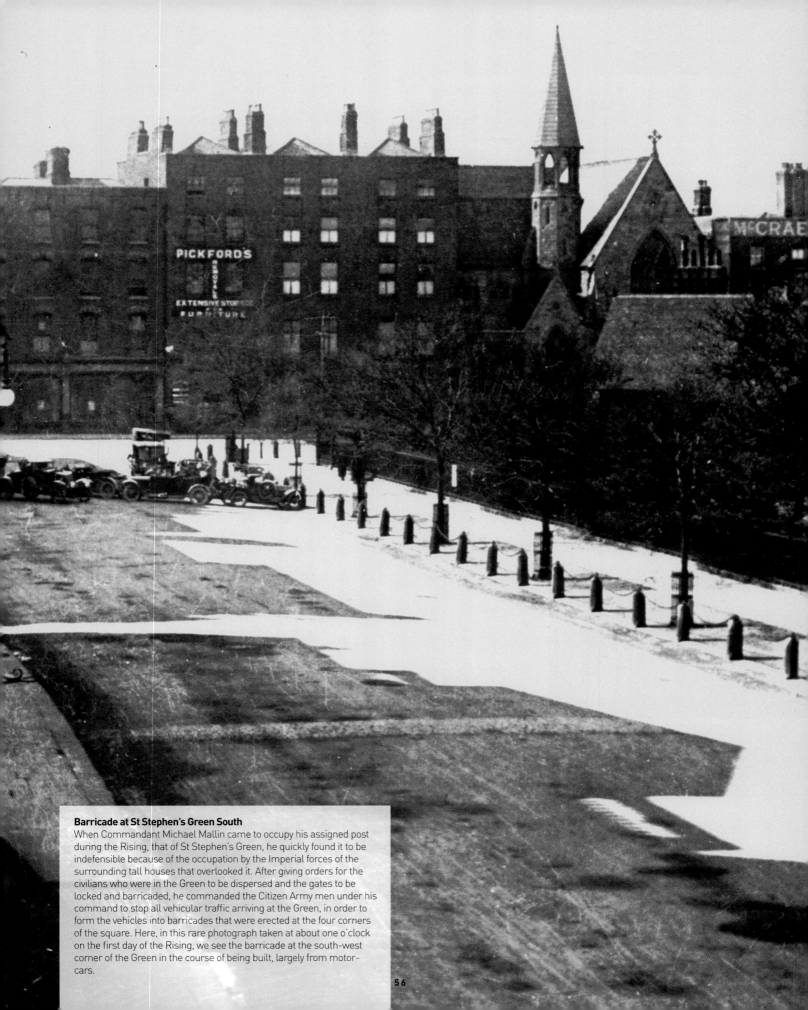

Barricade at St Stephen's Green South

When Commandant Michael Mallin came to occupy his assigned post during the Rising, that of St Stephen's Green, he quickly found it to be indefensible because of the occupation by the Imperial forces of the surrounding tall houses that overlooked it. After giving orders for the civilians who were in the Green to be dispersed and the gates to be locked and barricaded, he commanded the Citizen Army men under his command to stop all vehicular traffic arriving at the Green, in order to form the vehicles into barricades that were erected at the four corners of the square. Here, in this rare photograph taken at about one o'clock on the first day of the Rising, we see the barricade at the south-west corner of the Green in the course of being built, largely from motor-cars.

56

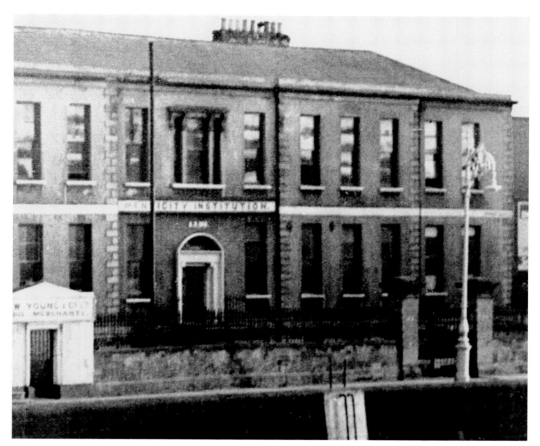

Mendicity Institution
Almost directly opposite the Four Courts on the south bank of the Liffey was the Mendicity Institution at Usher's Island. The duty of occupying it fell to the lot of the youngest commandant in the Irish Volunteers, Seán Heuston, who was just twenty-five. This building had been chosen as being suitable for giving covering fire in the defence of the Four Courts.

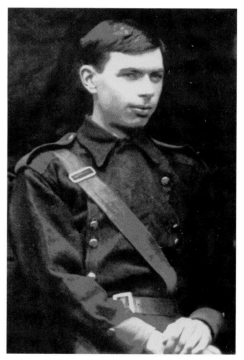

Commandant Seán Heuston
Together with Liam Mellows, Seán Heuston had been one of the original members of Constance Markievicz's Fianna Éireann and had joined the Irish Volunteers as soon as his age would permit.

Boland's Bakery

The long, low, inconspicuous building of Boland's bakery was occupied as his headquarters by Commandant Éamon de Valera, who rendered it still more inconspicuous by having his Green Flag with a harp run up on the top of a distillery rectifying tower nearby that did not form part of his command, thereby drawing artillery fire away from the real site of his HQ.

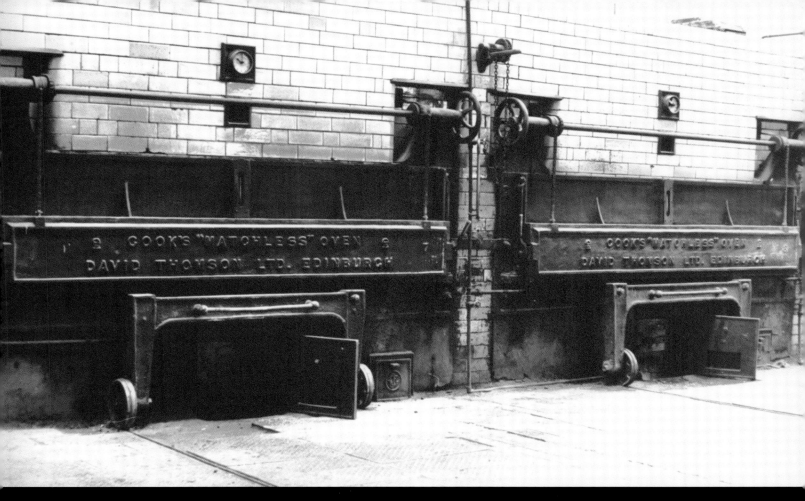

Boland's Bakery Ovens

Like Jacob's biscuit factory, Boland's bakery was a natural position for withstanding a siege. Though the bakers were to divide sharply into those who left immediately and those who volunteered to stay long enough to ensure that the bread already in the ovens was done for the use of the garrison, fortunately the latter predominated, leaving ample fresh bread ready.

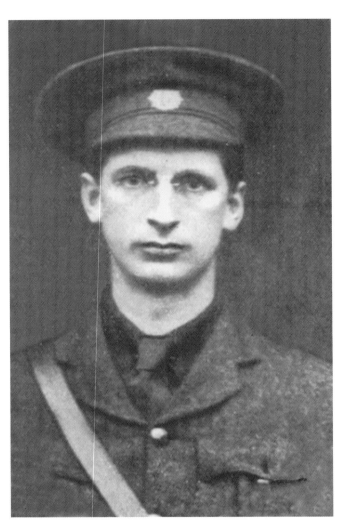

Commandant Éamon de Valera

Born in New York of an Irish mother and a Cuban father, de Valera was brought back to Ireland by a maternal uncle when he was two years old. Raised from then on in Ireland, he became a teacher of mathematics. Joining the Irish Volunteers in 1913, he quickly rose to be a commandant. Occupying Boland's bakery in 1916, he was responsible for inflicting more casualties on the Imperial forces than any other commandant, and he was the last of them to surrender his command.

The gates of Dublin Castle

While the other positions were being occupied, Dublin Castle itself had already come under attack. From as early as approximately five minutes past twelve on that Easter Monday morning a small body of Citizen Army men and members of Cumann na mBan under the command of Seán Connolly (no relation to James Connolly) had been given the assignment of striking at Dublin Castle. They opened their attack by shooting the sentry at the gates, opening them and entering the guard room. Unknown to them, and incredible as it may seem, Dublin Castle was at that moment defended only by a corporal's guard, consisting of five men.

The Under-Secretary for Ireland, Sir Matthew Nathan, was expected any moment to arrive at the Castle to attend a meeting of higher civil servants. Connolly's orders, however, were not to attempt to take the Castle but only to prevent troops from leaving it. Consequently he retired and occupied the buildings in the immediate vicinity, so losing his chance to capture the Castle itself. When the DMP telephoned, at ten minutes past twelve, to report on the movements of the Irish Volunteers they were informed that the Castle had come under attack, and reinforcements of Imperial troops were rushed there from the nearest army barracks.

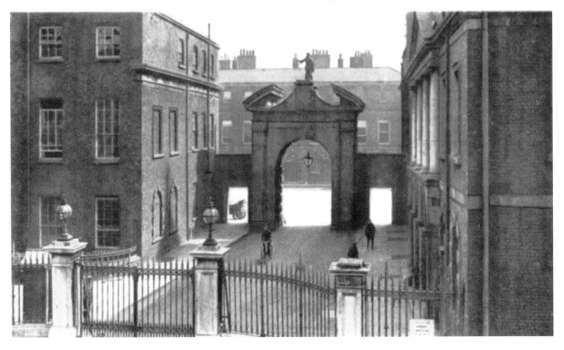

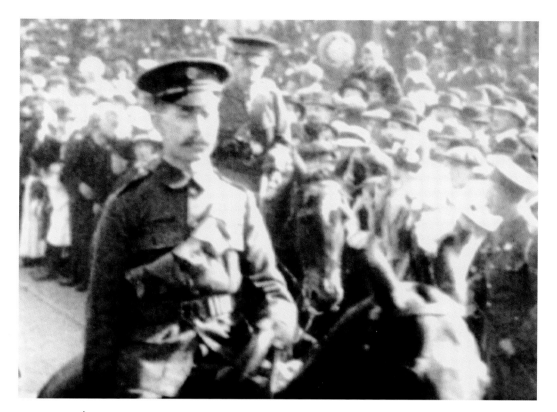

Commandant Éamonn Ceannt

Being strongly republican in feeling, Éamonn Ceannt joined the IRB, becoming a member of its National Council and, later, of the Military Council that planned the Easter Rising. In 1916 he commanded the 4th Battalion of the Irish Volunteers in Dublin, which was given the task of occupying the premises of the South Dublin Union in James's Street (now St James's Hospital); but because of MacNeill's countermanding order he was deprived of sufficient forces to hold it adequately. He is here seen taking part in the funeral of O'Donovan Rossa in 1915.

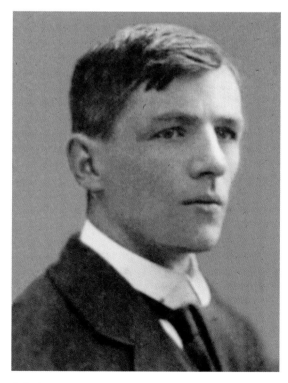

Seán Connolly

This brave young man lost his life at the hands of a British army sniper when attempting to raise a Tricolour over the offices of the *Dublin Evening Mail* at the corner of Parliament Street, which he had occupied.

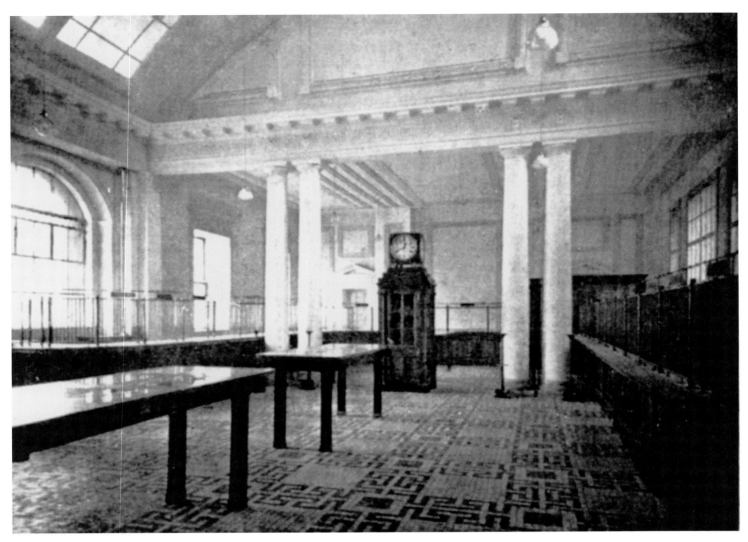

Main hall of the General Post Office

This is how the main hall of the GPO would have appeared to the Citizen Army, the Irish Volunteers and Cumann na mBan who appeared so suddenly on this Monday morning in 1916 and for a few members of the general public who were engaged in the business of buying stamps, handing in registered letters and telegrams and so forth. The telephone kiosk surmounted by a large four-faced clock is worthy of mention. The clock, kept at Greenwich Mean Time by a chronometer set at that time at Greenwich Observatory and sent over daily on the mail boat, was the standard time used in Ireland for all the railways.

The first task of the Irish Republican Army was to clear all civilians out of the premises before seeing to the defence of the building by breaking the windows giving on to O'Connell Street and barricading them. They were much facilitated by the staff abandoning their posts and rushing out of the two doorways, which were momentarily choked with people vacating the building. A British officer, Second Lieutenant A. D. Chalmers of the 14th Battalion, Royal Fusiliers, who happened to have come to the GPO to send a telegram to his wife, was quickly arrested and given to understand that he was a prisoner. Michael Collins went to the telephone kiosk and, tearing out the braided telephone flex, used this to bind his prisoner, depositing him in the kiosk itself. At about this time Patrick Pearse read the Proclamation of the Irish Republic standing on the step at the entrance.

POBLACHT NA H EIREANN.

THE PROVISIONAL GOVERNMENT

OF THE

IRISH REPUBLIC

TO THE PEOPLE OF IRELAND.

IRISHMEN AND IRISHWOMEN : In the name of God and of the dead generations from which she receives her old tradition of nationhood, Ireland, through us, summons her children to her flag and strikes for her freedom.

Having organised and trained her manhood through her secret revolutionary organisation, the Irish Republican Brotherhood, and through her open military organisations, the Irish Volunteers and the Irish Citizen Army, having patiently perfected her discipline, having resolutely waited for the right moment to reveal itself, she now seizes that moment, and, supported by her exiled children in America and by gallant allies in Europe, but relying in the first on her own strength, she strikes in full confidence of victory.

We declare the right of the people of Ireland to the ownership of Ireland, and to the unfettered control of Irish destinies, to be sovereign and indefeasible. The long usurpation of that right by a foreign people and government has not extinguished the right, nor can it ever be extinguished except by the destruction of the Irish people. In every generation the Irish people have asserted their right to national freedom and sovereignty ; six times during the past three hundred years they have asserted it in arms. Standing on that fundamental right and again asserting it in arms in the face of the world, we hereby proclaim the Irish Republic as a Sovereign Independent State, and we pledge our lives and the lives of our comrades-in-arms to the cause of its freedom, of its welfare, and of its exaltation among the nations.

The Irish Republic is entitled to, and hereby claims, the allegiance of every Irishman and Irishwoman. The Republic guarantees religious and civil liberty, equal rights and equal opportunities to all its citizens, and declares its resolve to pursue the happiness and prosperity of the whole nation and of all its parts, cherishing all the children of the nation equally, and oblivious of the differences carefully fostered by an alien government, which have divided a minority from the majority in the past.

Until our arms have brought the opportune moment for the establishment of a permanent National Government, representative of the whole people of Ireland and elected by the suffrages of all her men and women, the Provisional Government, hereby constituted, will administer the civil and military affairs of the Republic in trust for the people.

We place the cause of the Irish Republic under the protection of the Most High God, Whose blessing we invoke upon our arms, and we pray that no one who serves that cause will dishonour it by cowardice, inhumanity, or rapine. In this supreme hour the Irish nation must, by its valour and discipline and by the readiness of its children to sacrifice themselves for the common good, prove itself worthy of the august destiny to which it is called.

Signed on Behalf of the Provisional Government,

THOMAS J. CLARKE.

SEAN Mac DIARMADA.	THOMAS MacDONAGH.
P. H. PEARSE.	EAMONN CEANNT,
JAMES CONNOLLY.	JOSEPH PLUNKETT.

Thomas Clarke
Thomas Clarke (1857–1916).

Seán Mac Diarmada
Seán Mac Diarmada (1883–1916).

Patrick Pearse
Patrick Pearse (1879–1916).

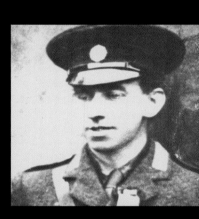

Thomas MacDonagh
Thomas MacDonagh (1878–1916).

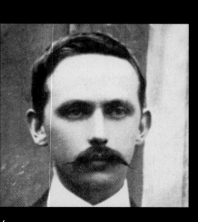

Éamonn Ceannt
Éamonn Ceannt (1881–1916).

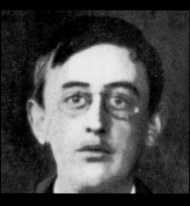

Joseph Plunkett
Joseph Plunkett (1887–1916).

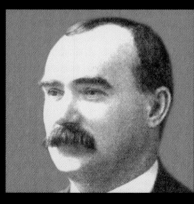

James Connolly
James Connolly (1868–1916).

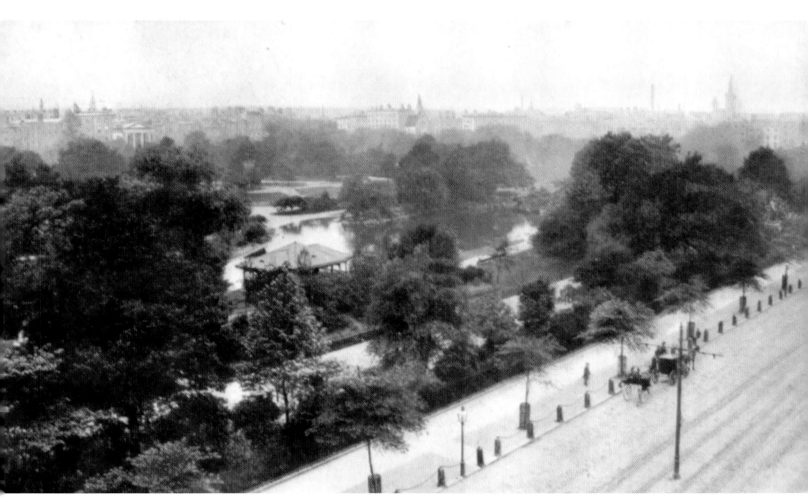

St Stephen's Green, from the Shelbourne Hotel
This photograph, taken from one of the top-floor windows of the Shelbourne Hotel on Tuesday morning, makes it very plain why St Stephen's Green was impossible to defend. The Shelbourne had been occupied by the Imperial forces since early on Monday afternoon, and a couple of Vickers machine-guns had been installed in upper windows on Tuesday. These guns, together with rifles, commanded virtually the whole of the Green, with their plunging fire making it indefensible to hold and forcing Commandant Michael Mallin to consider where he would retire to.

The College of Surgeons
Commandant Mallin chose the premises of the Royal College of Surgeons in Ireland as the strongest building available, and the evacuation of St Stephen's Green was completed on Wednesday.

Barricade at Fairview
This barricade at Fairview was largely composed of goods wagons from the Great Northern Railway, whose link with Belfast had been cut.

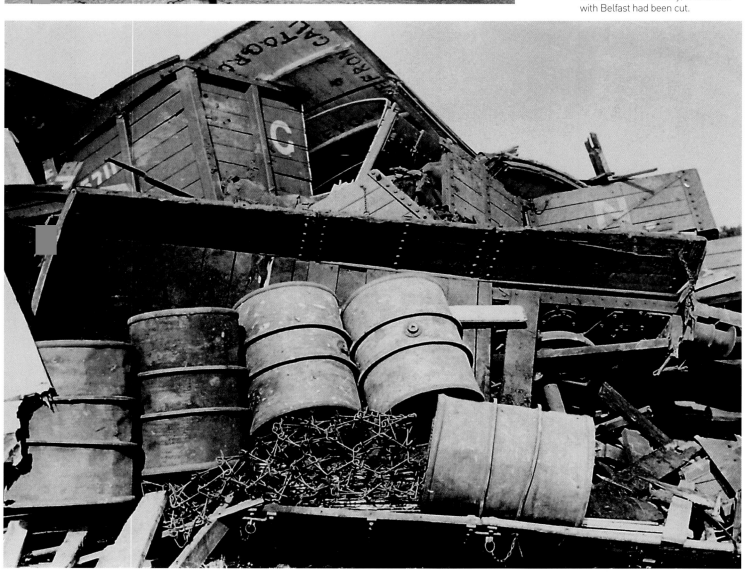

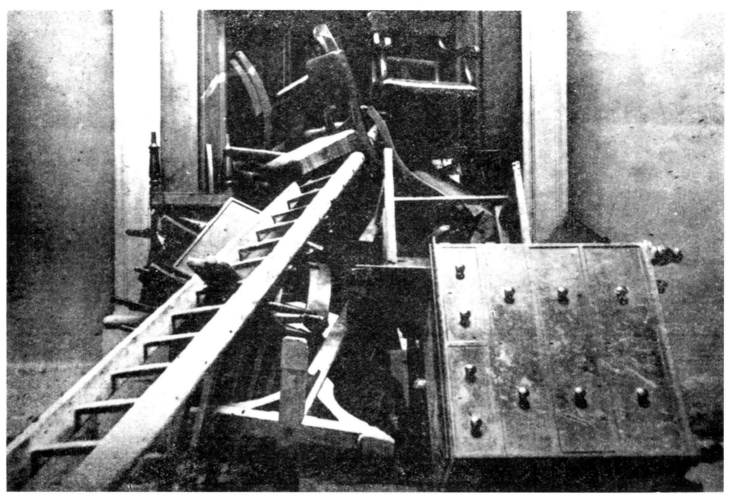

Barricaded door in the College of Surgeons
Barricading doors and windows was the first task to be undertaken.

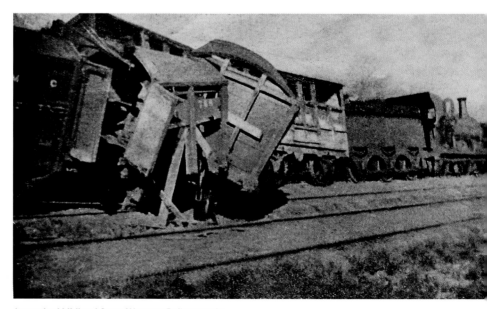

A wrecked Midland Great Western Railway train
A derailed cattle train of the Midland Great Western Railway near Blanchardstown, Co. Dublin.

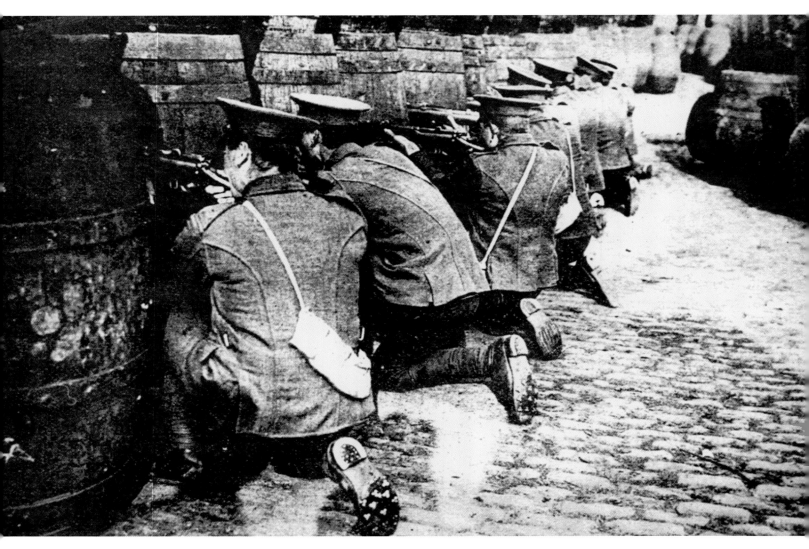

British soldiers defending the North Wall (1)
Here we see British soldiers defending the railway terminus at the North Wall.

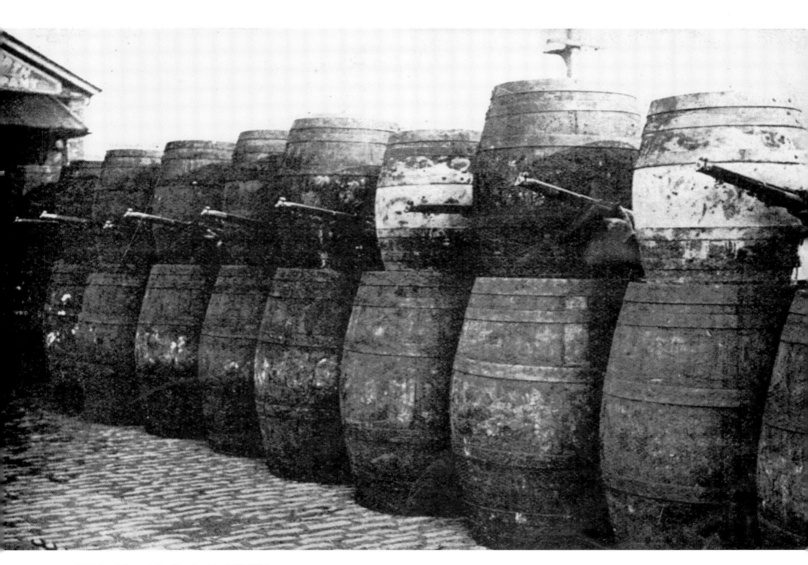

British soldiers defending the North Wall (2)
The soldiers have improvised a barricade of Guinness barrels.

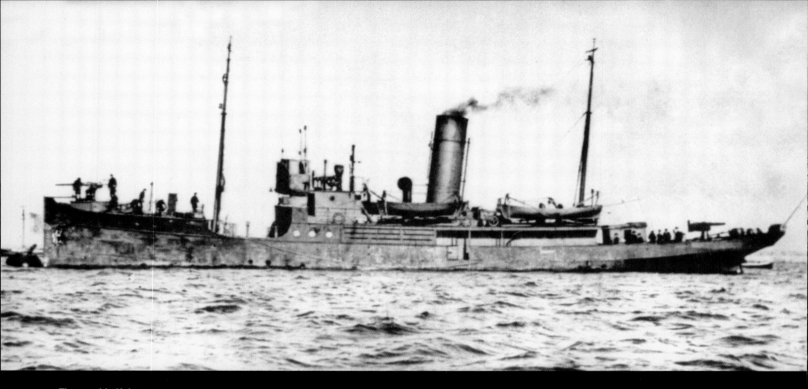

The gunship *Helga*

From first light on Wednesday, leaving its anchorage in Kingstown Harbour (Dún Laoghaire), the fisheries protection vessel *Helga* steamed up the Liffey until it considered itself to be in a position to begin its bombardment of Liberty Hall. But its position was badly chosen: the Loop Line railway bridge was in the way and its first shell gave it a glancing blow, producing an almighty clang. The second shell caught a house next door, and only with the third did it succeed in hitting Liberty Hall, causing the front door to fly open and the sole inhabitant, the caretaker, to take to his heels. Thereafter the *Helga* proceeded to pour shell after shell into the building, later joined in this by an 18-pounder delivered to Trinity College, until Liberty Hall was a gutted shell. Then the 18-pounder was assigned a new target: the buildings in O'Connell Street.

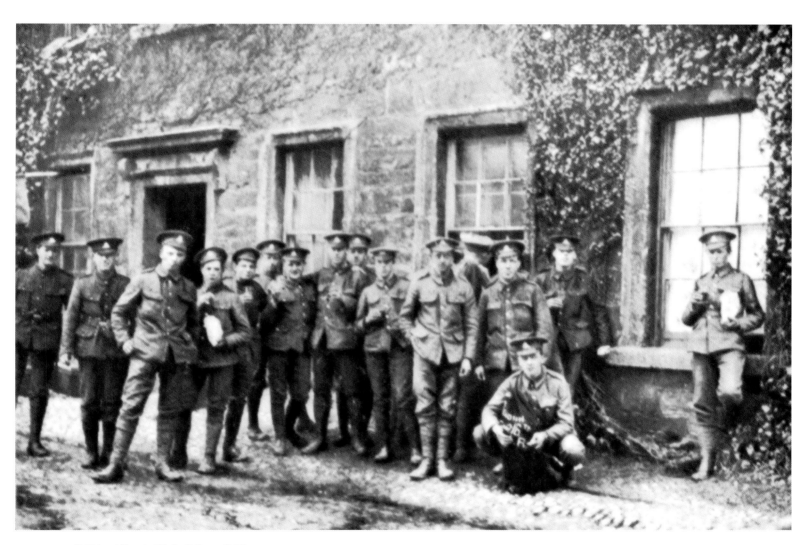

British soldiers in Trinity College, Dublin
What was to prove the most strategic position of all during the whole of the Easter Rising, Trinity College had formed no part of the plans made by the Military Council of the IRB. At the start of the insurrection the college had been held by the comparatively weak force composed of the Dublin University Officers' Training Corps, which, although it was armed with rifles, had very little ammunition for them. On Tuesday it was reinforced by units of the regular army and thereafter was further built up until it formed the main base for the Imperial forces. By Wednesday a line of bases stretching from Trinity College to Kingsbridge Station, including Dublin Castle, had been established and was being held, which effectually cut the republican forces in two.

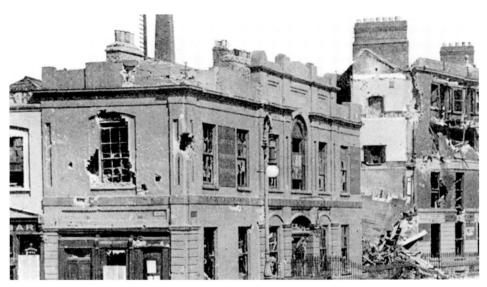

Liberty Hall shelled
Here we see the results of the combined bombardment of Liberty Hall.

British soldiers in Pembroke Road
That afternoon reinforcements of British troops began to arrive at Kingstown. They were composed of elements of the Sherwood Foresters and were given orders to march on Dublin. The column that took the Stillorgan Road reached its destination, the Royal Hospital, Kilmainham, without encountering any opposition, but those ordered to march to Dublin via Ballsbridge were not so fortunate. Here we see them in Pembroke Road.

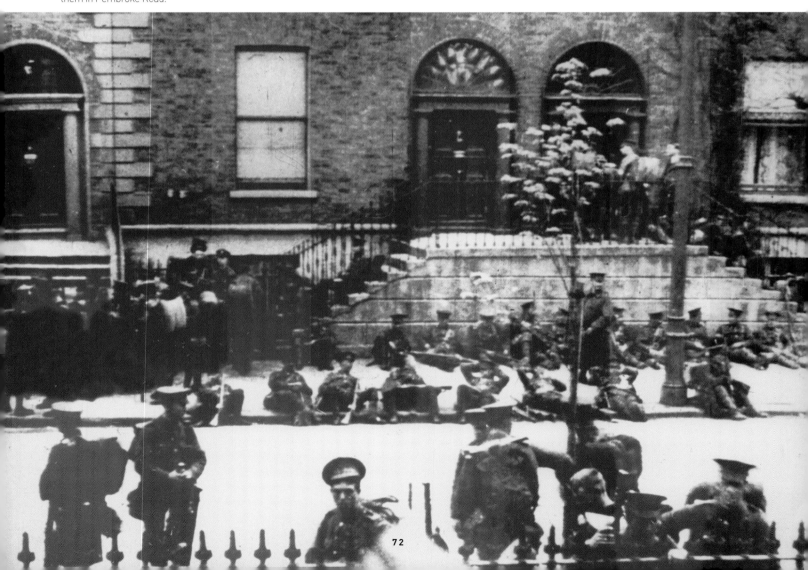

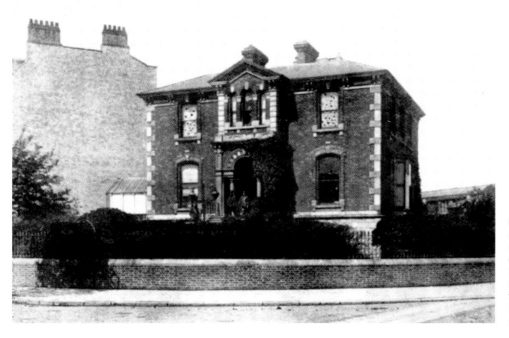

Carrisbrook House

Carrisbrook House was one of the extreme outposts of de Valera's command. At the junction of Pembroke Road and Northumberland Road, it faced into Ballsbridge itself, being separated from it by a short stretch of roadway. It was very lightly held by a couple of riflemen only.

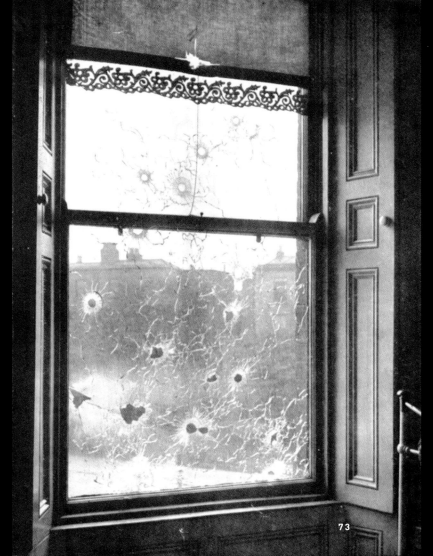

Carrisbrook House, interior

The two men inside Carrisbrook House had orders to withdraw as soon as they came seriously under fire.

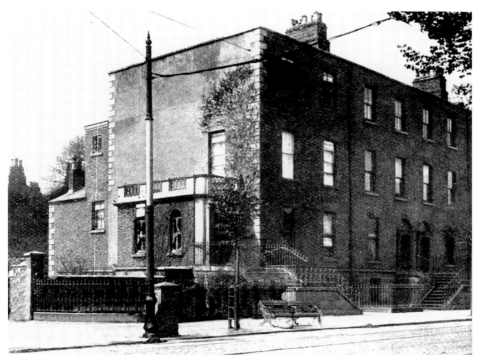

25 Northumberland Road

Another outpost of de Valera's command, this one designed to be more strongly held, was 25 Northumberland Road. In addition, along both Northumberland Road and Haddington Road men were posted, three in one house, two in another.

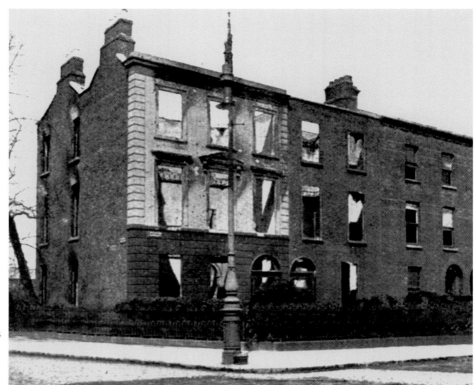

Clanwilliam House

The main centre of resistance was planned by de Valera to be at Clanwilliam House, which immediately overlooked Mount Street Bridge. Here the garrison consisted of seven men. By means of this imaginative disposition of the limited forces available to him de Valera was enabled to inflict the maximum number of casualties on the British forces advancing on his position. The garrison at Clanwilliam House did not evacuate their position until the house was in flames, withdrawing ultimately to Boland's bakery with the loss of three of their number.

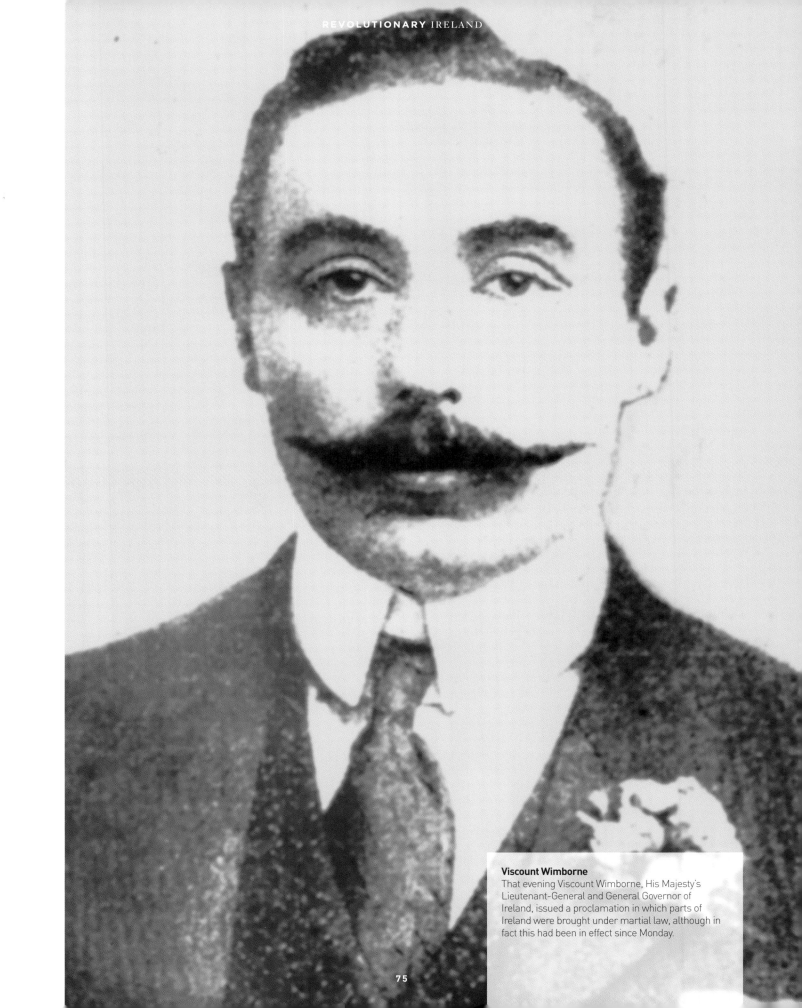

Viscount Wimborne
That evening Viscount Wimborne, His Majesty's Lieutenant-General and General Governor of Ireland, issued a proclamation in which parts of Ireland were brought under martial law, although in fact this had been in effect since Monday.

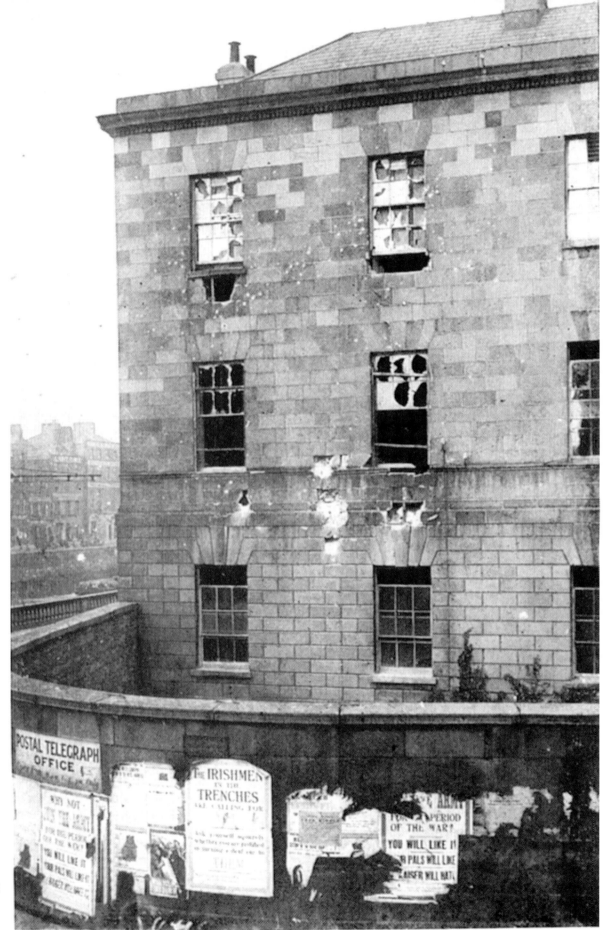

The east wing of the Four Courts
The Four Courts, as can be seen here, was still comparatively unscathed on Thursday and Commandant Daly had succeeded in capturing Linenhall Barracks, between Coleraine Street and Lisburn Street.

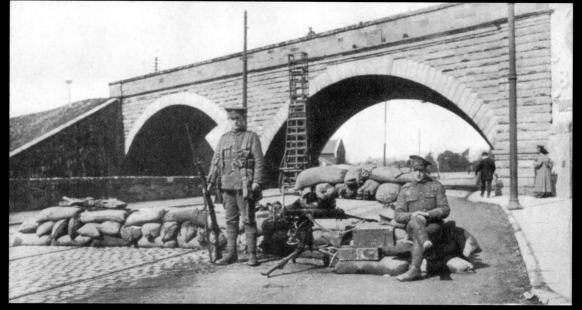

British machine-gun at Fairview
It was vital for the imperial interest that the Irish railway system be defended so that troops might be freely moved. Here we see a Vickers machine-gun post at the railway bridge at Fairview, manned by two soldiers and protected by sandbags, defending the main railway link with the north.

Detail of British recruiting posters on the wall
Partly removed British recruiting posters on the wall.

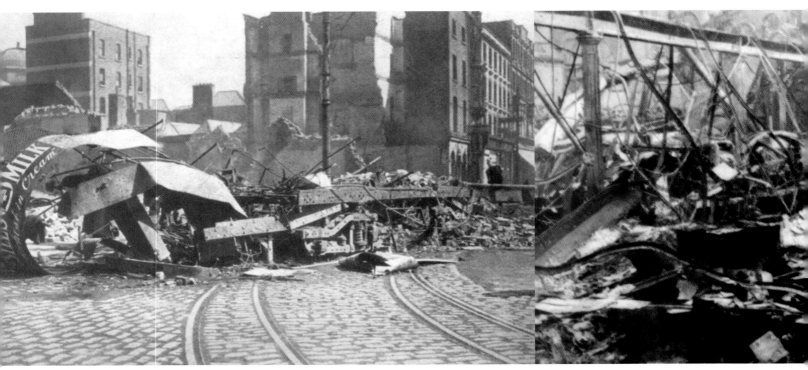

Destroyed tram in O'Connell Street
Connolly's idea that a capitalist government would hesitate to destroy capitalist property was now being put to the test and found to be very much wanting. This is what Crown forces did to one of William Martin Murphy's own trams.

***Freeman's Journal* presses destroyed**
The wrecked presses of the *Freeman's Journal*, which had been used to print three papers.

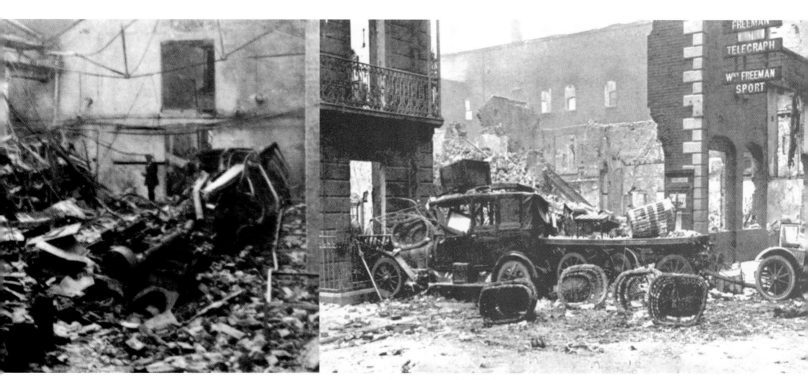

Barricade with the remains of O'Rahilly's car
This is what the same Crown forces did to the *Freeman's Journal* printing works. At the extreme right of this barricade can be seen what remains of Michael O'Rahilly's car, by means of which he had hastened back to the GPO in time to take part in the Rising.

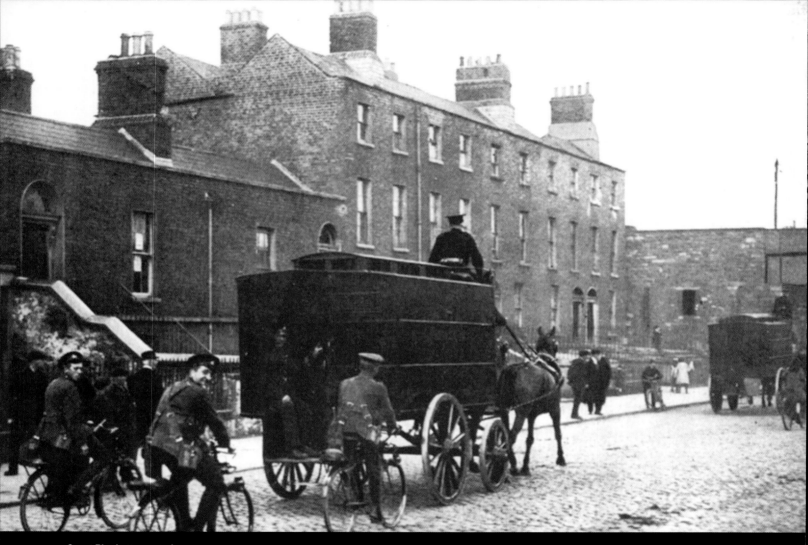

Count Plunkett arrested
All day on Wednesday and Thursday the prison vans were rumbling across Dublin, bringing those arrested to various detention centres. Count Plunkett was one of these.

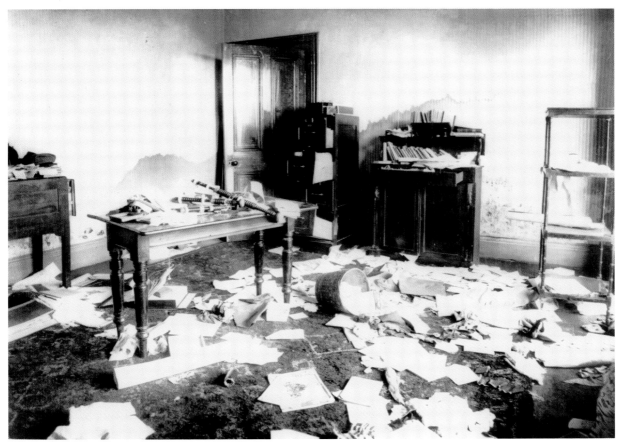

Joseph Plunkett's study at Kimmage (1)

This is the scene after a British army search of Joseph Plunkett's study at 'Larkfield', Kimmage, the home of the Plunketts. Lying on the carpet in the foreground is a damaged wax cylinder for an Edison Phonograph.

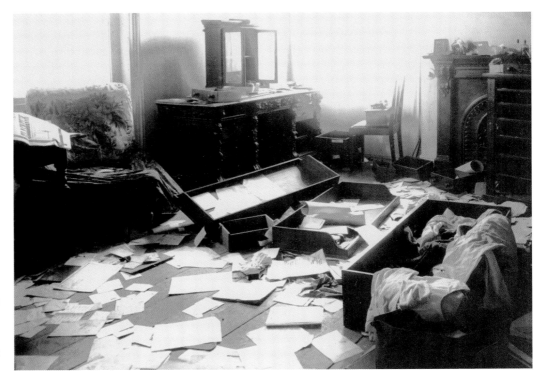

Joseph Plunkett's study at Kimmage (2)

Amidst the miscellaneous debris left by the search, on a chair beneath a window is seen an Edison Phonograph. This may be the machine on which Patrick Pearse was accustomed to record his important speeches, such as that at Dolphin's Barn in 1915.

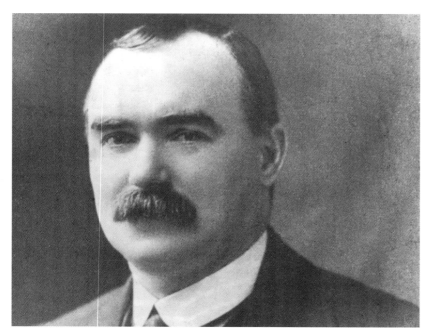

James Connolly

On Thursday afternoon James Connolly was wounded while setting outposts in the streets surrounding the GPO. He was twice hit by bullets in the lower leg, shattering the bones in his ankle. After his wounds had been dressed, although in great pain, he refused to be confined to that portion of the building that had been set aside for use as a hospital, insisting that his bed be wheeled about while he saw to the building's defences.

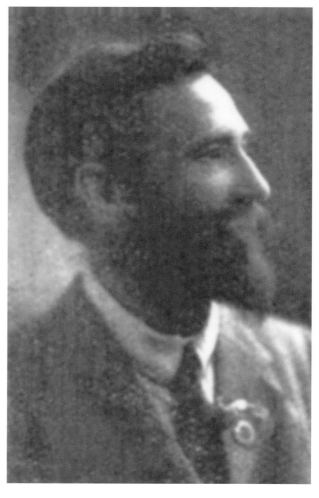

Francis Sheehy-Skeffington

Francis Sheehy-Skeffington, a distinguished pacifist, was a great friend of many of the leaders of the Rising but at the same time opposed it, preferring his own form of civil disobedience, which later influenced Mahatma Gandhi. He was to fall victim to the insane acts of Captain John Bowen-Colthurst of the Royal Irish Rifles, stationed in Portobello Barracks. The captain, who was leading a patrol in the Rathmines area on the evening of the 25th, arrested Sheehy-Skeffington, who had been a witness to the shooting dead of a youth named James Coade, a completely innocent victim of Bowen-Colthurst's mania. Two other unfortunate individuals, Patrick McIntyre and Thomas Dickson, both journalists, were also arrested and were brought with Sheehy-Skeffington to Portobello Barracks that night. On the morning of the 26th Bowen-Colthurst had all three men shot and their bodies clandestinely buried in the barracks.

General Sir John Maxwell
On Friday morning General Maxwell arrived on the scene and took over command. His first act was to issue the following warning: 'If necessary I shall not hesitate to destroy all buildings within any area occupied by the rebels.' His warning was scarcely necessary, however, as this had already been accomplished so far as the centre of Dublin was concerned. Incendiary shells had been fired at the roof of the GPO, setting it on fire, and the destruction was widespread throughout the whole area of Eden Quay and O'Connell Street.

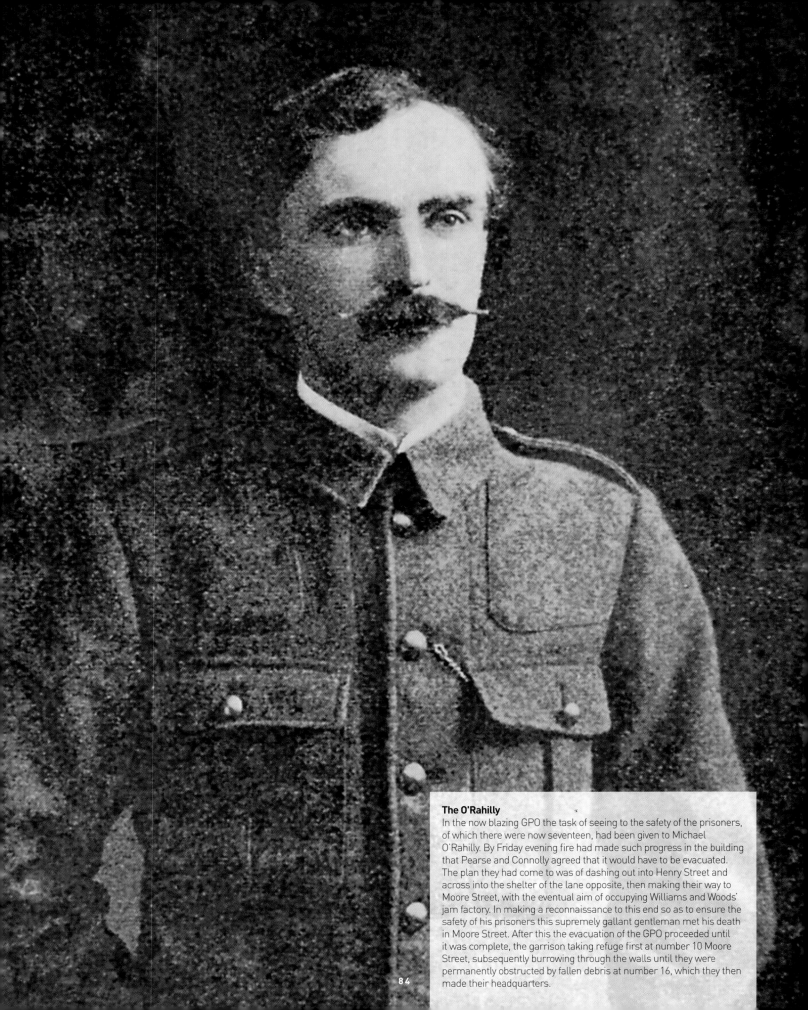

The O'Rahilly

In the now blazing GPO the task of seeing to the safety of the prisoners, of which there were now seventeen, had been given to Michael O'Rahilly. By Friday evening fire had made such progress in the building that Pearse and Connolly agreed that it would have to be evacuated. The plan they had come to was of dashing out into Henry Street and across into the shelter of the lane opposite, then making their way to Moore Street, with the eventual aim of occupying Williams and Woods' jam factory. In making a reconnaissance to this end so as to ensure the safety of his prisoners this supremely gallant gentleman met his death in Moore Street. After this the evacuation of the GPO proceeded until it was complete, the garrison taking refuge first at number 10 Moore Street, subsequently burrowing through the walls until they were permanently obstructed by fallen debris at number 16, which they then made their headquarters.

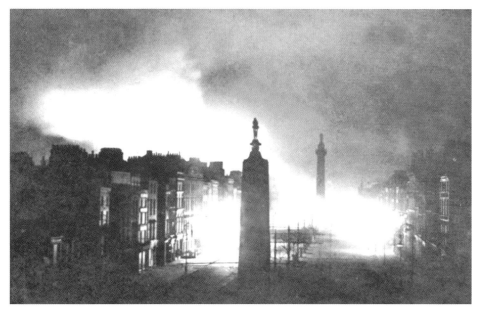

The centre of Dublin ablaze on Friday night
By Friday night extensive areas of the centre of Dublin were on fire.

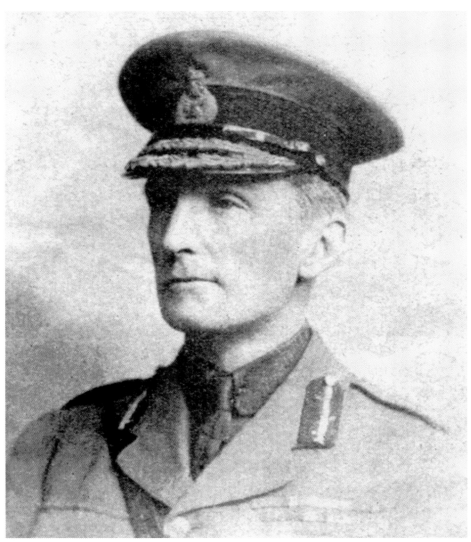

Brigadier-General Lowe
Brigadier-General William Lowe was in command of the Imperial troops serving in the Dublin area, and it is thanks to his orders that so much destruction was perpetrated there, even before the arrival of General Maxwell.

From Commander of Dublin Forces

To P. H. Pearce

29. April/16

1.40 P.M.

A woman has come in and tells me you wish to negotiate with me. I am prepared to receive you in BRITAIN ST at the North End of MOORE ST provided that you surrender unconditionally. You will proceed up MOORE ST accompanied only by the woman who brings you this note under a white flag.

W. H. M. Lowe
B. Genl.

Brigadier-General Lowe's note to Pearse
After taking council around James Connolly's bed in 16 Moore Street, the leaders of the Rising empowered Pearse to sue for terms of surrender. It was noon when they reached this decision, and Nurse Elizabeth O'Farrell was given the following message to be conveyed to the opposing forces: 'The Commandant-General of the Irish Republican Army wishes to treat with the Commandant-General of the British forces in Ireland.' Under cover of a white flag she made her way down Moore Street to the British post in Parnell Street, where she delivered her message to Brigadier-General Lowe. Lowe's reply can be seen in the photograph.

Richmond Barracks, Dublin

This is Richmond Barracks at Inchicore, Dublin, where most of the more important political prisoners were held pending their court-martial. De Valera, alone among the leaders, refused to surrender until he had personally spoken to Thomas MacDonagh, who was being held prisoner here. Then he returned to Boland's bakery and there handed over his field-glasses in token of surrender, not having a sword.

Surrender document, 1916

On Elizabeth O'Farrell's return to 16 Moore Street there was a short delay while the leaders considered Lowe's reply, and then Patrick Pearse and Elizabeth O'Farrell complied with its terms. At approximately 3:30 p.m. Pearse surrendered his sword to Brigadier-General Lowe. The Rising was over. It had lasted little more than six days.

Remaining in Lowe's custody, Pearse dictated and signed the order to surrender, and Elizabeth O'Farrell brought this to the various garrisons, where they were countersigned by James Connolly and Thomas MacDonagh.

> In order to prevent the further slaughter of Dublin citizens, and in the hope of saving the lives of our followers now surrounded and hopelessly outnumbered, the members of the Provisional Government present at Head-Quarters have agreed to an unconditional surrender, and the Commandants of the various districts in the City and Country will order their commands to lay down arms.
>
> P H Pearse
> 29th April 1916
> 3.45 p.m.

> I agree to these conditions for the men only under my own Command in the Moore Street District and for the men in the Stephen's Green Command.
>
> James Connolly
> April 29/16

> On consultation with Commandant Ceannt and other officers I have decided to agree to unconditional surrender also.
>
> Thomas MacDonagh

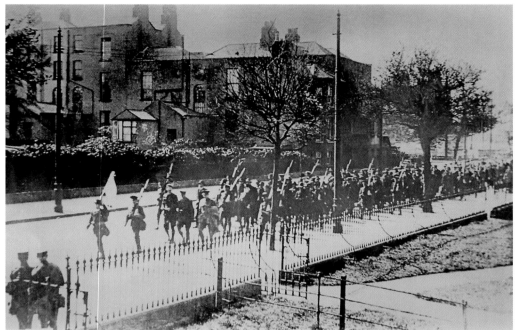

De Valera's garrison *en route* to the RDS
Led by an Irish Volunteer carrying a white flag, de Valera and the garrison were marched, under prisoners' escort, over Mount Street Bridge and up Northumberland Road en route to the Royal Dublin Society's grounds at Merrion Road, where they were held for a few days before being transferred to Richmond Barracks.

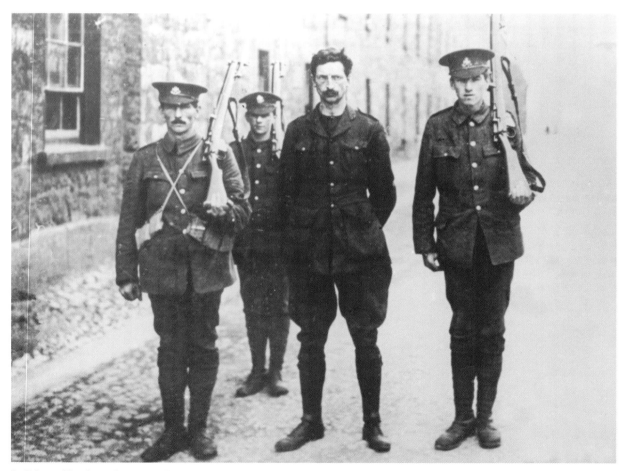

De Valera with prisoner's escort at Richmond Barracks
The garrison at Boland's bakery, under de Valera's command, had caused more British casualties than any of the others, but he and Countess Markievicz were the only commandants who took part in the Easter Rising to survive. He was not transferred to Richmond Barracks until shortly before his court-martial on 8 May, when some of the executions had already taken place. De Valera likewise was sentenced to death, but almost immediately the sentence was commuted to life imprisonment, as was that of Thomas Ashe, who had been involved in the fight at Ashbourne to the north-west of Dublin.

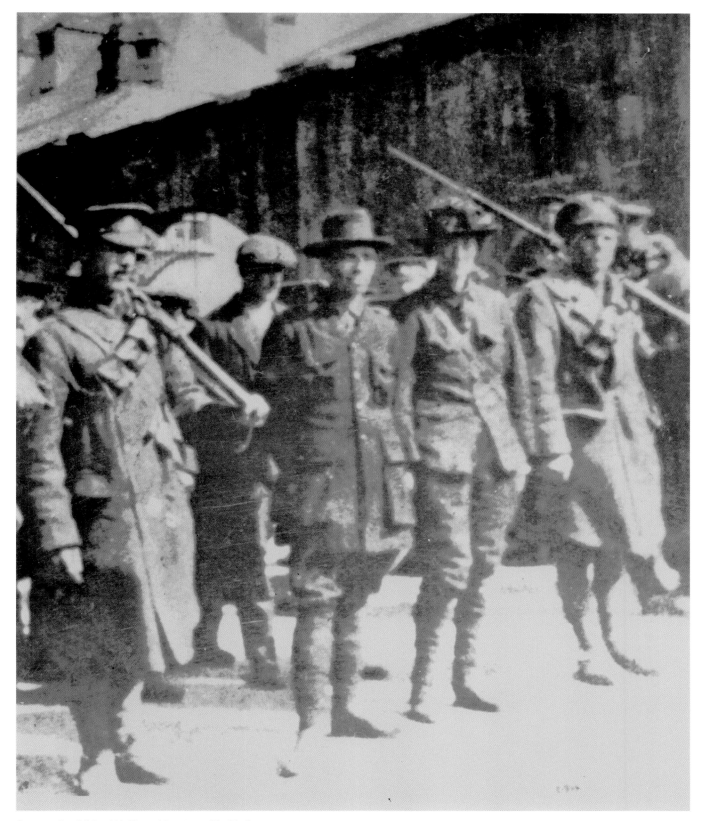

Commandant Michael Mallin and Constance Markievicz
Commandant Michael Mallin and Commandant Constance Markievicz under prisoners' escort at Ship Street Barracks.

Two other brothers of Joseph Plunkett at Richmond Barracks
The whole of the Plunkett family were passionate supporters of Irish republicanism. Here we see, in Irish Volunteer uniform, two other brothers of Joseph Plunkett.

Two prisoners of the 1916 Rising
Here we see, under prisoners' escort, two young working-class men held at Richmond Barracks.

General Maxwell and staff
General Sir John Maxwell and the officers of his staff.

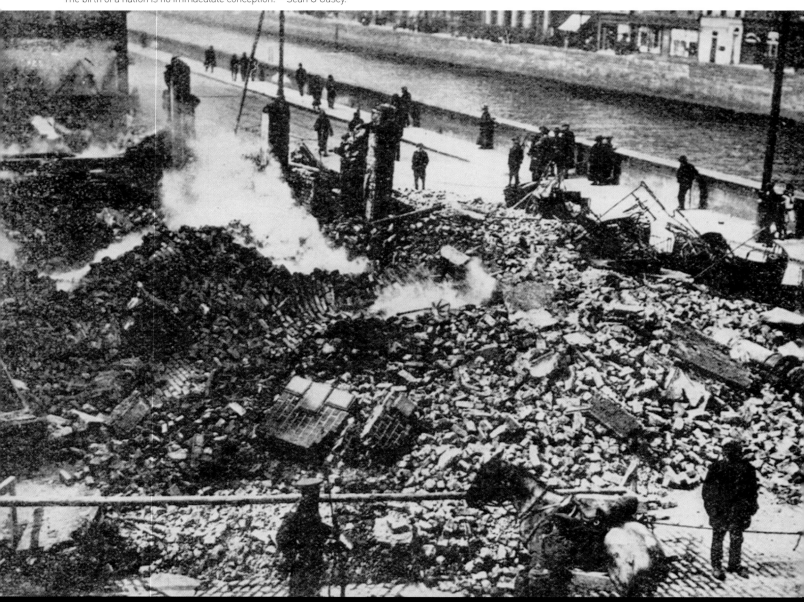

Eden Quay (1)

'The birth of a nation is no immaculate conception.'—Seán O'Casey.

The Rt Hon. John Redmond MP
Poor John Redmond now becomes a tragic and almost grotesque figure as his political position

Eden Quay (2)
Daniel O'Connell MP looks on.

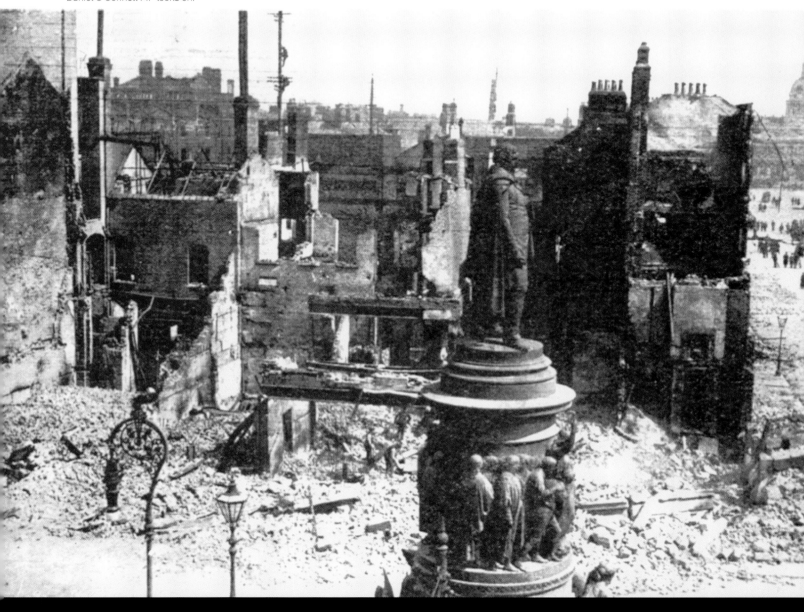

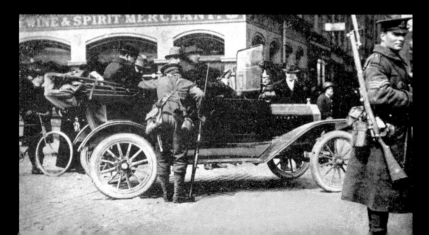

Car searched by British soldiers, Dublin
Parts of Ireland remained under martial law, and were to do so for a very long time. This oppressive circumstance led to increasing friction with the civilian population, and more and more resentment of the occupying power was felt by them as time went on.

Ruins of the Metropole Hotel
The ruins of the Metropole Hotel in O'Connell Street.

The shell of the General Post Office
The shell of the GPO. How much better it looks when deprived of its added top floor!

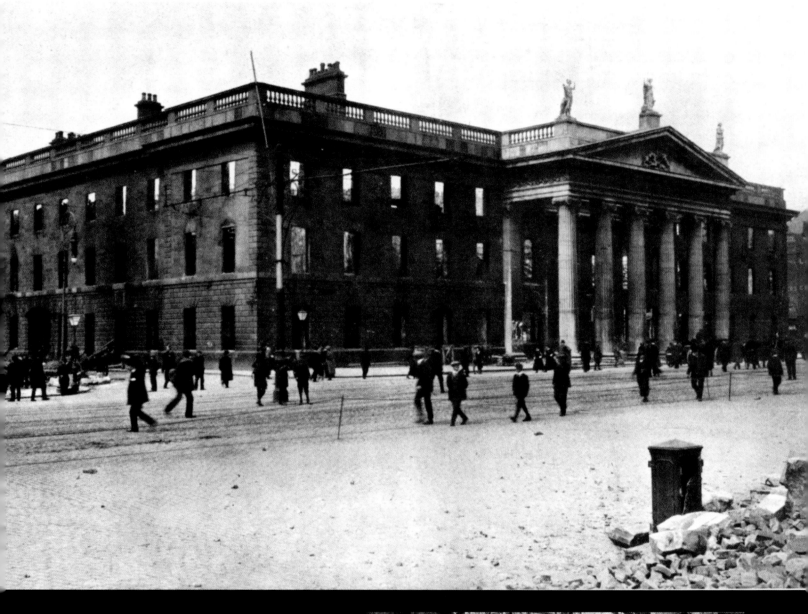

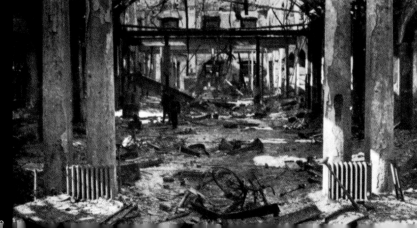

Main hall of the General Post Office after the fire
The main hall of the GPO after it was destroyed by fire

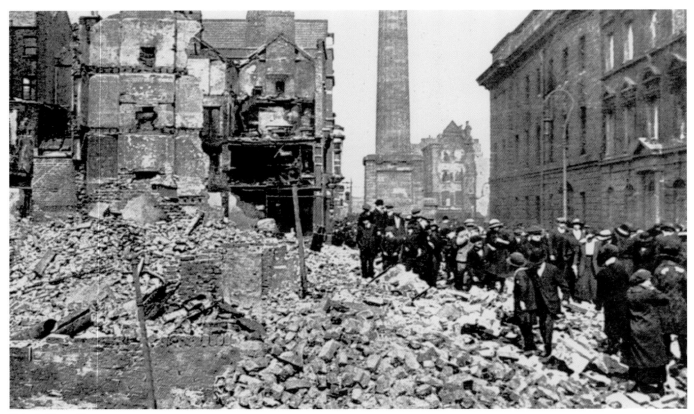

Ruins in Henry Street
Sightseers in Henry Street after the Rising.

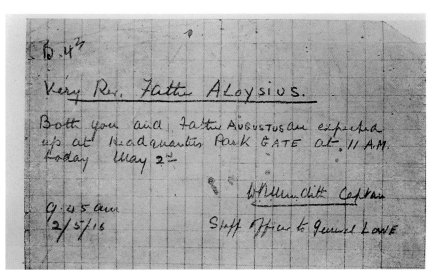

Pass issued by the military, Dublin
A pass issued by the military authorities in Dublin
with a view to allowing spiritual comfort to be
given to those about to be executed.

Newspaper boys
Newspaper boys in Dublin, 1916. They broke the news
that the executions had begun.

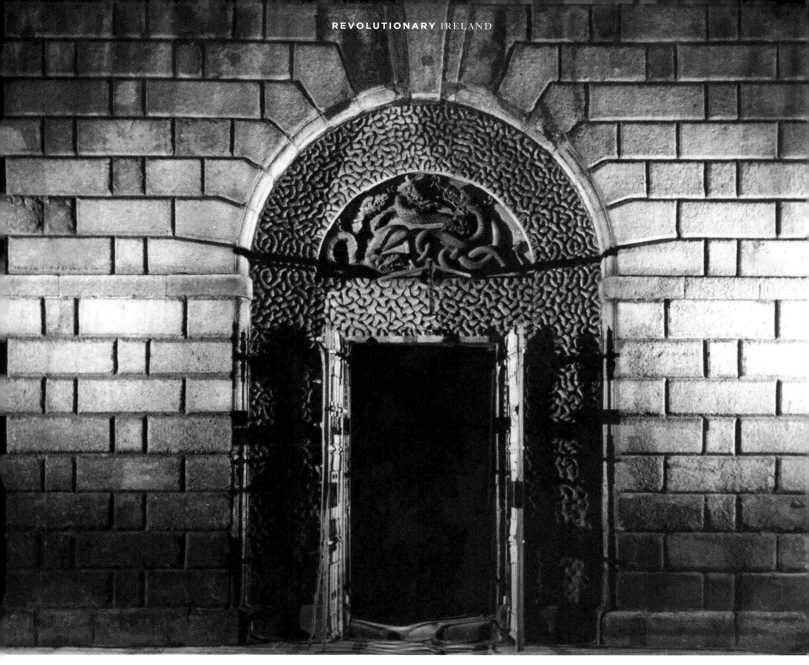

The doorway of Kilmainham Jail

Now begins the darker side of the 1916 story. As Dorothy Macardle says in *The Irish Republic*, 'if the Government had shown a politic clemency at this crisis the Rising might indeed have failed. But they had placed a military officer in charge and he dealt with the situation in a military way. On May 3rd the executions began.'

A few days earlier General Maxwell had given the order to have a collective grave dug at Arbour Hill Barracks capacious enough to hold a hundred bodies. He then proceeded with the courts-martial of the leaders of the Rising. These were held in secret under the military law governing courts-martial in the field. The condemned men were transferred to Kilmainham Jail while awaiting execution. They were to be shot there at first light and their bodies were then to be transported to Arbour Hill for burial.

Patrick Pearse

Patrick Pearse, shot on 3 May 1916. According to the latest Manual for Officers issued by the British army and dated 1915, in which was given the procedure for carrying out a military execution in the field, the prisoner is to be tied to a chair. The rifles, six in number, are to be loaded, three with blanks and three with live ammunition, and then laid on the ground awaiting the men of the firing-party. The prisoner's escort then carry the prisoner to the yard where the execution is to take place and set him down before a sandbagged wall. The officer in charge of the execution then offers the prisoner a blindfold and places a paper target over the position of his heart. The men of the firing-party are then marched in and march up to their rifles. When they are in position they are given the following orders: 'Mark time . . . Halt . . . Right turn . . . One pace forward march . . . Pick up arms.' In deference to the feelings of the prisoner, the final orders, 'Take aim' and 'Fire,' are given as hand signals.

The reason for loading half the rifles with blanks and half with live rounds is to confuse the minds of the firing-party, who will not know until after they have pulled the trigger whether or not they have caused an individual's death.

Thomas MacDonagh

Thomas MacDonagh, shot on 3 May 1916. Born in the village of
Cloghjordan, Co. Tipperary, in 1878, he was destined to become a
teacher, university lecturer, novelist, dramatist and poet. He was
keenly interested in the dramatic art, helped to found Edward Martyn's
Irish Theatre in 1914, and was himself the author of a play, *When
the Dawn Is Come*, which received its first performance at the Abbey
Theatre. As a poet his principal works were *Songs of Myself* and
Through the Ivory Gate.

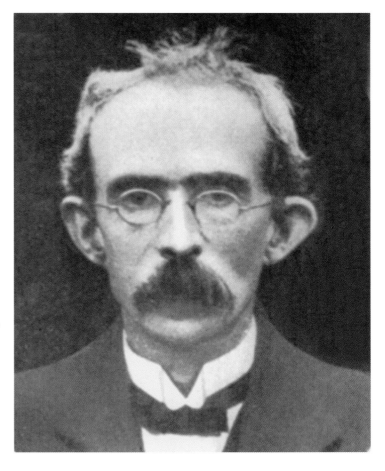

Thomas Clarke

Thomas James Clarke, shot on 3 May 1916. Of Irish parentage, he was
born in England in 1858 but spent most of his childhood in South Africa
until the age of ten, when he came to Dungannon, Co. Tyrone, and there
he lived until he was twenty-one. Emigrating to the United States, he
became involved in work for the recently founded Clan na Gael, which
sent him on a special mission to Ireland, but he was soon arrested and
imprisoned under the most severe conditions for fifteen years. On his
release in 1898 he wrote an account of his treatment at the hands of his
jailers. In 1901 he married Kathleen Daly, daughter of the distinguished
old Fenian leader John Daly, and dedicated himself to the preparation
of an insurrection in Ireland, in which he participated fully. He was
present in the GPO from the first, and his is the first signature on the
Proclamation of the Irish Republic.

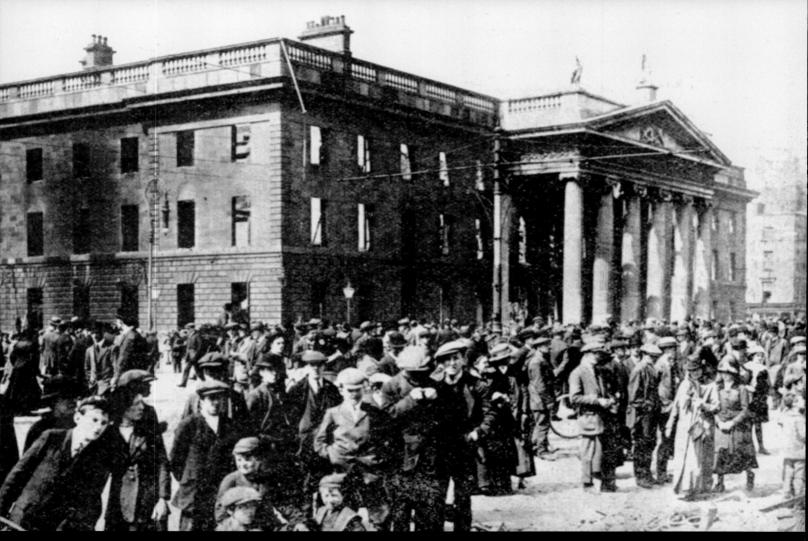

The General Post Office (3)
A bemused crowd in front of the GPO.

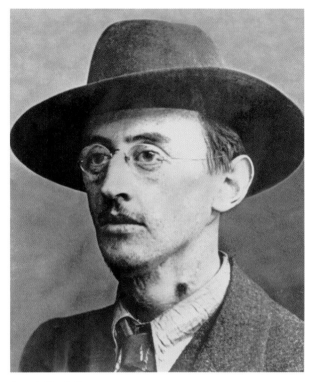

Joseph Plunkett

Joseph Plunkett, shot on 4 May 1916. The eldest son of Count Plunkett, he was born in 1887. His interests were to be science, philosophy and literature; to the latter he contributed a play, *The Circle and the Sword*, and a collection of poems. He collaborated with Thomas MacDonagh in the founding of Edward Martyn's Irish Theatre and edited the *Irish Review*. He was a founder-member of the Irish Volunteers and a member of its first Executive Council in 1913. A member also of the IRB, he was sent by that body on a number of secret missions to Switzerland, Germany and the United States in 1915. He was married to the painter Grace Gifford in the chapel of Kilmainham Jail the night before his execution.

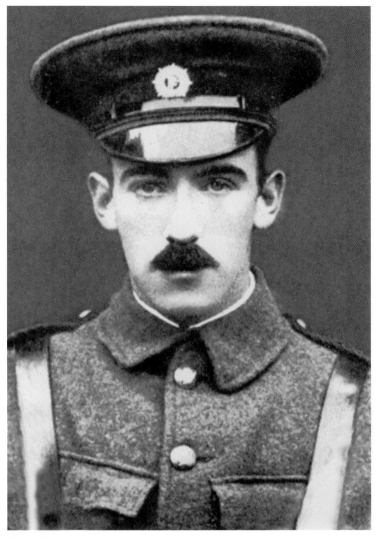

Edward Daly

Edward Daly, shot on 4 May 1916. Born in Limerick in 1891, he was a nephew of the old Fenian John Daly. Coming to Dublin in 1913, he was a founder-member of the Irish Volunteers. He lived in Dublin with the Clarkes, Mrs Tom Clarke being his sister. In 1916 he was assigned to the command of the Four Courts, taking in the area of the north-west of the city.

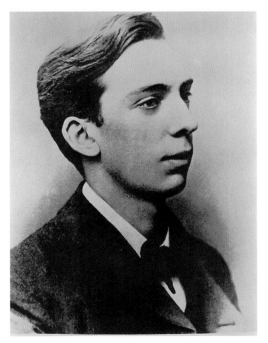

William Pearse

William Pearse, shot on 4 May 1916. Like his elder brother, Patrick, he was educated at the Christian Brothers' School in Westland Row. He taught under Pearse at St Enda's, founded the Leinster Stage Society and acted at the Abbey Theatre and at the Irish Theatre in Hardwicke Street.

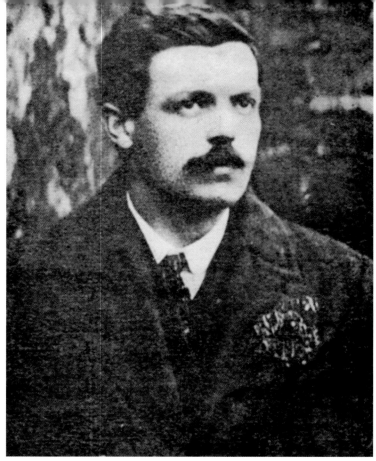

Michael O'Hanrahan
Michael O'Hanrahan, shot on 4 May 1916. Born in New Ross, Co. Wexford, he spent much of his early life in Co. Carlow. Becoming interested in Irish, he joined Conradh na Gaeilge and soon afterwards was a delegate to its second ard-fheis in 1900. He became a well-known journalist, contributing a steady flow of articles to the nationalist press.

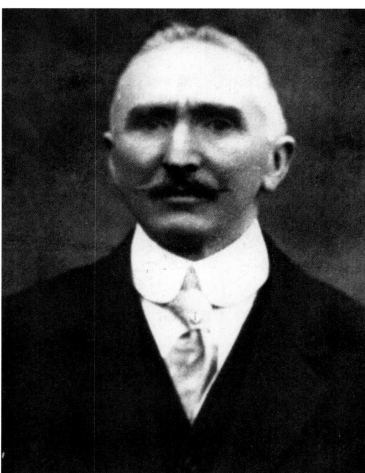

Major John MacBride
Major John MacBride, shot on 5 May 1916. Having fought for the Boers in the South African War and being a marked man with the British, Major MacBride was not admitted to knowledge of the secret date set for the Rising. Walking down Grafton Street on that fateful Monday morning he learnt that it was actually taking place, and going to Jacob's factory in Bishop Street he volunteered his services.

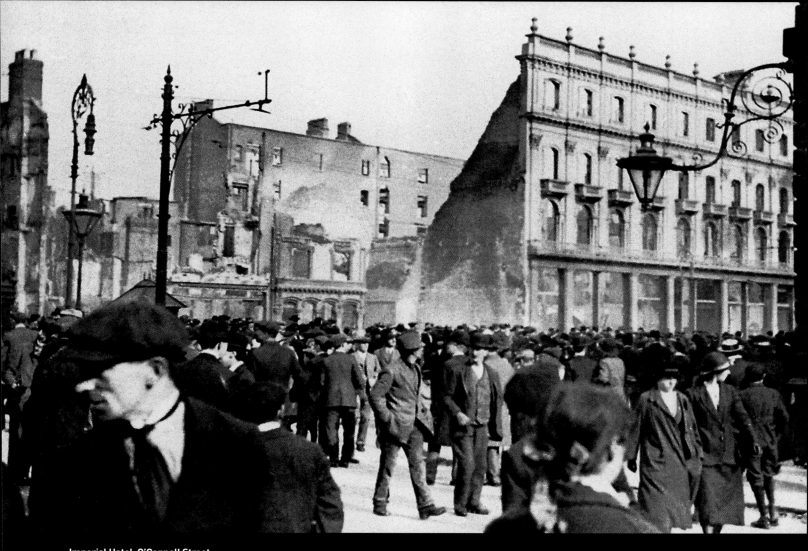

Imperial Hotel, O'Connell Street
Crowds in the vicinity of the Imperial Hotel, O'Connell Street, 1916.

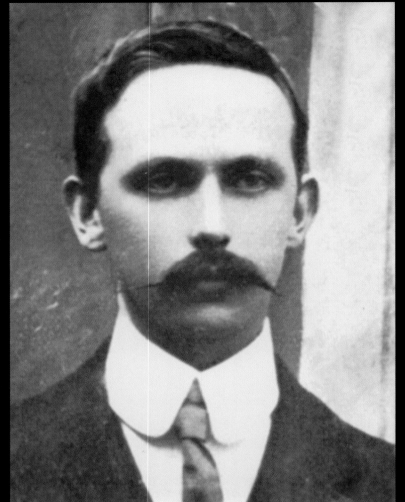

Éamonn Ceannt
Éamonn Ceannt, shot on 8 May 1916. Born in Galway in 1882 and educated in Dublin. He joined Conradh na Gaeilge soon after leaving school and, having made himself remarkable for his expertise in teaching Irish, was elected to its governing body. He was moreover a musician who worked to restore the popularity of the uilleann pipes, and he had great success in training many in their playing.

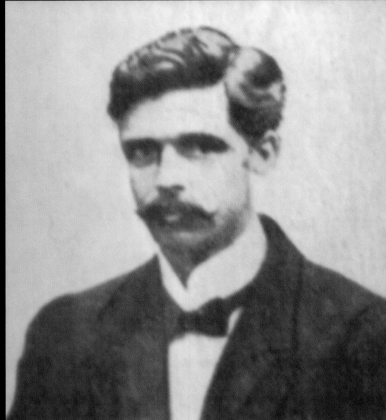

Michael Mallin
Michael Mallin, shot on 8 May 1916. He was a skilled silk-weaver by trade and a distinguished member of the Irish Citizen Army.

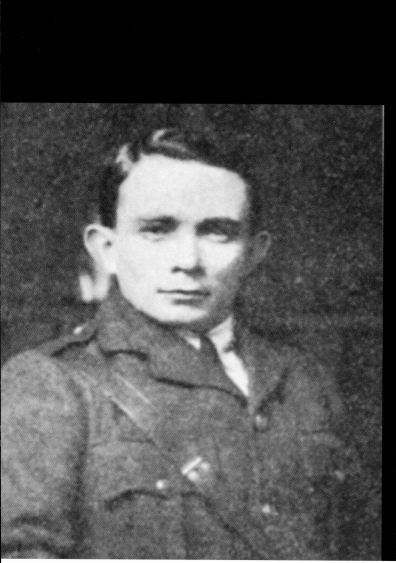

Con Colbert

Cornelius (Con) Colbert, shot on 8 May 1916. He was particularly known for his organising of Fianna Éireann throughout Ireland.

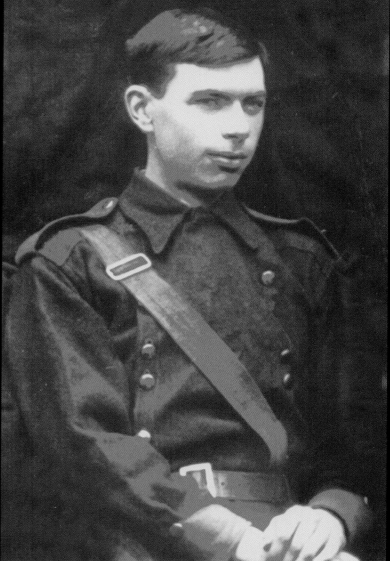

Seán Heuston

Seán Heuston, shot on 8 May 1916. A young employee of the Great Southern and Western Railway, he was also prominent in Fianna Éireann. His occupation of the Mendicity Institution was commemorated by Kingsbridge Station being renamed Heuston Station in 1966.

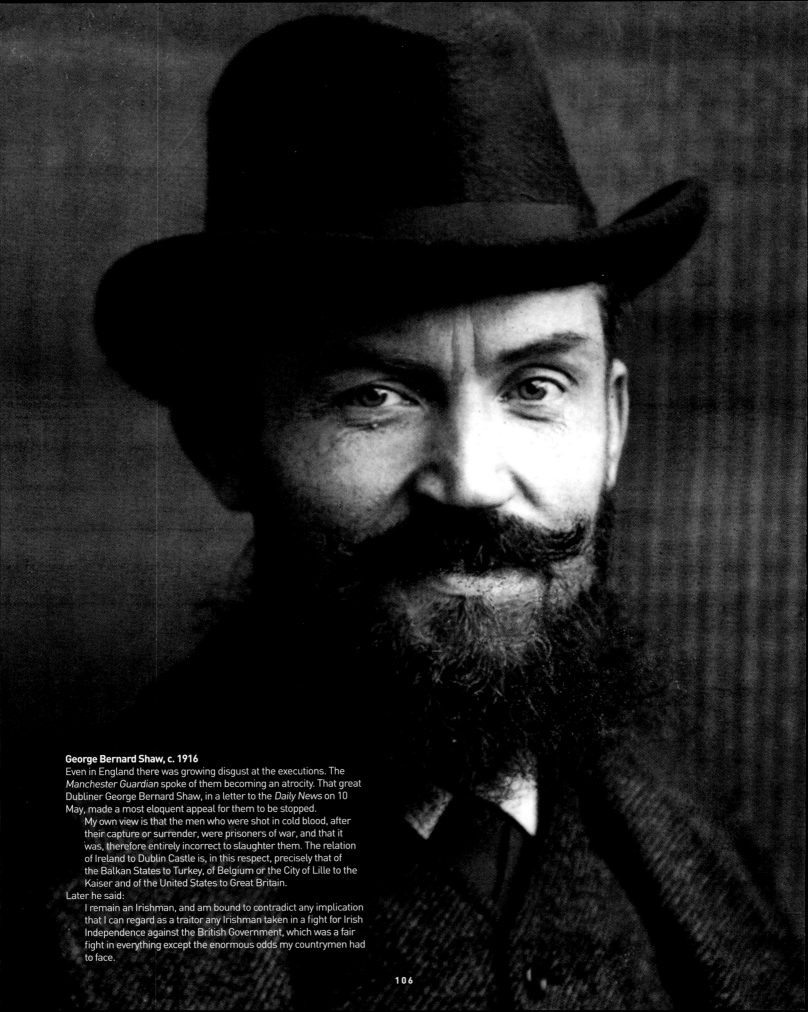

George Bernard Shaw, c. 1916

Even in England there was growing disgust at the executions. The *Manchester Guardian* spoke of them becoming an atrocity. That great Dubliner George Bernard Shaw, in a letter to the *Daily News* on 10 May, made a most eloquent appeal for them to be stopped.

> My own view is that the men who were shot in cold blood, after their capture or surrender, were prisoners of war, and that it was, therefore entirely incorrect to slaughter them. The relation of Ireland to Dublin Castle is, in this respect, precisely that of the Balkan States to Turkey, of Belgium or the City of Lille to the Kaiser and of the United States to Great Britain.

Later he said:

> I remain an Irishman, and am bound to contradict any implication that I can regard as a traitor any Irishman taken in a fight for Irish Independence against the British Government, which was a fair fight in everything except the enormous odds my countrymen had to face.

Royal Hibernian Academy
Passers-by outside the ruins of the Royal Hibernian
Academy in Lower Abbey Street, Dublin.

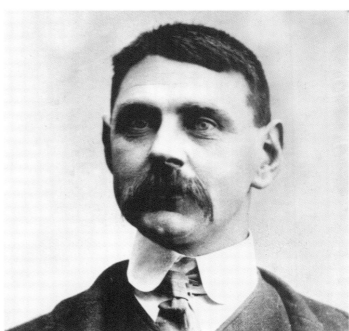

Thomas Kent
Thomas Kent, a brother of Éamonn Ceannt, shot in Cork,
9 May 1916.

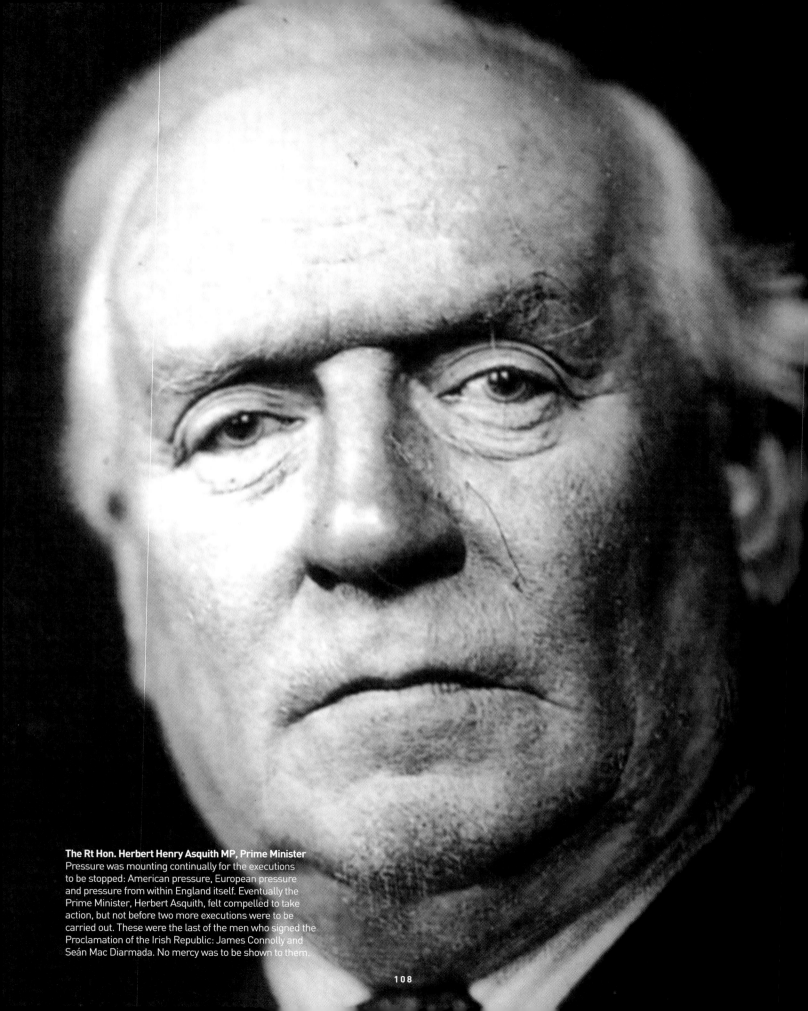

The Rt Hon. Herbert Henry Asquith MP, Prime Minister
Pressure was mounting continually for the executions
to be stopped: American pressure, European pressure
and pressure from within England itself. Eventually the
Prime Minister, Herbert Asquith, felt compelled to take
action, but not before two more executions were to be
carried out. These were the last of the men who signed the
Proclamation of the Irish Republic: James Connolly and
Seán Mac Diarmada. No mercy was to be shown to them.

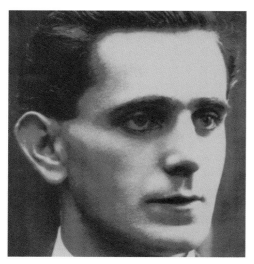

Seán Mac Diarmada
Seán Mac Diarmada, shot on 12 May 1916. As Shaw wrote in his famous letter to the *Daily News*,

> It is absolutely impossible to slaughter a man in this position without making him a martyr and a hero, even though the day before the Rising he may have been only a minor poet. The shot Irishmen will now take their places beside Emmet and the Manchester Martyrs in Ireland, and beside the heroes of Poland and Serbia and Belgium in Europe; and nothing in Heaven or earth can prevent it . . .

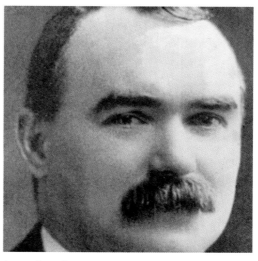

James Connolly
James Connolly, shot on 12 May 1916. *'Justum et tenacem propositi virum . . .'* (The man who is just and determined in his resolution): the words of the Latin poet Horace, echoing down the centuries, would seem to be the most fitting ones to describe the career of this unique individual. He fulfils, in his person, all the criteria described as those of a true man. *'Si fractus illabatur orbis impavidum ferient ruinae'*—If a crushed world should fall in upon him, the ruins would strike him untrembling.

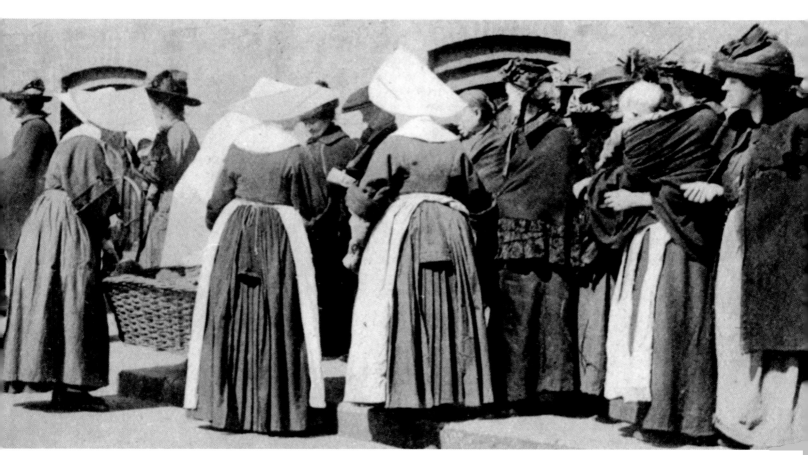

Sisters of Charity giving bread to poor women, 1916
Without the social resources known to us today (inadequate though they may sometimes prove to be), the poor of 1916 had to depend mainly on charitable organisations in times of crisis. Here we see Sisters of Charity distributing bread to the poor women of Dublin.

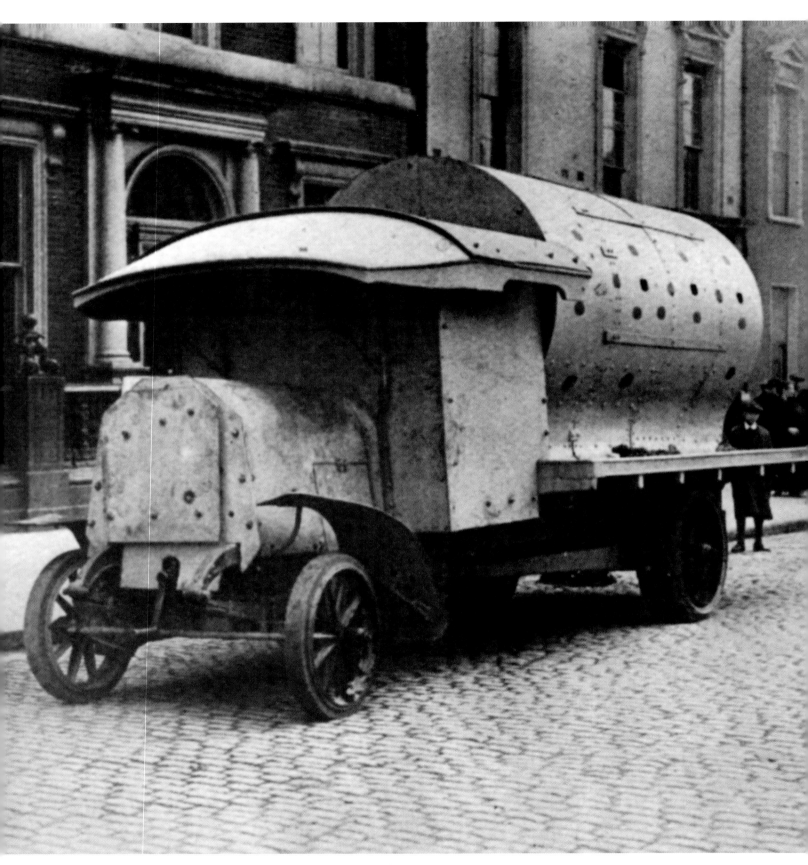

Improvised armoured car built by Great Southern and Western Railway, 1916
One of the most salient admissions of the state of unpreparedness on the part of the Imperial forces was the lack of armoured cars. Efforts were made, in the utmost haste, to supply this deficiency by improvisation. This one, constructed around the boiler of a railway locomotive, was built at the works of the Great Southern and Western Railway at Inchicore, Dublin.

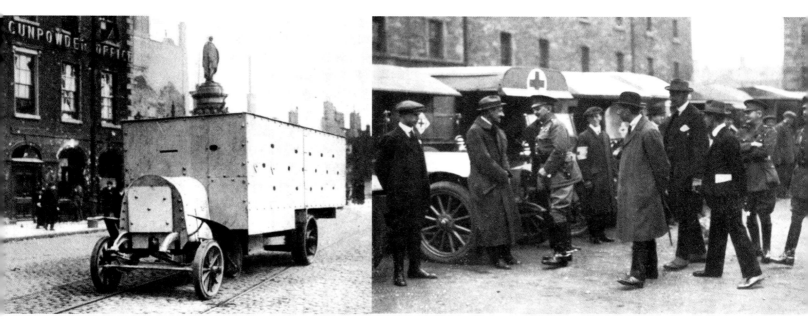

Armoured car built at Dublin Engineering Works, 1916
This somewhat cruder example, seen here at Bachelor's Walk, was built at the Dublin Engineering Works.

Military ambulances inspected by General Maxwell
Even as this photograph was being taken the tide of public opinion in many countries was beginning to turn against General Maxwell, seen here inspecting military ambulances at a barracks in Dublin. Among these may be the one that carried James Connolly on his last journey, the crew of which observed Connolly being tied to a chair in the yard where he was to be shot.

Dear *Mr. Asquith*

I sent you some time ago copies of correspondence with the Most Reverend Bishop O'Dwyer of Limerick.

He is the only dignitary of the R.C. Church who has taken up this attitude.

He sent the correspondence to the Cork Examiner (who published it) without asking my consent.

I am afraid this action has done some harm and incited others to defy authority.

I am getting reports now from the R.I.C. that Priests are offering "Mass" for the repose of the souls of those who have died, or been executed, martyrs to their country's cause etc.

It is an exceedingly difficult matter to deal with this question, and I think that if His Holiness the Pope could be induced to advise the Cardinal Archbishop and Bishops in Ireland to prevent Priests from mixing themselves up with matters, political, seditious or unconnected with their spiritual position, some good might come of it.

In regard to the Ladies we have under arrest here, I enclose for your information some letters on the subject. Doctor Kathleen Lynn's father is evidently anxious to get his daughter out of her present associates.

The letter from Miss Maloney gives a good idea of the part some of these ladies took in the rebellion and the steps that are being taken to agitate for the release of those we have for internment.

I do not like the temper of the people, all reports tend to show that a general rising could easily occur if any outside support is forthcoming.

Maxwell's draft letter to Asquith, 1916
General Maxwell's state of mind and his feelings of foreboding are well conveyed in this draft. Whether it was ever sent is an open question. He had aroused the indignation of Most Rev. Dr Thomas O'Dwyer, Bishop of Limerick, with a request to remove from their parishes those priests who favoured the insurgents. Dr O'Dwyer replied with a letter that he circulated to the press, in which he said:
> You took care that no plea for mercy should interpose on behalf of the poor young fellows who surrendered to you in Dublin. The first intimation that we got of their fate was the announcement that they had been shot in cold blood. Personally I regard your action with horror, and I believe that it has outraged the conscience of the country.

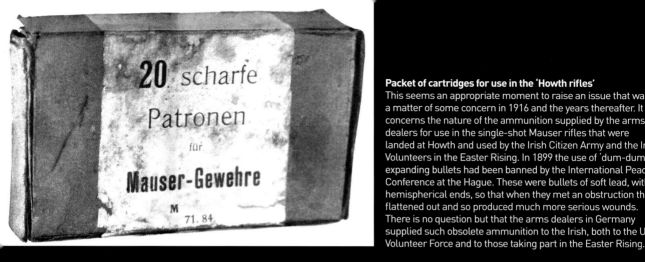

Packet of cartridges for use in the 'Howth rifles'

This seems an appropriate moment to raise an issue that was a matter of some concern in 1916 and the years thereafter. It concerns the nature of the ammunition supplied by the arms dealers for use in the single-shot Mauser rifles that were landed at Howth and used by the Irish Citizen Army and the Irish Volunteers in the Easter Rising. In 1899 the use of 'dum-dum' or expanding bullets had been banned by the International Peace Conference at the Hague. These were bullets of soft lead, with hemispherical ends, so that when they met an obstruction they flattened out and so produced much more serious wounds. There is no question but that the arms dealers in Germany supplied such obsolete ammunition to the Irish, both to the Ulster Volunteer Force and to those taking part in the Easter Rising.

British army rifle ammunition

The British army had altogether ceased to use this type of ammunition for many years before 1916. The type of ammunition employed had a nickel jacket to prevent it from flattening and was quite differently shaped, having an ogival profile.

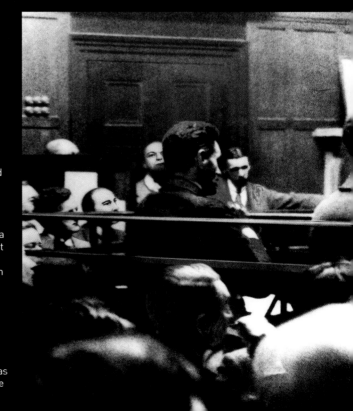

Sir Roger Casement during his trial for treason, 1916

On 26 June, at the Central Criminal Court in the Old Bailey in London, the trial of Sir Roger Casement was begun. Casement had petitioned to be tried in Ireland, but this was not to be permitted. Chief prosecuting counsel was the same F. E. Smith, now enjoying the privileges of knighthood, who had intervened so eagerly in support of the Conservative and Unionist Party interest in the north-east of Ireland in 1913 and who now occupied the position of Attorney-General of Great Britain, while Sir Edward Carson was a member of the British Cabinet and First Lord of the Admiralty. As Casement said prophetically during his trial,

> the difference between us was that the Unionist champions chose a path they felt would lead to the Woolsack [Chancellorship of the Exchequer] while I went a road that I knew must lead to the dock. And the event proves both were right.

But this was not all. An intense whispering campaign had already been launched against Casement, stigmatising him for homosexuality on the evidence of diaries he had kept in Putumayo. This was a despicable thing to have done when homophobia was so prevalent, as it was at the time.

The only statute in force at the time that allowed a sentence of death was one that dated from the time when kings of England pretended to the throne of France. Casement was tried under this for 'High Treason without the Realm of England' and was condemned to be hanged.

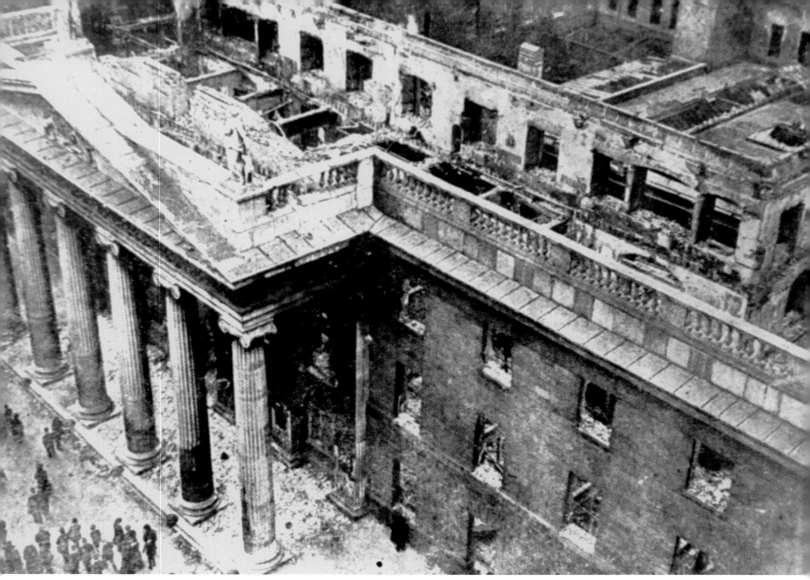

**Ruins of the General Post Office, from the top of the
Nelson Pillar, 1916**
Had it all been worth while, or had the old order
prevailed? Only the Irish themselves were capable of
providing an answer to this question.

Dead British soldier in a trench in France, 1916
Meanwhile the imperialist 'war to end wars' was being
pursued with undiminished vigour and a monstrously
ever-increasing number of casualties. It even looked as
though the balance of the war could tip in favour of the
Central Powers.

PART 3

The total crushing of the Easter Rising and the wholesale imprisonment and internment of so many of its participants were meant to bring home to the Irish people that they must give up all hope of ever having a sovereign state. But, barely a year later, the welcome given to the prisoners and internees was a salient indication of the turning of the tide of public opinion.

Even in prison, wise minds had been asking themselves the question, What do we do now? A plan was quickly formulated: to meet as soon as possible to constitute a separate National Assembly of the Irish People, which would be given, among other things, the task of mirroring the British administration in every important respect.

On 21 January 1919 this national assembly met for the first time and was named Dáil Éireann. By a democratic vote, it declared for a republic.

Meanwhile the British administration in Ireland was still largely intact. The workings of Dáil Éireann were not interfered with at first though kept under the most rigorous scrutiny. This policy was soon to change, to be replaced with one of violent opposition.

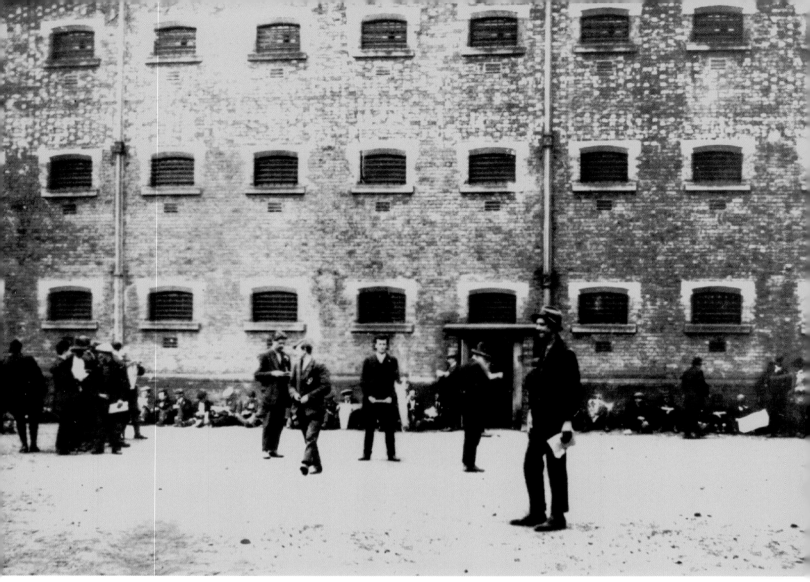

IRA prisoners in Stafford Jail

All members of the Irish Republican Army whom the British could get hold of were now locked up safely in various prisons and internment camps in England, together with a small number of Cumann na mBan members, including Constance Markievicz and Maud Gonne MacBride. Held without trial under the provisions of the Defence of the Realm Regulations, a wartime 'catch-all' measure, they could be detained indefinitely.

But in England there were growing signs of public discontent and even protest. General Maxwell's blundering was coming to be understood by intellectuals the world over, particularly in India, that vast British imperial possession. The jails and internment camps to which the prisoners were confined rapidly became forcing-houses for the republican cause, so that when, a little later, it was decided to transfer some 1,800 of the men to the internment camp at Frongoch in Wales, this process was much facilitated.

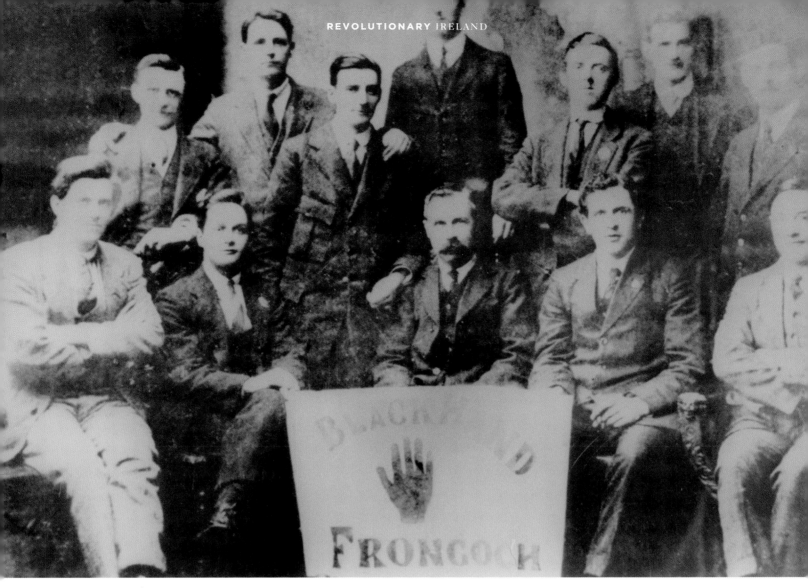

Members of the 'Black Hand' at Frongoch camp

Michael Collins had even succeeded at Frongoch in forming an association of the internees there into a branch of the IRB, called the Black Hand. It was this kind of activity that caused Henry Duke, successor to Augustine Birrell as Chief Secretary for Ireland, to say that 'the time had come when the risk of liberating the internees would be less than the risk of detaining them longer.'

On 22 December 1916 six hundred untried internees were released from Frongoch, and there were further releases a couple of days later from Reading Jail. In Ireland they were welcomed home with the traditional bonfires and torchlight processions. These men and their families helped to spread Irish republicanism further and to prepare the ground for the mass swing in public opinion that was to come.

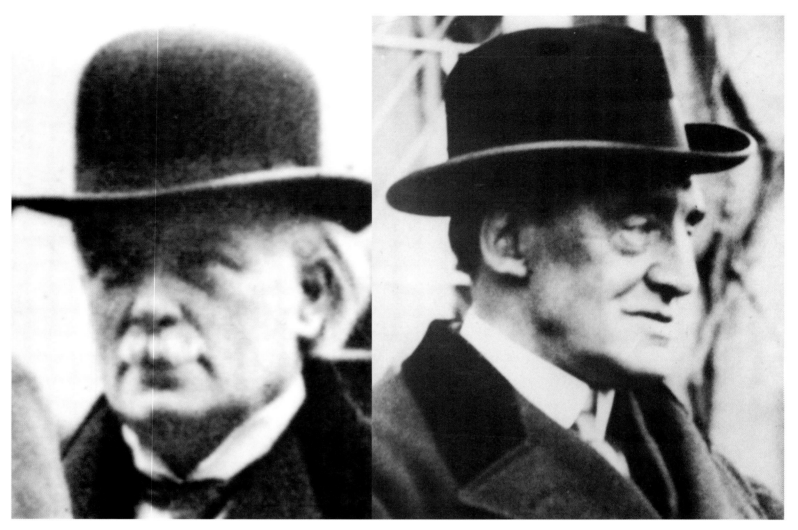

David Lloyd George becomes British Prime Minister
David Lloyd George—the 'Welsh Wizard', as he came to be called—
succeeded Herbert Asquith as Prime Minister, taking office on 6
December 1916. Ahead of him he had no easy series of tasks. The
imperialist war with the Central Powers was not going well; in fact the
mounting casualties suffered by the British and their allies, coupled
with the increased sinking of Allied shipping by German submarines,
threatened to tip the scales in favour of the Central Powers.

Most important of all was the fact that the United States had not
yet entered the war. On 22 January 1917 the President of the United
States, Woodrow Wilson, made an important speech to Congress, during
which he declared: 'No peace can last, or ought to last, which does not
recognise or accept the principle that governments derive all their just
powers from the consent of the governed, and that no right anywhere
exists to hand peoples about from sovereignty to sovereignty as if they
were property.' How could this be made to square with British policy
in Ireland, and how could already enraged Irish-American views of the
events of 1916 be mollified?

Sir Edward Carson keeps his position as First Lord of the Admiralty
Nothing could better exemplify the unchanging nature of British
imperialism than the retention of Sir Edward Carson's Cabinet seat and
the confirmation of his position of First Lord of the Admiralty, as well as
the honours soon to be conferred on Sir F. E. Smith in being raised to the
peerage with the title of Baron Birkenhead and the final attainment of
the 'Woolsack'.

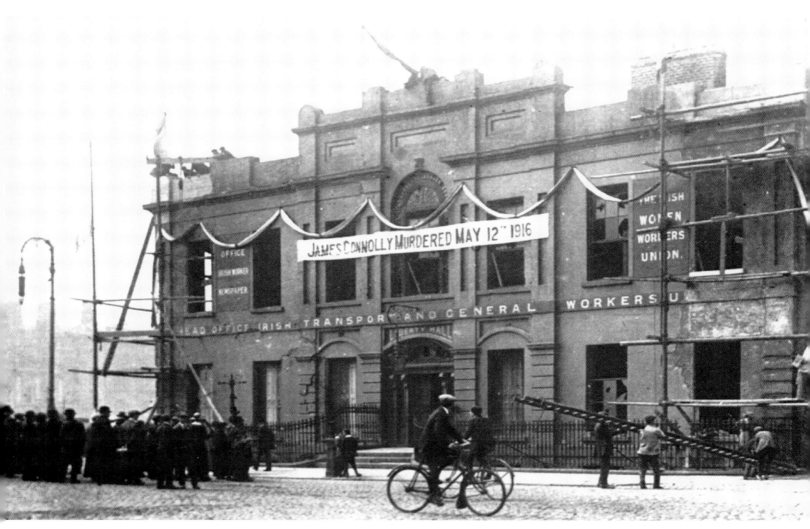

Liberty Hall being rebuilt, 1917
Passers-by in Beresford Place, Dublin, in January 1917 stop to stare at the
rebuilding of Liberty Hall and to read the unequivocal message on the banner
slung over the ruins, expressing the views of James Larkin and many members
of the ITGWU.

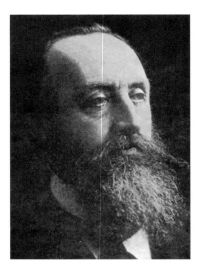

Count Plunkett, candidate for Roscommon, 1917

A by-election had been called early in 1917 in Co. Roscommon to fill a vacancy in the British Parliament. After the most careful consideration, the now reinvigorated Sinn Féin decided to nominate the scholarly nationalist George Noble, Count Plunkett. It was to be clearly understood that if elected he would refuse to take his seat in London, campaigning instead for an assembly to meet in Dublin.

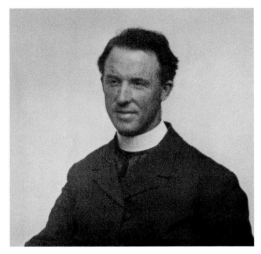

Father Michael O'Flanagan

Sinn Féin was exceptionally fortunate in its choice of a young priest, Father Michael O'Flanagan, to be Director of Elections. He was to show himself to be a man of exceptional energy and resourcefulness.

Lloyd George's Irish Convention, June 1917

In an endeavour to placate Irish-American and world public opinion, Lloyd George summoned an Irish Convention in 1917. It was to consist of 101 carefully selected members, but of these Sinn Féin was to be allotted only five. It was hardly a matter of surprise that Sinn Féin rejected the offer. Furthermore, the Convention was not to be permitted to consider the future of the north-eastern counties of Ireland. Already, on 2 June, Arthur Griffith had made his views plain:

> He [Lloyd George] summons a Convention and guarantees that a small minority of people will not be bound by its decision, and thus, having secured its failure, he is armed to assure the world that England left the Irish to settle the question of government for themselves and that they could not agree

Arrest of Count Plunkett, Beresford Place, 1917

Meanwhile in Dublin events were taking place at an increasing rate. Sinn Féin had organised a mass meeting at Beresford Place to hear addresses by Count Plunkett and Cathal Brugha on behalf of the majority of the men and women of 1916, who were still in English prisons and internment camps. Count Plunkett had not spoken for long when, at 7:29 p.m., he was arrested by the Dublin Metropolitan Police; and the same thing occurred when Brugha was endeavouring to speak. A riot ensued in which Inspector John Mills of the DMP lost his life. The two men were charged with sedition. But this kind of pressure convinced Lloyd George to release almost all the 1916 prisoners before the termination of the Irish Convention.

Dev steps ashore at Kingstown, 1917
Among the first to be released was Commandant Éamon de Valera, who is
seen coming ashore from the mail boat at Kingstown.

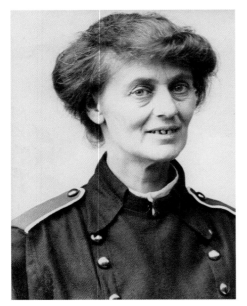

Constance Markievicz after her return from prison
Condemned to death but her sentence commuted to penal servitude for
life, Constance Markievicz was consigned to Holloway, the great women's
prison in Camden Road, London, with its mock-gothic architecture. There her
health deteriorated, as may be seen in this photograph taken shortly after her
release. She arrived by the afternoon mail boat at Kingstown and was given
a tumultuous welcome at Westland Row Station (now Pearse Station), being
escorted by cheering crowds that accompanied her and her sister, Eva, all the
way to Liberty Hall.

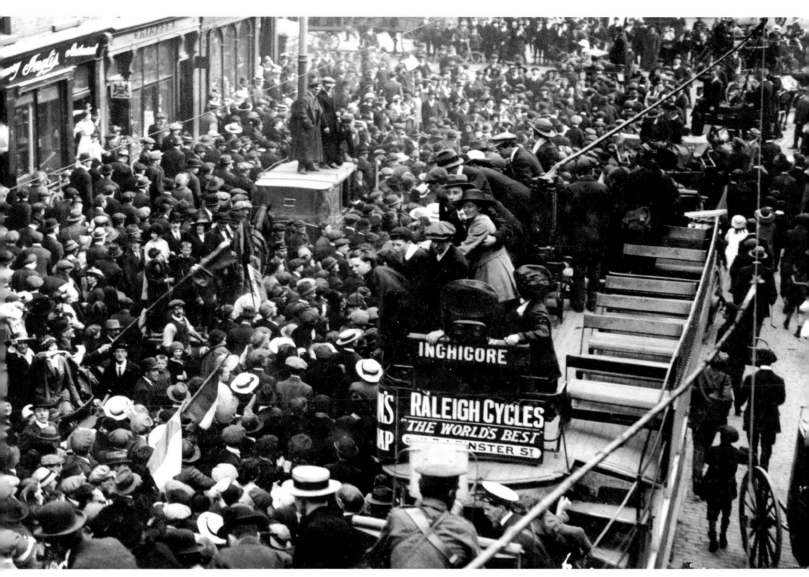

Welcome for the prisoners, Dublin, 1917
The people thronged into the streets of Dublin to such an extent that all traffic was virtually brought to a standstill in certain districts. The men and women prisoners and internees had a heroes' welcome, and bonfires blazed on the hills of Ireland that night.

De Valera wins in East Clare, 1917

The first thing that met de Valera on his emergence from the gates of Pentonville Prison in London was a telegram informing him that he had been selected by Sinn Féin to stand on its behalf in the forthcoming by-election in East Clare. He was to be opposed by the Irish Party's candidate, Patrick Lynch KC. De Valera was most forthright in all his speeches, proclaiming his absolute adherence to the terms of the Proclamation of the Irish Republic, but added:

> Ulster is entitled to justice and she will have it, but she should not be petted and the interests of the majority sacrificed to her. Give Unionists a just and full share of representation, but no more than their just share.

His opponent countered with a most singular piece of rhetoric:

> Clare voters do not want to see their sons shot down in a futile and insane attempt to establish an Irish Republic.

When the result of the by-election came it showed a victory for de Valera of more than two to one.

Kilkenny by-election, 1917

Since Count Plunkett's election in Roscommon, followed by that of Joseph MacGuinness for Longford and de Valera's win in Clare East, the by-elections had all been going in Sinn Féin's favour, and now in August another was due, in Kilkenny. When the editor of the *Kilkenny People* expressed in an editorial his preference for the Sinn Féin candidate, Alderman William T. Cosgrave, his paper was instantly suppressed by the authorities. Here the candidate is seen seated beside Lawrence Ginnell MP (wearing a silk hat) in the back seat of a model T Ford. The famous old filibusterer at Westminster had just resigned his seat in the British Parliament to be able to devote all his time to the Irish republican cause.

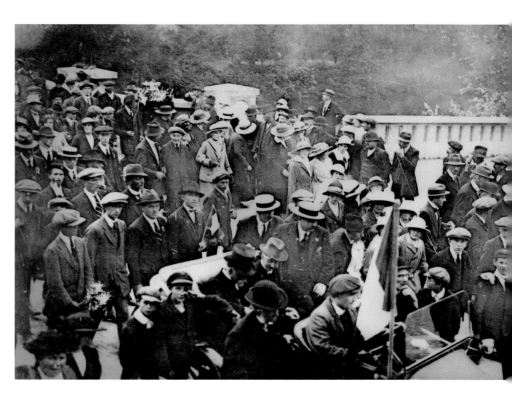

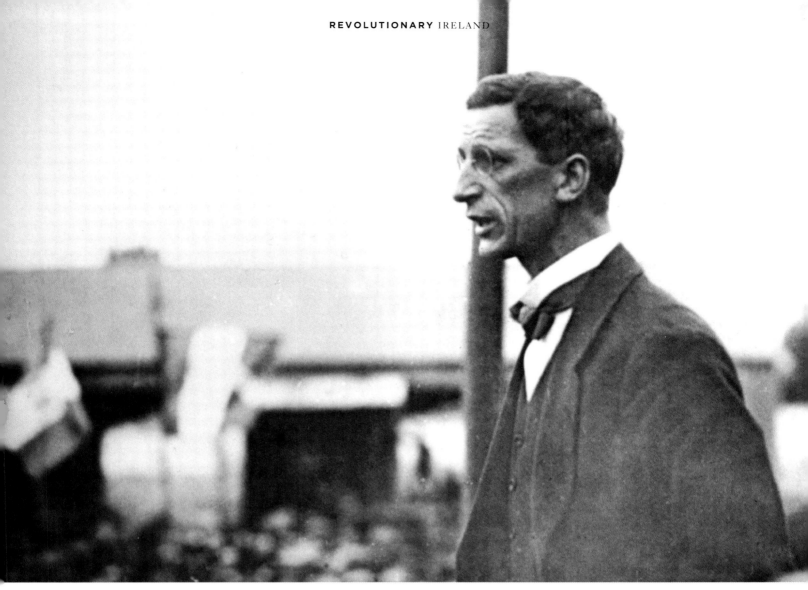

De Valera speaks at Kilkenny, 1917
De Valera adding his appeal for the election of Alderman Cosgrave. In another five years the two men were to be utterly opposed to one another in policy.

Constance Markievicz speaks at Kilkenny, 1917
Countess Markievicz giving an impassioned speech in support of Alderman Cosgrave at Kilkenny.

Thomas Ashe, 1917

Thomas Ashe was a musician with a keen interest in the Irish war-pipes. A member of the Irish Volunteers since its inception, he had commanded a party during Easter Week in an attack on the RIC barracks at Ashbourne, Co. Meath, with Richard Mulcahy as second in command. There were a considerable number of casualties on both sides, and an RIC inspector was killed. After holding out for five hours, the armed police surrendered to the Volunteers, who disarmed and released them. For this, both Ashe and Mulcahy were sentenced to death by court-martial, as were a total of eighty others. But General Maxwell's policy was being brought to an end under the pressure of public opinion, and the remainder of the death sentences were commuted to life imprisonment with hard labour or other lesser penalties. Ashe and Mulcahy were deported to England to serve their sentences, but they were released in 1917.

In August that year Ashe was arrested again and charged with making 'speeches calculated to cause disaffection,' and having been tried by a military court he was sentenced to a year's imprisonment with hard labour and confined in Mountjoy Jail, where on 18 September the Irish Volunteer prisoners demanded to be treated as prisoners of war. The prison authorities refused this, and the prisoners began wrecking their cell furniture. Ashe was deprived of his bed, bedding and boots and he and the other prisoners then went on hunger strike.

The Lord Mayor of Dublin, Laurence O'Neill, on visiting the prisoners found Ashe lying on the bare cell floor, inadequately clothed and suffering acutely from the cold. After fifty hours his bed and bedding were returned to him but he was now subjected to the barbarous practice of forcible feeding. In spite of his struggles in the surgical chair, a tube was passed into his stomach. O'Neill on his next visit found Ashe with such lesions and bruising on his face and throat that he knew the end was close. On 25 September Ashe collapsed in the surgical chair as he was being forcibly fed. He was transferred to hospital but died five hours later.

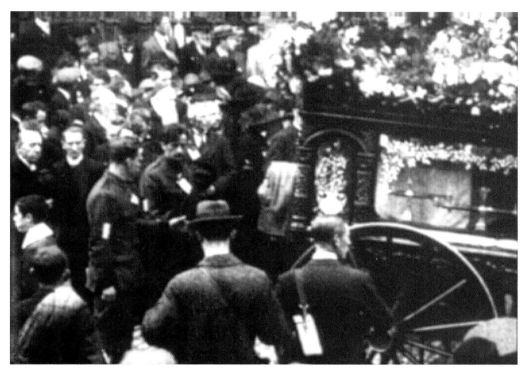

Funeral of Thomas Ashe, 1917
Thomas Ashe was given a funeral that surpassed even that given to the old Fenian O'Donovan Rossa. The city of Dublin came virtually to a standstill, and people thronged from all over Ireland to attend it. His body lay in state in City Hall, dressed in Irish Volunteer uniform, and when it was brought from there to Glasnevin Cemetery, Michael Collins gave the short oration. The events surrounding his death seemed to be a focusing point for public feeling throughout the country, bringing about a unification process that appeared to eliminate the minor differences that had heretofore prevailed.

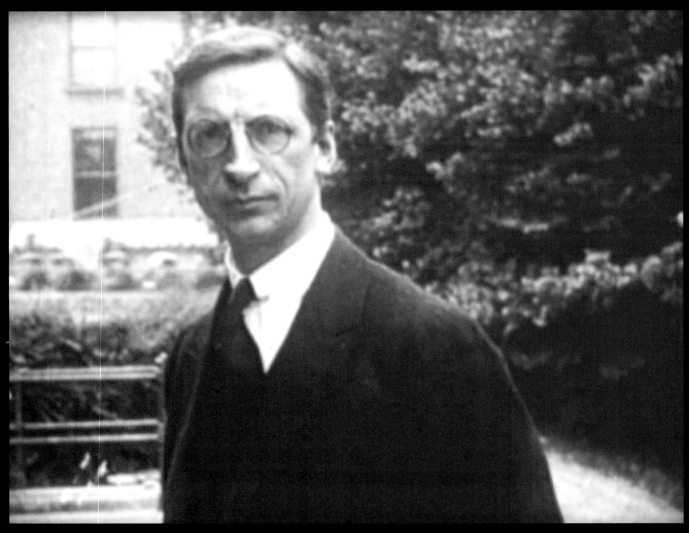

De Valera in Dublin, c. 1917

Throughout October, Sinn Féin was preparing to reorganise itself into a truly democratic party by appointing delegates to attend a specially convened meeting to be held at the Mansion House in Dublin and to this end formed a Provisional Executive Committee. Éamon de Valera succeeded in finding the right form of words to define the aims of the renewed Sinn Féin, which were unanimously accepted by this committee:

> Sinn Féin aims at securing the international recognition of Ireland as an independent Irish Republic. Having achieved that status the Irish people may by Referendum freely choose their own form of Government.

This was used to form the preamble of the draft constitution of Sinn Féin put to the assembled delegates in the Mansion House on 25 October, when de Valera was appointed President of Sinn Féin.

Meanwhile a serious setback to the war effort of the Allies was about to occur. Russia was to be in revolution and was to withdraw from the war and the American army was not yet in the field. The reactions of Lloyd George and practically the whole of the British government to this were well encapsulated by John Redmond when he said: 'Sinn Féin will be omnipotent, and you will be forced to appoint a military governor.'

Anti-Conscription general strike in Ireland, 1918

These were eventful days. On 19 April there was a by-election in Co. Offaly at which the Irish Party withdrew its candidate and the Sinn Féin candidate was returned unopposed. He was Dr Patrick McCartan, who was then in the United States.

On the 20th trade unionists from all over Ireland met in Dublin to decide on how organised labour should meet the threat of conscription. The outcome of their decision was to be a general strike, called for 23 April. With the exception of Belfast, Ireland shut down completely. No trains, trams or buses ran; no shops opened; all factories remained closed; and the guests at all hotels had to cater for themselves. This is how Dublin's main street appeared.

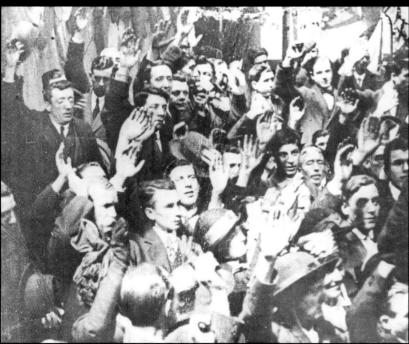

Anti-Conscription Pledge, 1918

Lloyd George, with the acquiescence of all the members of his cabinet, brought in a bill that would extend conscription to Ireland, and it was passed by Parliament on 16 April 1918. On the 18th the Lord Mayor of Dublin called a meeting at the Mansion House in which representatives of the Irish Party, Sinn Féin, the labour movement and other interests took part and at which was drawn up an Anti-Conscription Pledge and Declaration. Here we see the pledge being taken by those outside. That evening the Irish hierarchy were to assert their condemnation of conscription.

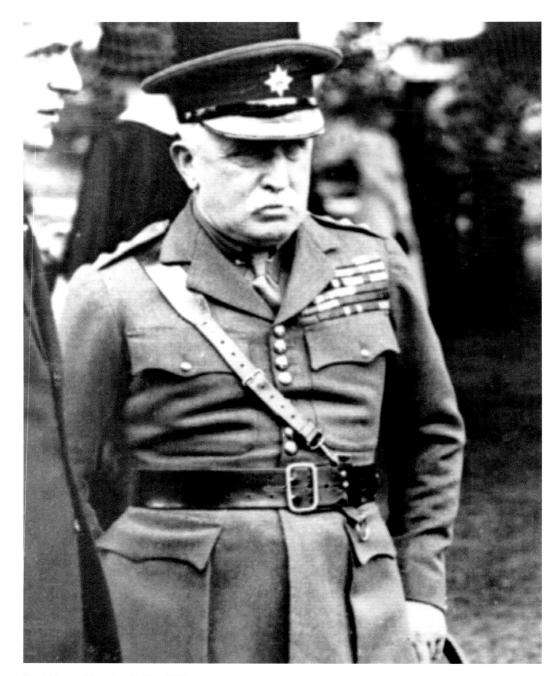

Field-Marshal French in Dublin, 1918

Lloyd George was preparing to put Ireland under
military rule with a vengeance. Field-Marshal Viscount
French was appointed as a replacement for Lord
Wimbourne. French declared:

> Home rule will be offered and declined, then
> conscription will be enforced. If they leave me alone
> I can do what is necessary. I shall notify a date
> before which recruits must offer themselves in the
> various districts. If they do not come, we will fetch
> them.

On 25 April a clause in the Defence of the Realm Act
was made to apply to persons of Irish birth.

Constance Markievicz with the children, 1918

Constance Markievicz is seen enjoying a little relaxation with the O'Carroll children in their garden, April 1918. This peaceful scene was soon to be disrupted. On 17 May, Countess Markievicz and seventy-two others, including Éamon de Valera, William Cosgrave, Arthur Griffith, Count Plunkett, Maud Gonne MacBride and Kathleen Clarke—the elite of Sinn Féin, in fact—were all arrested and deported to England, where they were to be interned. All seventy-three Sinn Féin members returned to the British Parliament had now been gathered in, save only Dr McCartan, who was still in America. The excuse made by the British government was of a 'German plot,' but no evidence of this was ever produced in any court.

However, matters were speedily coming to a head. On 21 June another by-election was held, this one for East Cavan. It was won by Arthur Griffith, one of the seventy-three already interned in England. Repressive measures now came thick and fast. Half the country had been designated 'proclaimed areas' and many districts were to be listed as 'special military areas'. The Irish Volunteers, Cumann na mBan, Conradh na Gaeilge and Sinn Féin had all been banned.

Then, on 11 December, came the Armistice. The great 'war to end war' was itself almost ended at last.

A Sinn Féin brougham, Dublin, 1918

The 25th of November saw the dissolution of Parliament in London. The date for polling was set: it was to be 14 December. In spite of the horrendous difficulties they experienced, with so many of their members still in prison or on the run, with all the press censored and any papers showing republican sympathies suppressed, with the postal service firmly under control by Britain and a bare three weeks to go until the poll, it is a tribute to the determination shown by Sinn Féin that it was able to show any progress at all and was able to draw up its election manifesto. This proclaimed that Sinn Féin was withdrawing all its elected members from the British Parliament, denying its right to legislate for Ireland, and using any and every means available to render impotent the power of England to hold Ireland in subjection by military force or otherwise. The message was clear, as clear as the message displayed on the side of the cab in the photograph.

In view of the extraordinary circumstances faced by Sinn Féin, the results of the poll were astounding. Out of 105 candidates, 73 Sinn Féin members were returned. Pledged to take their seats in an assembly in Dublin, they prepared to do just that.

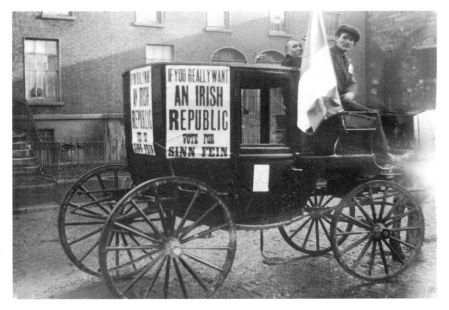

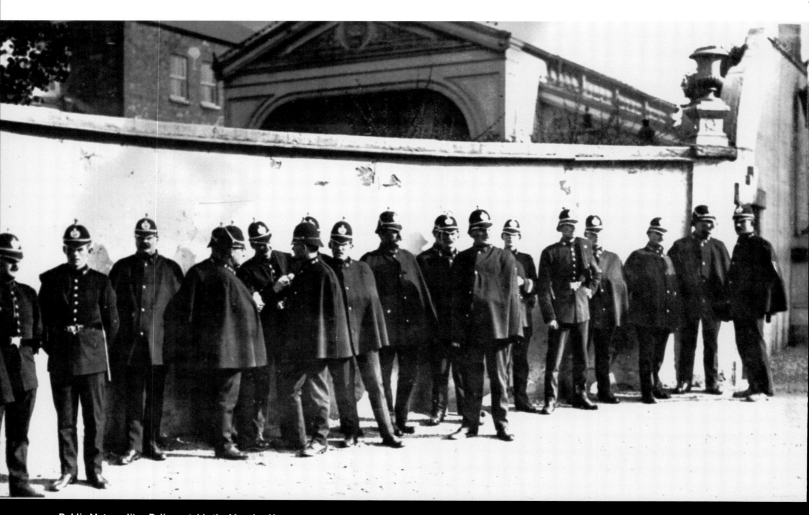

Dublin Metropolitan Police outside the Mansion House
The Mansion House in Dublin was selected as the venue, but the question was whether the assembly would be allowed by the Crown forces to take place on the day selected, 21 January 1919. There were ominous signs that this might not be so when many members of the DMP were seen gathering outside, but they contented themselves with keeping a close watch on everyone who turned up for the event. There was no attempt to prevent it taking place.

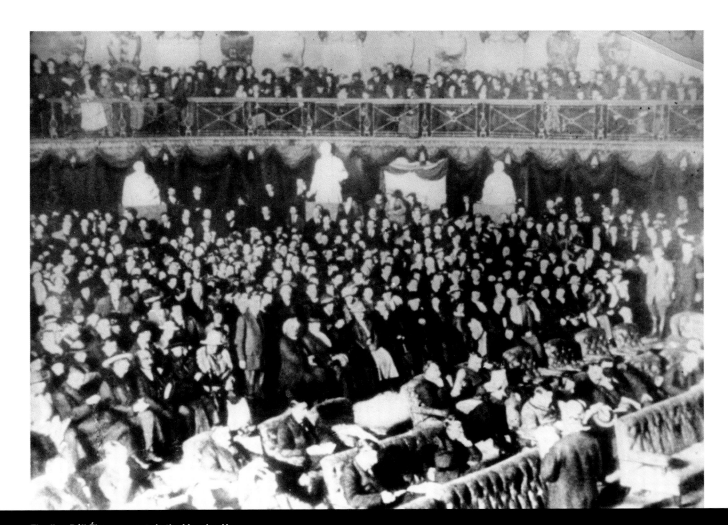

The first Dáil Éireann meets in the Mansion House
The first meeting of the first Dáil Éireann, in the Round Room of the Mansion
House. This was the solemn moment awaited by so many of the Irish people,
which they had longed for since 1916. The proceedings opened at 3:30 p.m.
Count Plunkett proposed that Cathal Brugha preside. Many vacant seats are to
be seen in the foreground; these were reserved for the the thirty-six members
who were still interned. Invited guests and members of the public were also

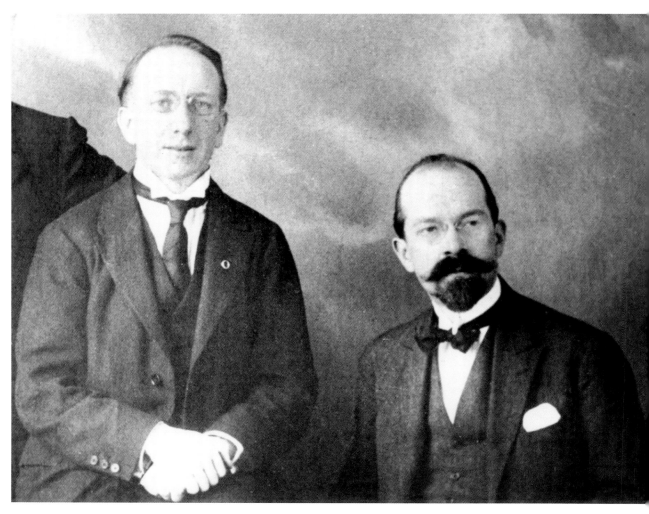

Alderman Seán T. O'Kelly and George Gavan Duffy
Another most important concern that occupied Dáil
Éireann was securing Ireland's place at the post-war
peace conference then taking place at Versailles. Those
delegates who had been originally selected to attend being
unable to do so on account of their continued internment,
the Dáil selected instead Alderman Seán T. O'Kelly and
George Gavan Duffy and sent them to Paris. But because
of the terms of reference of the Versailles conference,
which insisted on a unanimous vote of approval from all
its members for a territory to be included, Ireland's case
could not be heard, the British Empire having indicated
that its veto would always be used.

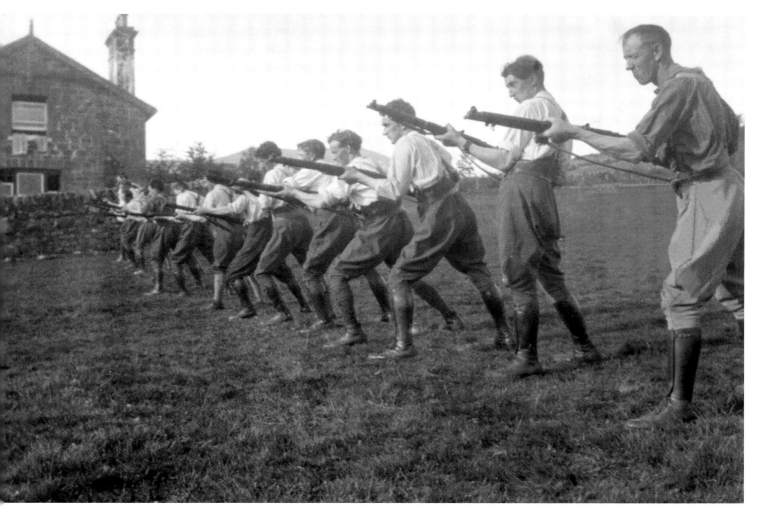

The IRA in training

It was obvious by now that the forces of the British government were preparing for a long struggle to keep Ireland in the Empire, regardless of the feelings of the majority of the Irish themselves. With Dáil Éireann set up, one of the first tasks was to secure the allegiance of the IRA, which up to now had been responsible to the Executive of the Irish Volunteers alone. In the absence of de Valera, who was still in Lincoln Jail, this was the most urgent problem facing Cathal Brugha as Minister for Defence. Recruitment was continuing, but training and equipping the Volunteers became an ever more urgent problem. This explains the increasing number of operations carried out by the IRA to capture arms and other *matériel de guerre* during the spring of 1919.

First Dáil internal loan, 1919

The Dáil, in its session of 19 June, had appointed trustees for a loan to be offered to the public in Ireland. Here we see, a short time later, Michael Collins, Minister for Finance, presiding over the first public issuing of the loan certificates. This event was held at St Enda's School, Rathfarnham; the elite of Sinn Féin all participated. The table at which they gave their signatures was the block upon which Robert Emmet was beheaded. All newspapers that carried advertisements for the loan were immediately suppressed by the British authorities, and efforts were made to seize the money handed over, but with little success. At this point the British army of occupation in Ireland was costing £10.8 million a year.

De Valera in Boston, July 1919
Having escaped from Lincoln Jail and having accepted the presidency of Dáil Éireann, Éamon de Valera was sent by that body on a mission to America, primarily with a view to promoting Dáil Éireann's first external loan. Travelling incognito, he arrived there in the second half of June. Here he is seen at the Boston Stadium being greeted by a vast crowd.

An RIC family, 1919
This group furnishes us with a rare glimpse of the family life of members of the Royal Irish Constabulary, that body of men devotedly loyal to the Crown, whose symbol surmounts the harp on their caps. They were intended to be the eyes and ears of successive British administrations, thus separating them from all but the Unionist community in Ireland. The poor lady, obviously the mother, has an anxious expression, as well she might have, for RIC stations had been attacked since 1916 with ever-increasing frequency by the IRA.

RIC men prepare to fire Very pistols, 1919
A sergeant and a constable prepare to fire Very pistols. These special pistols
were issued to every station of the constabulary for summoning assistance
from adjacent stations in any emergency. The pouch attached to the belts was
for carrying despatches from one station to another.

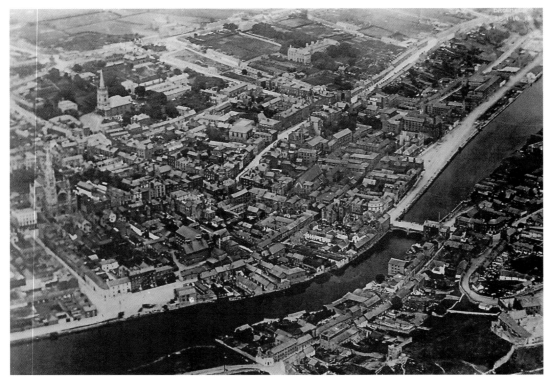

Aerial photograph of Drogheda, 1919

Crown forces were preparing for continued troubles in Ireland. In 1919 the Royal Air Force was commissioned to make an aerial photographic survey of the country. Here is one of its views of Drogheda.

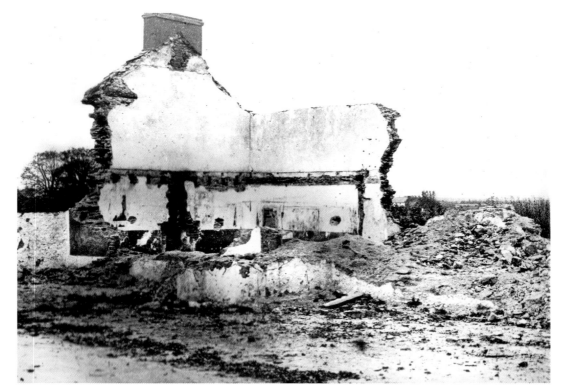

Destroyed RIC station, 1919

As the IRA became more numerous, RIC stations came under attack and with increased daring. A growing number of casualties resulted on both sides.

General French takes the salute at the Victory Parade
On the first anniversary of the Armistice a great British military parade took place in Dublin. Military hardware of all kinds was specially imported for the occasion, including tanks and armoured cars. The real object of this display was to convince the Irish people of the overwhelming might of the British Empire, rather than to commemorate the Armistice. General Lord French took the salute at College Green. When the parade was over the tanks and armoured cars remained in Ireland and were to be used in an attempt to overawe the people.

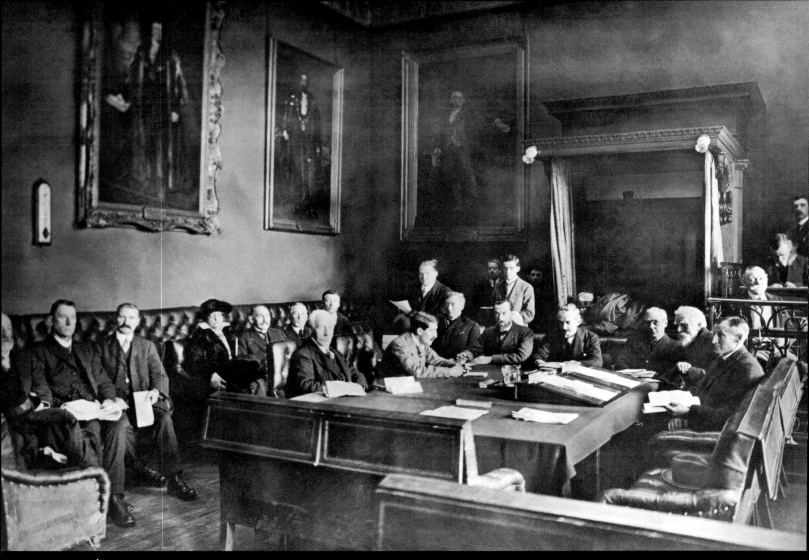

A Dáil Éireann commission in secret session, 1919

On 10 September 1919 the Dublin Castle authorities proclaimed Dáil Éireann
as a dangerous organisation and attempted to suppress it. Thenceforth
all its meetings had to be held in secret, but this did not apply to the Dáil
commissions, which were not proclaimed until several months later. Here we
see a meeting of the Dáil Éireann Commission of Inquiry into the Industrial
Resources of Ireland in session at Dublin City Hall on 29 November 1919.

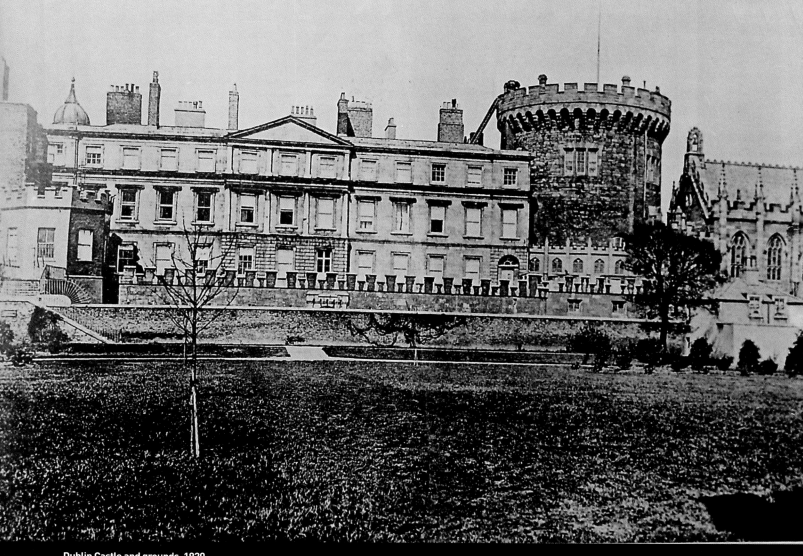

Dublin Castle and grounds, 1920
At the beginning of 1920 General French had 40,000 British soldiers, almost
10,000 RIC men and an unknown body of secret agents as well as tanks,
armoured cars and *matériel de guerre* of all kinds under his command—not
forgetting the backing of the British navy. The *Westminster Gazette*, speaking
of Lord French, said that during his term of office he had administered a
system of coercion such as there had not been within living memory.

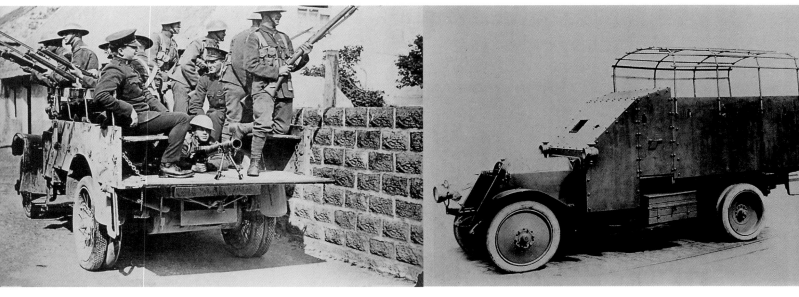

Mobile patrol of British soldiers and RIC, 1920
To cope with the IRA's guerrilla tactics, Crown forces were obliged to
follow suit and employ greater mobility, with patrols such as this one,
in which both soldiers and RIC are participating. They were quickly to
learn the vulnerability to sniper fire of these low-sided vehicles and
change to higher-sided vehicles with armour protection.

Crossley tender, 1920
The most frequently employed vehicle used for these purposes was
the Crossley tender. It was vulnerable to grenades because of its
open top, and here it is seen fitted with struts to take a covering of
chicken wire to protect it against this form of attack. On account of this
covering the tenders were frequently referred to as 'chicken coops'.

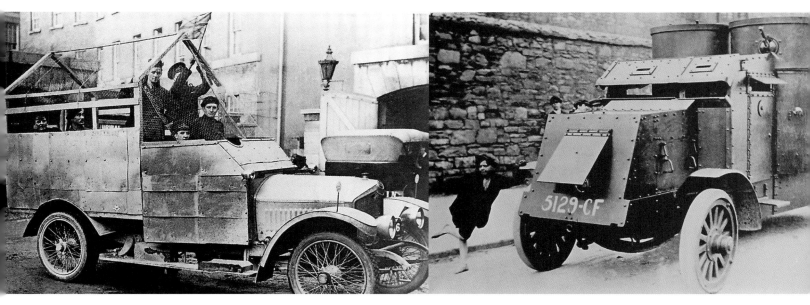

Improvised tender with wire netting
Here we see an improvised tender with wire netting fitted and
protected with armour of somewhat doubtful efficacy. To this the IRA
responded with a grenade furnished with hooks.

Street boy and Railton armoured car, Dublin, 1920
Numerous heavily armoured vehicles were employed by Crown forces also,
such as this Railton armoured car with twin turrets for machine-guns.

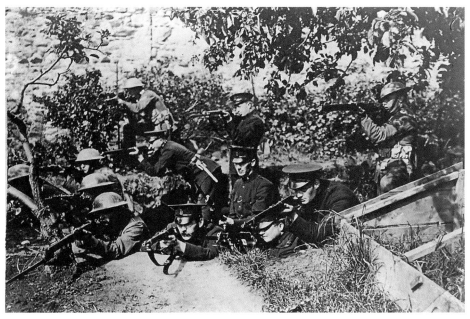

British military and RIC in an 'ambush', 1920
'Giving aid to the civil power,' Lloyd George's
pretence that what was taking place in Ireland was
just a 'police action', was worn threadbare now—
as phoney as this posed photograph of a supposed
ambush by members of the RIC supported by
British troops.

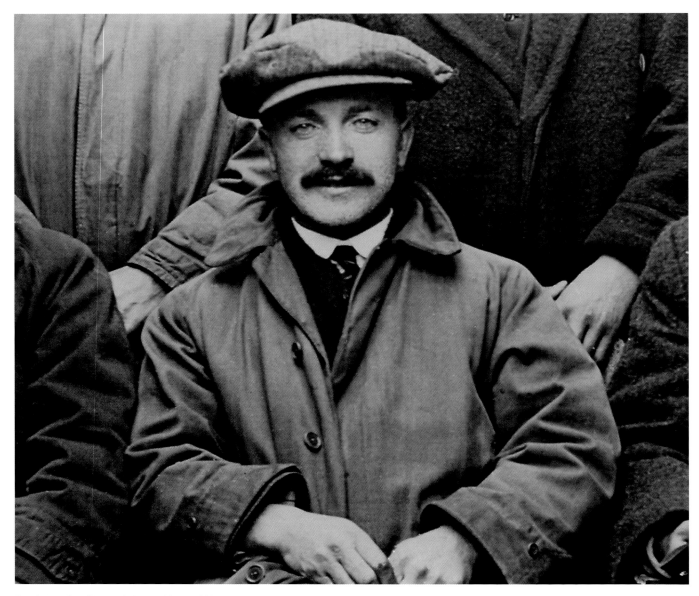

Tomás Mac Curtáin, Lord Mayor of Cork, 1920
But there was nothing phoney about the assassination of Tomás Mac Curtáin,
Lord Mayor of Cork. It was carried out by members of the RIC, assisted by units
of the British army that were 'giving aid to the civil power.' Tomás Mac Curtáin
was Commandant of the Cork Brigade of the IRA. He had been elected by the
Aldermen of Cork to be their Lord Mayor by a unanimous vote. He lived with
his wife and five children over his little shop. On the morning of 19 March 1920
an RIC constable was shot in the vicinity, and this was taken as a pretext for the
killing. At about 1:30 a.m. the following morning the surrounding streets were
cleared of all potential witnesses. A group of men with blackened faces broke
down the door of the shop and rushed up the stairs, where they found Mac
Curtáin just emerging from his bedroom. They shot him on the spot, though
it took him fifteen minutes to die. A coroner's jury returned, unanimously, a
remarkable verdict: they found that the Lord Mayor

> ...was wilfully murdered under the circumstances of most callous
> brutality; that the murder was organised and carried out by the Royal Irish
> Constabulary, officially directed by the British Government.

A verdict of 'wilful murder' was returned against Lloyd George, Lord French and
Ian MacPherson, the Chief Secretary for Ireland. The real motivation for this
killing must be sought, however, in the ever-growing success of the 'alternative
government' provided by Sinn Féin, particularly in regard to its measures to
promote the administration of law and policing.

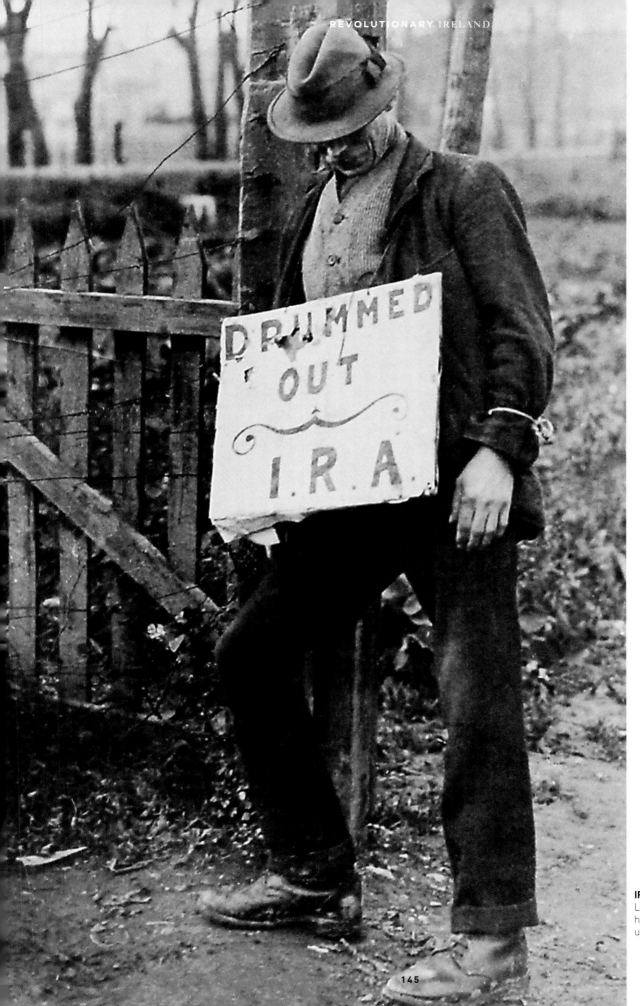

IRA punishment, 1920
Like all armies, the IRA had its problems with undisciplined personnel.

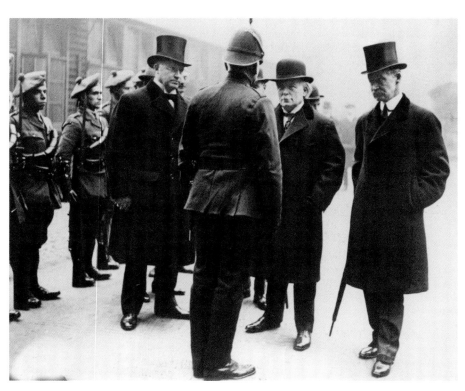

Sir Hamar Greenwood, Lloyd George and the 'Black and Tans'

In London, other and much more serious developments were taking place. A new force to serve in Ireland was being recruited by advertisement. They were to help the RIC with their duties and were to become known as the Black and Tans, from their black police trousers and khaki army tunics and in reference to the hounds of a famous hunt. They were to be paid at the rate of ten shillings per day. Here we see them at the extreme left of the photograph, which shows Sir Hamar Greenwood, the newly appointed Chief Secretary for Ireland, and David Lloyd George in London. Even before this photograph was taken the first members of the new force had already arrived in Ireland, on 25 March 1920.

Black and Tans, Dublin, 1920

As to the composition of the Black and Tans, one cannot do better than to quote Dorothy Macardle's work *The Irish Republic*:

> It was composed of men of the type needed for work to which men of the British Regular Army were not accustomed, and which the Royal Irish Constabulary, being composed of Irishmen, could not be relied upon indefinitely to perform. The despatch of this new force to Ireland helped to relieve England of a very dangerous type of unemployable—men of low mentality whose more primitive instincts had been aroused by the war and who were now difficult to control.

RIC Auxiliaries give bloodhounds the scent, 1920
As though the plague of the Black and Tans were not enough, the Imperial government in England was recruiting once again. This time it was to be former officers of the regular army who were asked to serve in Ireland. They were to be paid at the rate of one pound per day, were not to be under military discipline and were to be given immunity from prosecution by the civil courts—a most sinister condition, proclaiming what type of 'special duties' they would be called upon to perform. Here we see them standing by while dog-handlers are giving bloodhounds the scent.

British soldiers occupy a hotel, Killarney, 1920
General Sir Nevil Macready, Commander in Chief in Ireland, found himself in a quandary: he felt he still had not enough troops under his command to tackle the Irish situation. He asked the British government for yet more. But the seemingly inexhaustible barrel had run dry: there were no more to be had, and the British authorities were forced to ask Macready to wait until further supplies of men could be made available.

Hunger strike in Mountjoy Jail, Dublin, 1920
On 5 April a hunger strike in Mountjoy Jail began among the political prisoners held there. It had the same object that had motivated the earlier hunger strike in 1917: the recognition of political status. Almost immediately huge crowds gathered outside the prison, singing Fenian songs, much to the alarm of the Castle authorities, who responded by ordering tanks, armoured cars and lorryloads of troops to be sent to the vicinity.

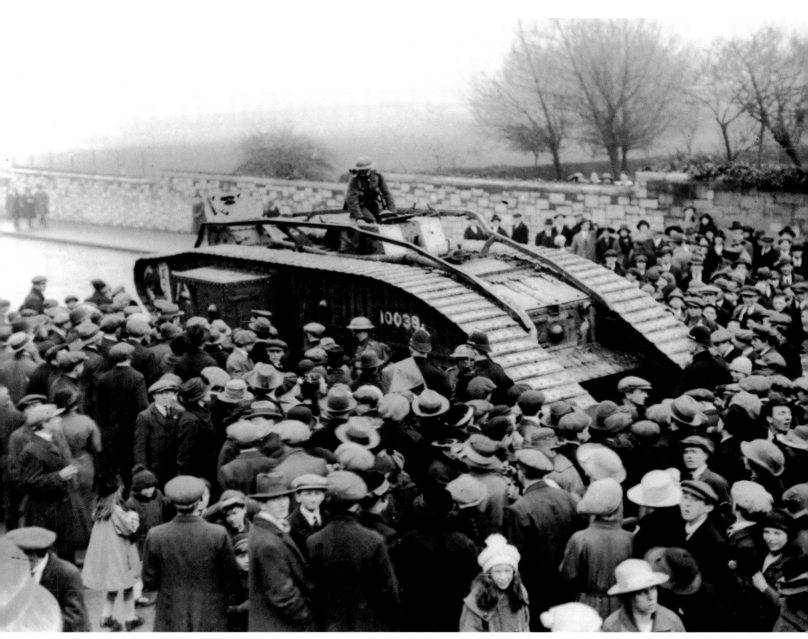

Tank at Mountjoy Jail, Dublin, 1920
A tank, escorted by British troops and Dublin Metropolitan Police, outside the walls of Mountjoy Jail, Dublin.

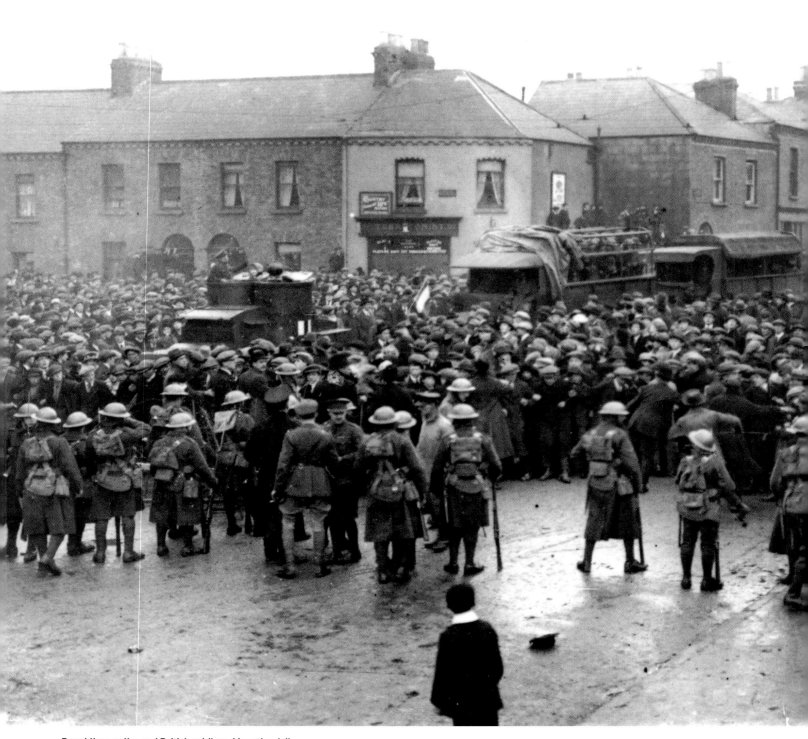

Republican police and British soldiers, Mountjoy Jail
A Railton twin-turret armoured car leading a convoy of military lorries bringing additional British troops to the vicinity of Mountjoy Jail while republican Police struggle to hold back the crowds during the hunger strike by political prisoners.

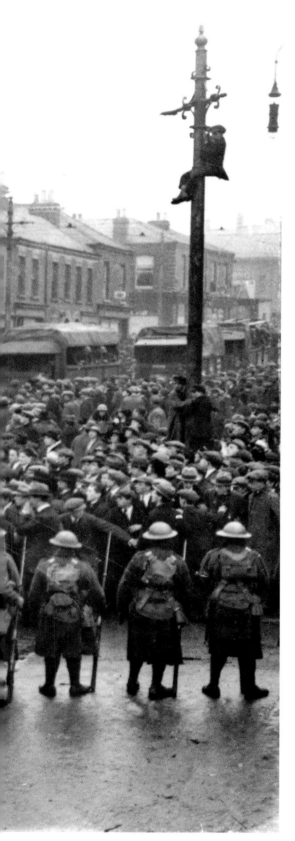

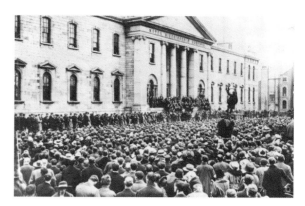

Huge crowd outside the Mater Hospital, Dublin, 1920
The Irish Labour Party and Trades Union Congress called for a general strike in support of the prisoners on 12 April. Three days later the prisoners were unconditionally released and conveyed by ambulance to the adjacent Mater Misericordiae Hospital, where we see this crowd gathered to await their arrival.

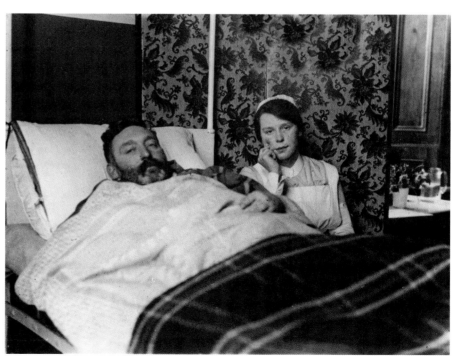

Hunger-strike patient in the Mater Hospital
A hunger-striker recovering in the Mater Hospital, Dublin.

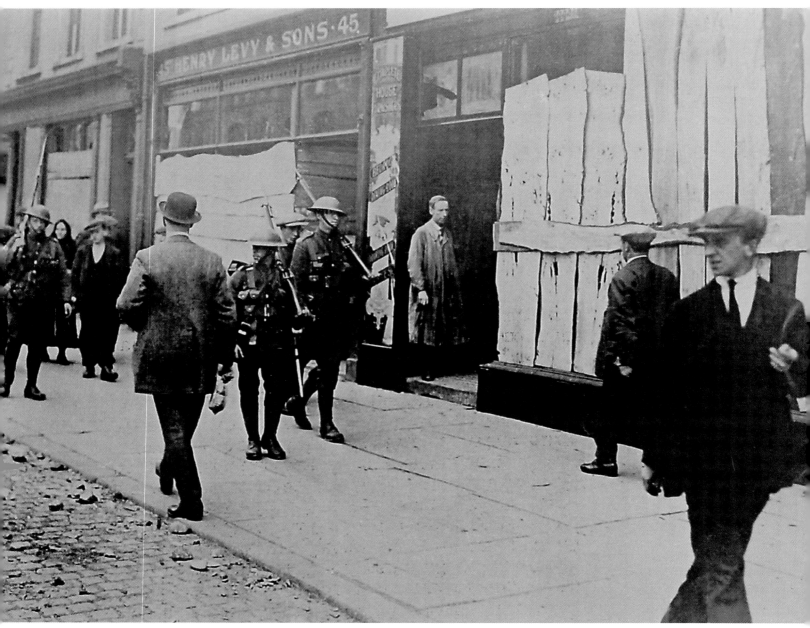

Mallow, 1920

Many towns and cities were in a state of siege, with shop windows boarded up and many other signs of military occupation. Most of the more outlying RIC barracks had been destroyed and the DMP had been disarmed, at their own request.

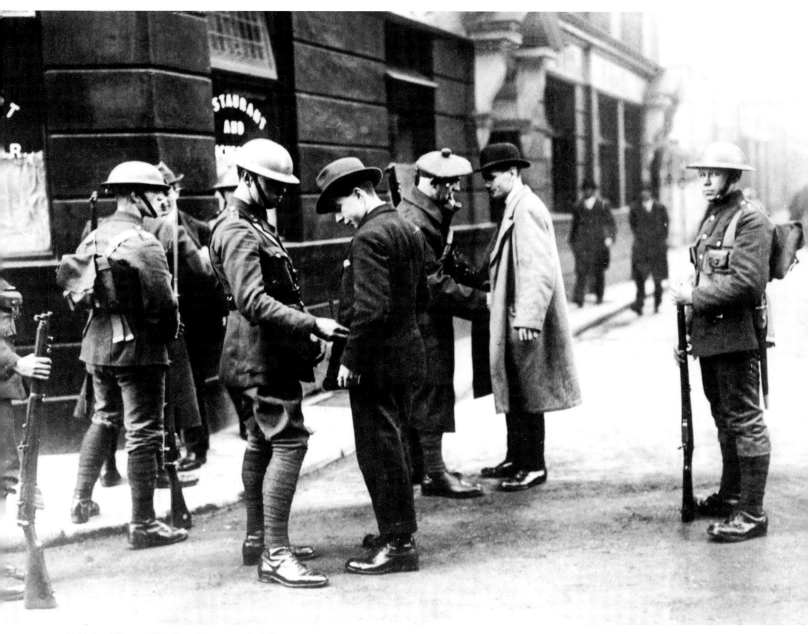

British soldiers and Black and Tans search civilians
By June 1920 this sight had become commonplace in all the cities and towns
of Ireland: British soldiers, RIC Auxiliaries and the ubiquitous Black and Tans
carrying out searches of the civilian population.

British soldiers man the wall of Mallow Barracks, 1920
At the beginning of June 1920 local elections were held in Ireland; the results were
announced on 12 June. The Unionists had secured majorities in only four counties:
Antrim, Down, Derry and Armagh. Out of 206 rural district councils, Sinn Féin had a
majority on 172.

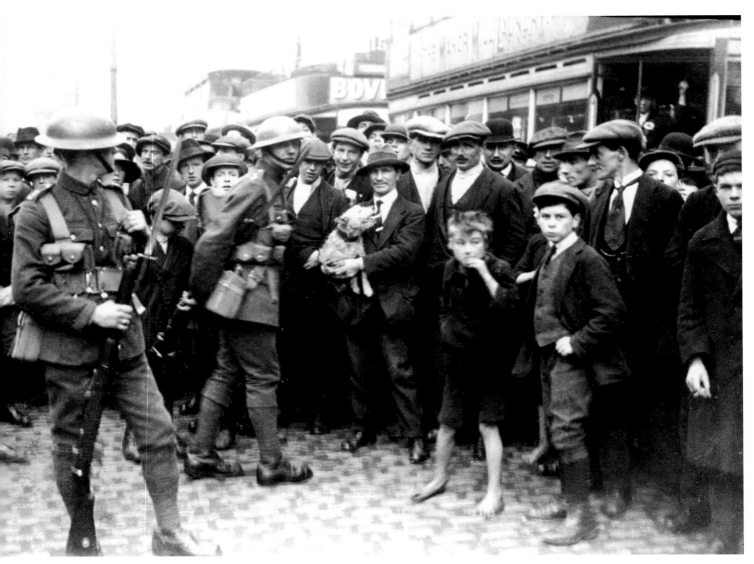

British soldiers in central Dublin, 1920
Raids by Crown forces were continually made in central Dublin because, as the
RIC became increasingly ineffective as a source of intelligence, random raiding
was the only alternative.

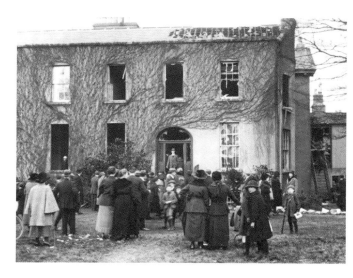

Cullenswood House, Dublin, 1920
Cullenswood House in Ranelagh, where Patrick Pearse had had his school before moving it to Rathfarnham and which had already suffered in 1916, was raided again in 1920.

Black and Tans raid the GAA
One of the many organisations to come under suspicion was the Gaelic Athletic Association, here seen having its head office in Dublin raided by the Black and Tans, who appear to have successfully seized a quantity of hurleys.

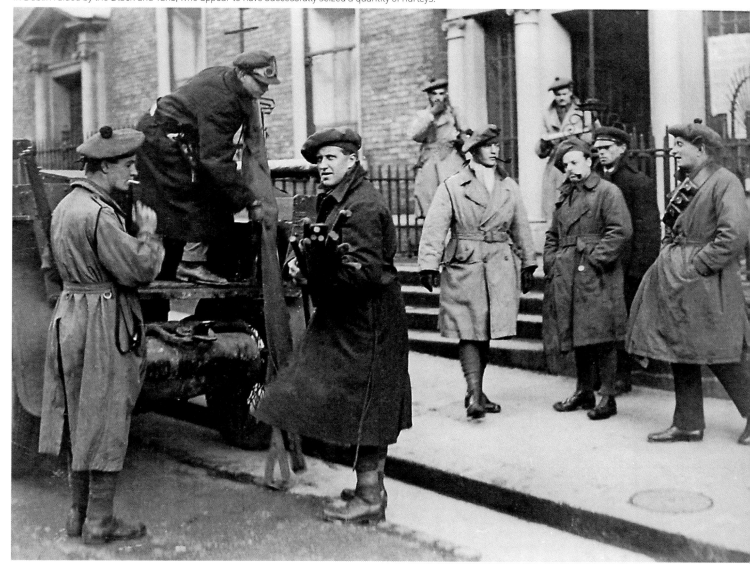

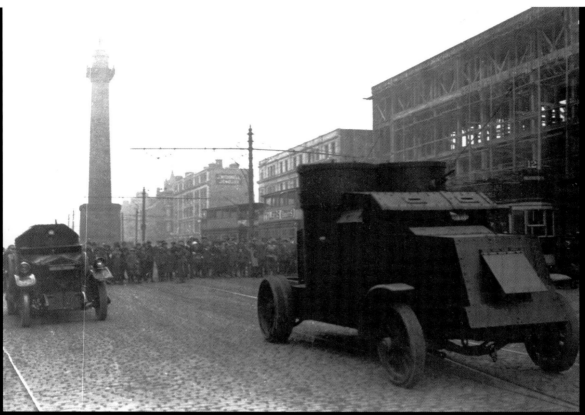

Armoured cars in Dublin, 1920
Left, a Rolls-Royce Whippet and a twin-turret Railton during a
raid in O'Connell Street, Dublin, 1920.

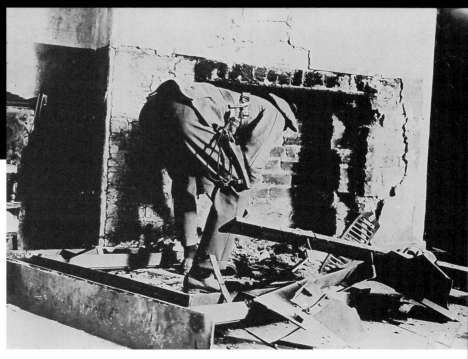

Black and Tans search a house, Dublin, 1920
'The stopping of a lorry outside a house was the signal for the
occupants hastily to throw on garments and rush to open the
door, in the hope of being in time to prevent its being broken in.
Then followed the rush of armed men upstairs and into every
room, attic and cellar, swinging revolvers and shouting threats,
the bursting open of cupboards, tearing up of floor boards and
ripping of mattresses. If, as frequently happened, the raiders
were drunk, or in a savage temper as the result of a recent
ambush, shots would be fired through the walls and ceilings
and breakables smashed. Any man found on the premises
was in danger of being shot out of hand. Those taken away in
lorries were sometimes shot dead and reported as "shot while
attempting to escape".'—Dorothy Macardle, *The Irish Republic*.

A tank named *Shurrr-Up*, Dublin, 1920
A somewhat crude effort at psychological warfare.

A tank being used for a battering-ram, Dublin

A tank being used to power a battering-ram during a raid in Dublin, 1920.

IRA suspects arrested, Dublin, 1920

IRA suspects being arrested in Henry Street, Dublin.

Raid by Crown forces, Westmoreland Street, Dublin
British soldiers hold back a large crowd during a raid by Crown forces in Westmoreland Street, Dublin.

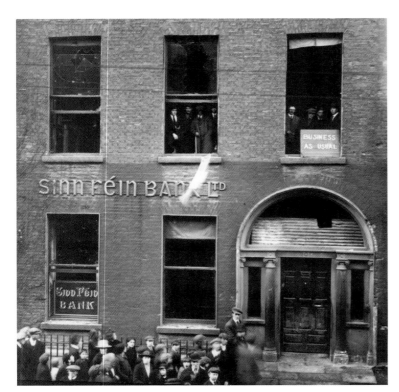

Sinn Féin Bank sacked, Dublin, 1920
Greatly increased activity on the part of the Crown Forces saw also the sacking of the Sinn Féin Bank in Dublin.

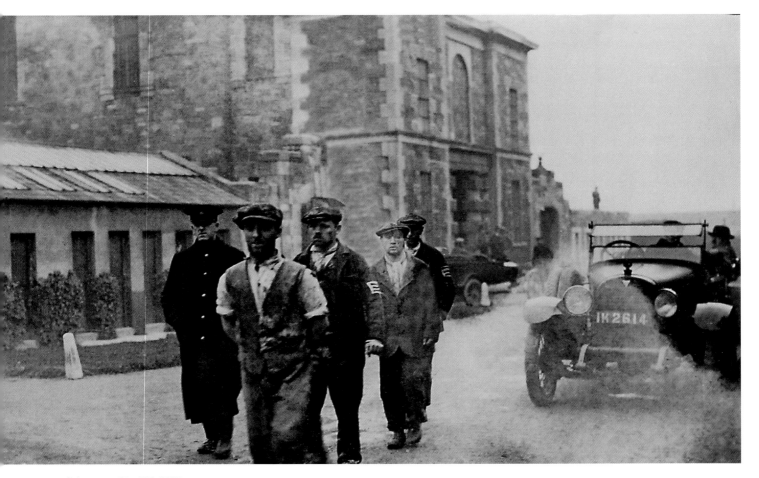

Prisoners of the RIC, 1920
Prisoners of the Royal Irish Constabulary being brought to barracks, 1920. The armbands indicate that the wearers are special constables.

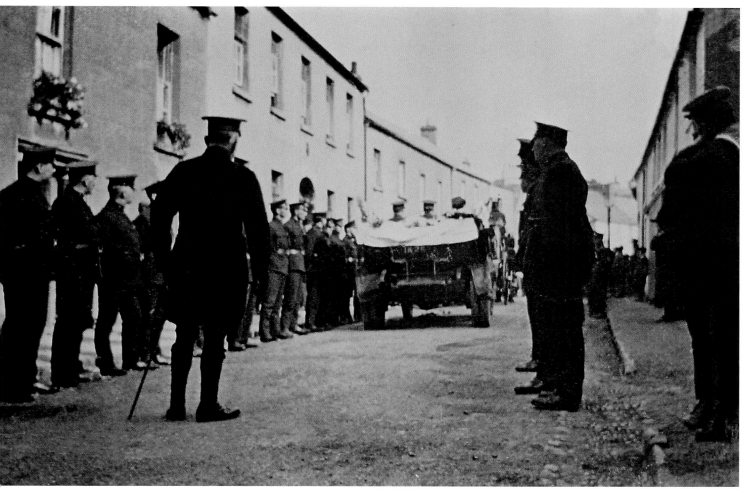

Funeral of an RIC chief constable
The funeral of an RIC chief constable, Co. Cork.

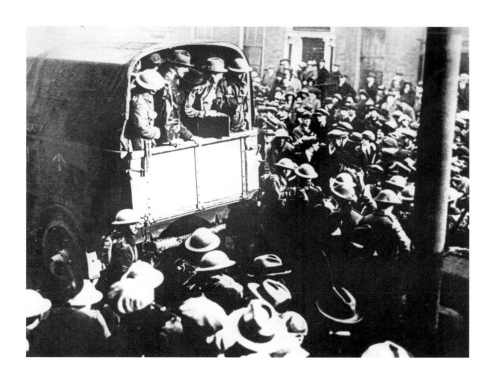

Sinn Féin arrests, Dublin, 1920
Members of Sinn Féin being arrested by Crown forces in Dublin, 1920.

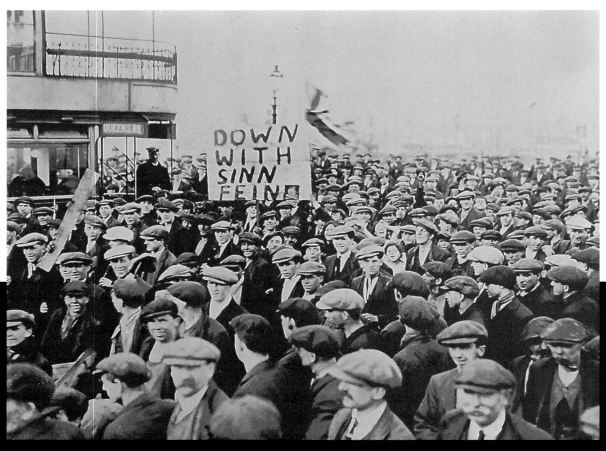

Protestant dockyard workers demonstrate, Belfast

On 19 July in Derry the organised anti-Catholic pogrom began, which was quickly followed by similar events on the 21st in Belfast (seen here), when Unionist politicians urged the Protestant dockyard workers to turn their Catholic fellow-workers out of their jobs in the shipyards. This was promptly done, with the greatest violence, to such effect that in a few days all the Catholic dockyard workers had gone. An estimated 5,000 Catholics were involved, a number of deaths occurring.

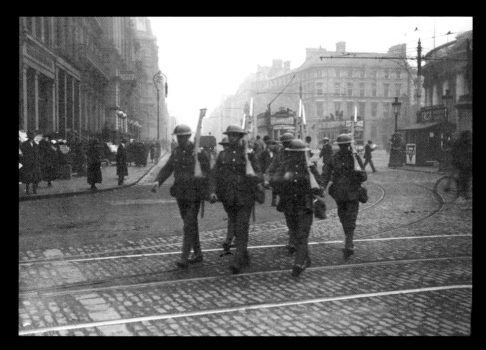

British soldiers patrol Belfast, 1920

Belfast riots, 1920

In August organised attacks began on the Catholic quarters of Belfast. They were to be subject to nightly burnings, looting and pillage, carried out by the UVF and supported by violent, lawless mobs with the full acquiescence of many Unionist politicians. Many deaths resulted. At a time when it was already stretched to the full by operations in Ireland, the British army was called upon to produce yet more troops. It was quite unable to supply them in adequate numbers to tackle the real problem that was occasioned by the UVF and their following, even had this been deemed politically expedient in London.

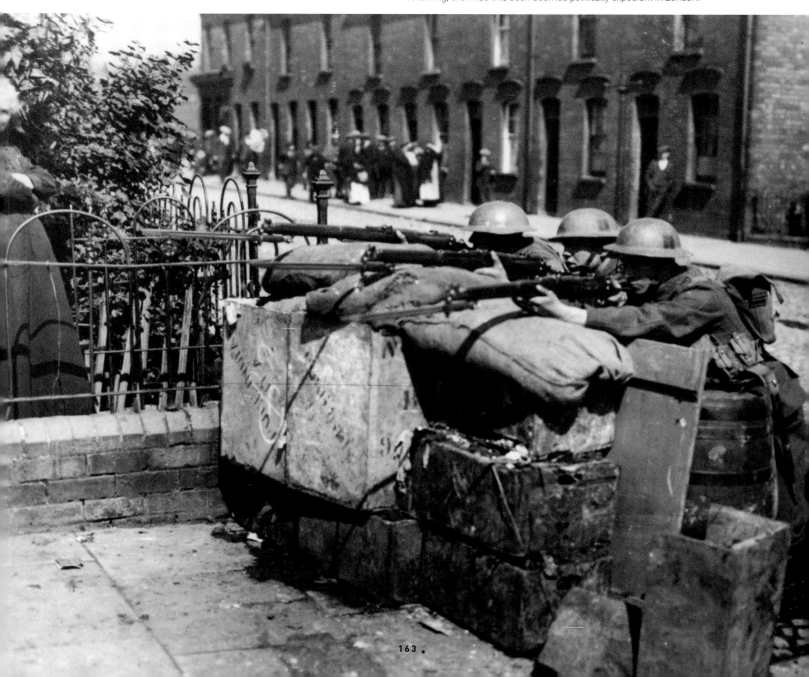

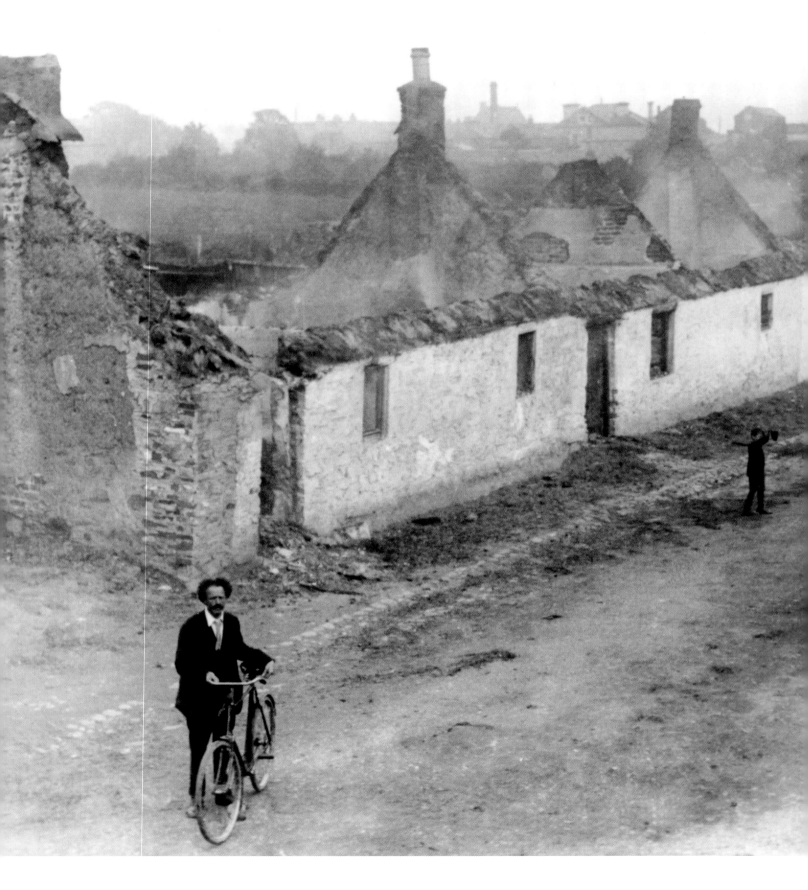

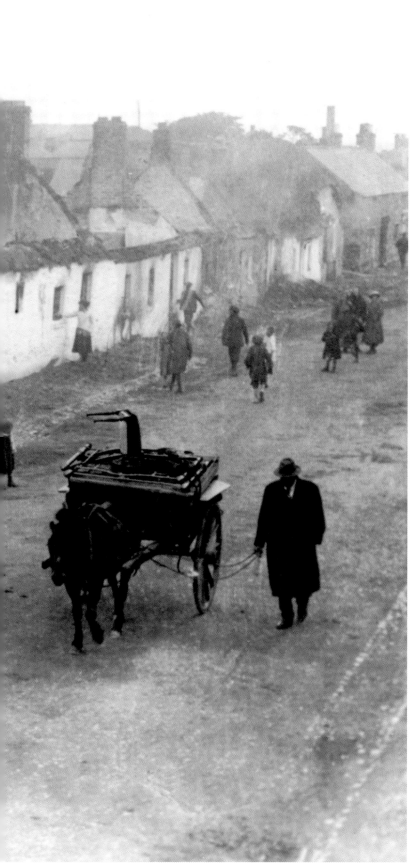

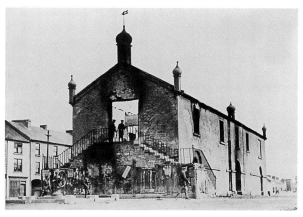

The sack of Trim, 1920
A few days later Trim, Co. Meath, was to suffer the same fate, the Town Hall being burned and many houses destroyed. Further attacks of a similar nature took place in other parts of Ireland. A reign of terror was being employed by Crown forces under General Macready and Lord French.

The sack of Balbriggan, 20 September 1920
From the middle of April a most sinister development involving the RIC Auxiliaries and their allies, the Black and Tans, had been taking place. It was beginning to be clear what precisely the 'special duties' were that they were to be asked to perform: nothing less than a concerted plan to destroy the whole of the co-operative movement in Ireland, which was the life work of Sir Horace Plunkett. Creameries came under attack in all parts of Ireland, and as well as this the Condensed Milk Company of Ireland and Cleeve's factory at Mallow were razed to the ground. This continued all through the summer months and into the autumn.

On 20 September, as a result of a quarrel in a public house, a Black and Tan was shot dead and his companion wounded in Balbriggan. No evidence as to who may have been responsible for the shooting was ever produced, but the town was unfortunately near Gormanston, where there was a training camp for RIC Auxiliaries. That night lorries were heard arriving in Balbriggan. Shouts and the breaking of glass succeeded. Twenty-five houses were destroyed and the smaller hosiery factory was burned to the ground.

Terence MacSwiney lying in state, Cork, 1920

Then an event, long expected, occurred: the death of
Terence MacSwiney in Brixton Prison, London. He had
been arrested on 12 August at Cork City Hall while
presiding over a meeting of the Cork Battalion of the
IRA and refused food from the moment of his arrest.
He died on the seventy-fourth day of his hunger
strike, 25 October. After his body had been handed
over to his next of kin the funeral arrangements
were proceeded with, the first of these consisting of
a Solemn Requiem Mass at Westminster Cathedral,
London. After this the body, accompanied by relatives
and friends, was put on the train at Euston Station to
be taken to Holyhead; but here it was forcibly taken
from the custody of the relatives, who had planned
for a Solemn Requiem Mass to be held at the Pro-
Cathedral, Dublin, and instead put aboard a British
destroyer for shipment direct to Cork. Here it is seen
at Cork surrounded by relatives and a guard of honour
of the Cork Battalion of the IRA. MacSwiney's death
drew the attention of the entire world to the plight of
Ireland under British Imperial rule.

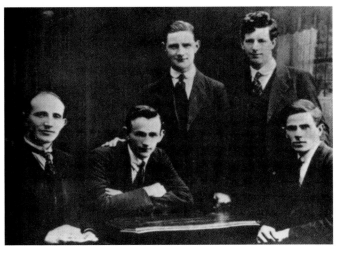

The 'Squad' formed by Michael Collins

During the course of 1920 Michael Collins, as Director of Intelligence, formed
the conclusion that the part-time duties of the IRA were not going to be enough
to counter the remarkable spy network established by the forces of the Crown in
Ireland. He therefore set up a special unit to deal exclusively with this problem.
Here we see some members of this group, which he called his 'Squad'.

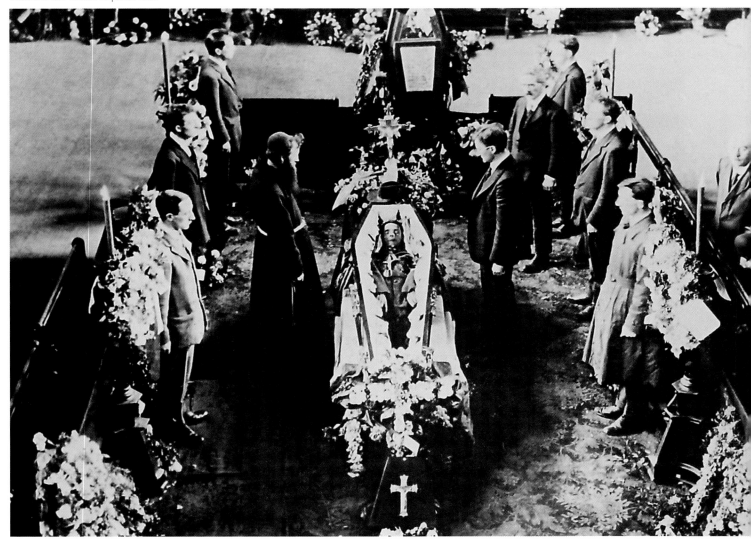

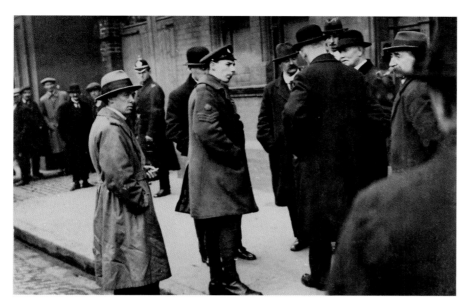

Detectives of G Division, DMP, 1920
Especially to be feared by all members of Dáil Éireann, Sinn Féin and the IRA were these plain-clothes detectives of G Division of the Dublin Metropolitan Police, whose duty it was to identify members of these organisations and give this information to the Crown forces.

Castle spies, 1920
Even more to be feared was this group of spies, who were to become the most important target to be assigned to Michael Collins's Squad. Early in the morning of 20 November the unit struck, shooting dead most of those who appear in this photograph. In revenge, Crown forces carried out a massacre at Croke Park during a football match, turning machine-guns upon the panic-stricken crowd. Twelve deaths and many more injuries were the result.

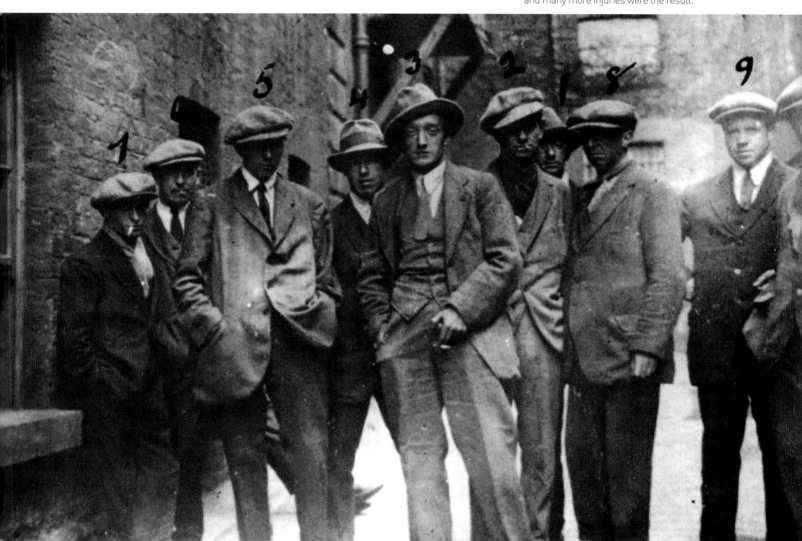

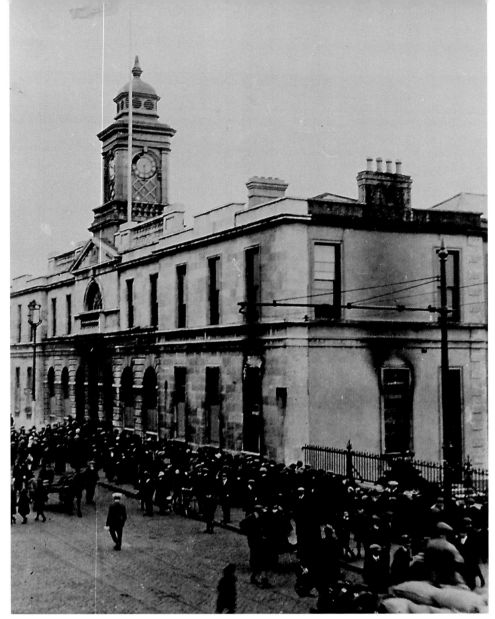

Cork City Hall burned, 1920

On the evening of 11 December, Crown forces set fire to Cork, making their attack mainly on the shopping districts, but later at night Cork City Hall was also burned. Bodies of Auxiliaries and Black and Tans roamed the streets, having cleared them of all civilians. The damage was particularly extensive in Robert Street, where almost all the buildings were totally destroyed. The cost of the damage was estimated to amount to between £2 and 3 million in the currency of the time, which the British insurance companies refused to pay, claiming 'malicious damage'.

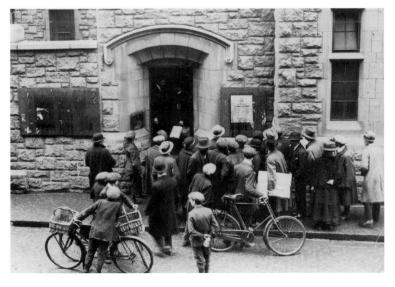

Martial law proclaimed, 1920

On 14 December the Competent Military Authority proclaimed the death penalty for any persons convicted by a military court of being in possession of arms or wearing clothing 'likely to deceive' in all those counties coming under martial law.

PART 4

Dáil Éireann had declared for a republic—there can be no question about that. But how was this to be accommodated with the insensate demands of the imperialist faction in Great Britain that 'imperial unity is essential'? The whole tragi-comedy of the Irish Free State is bound up in this problem. But where are the imperialists today? What of the British Empire?

The shadow of civil war was looming from the moment Dáil Éireann declared, so bravely, for a republic, though three-and-a-half years were to elapse before the nightmare overwhelmed us. During the Civil War we did far worse things to ourselves than were done to us in the 'Tan War'. One has only to reflect on the horrors that occurred at Ballyseedy Cross and Mount Gabriel to be assured of this.

Let us resume our story at the start of January 1921.

Lord French awards medals at Dublin Castle, 1921
Meanwhile, seemingly, life went on as normal at Dublin Castle.

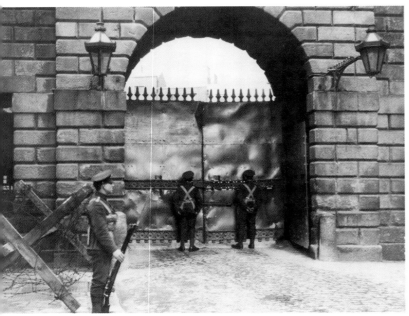

Main gate of Dublin Castle, 1921
However, at the main gate of Dublin Castle quite another picture presented itself: a state of siege!

Black and Tans guard the Mansion House, 1921
At this point the Lord Mayor of Dublin, Laurence O'Neill, took the unusual step of asking the RIC for their protection. It was at once supplied, in the form of a guard of Black and Tans being assigned the duty of protecting the Mansion House. By this adroit move Laurence O'Neill sought to avoid the fate that had overwhelmed Tomás Mac Curtáin.

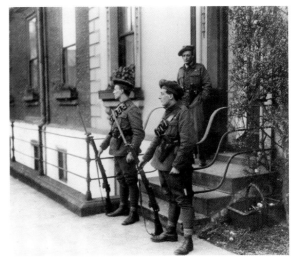

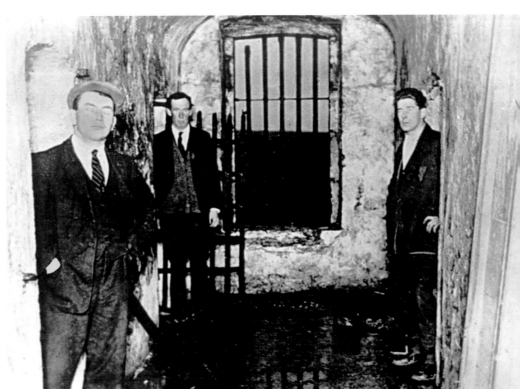

Crown forces prisoners, 1921
So great had the acute shortage of prison space become that accommodation had to be sought for new prisoners in old jails.

Fake actuality photograph, Killiney, Co. Dublin

The forces of the British Empire were rapidly losing the propaganda battle, with ever-increasing numbers of even the British public becoming aware of what Lloyd George's 'police action' really entailed. To counter this the British Government sent two veteran newsreel cameramen to Ireland, Gemmel and Starmer. Their task was to supply material to show that Crown forces were winning the battle against the IRA and Dáil Éireann. They set about their task by filming a series of fake actualities about the work of the RIC Auxiliaries and the Black and Tans, but only in the vicinity of Dublin and the Glen of Imaal in Co. Wicklow. This material contained, among other spurious items, a coverage of 'prisoners' being hustled up an outside staircase at Beggarsbush Barracks and into a doorway at the top, and a 'captured' Tricolour along with them. There was also a fake coverage, purporting to have taken place in Co. Kerry, of an action against the IRA.

This material was intended for use in England only, but a Liverpool film distributor would appear to have sent it to Dublin, where it was quickly recognised for what it was, faked actuality material showing views of Killiney. Here we see a still from the film that shows an 'engagement' taking place on Vico Road, Killiney.

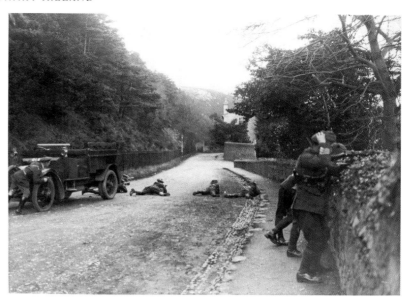

The Lord Mayor receives American White Cross delegates

Laurence O'Neill, Lord Mayor of Dublin (first on left), receives delegates of the American Committee for Relief in Ireland on the steps of the Mansion House, Dublin. This fund, known as the American White Cross, was to be of the greatest assistance in relieving distress caused by Crown forces and was subscribed to not alone by all the states of the United States but by contributions from Continental Europe as well and even from the United Kingdom.

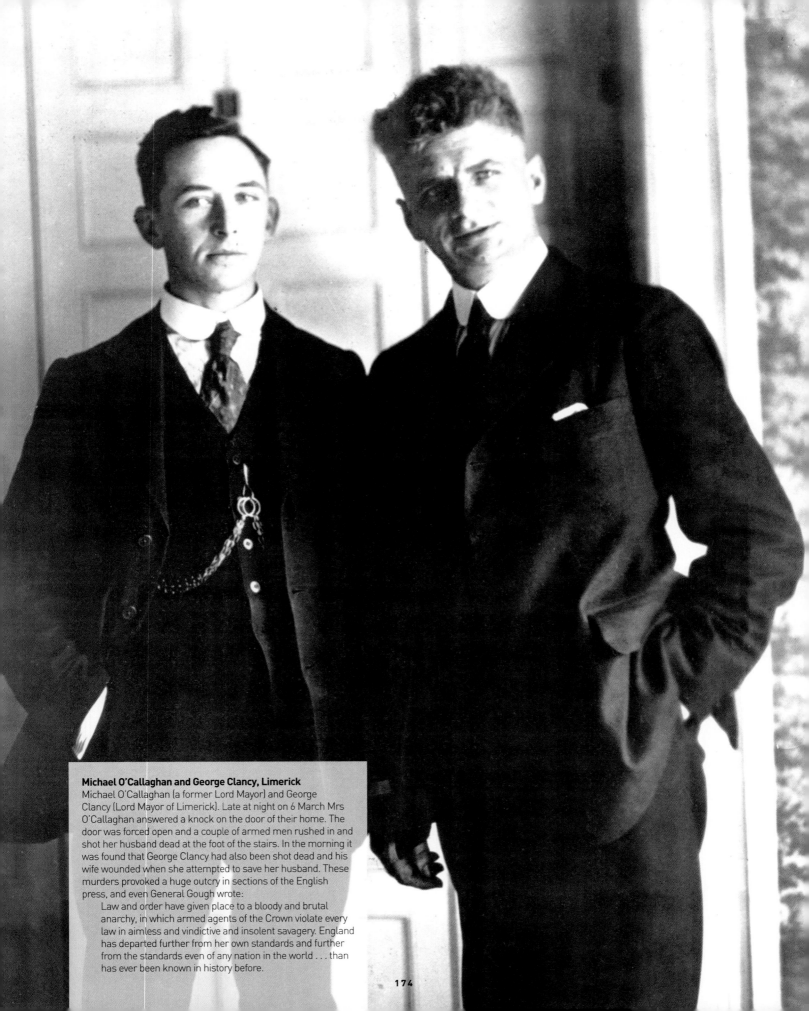

Michael O'Callaghan and George Clancy, Limerick
Michael O'Callaghan (a former Lord Mayor) and George
Clancy (Lord Mayor of Limerick). Late at night on 6 March Mrs
O'Callaghan answered a knock on the door of their home. The
door was forced open and a couple of armed men rushed in and
shot her husband dead at the foot of the stairs. In the morning it
was found that George Clancy had also been shot dead and his
wife wounded when she attempted to save her husband. These
murders provoked a huge outcry in sections of the English
press, and even General Gough wrote:

> Law and order have given place to a bloody and brutal
> anarchy, in which armed agents of the Crown violate every
> law in aimless and vindictive and insolent savagery. England
> has departed further from her own standards and further
> from the standards even of any nation in the world . . . than
> has ever been known in history before.

174

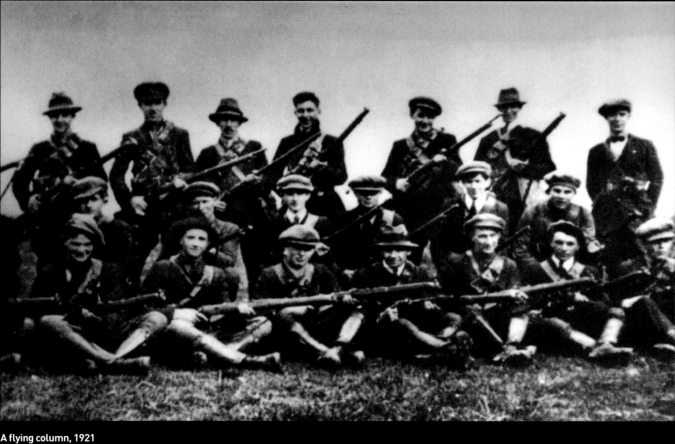

A flying column, 1921
By this time the IRA had completely changed its strategy to one of guerrilla
warfare, employing 'flying columns' to engage with Crown forces. But with
the lengthening days of summer approaching and the guerrilla army's one
protection, the cover of night, steadily decreasing, the IRA was finding it harder

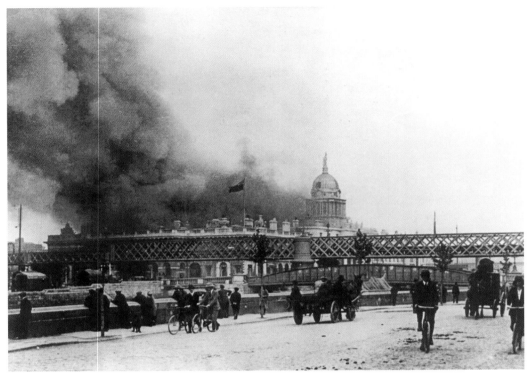

The burning of the Custom House (1)

All the British administration's records of taxation and local government were stored in Gandon's beautiful building. It had long been a potential target of the IRA but so far had been spared, in consideration of its outstanding architectural qualities. The decision to make it a target was reluctantly reached after a long consultation between Michael Collins and the headquarters staff of the IRA. Just before 1 p.m. on 25 May the Dublin Brigade struck by forcing their way in and ordering all those in the building to evacuate it at once. All but the caretaker complied; he was shot. The IRA then set the building ablaze. A precautionary disabling of all the fire engines in the vicinity ensured that the fire would take a firm hold of the building.

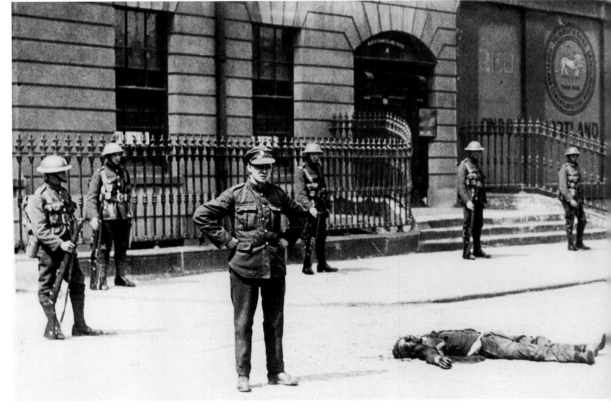

The burning of the Custom House (2)

Regular British soldiers, RIC Auxiliaries and Black and Tans were quickly on the scene and caught the IRA while trying to disperse. A sharp action ensued in which there were casualties on both sides, with approximately eighty members of the IRA captured.

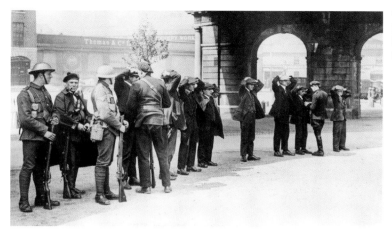

The burning of the Custom House (3)
Many casual passers-by were held as suspects. Here we see some in Beresford Place, just under the Loop Line bridge, guarded by regular soldiers while being searched for arms by Auxiliaries.

The burning of the Custom House (4)
British regular soldiers search in the ruins of the Custom House for any documents that might have escaped the fire. There were some losses of historical material, which is to be deplored, but there is no doubt that in this fire the British administration in Ireland suffered a very severe blow.

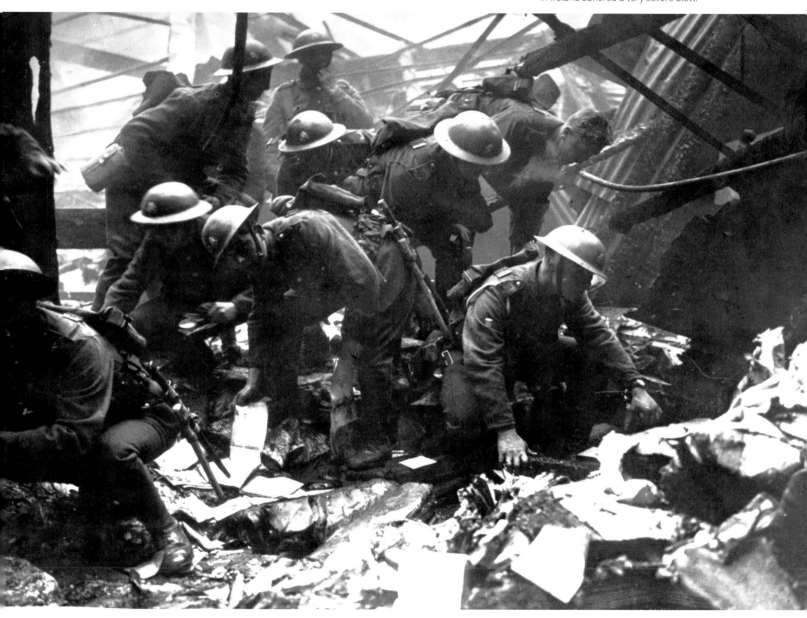

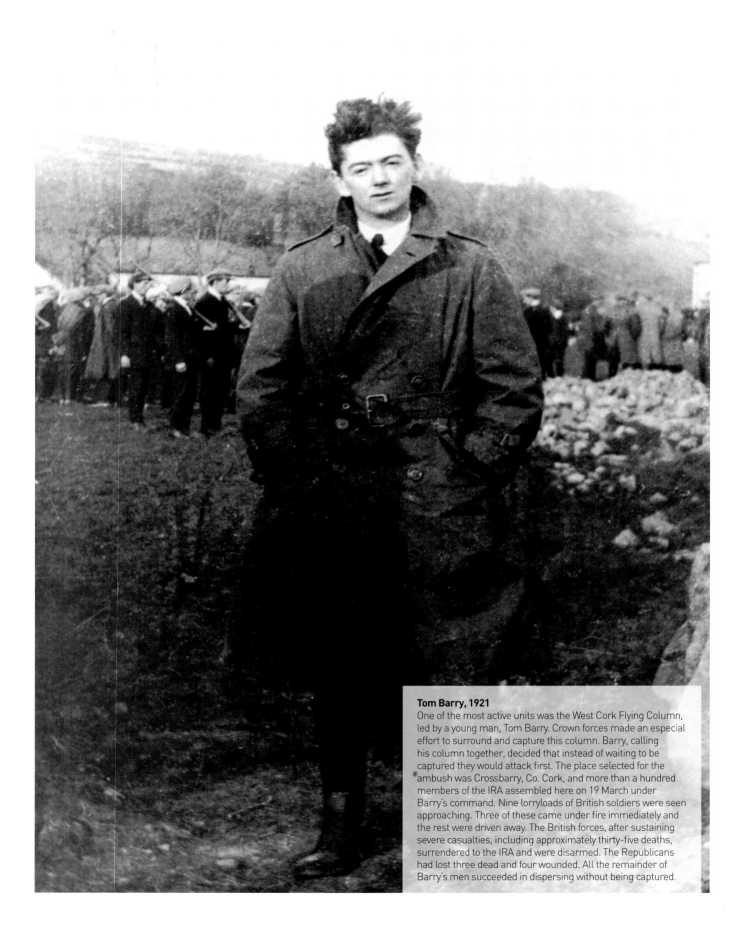

Tom Barry, 1921
One of the most active units was the West Cork Flying Column, led by a young man, Tom Barry. Crown forces made an especial effort to surround and capture this column. Barry, calling his column together, decided that instead of waiting to be captured they would attack first. The place selected for the ambush was Crossbarry, Co. Cork, and more than a hundred members of the IRA assembled here on 19 March under Barry's command. Nine lorryloads of British soldiers were seen approaching. Three of these came under fire immediately and the rest were driven away. The British forces, after sustaining severe casualties, including approximately thirty-five deaths, surrendered to the IRA and were disarmed. The Republicans had lost three dead and four wounded. All the remainder of Barry's men succeeded in dispersing without being captured.

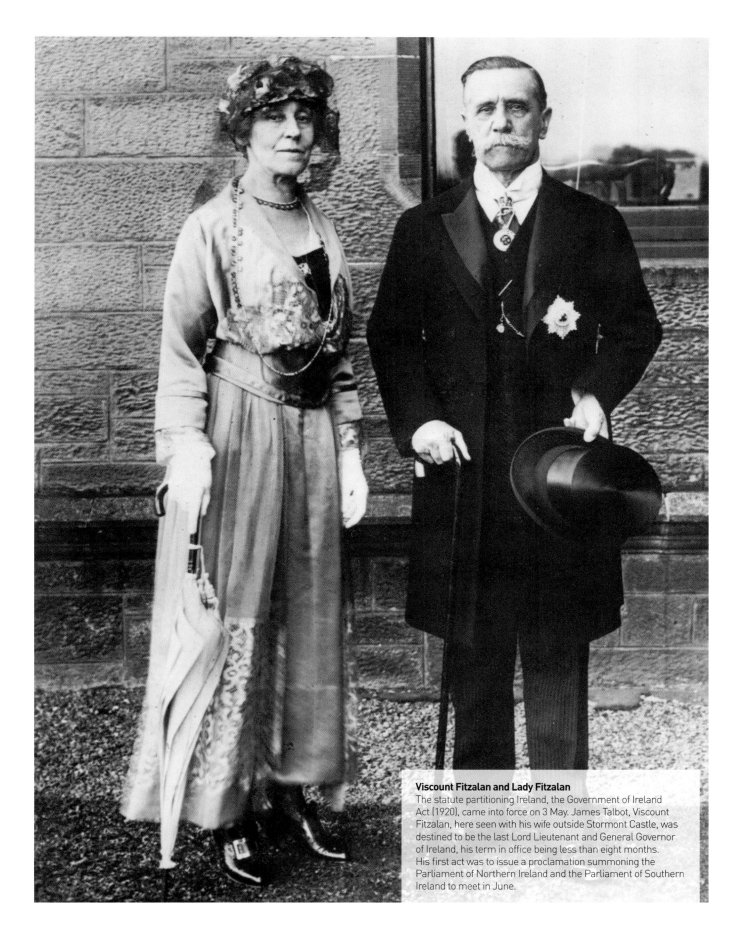

Viscount Fitzalan and Lady Fitzalan
The statute partitioning Ireland, the Government of Ireland Act (1920), came into force on 3 May. James Talbot, Viscount Fitzalan, here seen with his wife outside Stormont Castle, was destined to be the last Lord Lieutenant and General Governor of Ireland, his term in office being less than eight months. His first act was to issue a proclamation summoning the Parliament of Northern Ireland and the Parliament of Southern Ireland to meet in June.

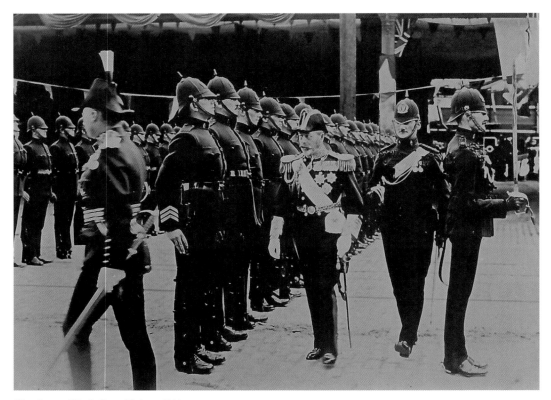

King George V in Belfast, 22 June 1921
King George V and Queen Mary travelled to Belfast aboard the royal steam-yacht *Victoria and Albert* for the opening of the inaugural session of the Parliament of Northern Ireland. The King had been much disappointed by the draft of the speech he was to make on this occasion, and he decided to take the highly unusual step of consulting General Smuts of South Africa on a draft of a more conciliatory nature. This—not without great difficulty—was agreed by the British Cabinet and so became the basis of the speech that he delivered to the Parliament of Northern Ireland.

The First Parliament of Northern Ireland, 1921
The first meeting of the Parliament of Northern Ireland took place in the Council Chamber of Belfast City Hall on 22 June 1921, not in the imposing structure later to be built at Stormont.

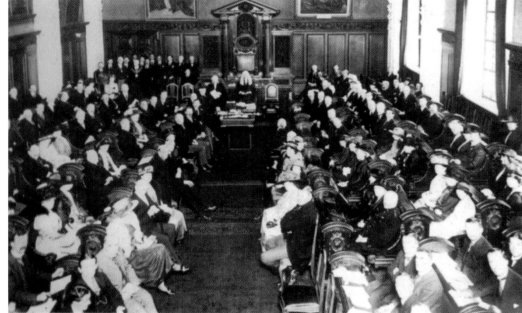

The Truce: a crowd before the Mansion House

World pressures that even the most dedicated of imperialists could not ignore were steadily mounting for a settlement of the state of affairs in Ireland. Already a meeting in Dublin had taken place between Lord Derby and de Valera, and on 25 June the latter received a letter from the British Prime Minister proposing a peace conference.

Meanwhile, at Dublin Castle, the Parliament of Southern Ireland had met. Out of the 128 seats comprising the lower house only four members were present—the Unionist members representing the University of Dublin (Trinity College)—but even here there was a significant absentee: Sir James Craig. Of the upper house only fifteen attended, those nominated by the Governor-General, Viscount Fitzalan. After fifteen minutes of deliberation this group, not having a quorum, adjourned *sine die*.

On 4 July, at the invitation of the Lord Mayor of Dublin, de Valera made the Mansion House his headquarters and issued an invitation to the representatives of the Unionist minority in Ireland to meet him there for the purpose of framing the reply he should make to Lloyd George's invitation. All but Sir James Craig accepted. De Valera insisted that there must be a truce before negotiations could be undertaken with the British government. At first this condition was refused, but one of the Southern Unionists, Lord Midleton, was instrumental in obtaining Lloyd George's consent; and so, on 8 July, General Macready (Commander in Chief), Alfred Cope (Assistant Under-Secretary for Ireland) and Colonel John Brind (Military Intelligence) came to the Mansion House to discuss the terms for a truce; but it was not until 3 a.m. the following morning that all conditions were agreed.

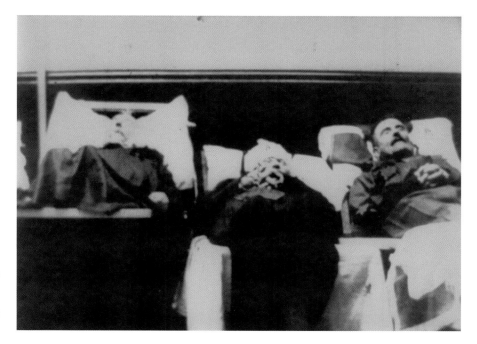

Victims of the Belfast pogrom, 1921

In Belfast on the night of 10 July, Orange rioters, guided by special constables, attacked and burned to the ground more than 160 houses belonging to Catholics, killing fifteen people. The delegates of the American White Cross found a thousand Catholics taking shelter in storehouses, school buildings and stables. This appalling onslaught became known as Belfast's 'Bloody Sunday'.

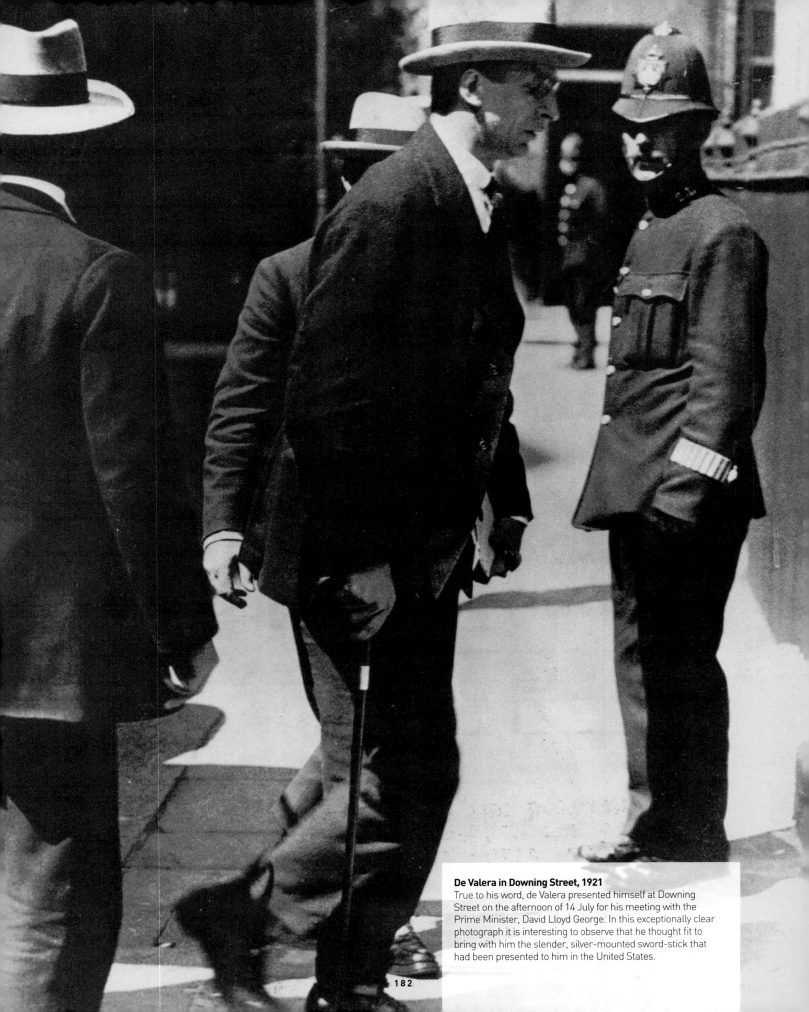

De Valera in Downing Street, 1921
True to his word, de Valera presented himself at Downing Street on the afternoon of 14 July for his meeting with the Prime Minister, David Lloyd George. In this exceptionally clear photograph it is interesting to observe that he thought fit to bring with him the slender, silver-mounted sword-stick that had been presented to him in the United States.

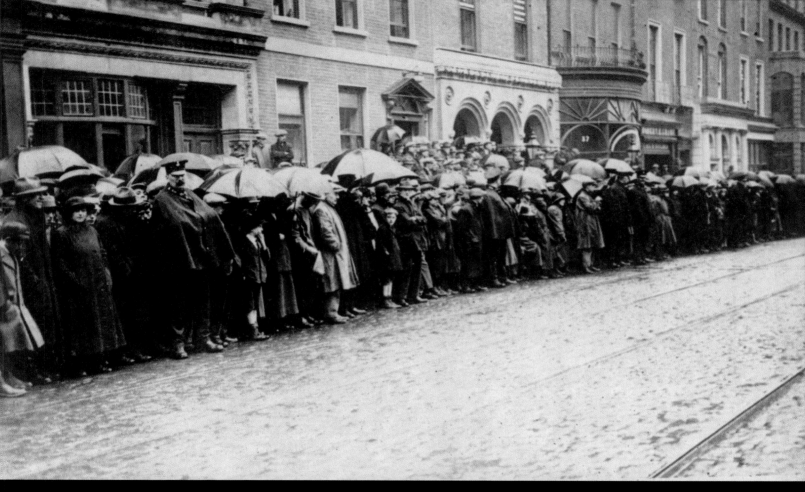

Spectators await the opening of the second Dáil
In the rain, spectators in Dawson Street, Dublin, await the opening of the
second Dáil. On 16 August it met in public session to consider Lloyd George's
proposals. On 23 August, in private session, it voted unanimously to reject
them, and on 26 August, this time in public session, it re-elected Mr de Valera
as President of the Irish Republic as well as electing a ministry. September
was taken up with a continuous exchange of letters and telegrams between
Lloyd George and de Valera, in which the latter reaffirmed his stand for a

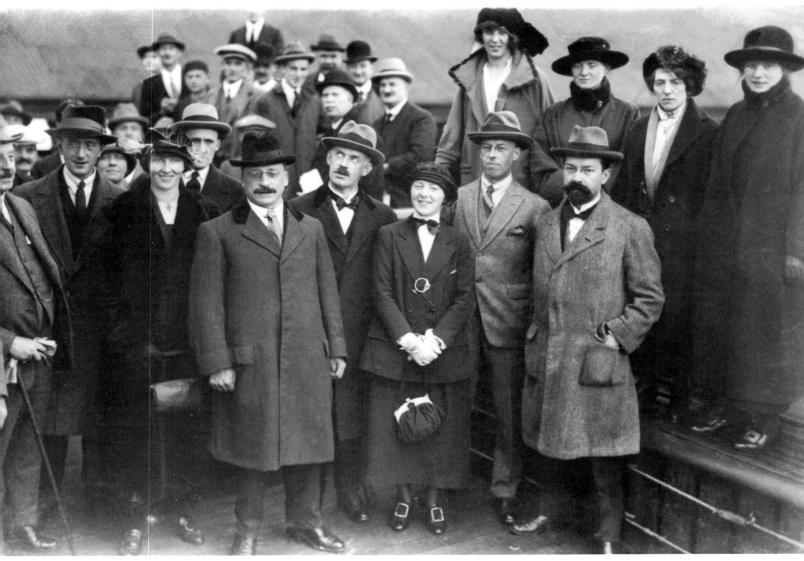

Delegates at Holyhead on their way to London

At Holyhead, on their way to London, the chosen delegates and their secretaries posed for this photograph. Only two faces are missing from it: those of Erskine Childers and Michael Collins. The latter had made other travel arrangements. All the delegates had been given the clearest instructions:

2. It is understood that before decisions are finally reached on a main question that a despatch notifying the intention to make these decisions will be sent to members of the Cabinet in Dublin, and that a reply will be awaited by the Plenipotentiaries before final decision is made.

3. It is also understood that the complete text of the draft treaty about to be signed will be similarly submitted to Dublin and reply awaited.

Four delegates at Hans Place, London, 1921

George Gavan Duffy TD, Michael Collins TD (Minister for Finance), Arthur Griffith TD (Minister for Foreign Affairs) and Robert Barton TD (Minister for Economic Affairs) at 22 Hans Place, London. Lloyd George had studied, most carefully, the records of all those forming the Irish delegation. He knew their strengths and weaknesses. He knew that Arthur Griffith had expressed sympathies for a 'dual monarchy'; he selected him to be put through the squeezer first and weakened him with compromising correspondence.

Collins was an altogether different proposition, a man of immense natural resilience and self-confidence, a truly formidable character; but his Achilles heel proved to be the Six Counties and his belief that they would be forced by economic circumstances to come in with the rest of Ireland. In addition to this Collins's main power base was with the IRB, particularly in America, where some of its supporters were showing signs of wishing to reach an agreement with England. But Lloyd George's main strength lay in the fact that the partition of Ireland was already a *fait accompli*.

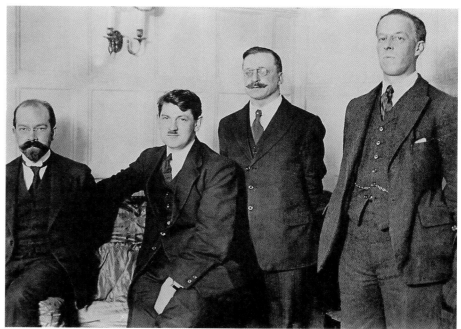

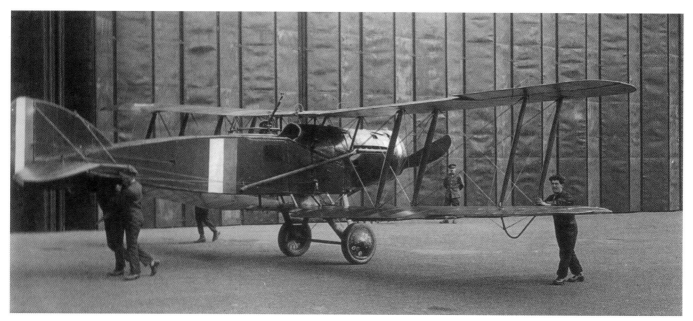

Michael Collins's aircraft at Croydon Airport, 1921

For reasons of security, Michael Collins had decided on alternative means of travelling to London. His close associate and best friend, Emmet Dalton, had purchased for him, from the Bristol Aircraft Company, one of the latest of their two-seater fighters, and by this means he planned to escape from London, should this be needed.

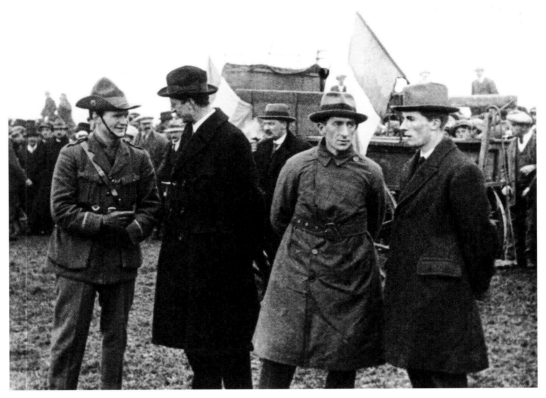

De Valera and Mulcahy at the IRA review, 1921
Taking advantage of the Truce, Cathal Brugha, as Minister for Defence, ordered a review of the Western Divisions of the IRA. Here de Valera and General Richard Mulcahy are seen at East Clare. But the impression of unity does not correspond to reality: tensions were already mounting rapidly, on account of the difficulties encountered in London in reaching an agreement. Already many individuals were asking themselves the much-dreaded question, What if the talks should break down?

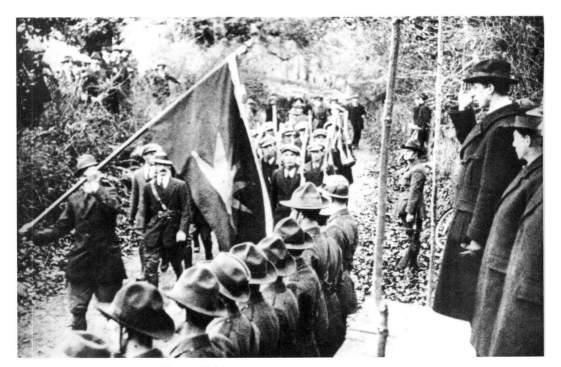

De Valera takes the salute of the Western Divisions
Even as he took the salute, with Cathal Brugha standing beside him on the platform, there must have been other concerns in de Valera's mind. The cruel realities of Lloyd George's insensate imperialist demands, backed up by so many prominent political figures, such as Sir Edward Carson and Sir Henry Wilson, Chief of the Imperial General Staff, must have been colouring his thoughts. He knew his own inner strength; but what of the strength of others?

De Valera as Chancellor of the National University of Ireland, 1921

The news from London, where his colleagues were being ground to powder by the pressures exerted on them by Lloyd George, occasioned de Valera's sudden return to Dublin on Friday 5 December. Here he met Arthur Griffith, who told him of the latest developments and to whom he said that they were unacceptable. That evening Michael Collins, casting security to the winds, George Gavan Duffy and Erskine Childers took the 'Irish Mail'. At Euston Station in London they were handed the latest emendations of the draft agreement.

At Dublin, the following day, the full ministry assembled. Opinion was divided about acceptance, Griffith being of the opinion that a matter of such grave consequence should be decided by the Dáil itself. De Valera maintained his stand for a republic, believing that the principle of 'external association' was still viable. Here we see de Valera, on 19 November 1921, receiving the honour of being elected Chancellor of the National University of Ireland.

But events in London were to take another and altogether surprising twist. On 6 December all the delegates signed the agreement, without first submitting it for approval by the ministry in Dublin, as they had been pledged to do. Lloyd George and those who supported him had triumphed. Ireland, already partitioned and still under the Imperial Crown, had gained less than full Dominion status. Bitterly did the adherents of the republican ideal resent this turn of events.

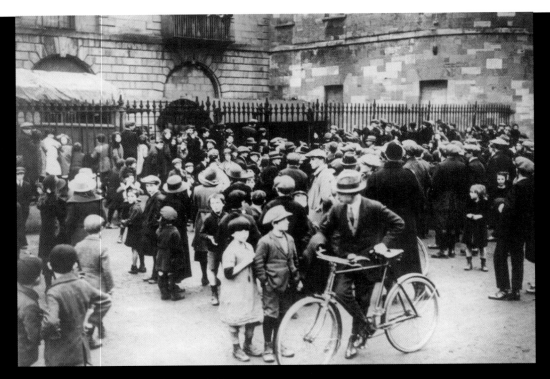

Prisoners released from Kilmainham Jail, 1921
Within a few days the British began to release the political prisoners and internees. A crowd has gathered at Kilmainham Jail in Dublin to await the first prisoners to be released, but many other prisoners who had been convicted under the Defence of the Realm Act were kept in imprisonment for some months more.

Internees being released at Ballykinler, 1921
At Ballykinler Internment Camp in Co. Down conditions were more sombre, less welcoming for the released internees, who had, for the most part, a long train journey ahead of them but also the prospect of being home by Christmas.

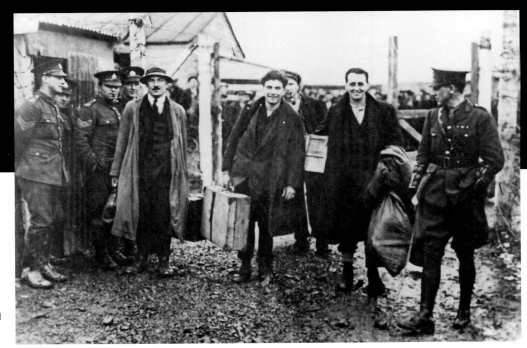

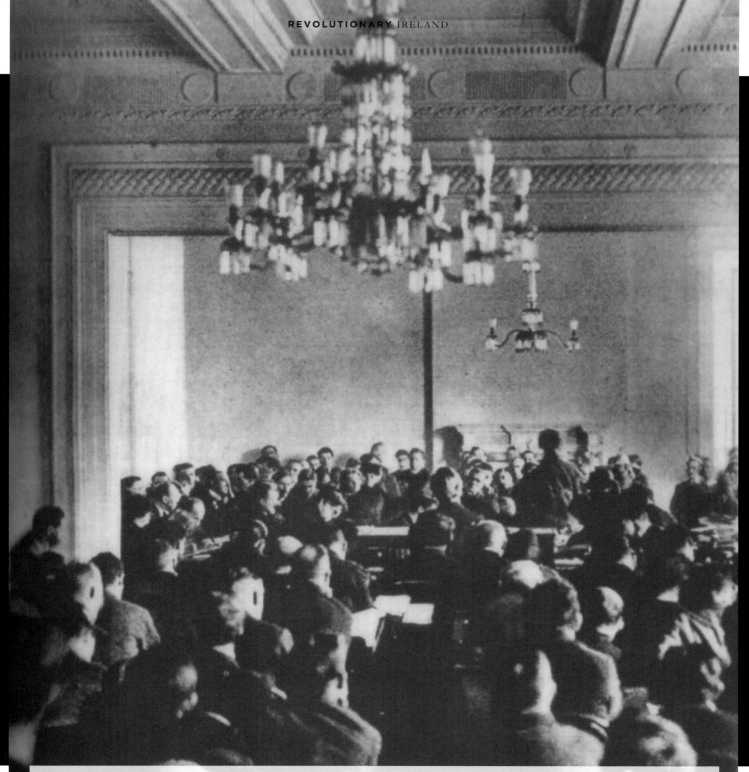

The Treaty debate, National University of Ireland, 1922

As if to make a break with the past, there was a change of venue for meetings of Dáil Éireann. University College, Dublin, was the place selected. On 3 January 1922 the second Dáil met for the first time in the Convocation Hall of the university in Earlsfort Terrace. The arguments for and against the Treaty were to become ever more assertive. Countess Markievicz made a remarkable contribution to the debate, claiming that 'it is the capitalist interests in England and Ireland that are pushing this Treaty, to block the march of the working people in England and Ireland.' The position of the pro-Treaty TDs might be summarised in Piaras Béaslaí's contribution: 'What we are asked is to choose between this Treaty on the one hand and, on the other, bloodshed, political and social chaos and the frustration of all our hopes of national regeneration.'

Michael Collins made a singular and sinister suggestion to President de Valera, 'that you allow the Treaty to go through and let the Provisional Government come into existence; and if necessary you can fight the Provisional Government on the republican question afterwards.' De Valera replied: 'We will do that if you carry ratification, perhaps.' The position on both sides of the debate was consolidating rapidly.

Observing the way things were going, de Valera offered his resignation on 6 January, explaining that he could not continue to hold office with divided responsibility, but offered to remain in office for a further day on the understanding that Griffith's motion to approve the Treaty should be taken within twenty-four hours. On 7 January, Griffith's motion was taken; there was a majority of seven for the Treaty. On 9 January de Valera's resignation was on the table. A motion calling for his re-election as President of the Republic was then taken and was lost, by two votes. Next a motion calling for Arthur Griffith to form an executive was proceeded with; and while this was in process all the republican deputies left the chamber in protest.

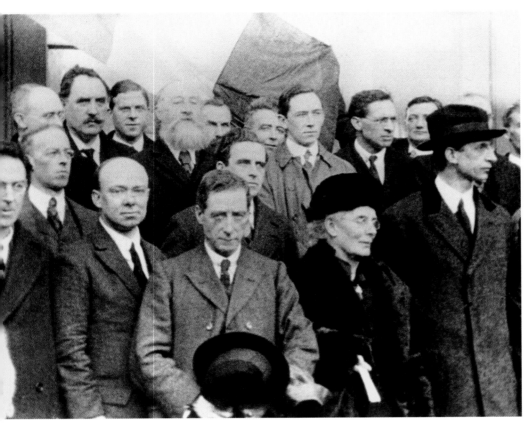

Republicans leave second Dáil in protest, 1922
Here are some of those republicans, including de Valera, Mrs Pearse, Cathal Brugha, Seán MacEntee, Count Plunkett, Dr James Ryan and Robert Barton, standing beneath the Tricolour flag that symbolises their allegiance. When this formal protest was over they returned to the Dáil, but their numbers were insufficient to block Griffith from forming a new government and proceeding with his plans, in which Michael Collins was to be Minister for Finance and Richard Mulcahy to be Minister for Defence. Preparations were continuing to bring the proposed 'Irish Free State' into being, according to the provisions of the agreement signed in London.

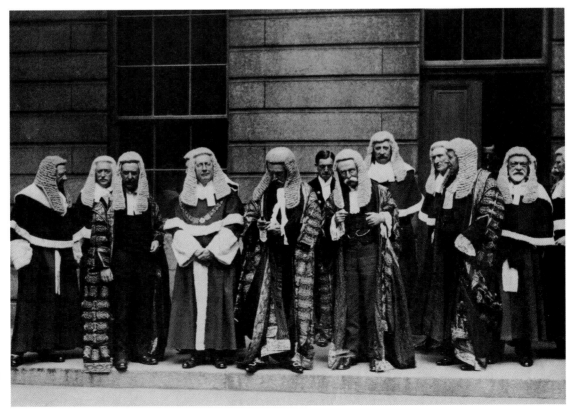

The last judges of the British administration, 1922
While these momentous events were taking place elsewhere, at the Four Courts the last judges of the British administration were preparing to leave.

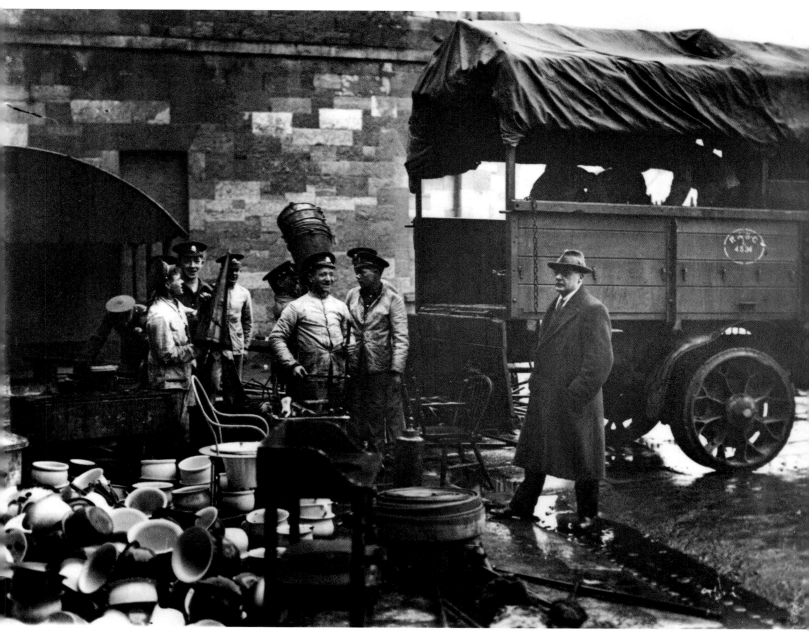

British evacuate Kilmainham Jail, 1922
At Kilmainham Jail, under the eye of a civil servant, British soldiers in fatigue uniforms were busy.

The so-called surrender of Dublin Castle, 1922
James Talbot, Viscount Fitzalan, now summoned the leaders of the Provisional Government to meet him in Dublin Castle on 16 January, where the new government was 'duly installed'. Here we see them leaving the building, led by a somewhat nervous-looking Kevin O'Higgins, followed by Michael Collins and Éamonn Duggan. Shortly afterwards Collins went to London to visit Winston Churchill to discuss with him the details of the transfer of powers.

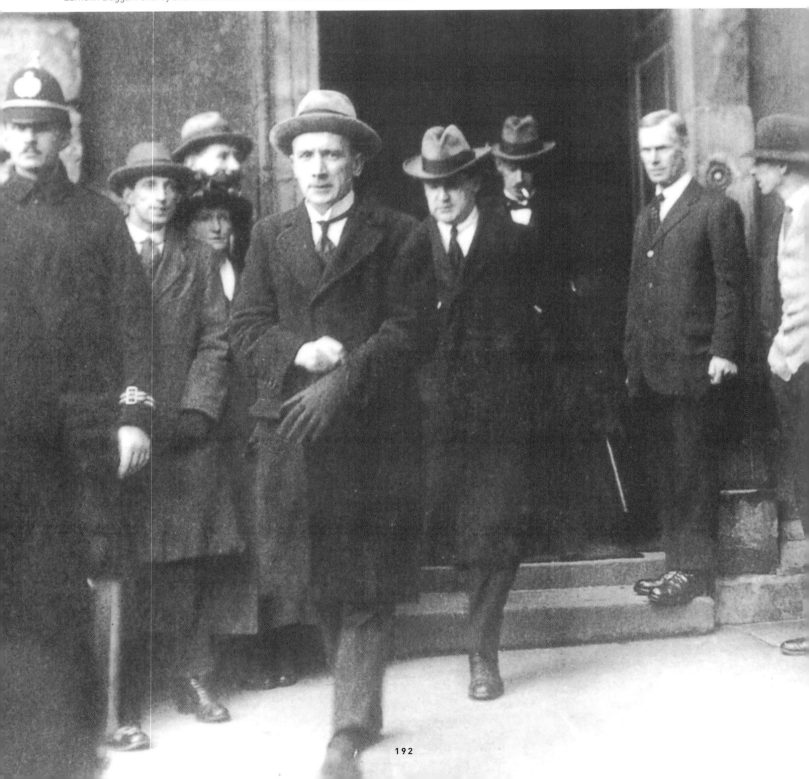

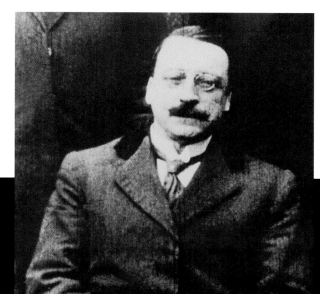

Arthur Griffith at a meeting of the new government, 1922
On 11 January 1922 Arthur Griffith summoned a meeting of the Parliament of Southern Ireland, to take place on Saturday 14 January at the Mansion House, de Valera being summoned only for his constituency of East Clare. All the republican deputies boycotted the assembly, but it was attended by all the pro-Treaty deputies, as well as the four Unionists returned by the University of Dublin, save only Sir James Craig. When the Parliament met it gave its formal approval to the agreement and then proceeded to elect a Provisional Government for the 26 counties.

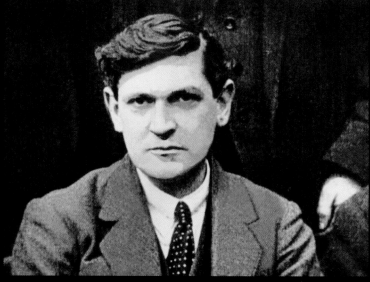

Michael Collins at a meeting of the new ministry, 1922
Michael Collins was appointed Chairman of the Provisional Government. This gave him yet more power. It was clear at this point that he had eclipsed Griffith.

Civic Guard in training, Phoenix Park, Dublin, 1922
The Provisional Government of the projected Irish Free State was training a new peace-keeping force to replace the Republican Police who had done such a good job under Dáil Éireann. This new corps was to be known as the Civic Guard. We see them here undergoing the first stages of their training at the old RIC Depot in the Phoenix Park, Dublin, at the end of January 1922. Recruitment to this body and to the army of the Provisional Government was to be greatly promoted by the prevailing level of unemployment as well as by the many thousands of Irishmen discharged from the British forces.

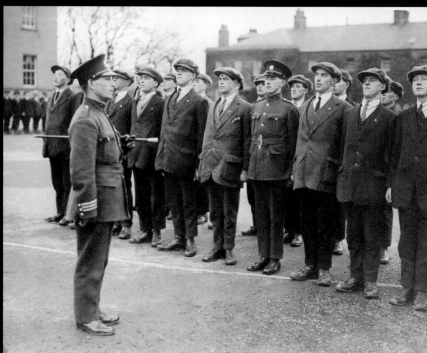

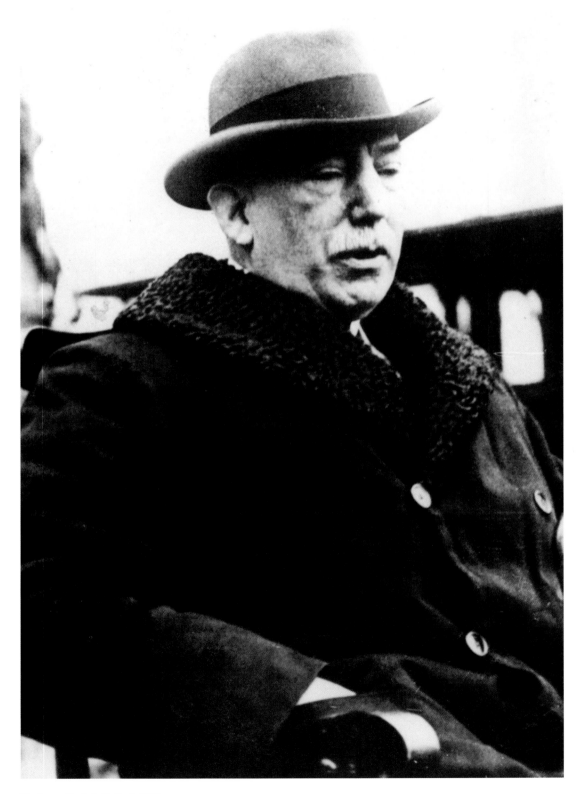

Sir James Craig in Belfast, 1922
Towards the end of January 1922 Michael Collins met Sir James Craig, Prime Minister of Northern Ireland, in London. He made an agreement with him, published on 21 January, to set up a Boundary Commission to establish the border between the Irish Free State and Northern Ireland. Unionists hailed this as a formal recognition by Collins of the status of Northern Ireland. Craig said in Belfast on 25 January: 'I will never give in to any rearrangement of the boundary that leaves our Ulster area less than it is under the Government of Ireland Act.'

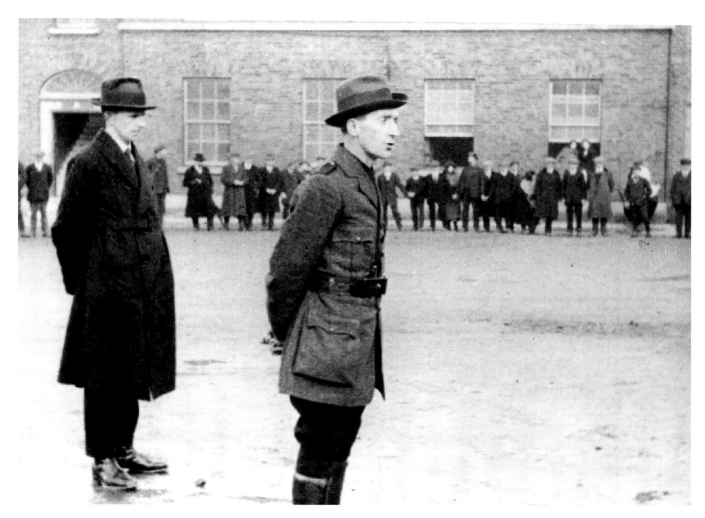

General Mulcahy, Minister for Defence, speaks, 1922
On the last day of January 1922 a small body of troops from the Provisional
Government's army took over Beggarsbush Barracks in Dublin, just evacuated
by the RIC Auxiliaries and the Black and Tans. Watched by General Eoin
O'Duffy, Chief of Staff, General Richard Mulcahy, the Minister for Defence,
spoke to the troops and told them they were 'going ahead under the old flag
with the old aspirations in their hearts, still guarding the old ideals.'

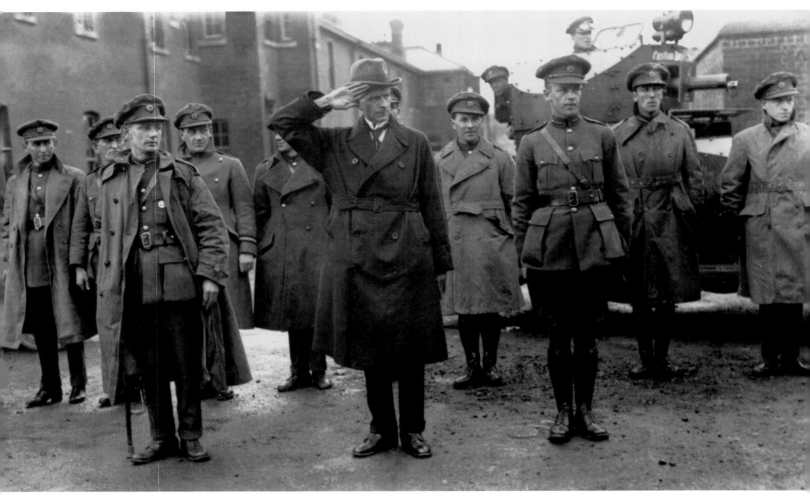

Portobello Barracks handed over, Dublin, 1922
Early in February another Dublin barracks, Portobello Barracks (now
Cathal Brugha Barracks) in Rathmines, was handed over to the Provisional
Government, and with it a number of armoured cars. Standing in the
foreground are (left to right) General Tom Ennis, General Eoin O'Duffy (Chief
of Staff) and General Emmet Dalton. General Dalton had been assigned to the
position of Director of Training under the Dáil, because he had formerly been
an officer of the British army. With the tacit approval of the British he had been
enabled to buy for Michael Collins the aircraft by which Collins was planning
to escape from London. Now he was involved in the handing over to the
Provisional Government of *matériel de guerre*, including these armoured cars.

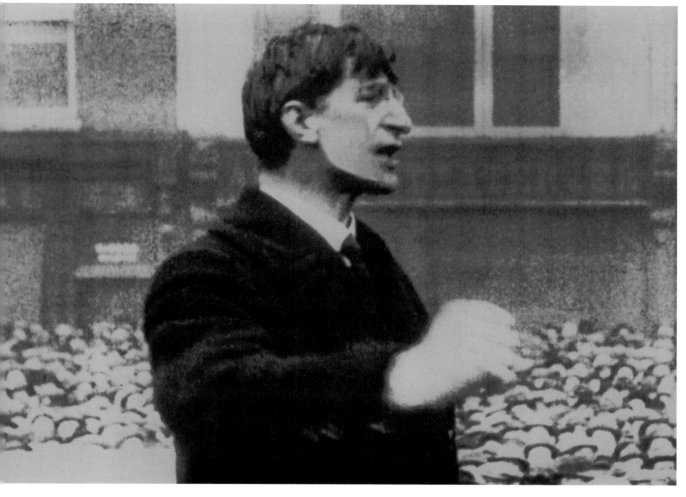

De Valera's anti-Treaty meeting, 1922 (1)
Éamon de Valera, who was still President of Sinn Féin, opened his campaign against the Treaty on 12 February with a huge meeting in O'Connell Street, Dublin.

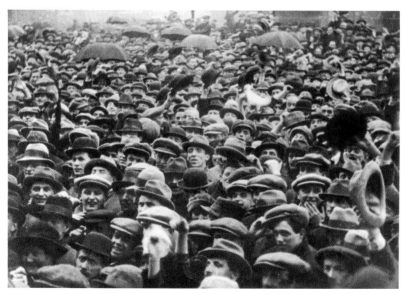

De Valera's anti-Treaty meeting, 1922 (2)
It was raining at the time, but this did not deter the large crowds that had come to hear de Valera make his impassioned plea for continuing allegiance to an Irish Republic. It is only with the greatest difficulty that we can realise today the acute, overwhelming resentment felt by so many who had struggled so hard for a republic to see this being snatched away, to be replaced with continuing formal allegiance to the British Crown.

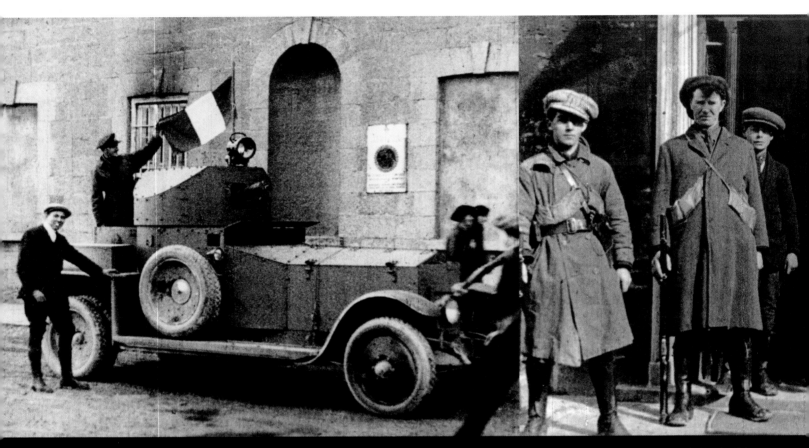

Armoured car sent down from Dublin, 1922

The Provisional Government was so alarmed by the events taking place in Limerick that it hastened to send one of its newly acquired armoured cars to Strand Barracks, under the command of Captain Bill Stapleton, on a part-training part-reconnaissance operation. It was crewed by five men, including Captain Stapleton. Two of these men were former Black and Tans who knew how to work the machine and who were to instruct the others in its operation. Captain Stapleton is here seen at Strand Barracks, with his hand on the flag.

When the threat of imminent civil war had been averted in Limerick and this armoured car was on its way back to Dublin via Templemore, Co. Tipperary, Captain Stapleton elected to spend the night at Templemore Barracks, without realising that the garrison had gone over to the republican side. He and his crew were arrested and the armoured car was later handed over to the Mid-Limerick Brigade of the IRA

The Glentworth Hotel, Limerick, occupied by the IRA

Ernie O'Malley, Commandant of the Mid-Limerick Brigade, had withdrawn all the troops he commanded from the authority of Dáil Éireann shortly after that body had voted for the Agreement and refused to take orders from General Mulcahy. Limerick and its barracks were at this time still occupied by British troops but were due shortly to be taken over by the Provisional Government. On 18 February, O'Malley issued the following proclamation:

> The aims of the head of the army and the majority of its G.H.Q. Staffs are now unquestionably to subvert the Republic, support the Provisional Government and make possible the establishment of the Irish Free State. We declare that we no longer recognise the authority of the head of the army . . .

On 23 February a force loyal to the Provisional Government, under the command of Captain Seán Hurley, took over from the British the barracks they were holding. Captain Hurley was promptly arrested by the Mid-Limerick Brigade and held for four days while Commandant O'Malley marched on Limerick with seventy men, aiming to rush the Strand Barracks and, counting on desertions from the pro-Treaty forces, to capture it. He was disappointed in this, however, and had to content himself with occupying several hotels, including the Glentworth, which he made his headquarters

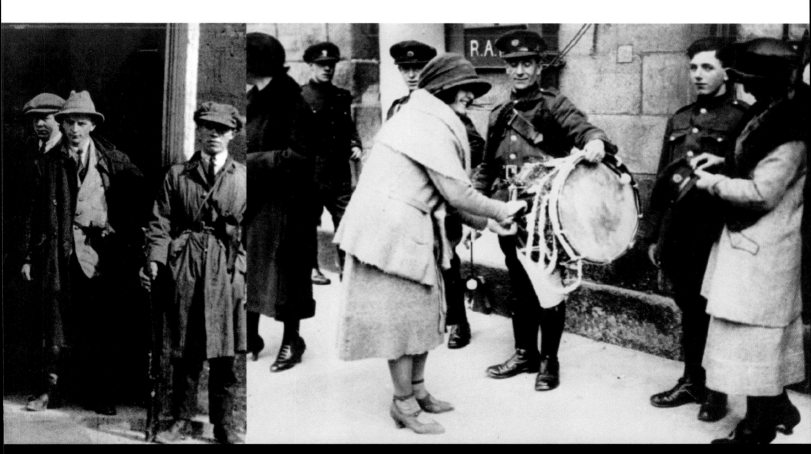

Ladies give shamrock to Provisional Government troops
No expense was to be spared when it came to providing bunches
of shamrock on St Patrick's Day for the troops of the Provisional
Government at GHQ in Beggarsbush Barracks, Dublin.

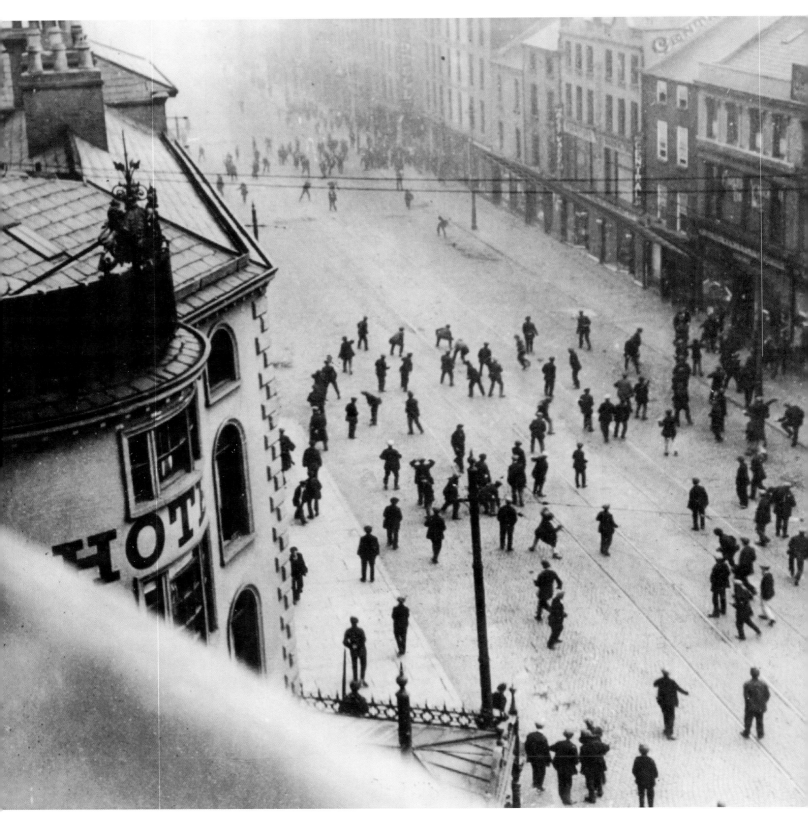

Rioting in Belfast, March 1922

Riots in Belfast were still continuing and increasing. Early in March the Parliament of Northern Ireland had passed the Civil Authorities (Special Powers) Act. Under this act coroners' courts could be eliminated and the requirement for inquests was abolished. Trial by jury was suspended and the application of the death penalty was further extended. These new powers were intended for use mainly against Catholics and Republicans bearing arms, while licences for guns were given to Orangemen and Unionists. As well as the notorious A Specials, a further force, the B Specials, was to be formed, and in a very short time what we would now call ethnic cleansing was being encouraged to take place nightly. The British government saw to the supply of many of these additional arms, at the request of Sir James Craig; and Michael Collins's attempts to have the pogroms stopped were a dismal failure.

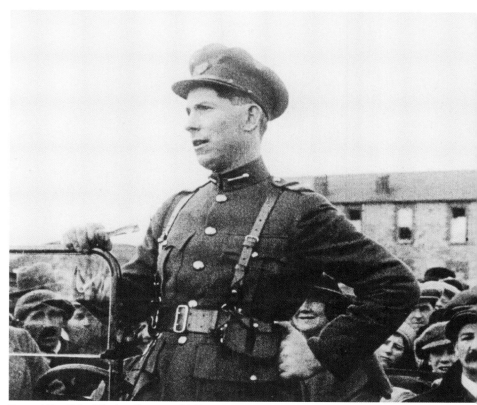

General Mac Eoin at the handing over of Athlone
Known familiarly as the 'Blacksmith of Ballinalee', General Seán Mac Eoin was one of the most popular figures in the Volunteers at the time of the 'Tan War'. Here we see him, in Provisional Government uniform, at the taking over of Athlone Barracks from the British army on 31 March 1922. He was one of the first commandants to be persuaded by Collins to accept a command in the Provisional Government's forces.

Rory O'Connor after meeting of IRA Convention
General Richard Mulcahy had tried to have the IRA Convention prohibited, but it met eventually on 9 April. A motion proposing the immediate setting up of a military dictatorship was lost by only two votes, one of them being that of Cathal Brugha. Next the Convention went on to form an Executive and a Republican Army Council. Here we see Rory O'Connor, the IRA's Director of Munitions, after this momentous meeting that brought the Civil War appreciably closer.

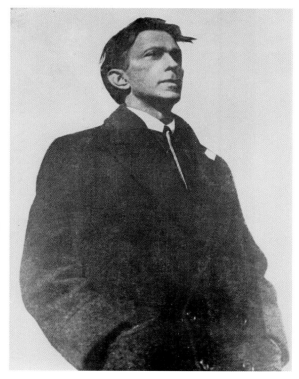

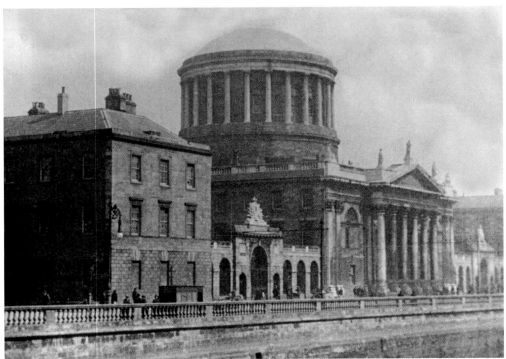

The Four Courts, 1922
Only six days later, on 15 April, the IRA struck. Republican troops under the command of Rory O'Connor occupied the Four Courts in Dublin. The next day Kilmainham Jail was also occupied, together with a group of hotels on the east side of O'Connell Street.

Sligo Town Hall defended by pro-Treaty troops
Provisional Government troops occupied Sligo Town Hall on 16 April 1922. Arthur Griffith had proposed calling a public political meeting on that date in Sligo, but this meeting had been menaced by the presence in the town of growing numbers of armed Republicans. Only the intervention of General Seán Mac Eoin and a considerable body of soldiers under his command enabled Griffith to make good his arrangements.

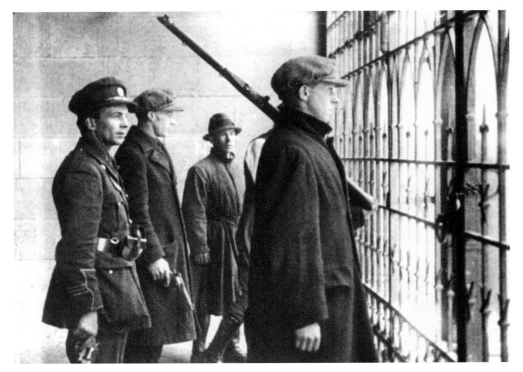

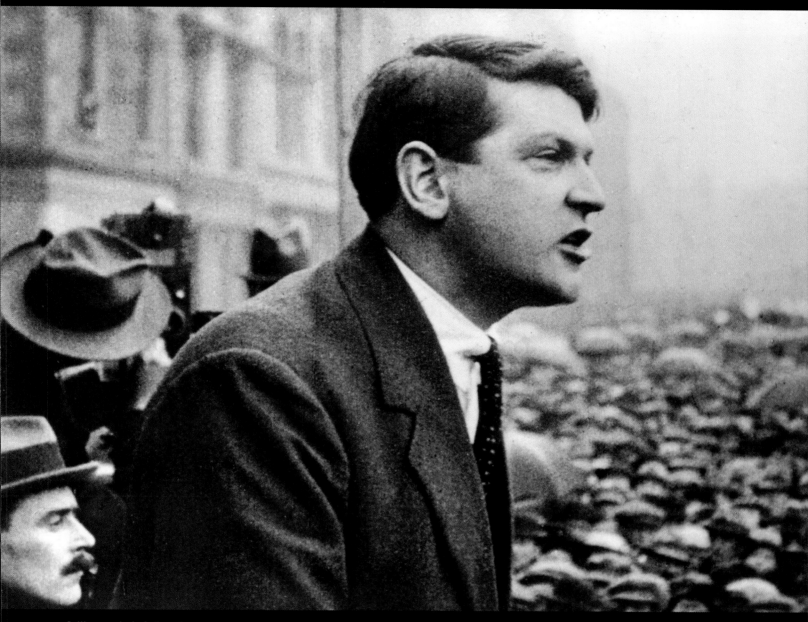

Collins speaks in College Green

On 20 April 1922 Michael Collins was the principal speaker at a huge meeting in College Green, Dublin, when the pro-Treaty party launched its campaign in the capital. He asked his hearers to accept the terms of the Agreement as a step towards freedom and independence—'the freedom to achieve freedom,' as he put it. He further assured them that the Boundary Commission would award very large areas of Northern Ireland to the Irish Free State, on the basis of demographic evidence.

But if Collins was indeed correct in his informed view that the IRA could not hold out against a renewed onslaught by the British army, he failed to convince the leaders of the IRA of this most salient fact. Could this failure have been, in part, a result of the information and assessments provided by Collins's intensely efficient intelligence network being kept too confidential and not being disclosed widely enough before attitudes had a chance to harden? Had such a policy of disclosure to the leaders of the IRA been brought into operation in January 1922, might not civil war have been averted? Collins's involvement with secrecy and secret organisations may have rendered him, in this instance, not a good communicator.

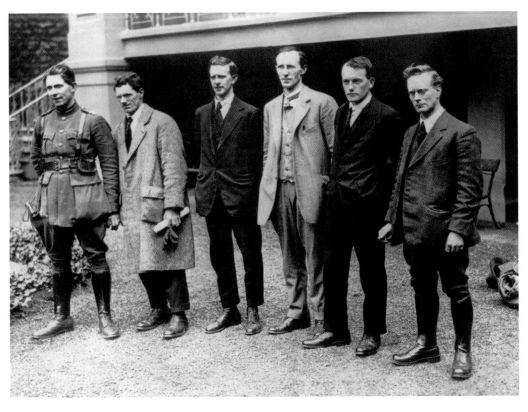

Truce officers meet at the Mansion House, 1922

Early in May actual fighting, with casualties on both sides, had broken out in Kilkenny when republican troops had seized Kilkenny Castle and a number of hotels. The Provisional Government forces responded by driving the Republicans out of their positions. But so critical were conditions that a group of army officers from both sides met at the Mansion House, Dublin, on 8 May and agreed to a truce. Here we see six of them (left to right): Seán Mac Eoin (Pro-Treaty), Seán Moylan (Republican), Eoin O'Duffy (Pro-Treaty), Liam Lynch (Republican), Gearóid O'Sullivan (Pro-Treaty) and Liam Mellows (Republican). They had been successful in averting civil war for the second time.

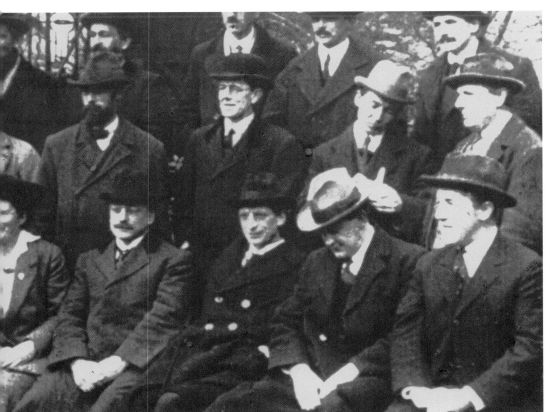

Dáil Pact meeting in the Mansion House, 1922

All through this troubled period the second Dáil was still in session, meeting once again at the Mansion House. Here, on 20 May, the two sides of the great divide reached an agreement on how the forthcoming general election should be conducted. The agreement made provision for a coalition government that would, as nearly as possible, restore the balance of power in the Dáil to where it had been before the Treaty debate had taken place. Sinn Féin added its weight to this by endorsing the proposal at its ard-fheis on 23 May. It looked as though civil war had been averted, for the third time.

On 31 May an important debate about whether or not the Collins-de Valera Pact violated the terms of the Treaty took place in the British House of Commons. Both Arthur Griffith and Michael Collins were present in the Distinguished Strangers' Gallery. In the course of the debate, on being questioned by Sir Henry Wilson, Chief of the Imperial General Staff, Winston Churchill replied: 'In the event of the setting up of a Republic it would be the intention of the Government to hold Dublin as one of the preliminary and essential steps for the military operations.' Sir Henry Wilson commented: 'If serious trouble arises on the frontier between the Six Counties and the Twenty-six Counties, I hope that the Government will not restrain the military from crossing the frontier in their own self-defence.'

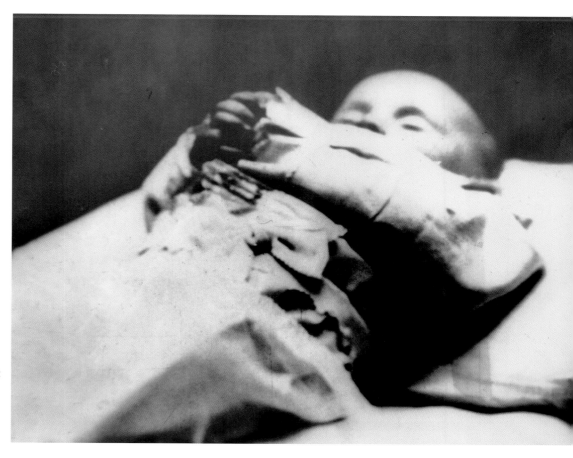

Infant victim of pogrom, Belfast, 1922
In Belfast and in other parts of Northern Ireland the pogroms were taking a more vicious form still, with the murdering of infants and young children as well as adults.

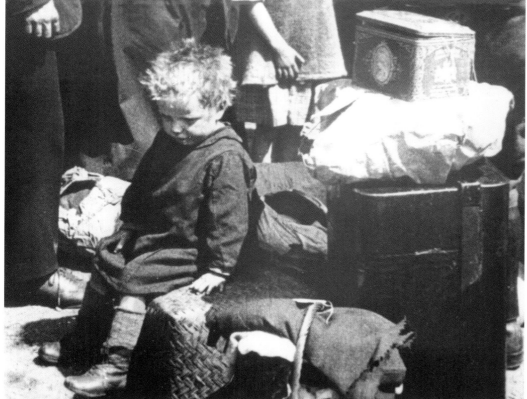

Child refugee from Belfast in Dublin, 1922
Many Catholics sent their children for safety to Southern Ireland. Here we see one in Dublin.

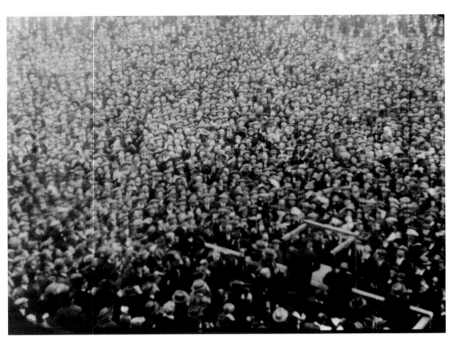

Collins speaks in Cork, 1922

Four days before the date set for the general election Michael Collins went to London to meet Churchill at the Colonial Office. He then hurried back to Ireland for his monster meeting in Cork on 14 June. Before a vast audience he declared:

> You are facing an election here on Friday, and I am not hampered now by being on a platform where there are Coalitionists. I can make a straight appeal to you, to the citizens of Cork, to vote for the candidates you think best of, whom the electors of Cork think will carry on best in the future the work they want carried on.

Republicans' reaction to Collins's speech, Cork, 1922

This flagrant breaking of the electoral pact caused fighting to break out among the crowd, and guns were drawn, but they were fired into the air, and there were fortunately no casualties.

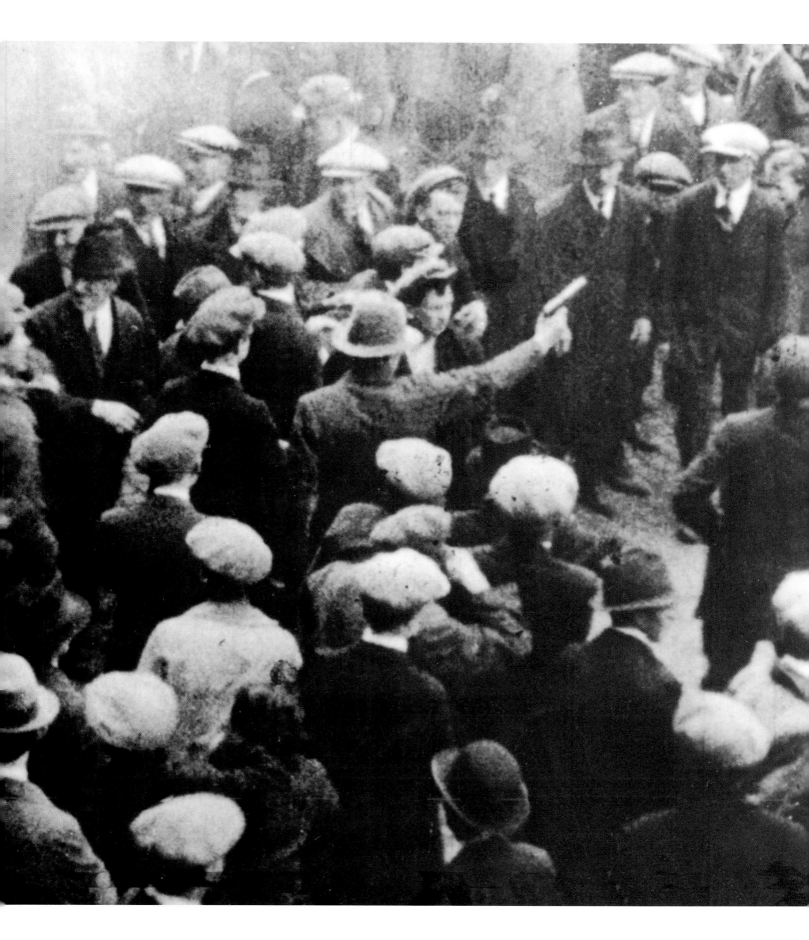

De Valera speaks at Mooncoin, 1922
The most grievous disappointment and foreboding are visible on the face of Éamon de Valera as he prepares to speak at Mooncoin, Co. Kilkenny. He had been hoping against hope that the Election Pact would hold.

Liam Mellows speaking at Bodenstown, 1922
When the results of the general election were announced, on 24 June, they were a great disappointment to the Republicans: 58 per cent of Southern Ireland had voted for the Treaty. On the day following, many prominent Republicans made a visit to the grave of Theobald Wolfe Tone at Bodenstown, Co. Kildare. Here, watched by Miss Margaret Pearse and Miss Molly Hyland, Commandant Liam Mellows gives an uncompromising speech on behalf of republicanism.

At a momentous meeting that had taken place in the Mansion House, Dublin, on 18 June the IRA sought to reunite itself, but too much dissension was evident, and the meeting broke up.

Rory O'Connor at Bodenstown, 1922

This tragic photograph, the last to be taken of Rory O'Connor, expresses better than words could do the deep disappointment suffered by Republicans. The men of the Four Courts garrison were already preparing for launching an attack on Northern Ireland, believing it was the only way of reuniting the IRA. According to this report in the *Manchester Guardian*,

> a conference was held in Dublin yesterday at which Mr. Griffith, Mr. Cope (Assistant Under-Secretary), Major General Dalton and two British Military officers were present, to consider the continued occupation of the Four Courts by the Irregulars under General Rory O'Connor. The proceedings were secret.

Further, on the night of 27/28 June, according to General Macready's memoirs,

> through representations to London by Cope, I received instructions to hand over two eighteen-pounder field-guns to the Provisional Government with a reasonable supply of ammunition of which only sufficient for our needs was on hand . . .

> Although the Provisional Government wanted the guns they were not at all sure they had any men who could work them, nor was it to become known until they were in action that the British Government had loaned them. In the end, General Dalton, the only man who among Collins' officers had any knowledge of such things, came up after dark to our artillery lines with some motor-lorries, on the tails of which the guns were hitched and taken into town.

At 1 a.m. on the morning of 28 June all was quiet at the Four Courts. A few minutes later there assembled soldiers of the Provisional Government, among whom were two groups of men who drove Lancia armoured cars against the two main gates, abandoning them there. The field guns collected by General Emmet Dalton were positioned at the foot of Winetavern Street and Bridgefoot Street and trained on the Four Courts. At 3:40 a.m. the commandant on duty in the Four Courts was given an ultimatum, signed by General Tom Ennis, demanding that they surrender by 4 a.m. At seven minutes past that hour the 18-pounders began to fire. The Civil War had begun.

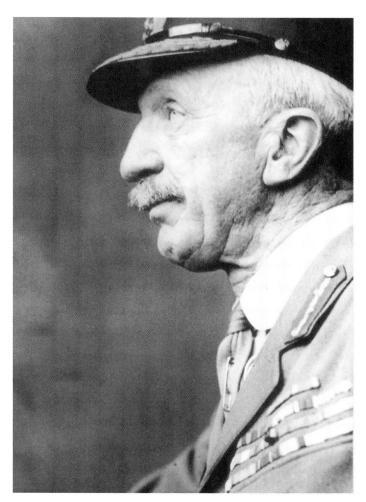

Sir Henry Wilson

On 22 June, Sir Henry Wilson, standing on the doorstep of his house in London, was shot dead. Reginald Dunne and Joseph O'Sullivan were at once captured. They were both ex-servicemen of the British army. At their trial and afterwards, until both were executed by hanging, they did not furnish any information that could connect them with the IRA. A little over a year previously Michael Collins had prepared a 'death list' of British senior political figures, and among these names was that of Sir Henry Wilson. From the time he signed the Agreement, Collins had been cancelling names from this list, until only one name remained. Having been present in the Distinguished Strangers' Gallery to hear the exchange between Churchill and Wilson, Collins decided that the latter's name should be retained.

But the assassination had given the British government, particularly that clique that favoured Lord Birkenhead's cynical 'economy of British lives,' the excuse they were looking for to bring pressure on the Provisional Government to attack the Republicans, especially those in the Four Courts.

The siege of the Four Courts, 1922
All through Thursday and into Friday the siege continued. By Friday morning the building was ablaze.

Field gun at the bottom of Bridgefoot Street, Dublin, 1922
Because of the gunners' lack of experience, their commanding officer, Colonel Anthony Lawlor, had no time to train them in the use of the sights; instead the breeches of the guns were opened and the guns were sighted by looking through the barrel.

Here we see the gun at the end of Bridgefoot Street about to be fired. A pickaxe has been used on the tarred surface to emplace securely the 'spade' of the gun so as to control its recoil. Five further shells lie in the road ready for use. At first these were all of thin-cased high-explosive type; later in the siege the Provisional Government was to appeal to the British government to provide armour-piercing and incendiary shells. A Lancia armoured car has been positioned on the corner to help give some cover to the gunners; but no hearing protectors have been supplied!

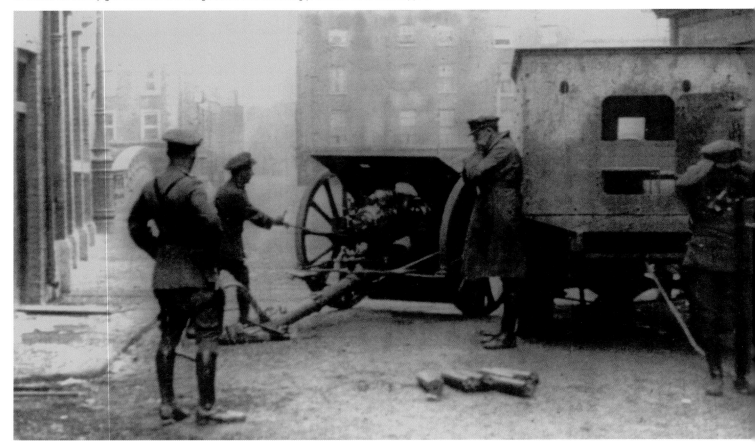

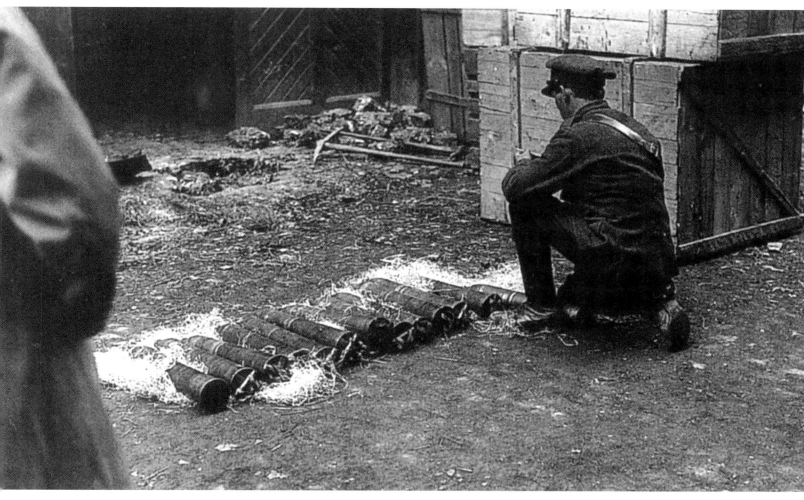

Ammunition for the siege of the Four Courts, 1922
As the siege of the Four Courts wore on and ammunition for the two field guns began to become scarce, a British destroyer was hurriedly sent to obtain more from the nearest arsenal, which happened to be Carrickfergus Castle in Co. Antrim. Here we see the ammunition, having just been unpacked, still surrounded by wood-shavings.

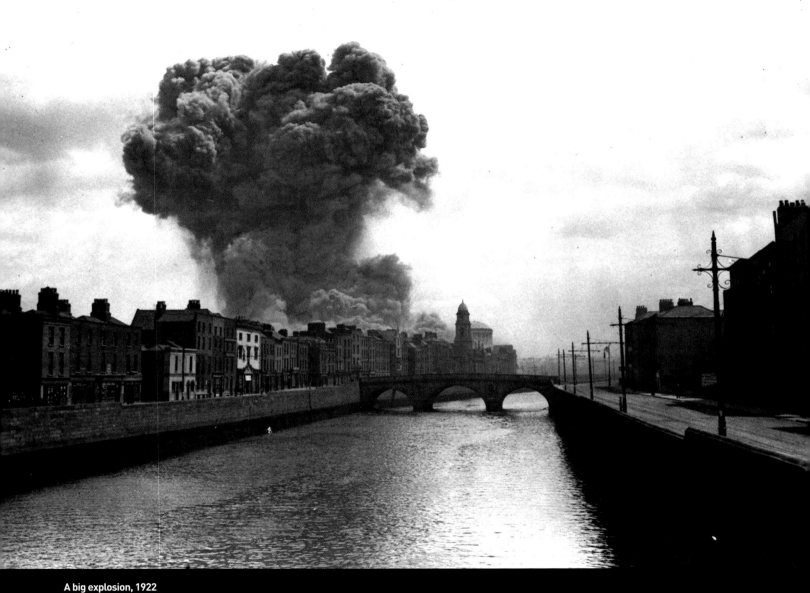

A big explosion, 1922
The Provisional Government had succeeded in making a breach in the Public Record Office, immediately behind the Four Courts, and a considerable number of their troops were there. Unluckily, the cellars here were where the garrison had stored their munitions. The flames from the burning buildings eventually reached them and they exploded with a blast so great that many Provisional Government soldiers were killed.

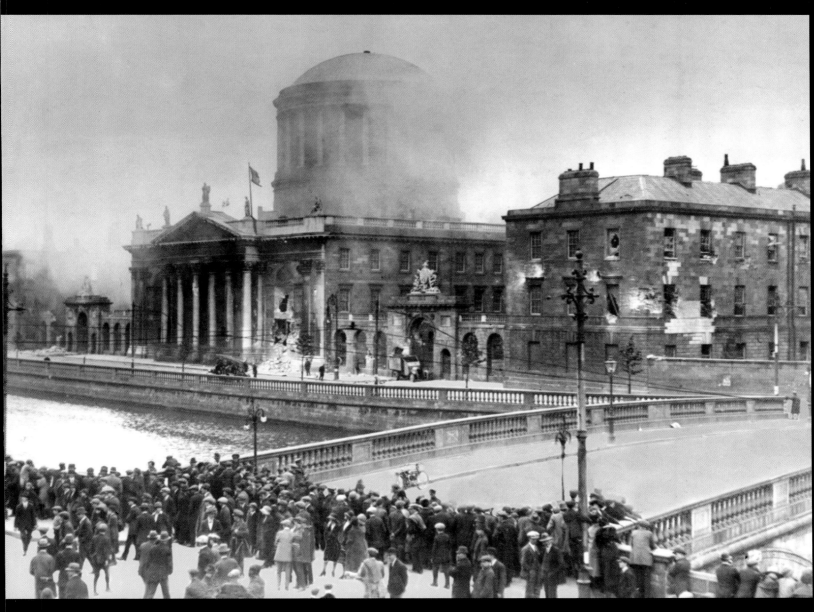

The surrender of the Four Courts, June 1922

At about noon on Friday 30 June the Four Courts garrison surrendered. They had just been ordered to do so by Commandant Oscar Traynor.

> If the Republic is to be saved your surrender is a necessity. As Senior Officer outside I take it that I am entitled to order you to make a move which places me in a better military position. This order must be carried out without discussion. I take full responsibility.

Under cover of a white flag, more than a hundred members of the garrison marched out of the blazing building and stood in ranks in the roadway, Commandant Rory O'Connor at their head. A press photographer attempted to take a picture but was prevented by O'Connor, who wished, very naturally, to spare the men who had served under him any humiliation. But Commandant O'Connor, had he reflected, would have realised that in doing this he was also denying the garrison of the Four Courts their honourable place in Irish visual history.

The prisoners, including O'Connor, were taken directly to Mountjoy Jail, where they claimed the right to be treated as political prisoners. Along the way six prisoners, including Commandant Ernie O'Malley, managed to escape. Coincidentally, this was the day that had been appointed for the dissolution of the second Dáil.

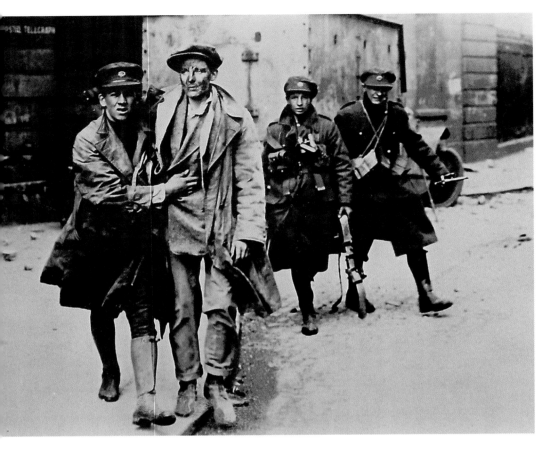

A wounded Republican prisoner, Four Courts, 1922
A wounded Republican, one of the garrison, being helped to walk by a medical orderly of the Provisional Government's troops after the siege of the Four Courts. A Lancia armoured car belonging to the besieging troops is seen in the background.

Father Dominic under arrest, Four Courts, 1922
Two brave Franciscan monks stayed in the Four Courts during the whole of the siege, Father Dominic and Father Albert. When the siege came to an end Father Dominic was arrested.

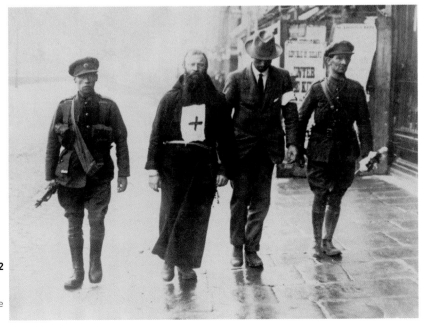

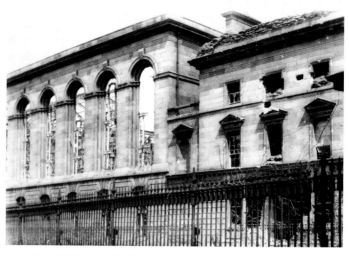

18-pounder field gun firing on the 'Block', July 1922
The next objective of the Provisional Government's forces was to dislodge the Republicans from the 'Block', the line of hotels that stretched along the east side of O'Connell Street, from the Hammam Hotel to the Gresham. They had established their headquarters in these hotels and occupied in addition many outposts giving cover to snipers. The field gun has just been fired and the blast has dislodged a shower of glass, still falling, from an already shattered window of Bailey Brothers at the left. Two armoured cars have been positioned to give much-needed extra protection from snipers to the gun crew. The level of high-amplitude transients emitted by this type of weapon is clearly indicated in this photograph.

Ruin of the Public Record Office, July 1922
The fires in the Four Courts and the Public Record Office blazed for days, being considered too dangerous to tackle by the fire brigade on account of frequent explosions. When they were eventually put out it was seen what a devastating loss had been inflicted on the people of Ireland.

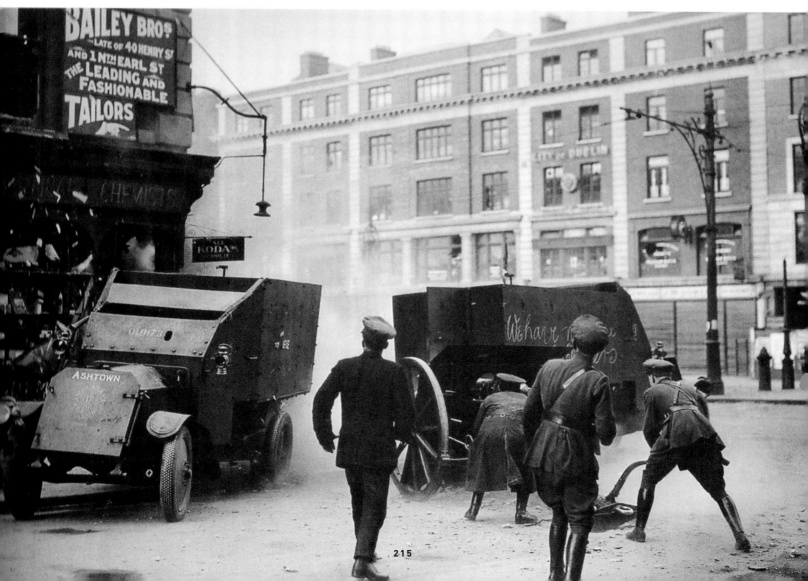

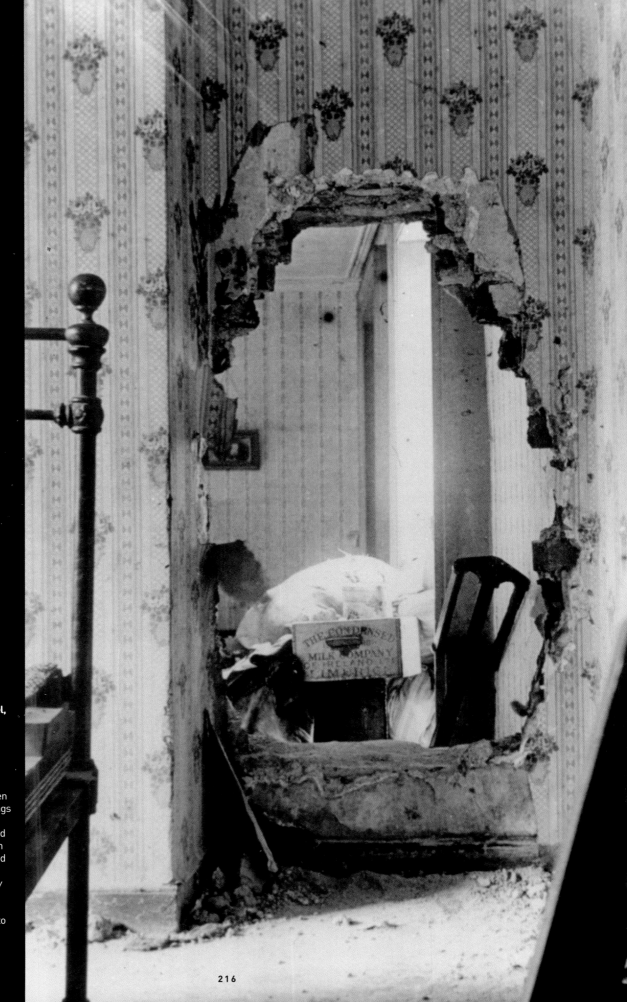

Interior of the Hammam Hotel, 1922
The Republican command had not been idle during their occupation of the Block. No effort had been spared in making their position more secure. Partition walls and even the walls of contiguous buildings had been pierced to secure better communication. Nor had the inner needs of the garrison been neglected, as is evidenced by this packing-case labelled *The Condensed Milk Company of Ireland—Limerick*. Officers commandeering supplies had been scrupulously instructed to give official receipts.

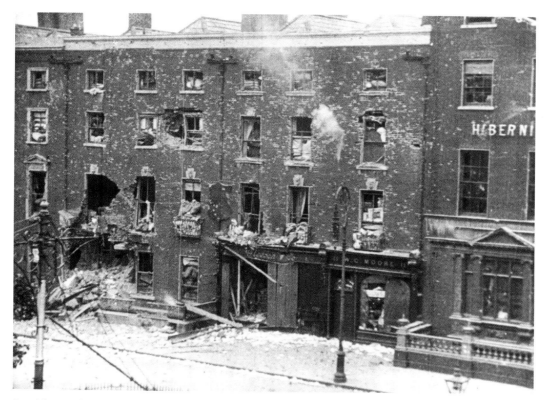

Republican position in O'Connell Street, 1922
Unlike the substantial stonework of Gandon's masterpiece that had caused the Provisional Government to request armour-piercing shells, the houses here were of soft Georgian and Victorian brick. A rifle round has just struck one of the houses and a cloud of pulverised brick-dust is dispersing. A breach made by 18-pounder fire is clearly visible on the left. Vigorously though the Republicans defended their positions, they were outgunned by the Provisional Government's artillery. On Monday, Austin Stack, Oscar Traynor and de Valera left the Block to organise opposition in the guerrilla war they anticipated in the rest of the country.

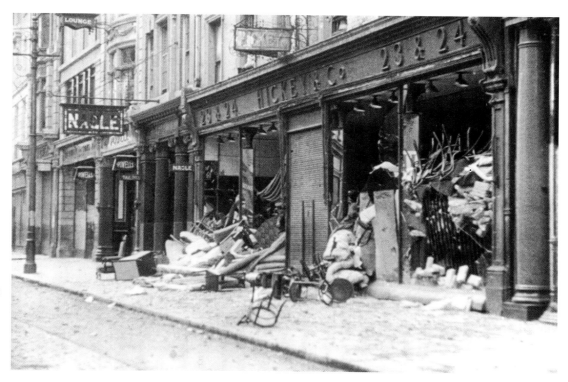

Republican outpost in Henry Street, Dublin, 1922
Apart from their headquarters in the Block the Republican forces had many outposts in surrounding streets. This one is in Henry Street.

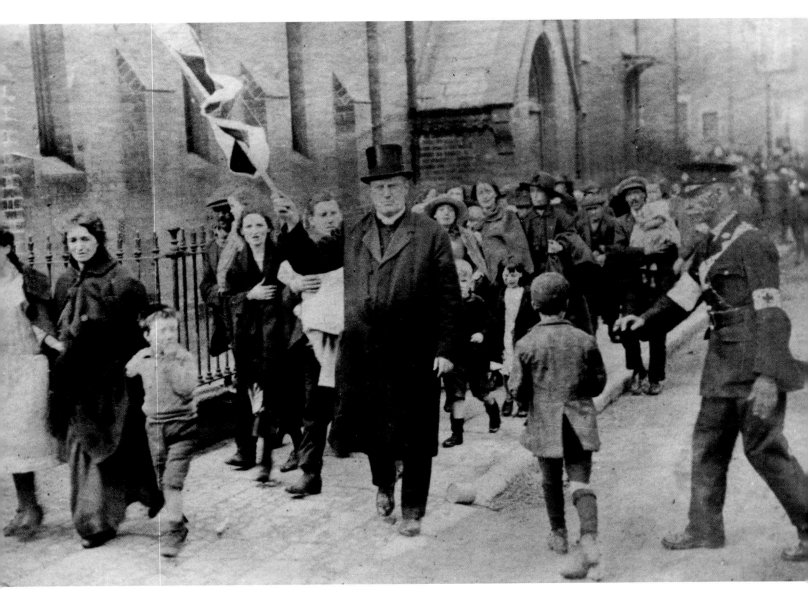

Parish priest leads parishioners to safety, 1922

A priest leads his parishioners to safety.

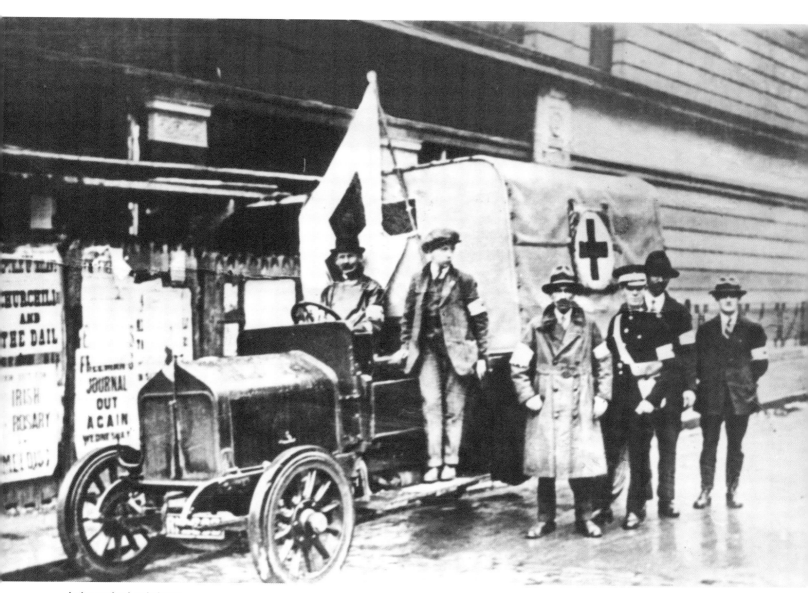

An improvised ambulance
An improvised ambulance in Dublin in 1922.

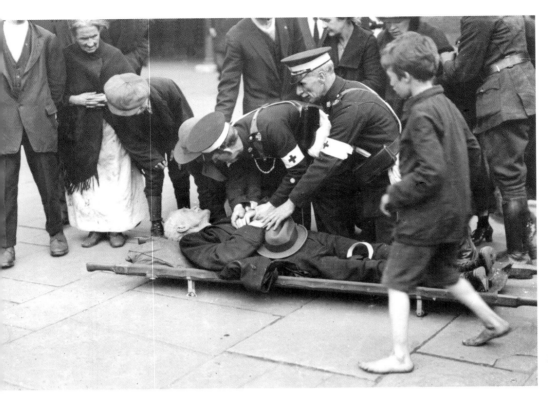

St John Ambulance men in Dublin, 1922
Members of the St John Ambulance Brigade
prepare to transport an elderly man to safety.

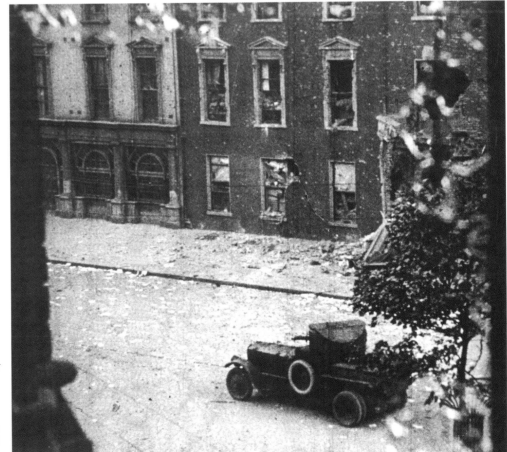

**Provisional Government armoured
car, Dublin, 1922**
The Republicans defended their
positions in the city with the utmost
tenacity, forcing the Provisional
Government to employ draconian
measures against them. The crew of
this Rolls-Royce Whippet armoured car
was given orders to advance. Equipped
with a Vickers water-cooled machine-
gun capable of giving sustained bursts,
it was used to supply covering fire to
enable a party of Government troops, in
a Lancia, to gain access to a weak point
in the Block.

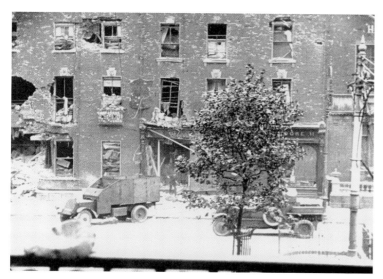

Fighting in O'Connell Street, 1922
Some of the crew of the Lancia scrambled in and set incendiary devices ablaze before regaining the protection of their vehicle. Amidst the debris of the building the fire spread rapidly.

Government soldiers prepare a petrol bomb, 1922
Provisional Government soldiers prepare an incendiary device for use against the Gresham Hotel. By the evening of Wednesday 5 July almost the whole of the Block was ablaze, from end to end. Cathal Brugha was the last defender to leave: he came out, a revolver in each hand firing, and fell mortally wounded. He was taken at once to hospital but died two days later.

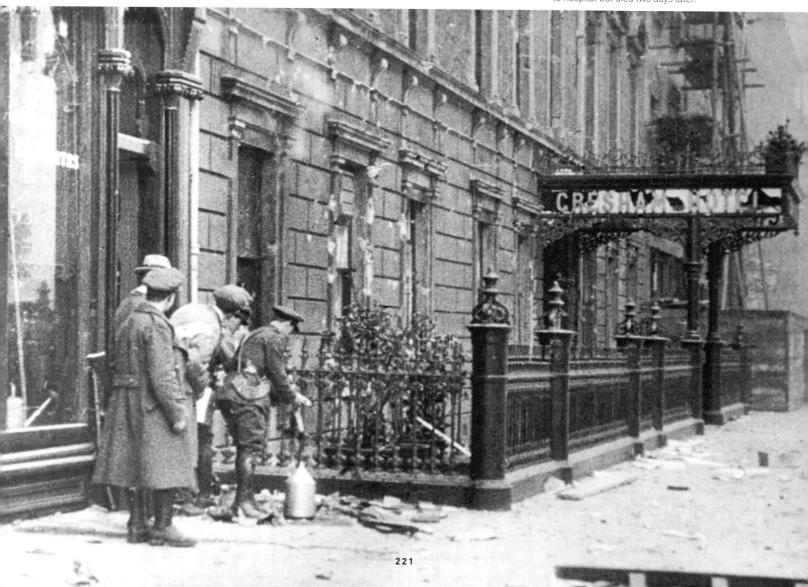

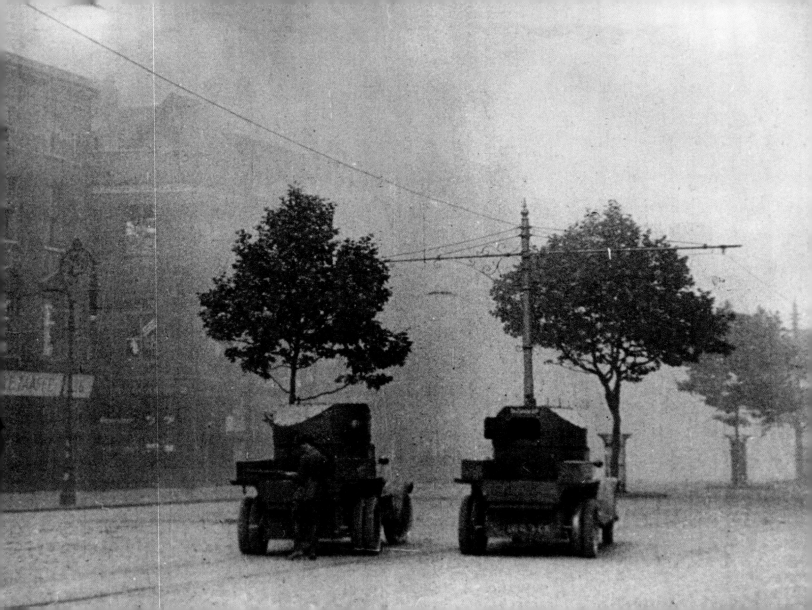

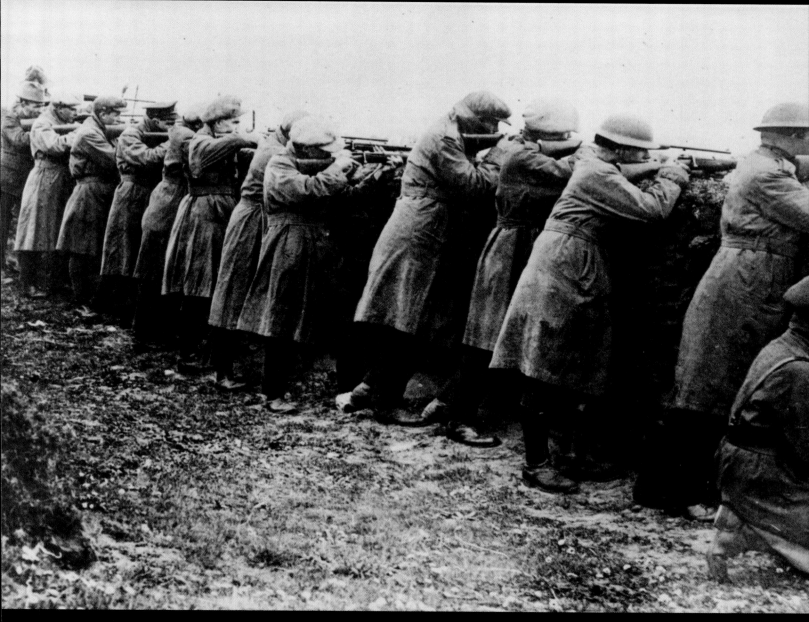

Western Division, IRA, 1922

The Western Division of the IRA had been very active. In spite of being acutely short of arms it had occupied the town of Ennis on the very day the Four Courts surrendered, and Castlebar a few days later. It had a further success to report, having captured the Rolls-Royce Whippet armoured car named *Ballinalee* after General Seán Mac Eoin. To counter this, Provisional Government troops were sent around by sea, landing at Westport and advancing on Castlebar.

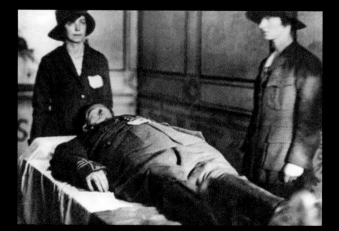

Cathal Brugha's body tended by members of Cumann na mBan
As well as Cathal Brugha about sixty men from both sides had been killed in the fighting in Dublin, which had lasted for eight days.

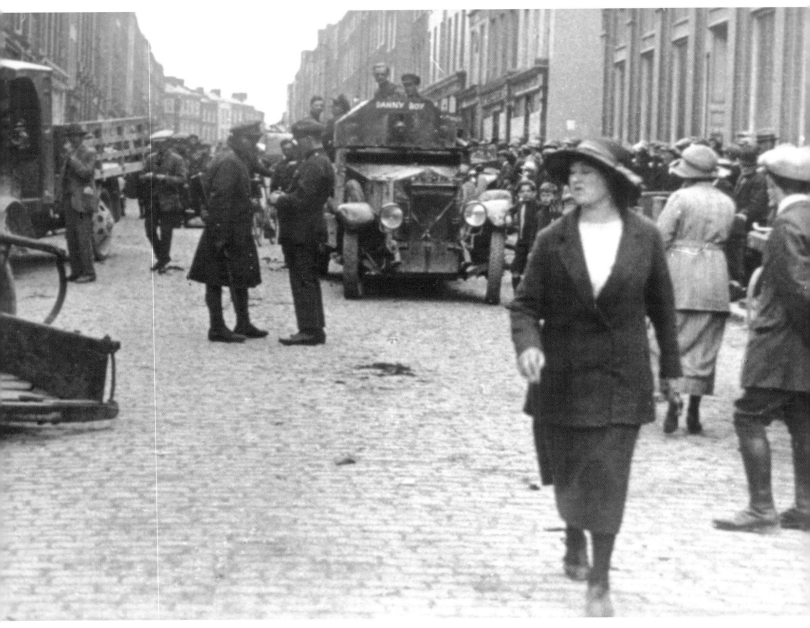

Provisional Government soldiers in Limerick

Liam Lynch, together with a group of Republicans from Co. Cork, went to
Limerick on 1 July. Lynch tried to organise a truce with the commandant of the
Provisional Government forces there, but orders from Dublin prevented this
from happening, and government forces were poured into Limerick until the
Republicans were driven completely out of the city.

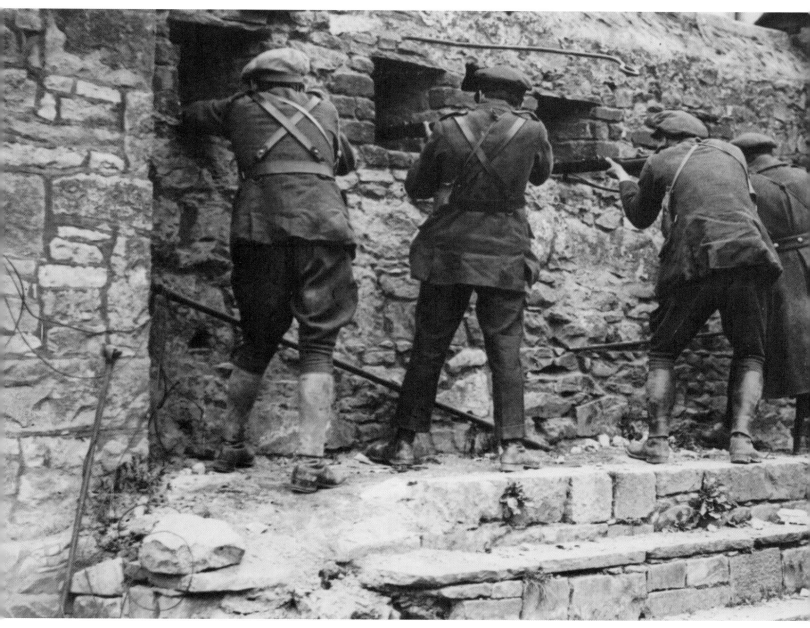

Provisional Government soldiers in King John's Castle
Limerick was to be made the strategic base for recapturing from the
Republicans the whole of the southern and western parts of Ireland.

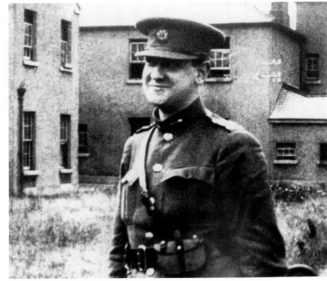

Michael Collins appointed Commander-in-Chief
Michael Collins, as well as being Chairman of the Provisional Government, was now appointed Commander-in-Chief of the Provisional Government's army, at the head of a 'war cabinet' consisting of fifteen men. This was to be the apogee of his power, virtual dictator of 'Southern Ireland' (for the Irish Free State was not yet formally in existence).

Major-General Murphy in Limerick, 1922
Major-General Humphrey Murphy had been appointed by General Mulcahy, Minister for Defence, to lead the advance of the Provisional Government forces to the south of Limerick, which took place fairly rapidly at first.

Republicans occupy Carrick-on-Suir, July 1922
In the middle of July the Republicans held most of the southern counties. Here we see them in Carrick-on-Suir, Co. Tipperary, preparing to fell a tree to block a street in the town as a defence against the armoured cars of the Provisional Government forces.

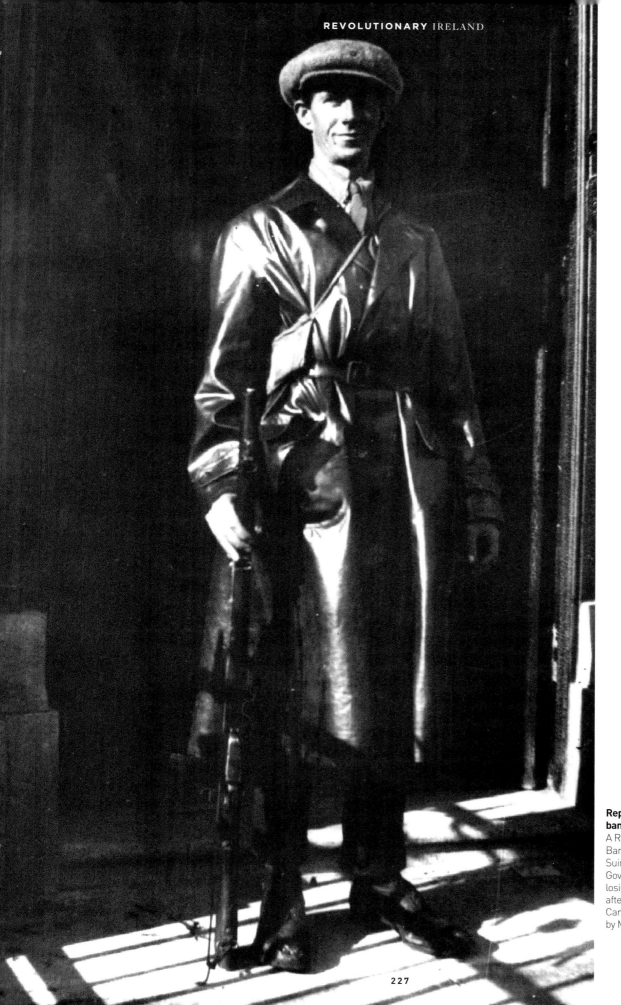

Republican sentry guarding a bank, Carrick-on-Suir
A Republican sentry guarding the Bank of Ireland in Carrick-on-Suir. Pressed by the Provisional Government's army, the IRA was losing ground steadily. Shortly after this photograph was taken, Carrick-on-Suir fell to the force led by Major-General John Prout.

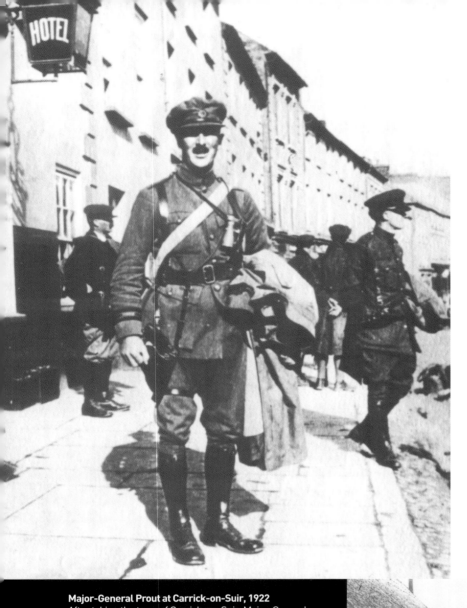

Major-General Prout at Carrick-on-Suir, 1922
After taking the town of Carrick-on-Suir, Major-General Prout continued his advance until he had gained the towns of Cahir and Clonmel. The Republicans took to the surrounding hills, from which they hoped to harry the Provisional Government's forces by means of guerrilla tactics.

Provisional Government soldiers at Claregalway
A Provisional Government force under the command of General Seán Mac Eoin occupied Claregalway on 20 July, in the push forward to Swinford and Castlebar. A typical 'chicken-coop' covered with wire netting and containing troops is partly seen at the right.

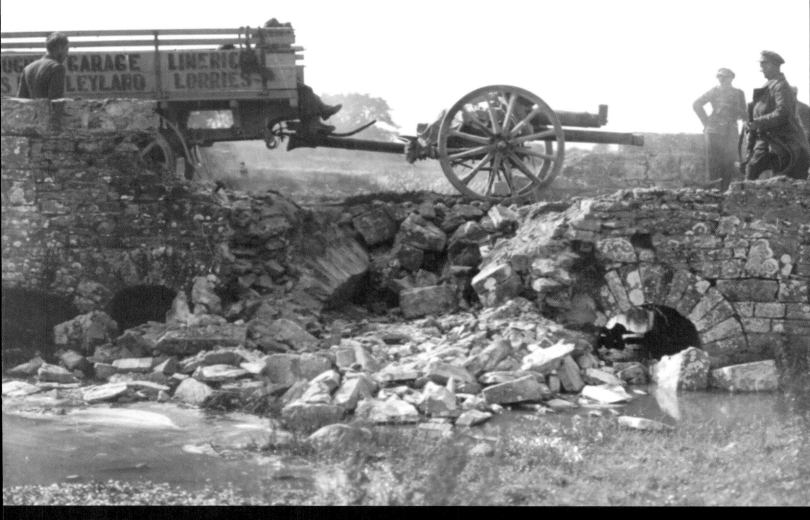

Provisional Government soldiers fill in a bridge
This small bridge across a minor tributary of the
Maigue was mined by the IRA when retreating
on Bruree, Co. Limerick. But it was to be fairly
rapidly filled in by Provisional Government troops
and sufficiently well to allow this 18-pounder gun
of Major-General Murphy's, hitched to the tail of
a lorry commandeered in Limerick, to be drawn
across on Sunday 30 July.

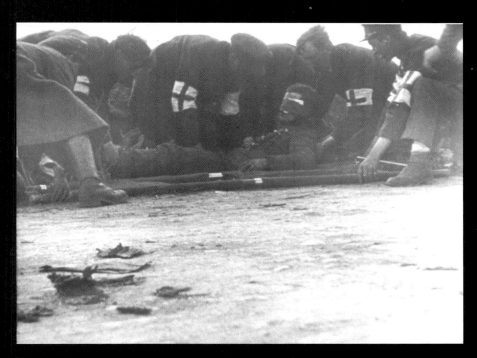

Provisional Government casualty, 1922
The Republicans elected to make a stand
around Bruree, and consequently there were
more casualties on both sides and more
Republicans captured. Here we see one, on
the pro-Treaty side, being tended by medical
orderlies.

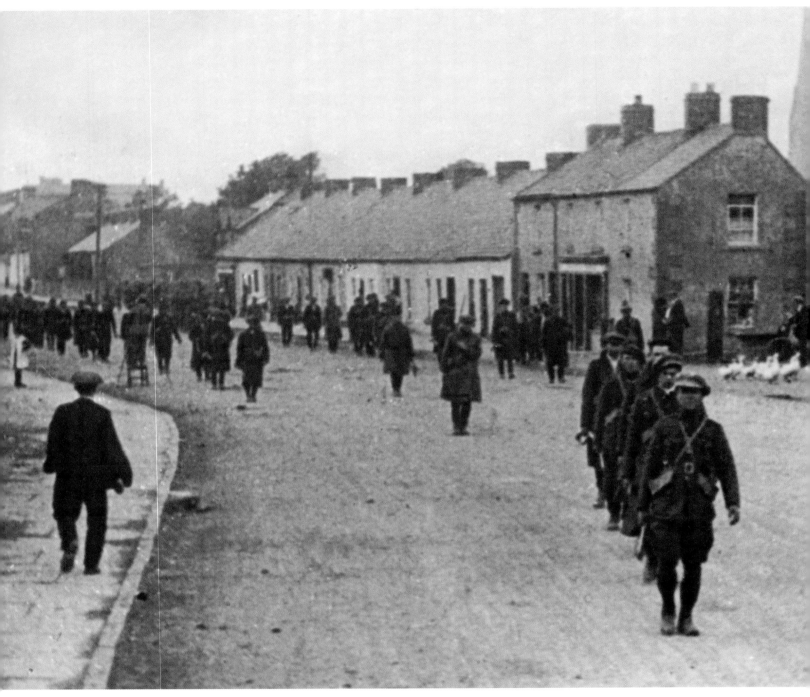

Provisional Government soldiers advance, Kilmallock
Provisional Government troops continue their advance to the south of Kilmallock, Co. Limerick.

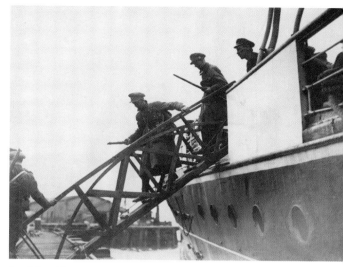

Provisional Government troops landing at Fenit
The Commander-in-Chief of the Provisional Government's
forces, Michael Collins, had formed a plan that was aimed
at crushing Republican resistance in the south-west in the
shortest possible time. Seaborne troops were to be landed at
Fenit, Co. Kerry, and Passage West, Co. Cork. He accordingly
chartered the B&I Line's *Lady Wicklow*. It was hastily made
ready as a troop-carrier and left the port of Dublin in the
early morning of 1 August. The landing at Fenit took place at
2 a.m. the following day; this photograph must therefore be
considered a 'reconstructed actuality'.

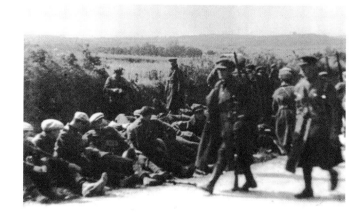

Republican prisoners of the Provisional Government
Captured republican prisoners.

Provisional Government soldiers captured by the IRA, Swinford, 2 August 1922
Here, under the watch of a couple of armed Republican guards, we see a group of
Provisional Government prisoners at Campbell's Field, Swinford, Co. Mayo, captured
in August 1922 in the recent fighting. They have just been enjoying a hurling match.

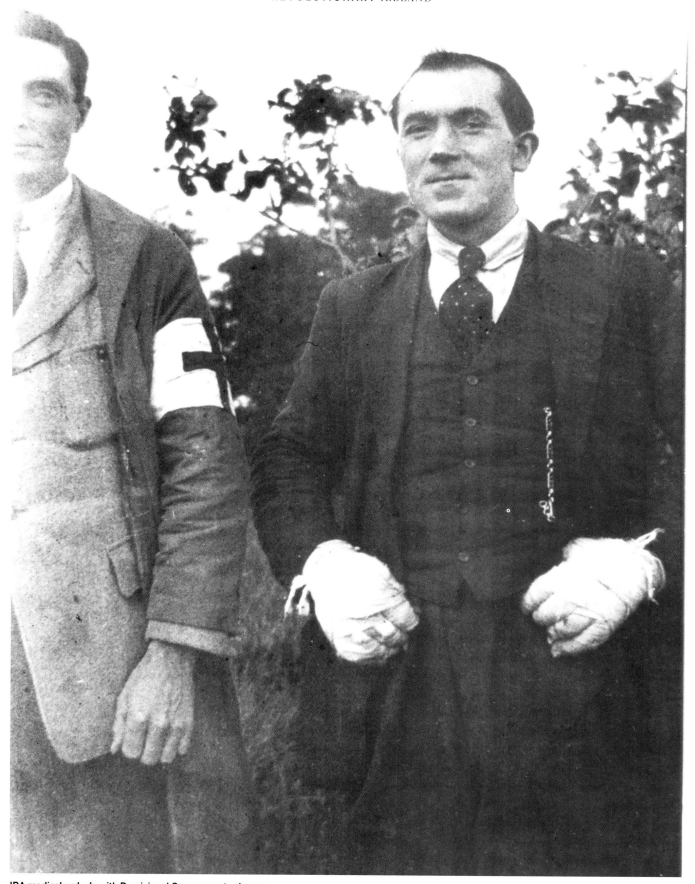

IRA medical orderly with Provisional Government prisoner
Wearing a red cross armband, a medical orderly of the IRA has just attended to the needs of his patient, a prisoner from the Provisional Government's army.

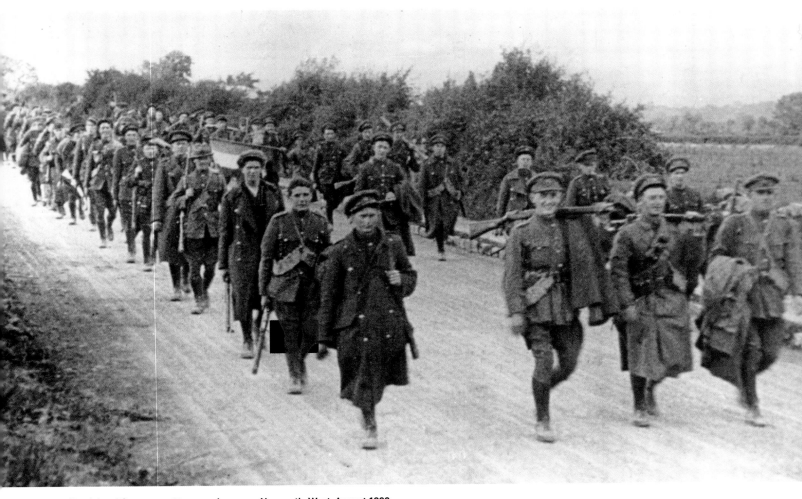

Provisional Government troops advance on Newcastle West, August 1922
Provisional Government troops advancing on Newcastle West, Co. Limerick, on
6 August 1922.

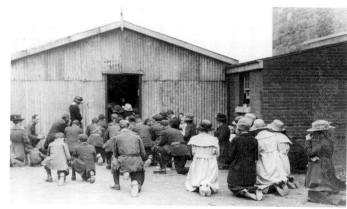

Service for the dead, Portobello Barracks, Dublin
A service for the dead taking place at the mortuary in Portobello Barracks, Dublin, 6 August 1922.

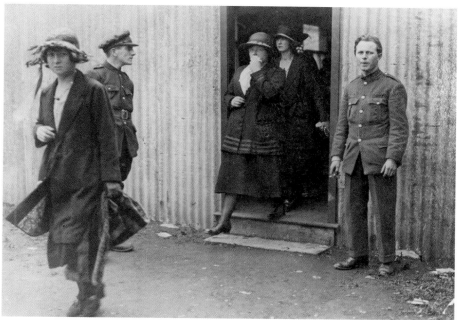

Women leaving the mortuary, Portobello Barracks
Women leaving the mortuary in Portobello Barracks, Dublin, 6 August 1922.

General Ennis and General Mulcahy at Portobello Barracks, August 1922
General Tom Ennis and General Richard Mulcahy at Portobello Barracks, Dublin, about to set out by staff car for the North Wall, 7 August 1922. General Ennis was to take command in the field. This time, in addition to the B&I Line's *Lady Wicklow*, the Provisional Government, with the compliance of the British government, had also commandeered under contract the London and North-Western Railway Company's *Arvonia* (ex-*Cambria*). Both vessels were now berthed at the end of the North Wall.

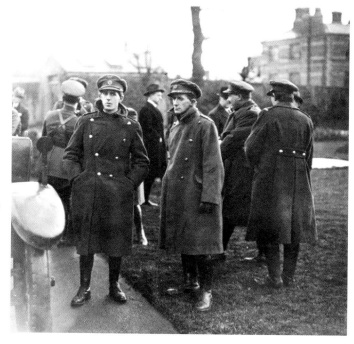

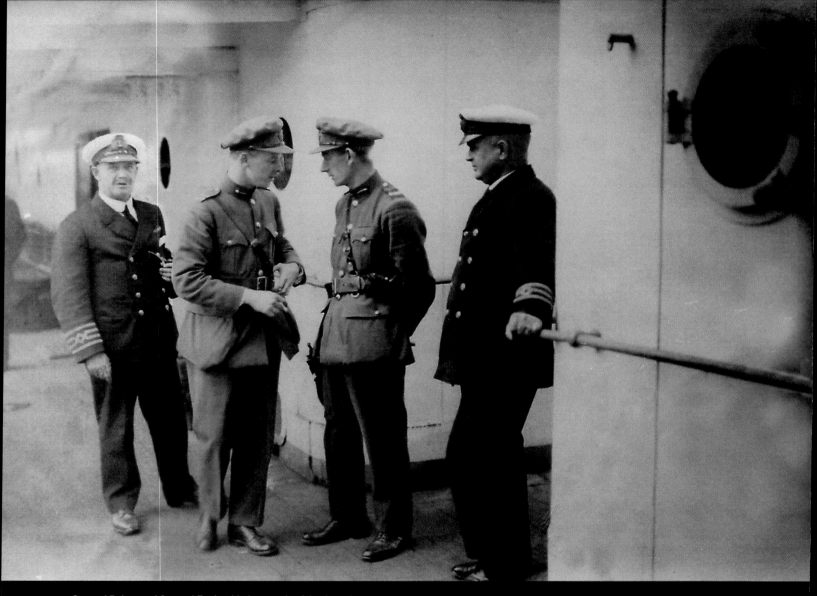

General Dalton and General Ennis with the captain of the *Arvonia*

General Richard Mulcahy had given this operation wholly to General Emmet
Dalton and placed General Tom Ennis immediately under him. Here he is
seen conferring with General Ennis, watched by the captain of the *Arvonia*
(on the left) and the first officer (on the right). The captain has a look of some
misgiving on his face, as he believed at this moment that this operation would
be the last one to be performed by his ship. On their voyage to Cork Harbour
that night the two vessels were shadowed by units of the British Navy and even
challenged by them, but Dalton sent back a request to them not to give any
information about their whereabouts or intentions, and this was seemingly
complied with.

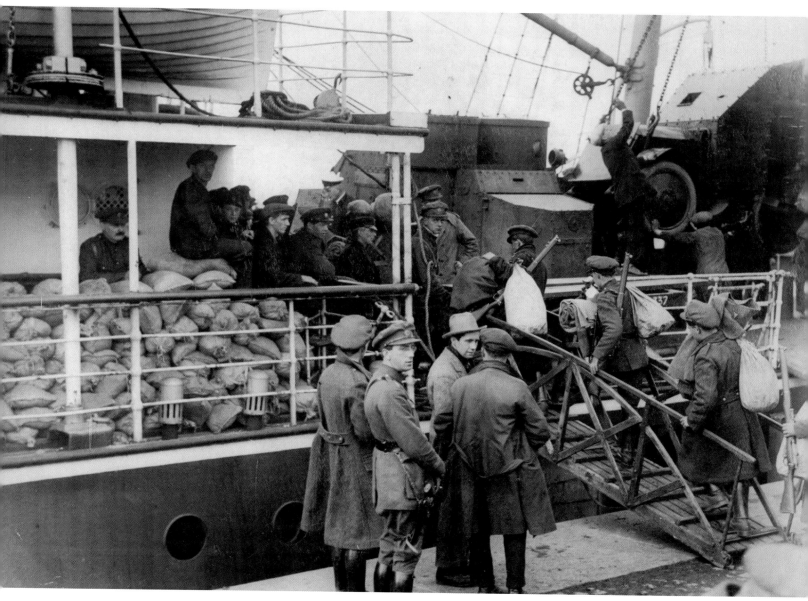

Provisional Government soldiers boarding the *Arvonia*
It will be seen that the heavy Railton Peerless armoured car has already been put on board, a comparatively easy task for the Titan crane, whose grappling-hooks and chains are seen swinging a Lancia armoured car aboard. Notice too the sandbag barrier.

The *Arvonia* and the Titan crane, North Wall, Dublin
The two ships, *Arvonia* and *Lady Wicklow*, are berthed in such a way as to give the great Titan crane, which used to be such a prominent feature at the end of the North Wall, equal access to both vessels. One leg of this giant crane is seen in the photograph. The Arvonia seems to have been used chiefly as the main troop-transport and for carrying their heavy equipment, such as armoured cars and field guns, leaving the *Lady Wicklow* to take the overflow of troops. As is the case with many troop-transports, many men and women have come to witness the departure of their loved ones.

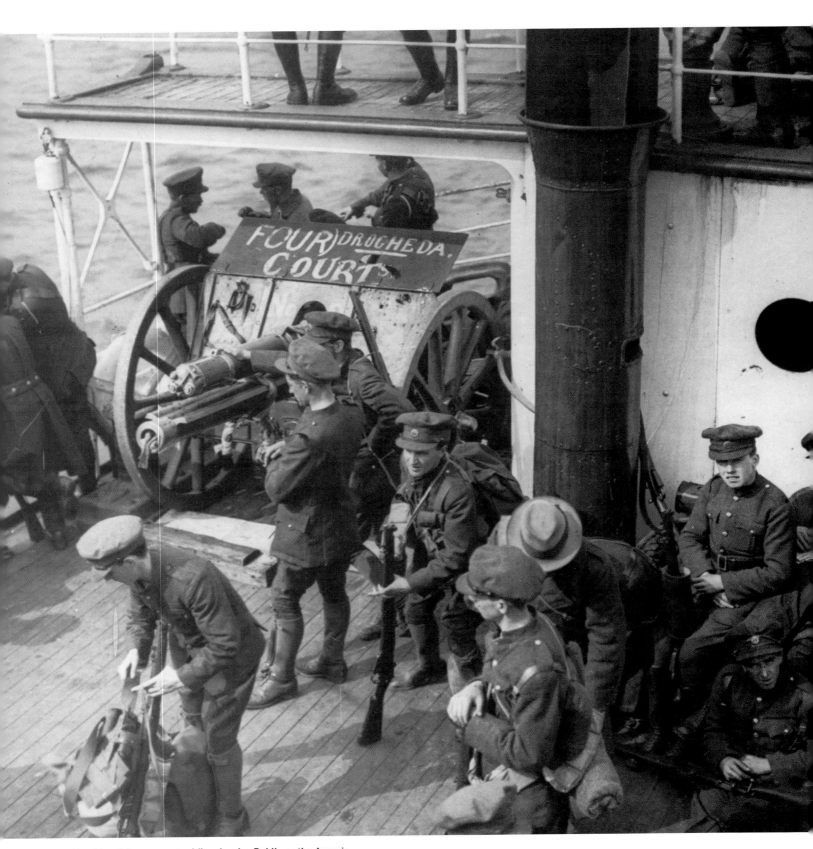

Provisional Government soldiers leaving Dublin on the *Arvonia*
Government troops sailed from Dublin on the *Arvonia* on 7 August 1922, accompanied by an 18-pounder field gun. When the ship came under new owners it was renamed, but the ship's bell is still marked with its former name, *Cambria*, because of a nautical superstition that prevailed at the time that it would have brought bad luck to change the name on ships' bells.

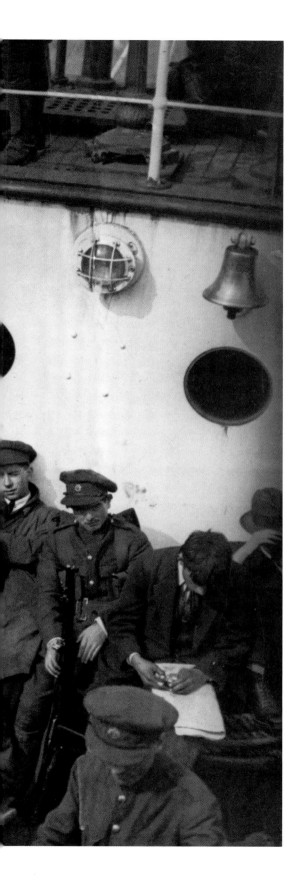

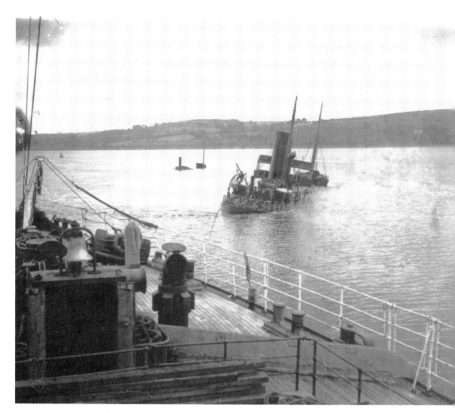

Republican block-ships sunk in the buoyed channel
When the *Arvonia* and *Lady Wicklow* got inside Cork Harbour they found that the Republicans had sunk block-ships, not in the dredged waters of the navigable channel but at its edge. This unaccountable fact, and the total absence of mine defences, would suggest that Michael Collins expected that his maritime expedition would meet with little resistance, as in fact proved to be the case.

A letter home
One cannot but observe how young the recruits to the Provisional Government's army are, one of whom is writing a letter aboard the *Arvonia*.

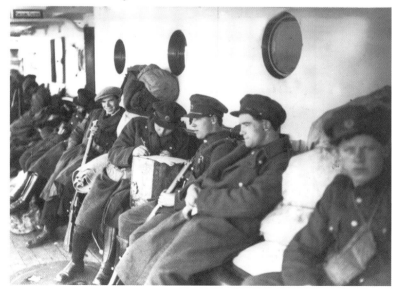

Landing a Railton armoured car at Passage West

The absence of the Titan crane was acutely felt at Passage West, particularly when it came to landing the very heavy Railton Peerless armoured car. The strategy employed was to wait until the tide brought the *Arvonia's* main deck level with the quay wall. Then heavy baulks of timber were laid over the gap and, with the local crane taking as much weight as it was able to support, the twin-turreted Peerless was driven ashore. The insignia painted on the turret of the Peerless, clearly seen in this photograph, is not without interest.

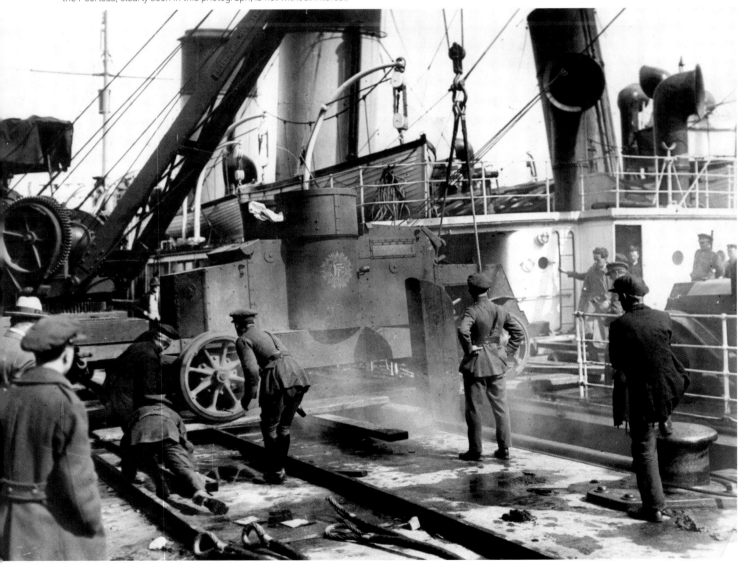

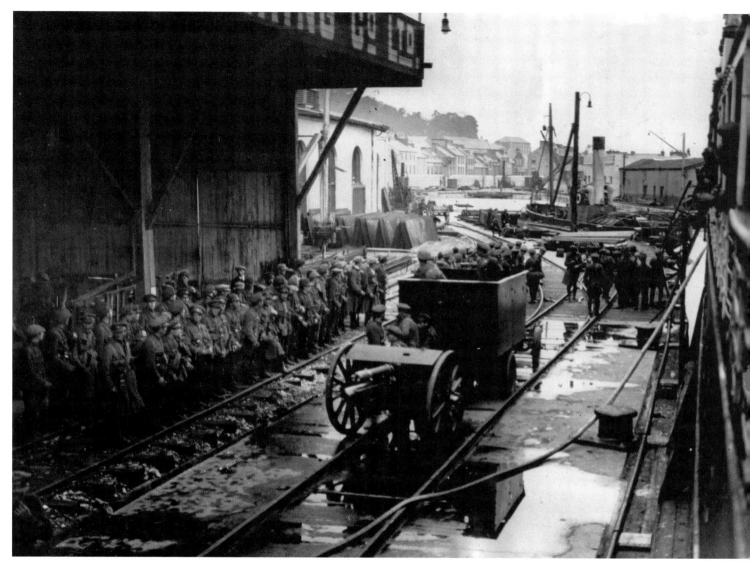

The operation is completed
The operation was successfully completed, with strikingly little resistance from Republican forces.

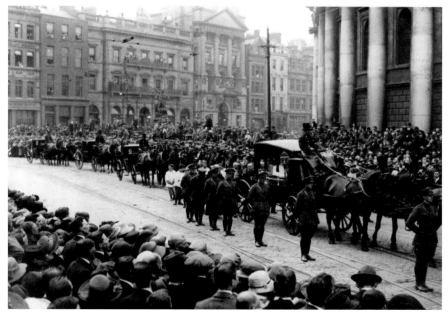

The funeral of Arthur Griffith at College Green, Dublin, August 1922
On 12 August 1922, completely unexpectedly, came the death of the leader of the Sinn Féin movement, Arthur Griffith. Huge crowds attended his funeral, seen here passing through College Green. He had been a much-loved public figure in his time, until he became enmeshed in the Treaty negotiations, and even here much understanding and forgiveness for his position was shown by the general public.

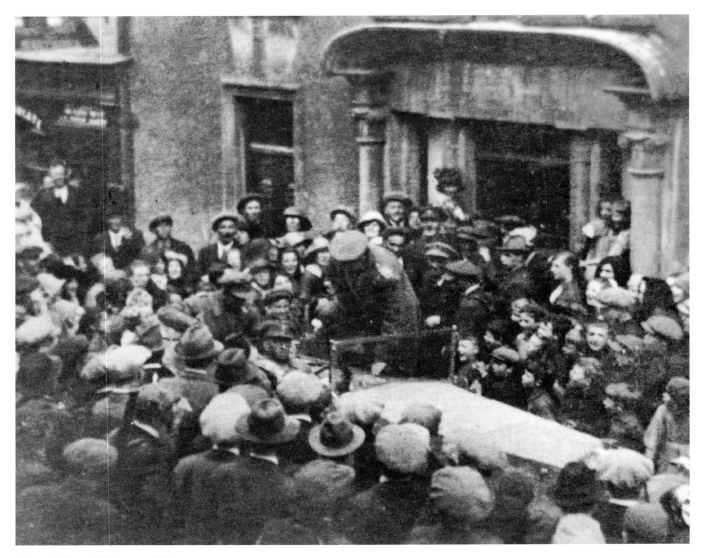

Michael Collins at Skibbereen, 1922
In the vicinity of the little town of Skibbereen, Co. Cork, strange events were
taking place. It was rumoured that Éamon de Valera was in the neighbourhood,
seeking a meeting with Michael Collins so that between them they could
bring the Civil War to an end. Collins went there on 22 August, but the meeting
never took place, and he left again to get back to Cork that night. Here we see
him getting into his Leyland staff car at Skibbereen. This was to be the last
photograph taken of Michael Collins alive.

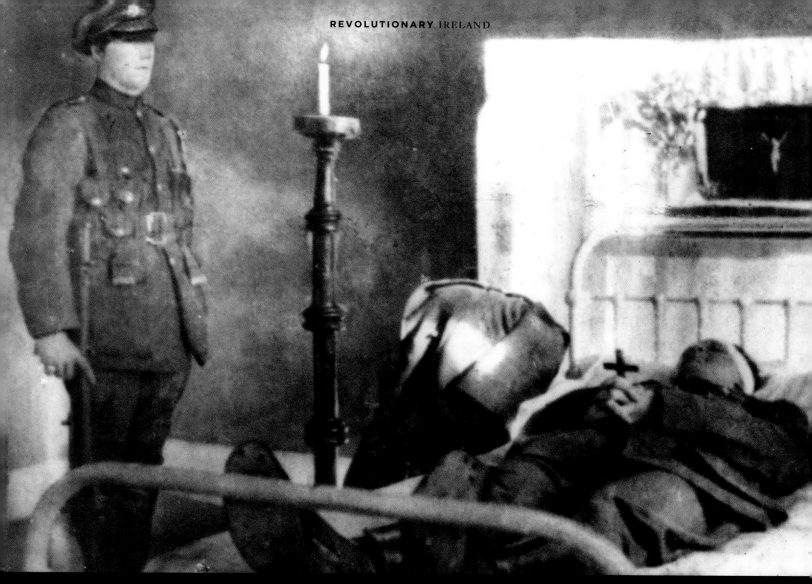

Collins's body at Shanakiel Hospital, Cork

Michael Collins's body lying in a hastily prepared room at Shanakiel Hospital, Cork, on 23 August 1922. According to the official announcement,
> General Michael Collins, Commander-in-Chief of the Army, was killed in an ambush by irregulars at Beal-na-Blath, between Macroom and Bandon, on last night (Tuesday). Towards the close of the engagement, which lasted close upon an hour, the Commander-in-Chief was wounded in the head.

But, in spite of the apparent clarity of this statement, speculation has persisted to this day about what really took place at Bealnablagh. Dorothy Macardle, in *The Irish Republic*, gives the following account of events:

> It transpired that the Republican attackers had numbered not more than six.
>
> The I.R.A. post had learned that a very large enemy convoy had passed over the road. Orders were issued for it to be ambushed when returning. The convoy delayed and the order was countermanded, but the countermand did not reach the last section and five or six men remained on duty, waiting behind a small fence where the road had been blocked. The convoy came along the road. It consisted of a scout on a motor-cycle, a Leyland car in which were five staff officers, all armed, a touring car, a Crossley tender with a Lewis gun, and an armoured car. The Republicans opened fire; the officers, throwing themselves out of the car, replied from the road.
>
> For over half an hour the Volunteers lay firing, under fire themselves from the armoured car. They saw an officer fall, shot through the head. The men with him carried him to a car and the convoy drove off.
>
> The armoured car was a Rolls-Royce Whippet with a Vickers machine-gun mounted in a turret, but the gunner claimed that, after firing one round, the Vickers gun jammed and was unable to play any further part in the action. There is a conflict of evidence with Dorothy Macardle's account here. In passing, one must note that the Vickers machine-gun had a facility for firing single shots. But the gunner of the Whippet may not have been a reliable witness. He

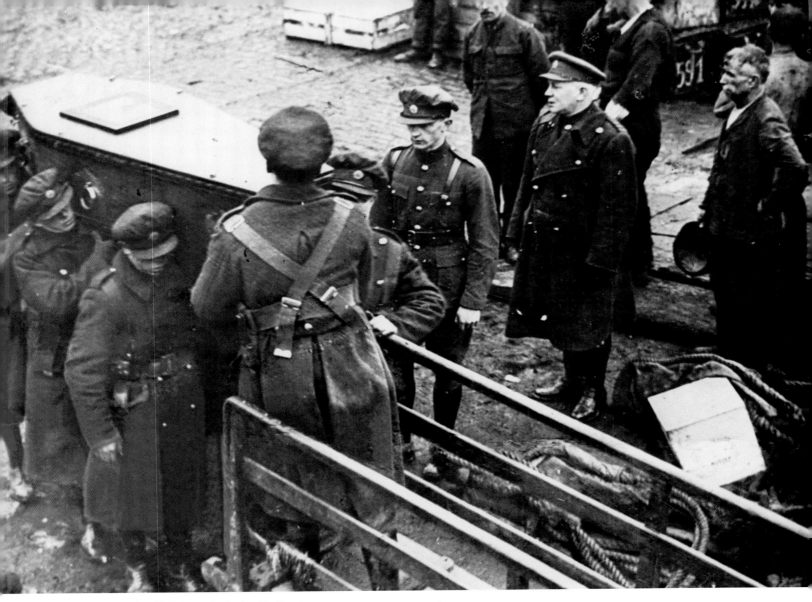

Michael Collins's coffin being embarked on the *Classic*
In greatcoat and cap on the right is Commandant Frank O'Friel, just after his promotion in the field to that rank by General Emmet Dalton. Standing in front of him is General Tom Ennis. Michael Collins's body, in a temporary coffin, is just being brought aboard the specially commandeered troopship *Classic* at Penrose Quay, Cork, with a view to bringing it securely to Dublin.

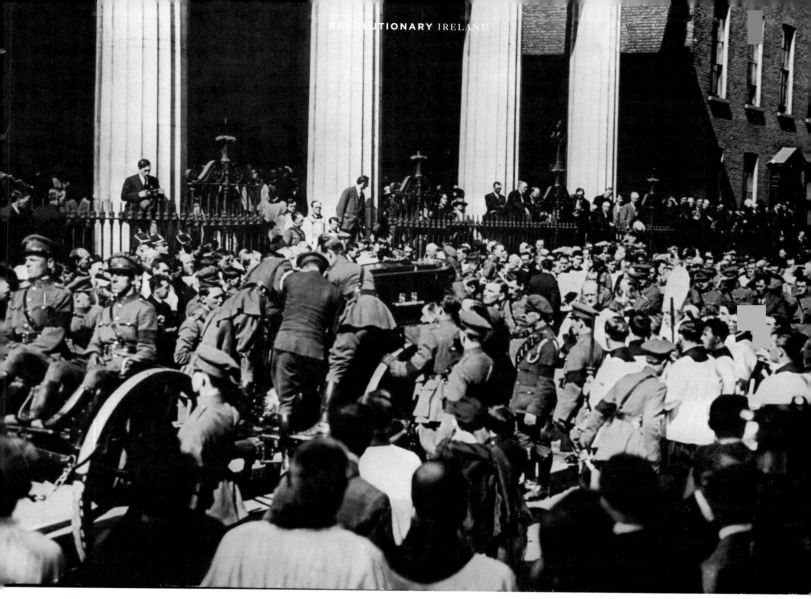

Funeral of Michael Collins, Dublin, August 1922
The body of Michael Collins being placed on a gun carriage after
a Requiem Mass at the Pro-Cathedral, Marlborough Street,
Dublin, on 28 August 1922. Earlier that week an autopsy had
been performed by his friend, the surgeon and poet Oliver St
John Gogarty.

Erskine Childers's cottage, Ballyvourney, Co. Cork
Meanwhile, from a tiny two-room cottage near Ballyvourney, Co.
Cork, Erskine Childers was continuing to bring out his news-sheet
An Phoblacht. But in spite of the most stubborn resistance, the
Republican cause was lost. It is so much easier to start wars than
to stop them! The Civil War had almost nine months more to run,
and the bitterest experiences were yet to come.

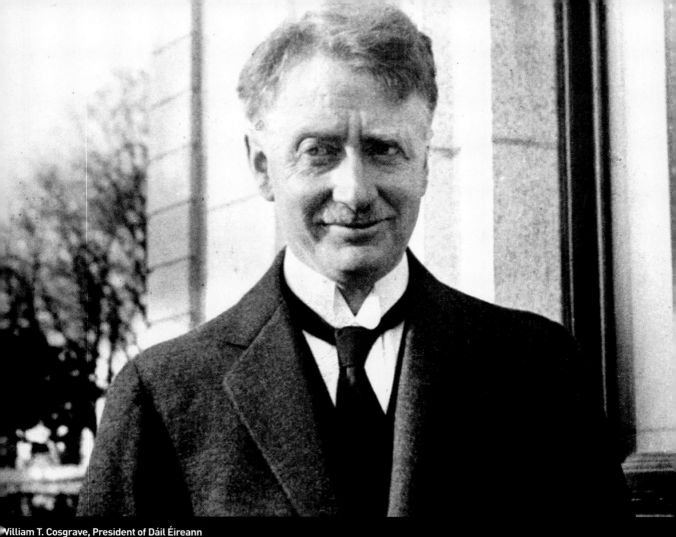

William T. Cosgrave, President of Dáil Éireann
On 9 September 1922, when the Provisional Parliament reassembled, William T. Cosgrave was elected President. He appointed himself also Minister for Finance and appointed Desmond Fitzgerald Minister for External Affairs, Ernest Blythe Minister for Local Government, and Kevin O'Higgins Minister for Home Affairs. Richard Mulcahy was reappointed Minister for Defence and in addition was made Commander-in-Chief of the Army.

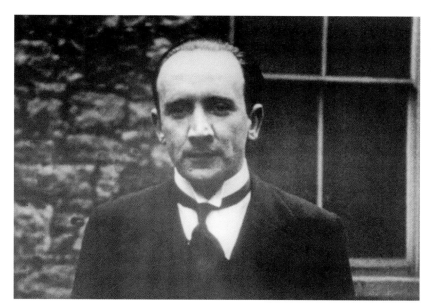

Kevin O'Higgins, Minister for Home Affairs (1)
Kevin O'Higgins was only thirty at the time of his appointment to the Ministry of Home Affairs. He and Richard Mulcahy were to pursue an increasingly severe attitude towards the IRA as time went on.

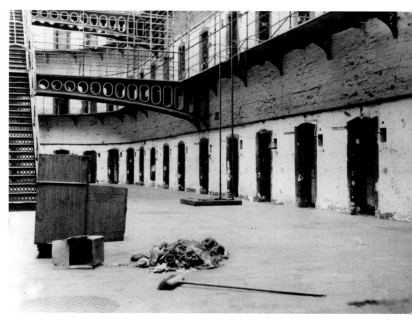

Kilmainham Jail renovated, 1922
As the civil war wore on, Kilmainham Jail in Dublin, as well as Mountjoy Jail, were quickly renovated in order to take new batches of prisoners, and the prisons of Ireland were again to see inmates demanding to be granted political status. In addition to the prisons, internment camps were to be opened at the Curragh Camp and elsewhere.

'Tintown', Curragh Camp, Co. Kildare, 1922
The internment camps, including the one at the Curragh Camp, Co. Kildare, were quickly filled with IRA internees.

A Republican funeral, 1922
Rarely could an assembly such as this take place at the graveside of a
Republican to enable the last military honours to be given to the dead.

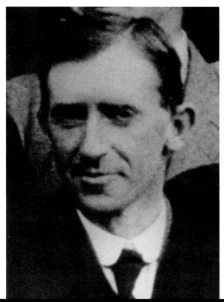

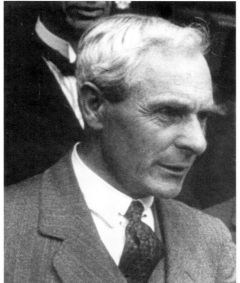

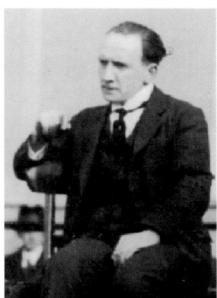

General Mulcahy, 1922
On 27 September, General Richard Mulcahy asked for emergency powers to be granted to the Provisional Government's army to enable the setting up of military courts. These special courts would be empowered to order death sentences to be carried out by the military.

Thomas Johnson, 1922
The leader of the Irish Labour Party, Thomas Johnson, opposed the setting up of military tribunals, saying:
> I predict, with very great sorrow, that if this Order is passed, we will learn of many more cases of Colleys and Nevilles, and other men who have lost their lives, for which no explanation has been given to the courts or to the public.

But the Labour Party had only thirteen seats, and the motion was carried.

Kevin O'Higgins, Minister for Home Affairs (2)
During this debate Kevin O'Higgins gave expression to an altogether exceptional piece of innuendo.
> I do know that the able Englishman who is leading those who are opposed to this Government has his eye quite definitely on one objective, and that is the complete breakdown of the economic and social fabric . . .
> He has no constructive programme, and so keeps steadily, callously and ghoulishly on, striking at the heart of this Nation.

This motivated William Davin to enquire, 'On a point of information, may I ask to whom you are referring?' O'Higgins answered: 'I am now

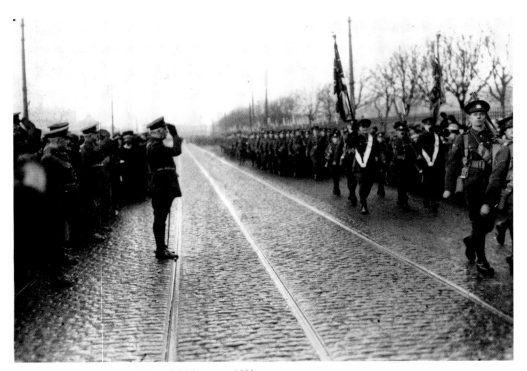

General Macready reviews the last British troops, 1922
The last British troops, except for small garrisons still occupying Bere Island and Spike Island, Co. Cork, were leaving Southern Ireland. General Sir Nevil Macready took the salute.

Erskine Childers

As the IRA was forced to retreat further and further into the hills, Erskine Childers had to move the tiny printing press with which he continued to bring out *An Phoblacht*. Being summoned in early November to a meeting in Dublin of the republican Council of State, of which he was about to be appointed secretary, he endeavoured to make his way via Co. Waterford and Co. Wexford to Annamoe, Co. Wicklow, where he proposed spending the night of 10 November at the home of his cousin Robert Barton. At about 2 a.m. the house was surrounded by Provisional Government soldiers, and Childers was arrested. In his possession was found a small Colt automatic pistol, which had been presented to him by Michael Collins and which the presence of women had prevented him from using.

On 17 November the trial of Erskine Childers before the newly established military tribunal was held, in camera, and he was condemned to death. The same morning was to see the commencement of executions. Four ordinary members of the IRA were to be the first, executed on a similar charge.

When, later that day, in the Provisional Parliament members of the Labour Party sought an explanation, Kevin O'Higgins answered them as follows:

> . . . It was better at first to take the average case, to take the cases which had nothing particular, no particular facts about them to distinguish them from the cases of thousands all over the country who are leading the Nation to death. If you took as your first case some man who was outstandingly active or outstandingly wicked in his activities the unfortunate dupes through the country might say, 'Oh, he was killed because he was a leader,' or 'He was killed because he was an Englishman,' or 'He was killed because he combined with others to commit rape.'

These men were the first of seventy-seven to be executed under the military courts called for by General Mulcahy. Their names deserve to be remembered: Patrick Cassidy, John Gaffney, James Fisher, Robert Twohig.

Erskine Childers was executed just after dawn (at his request) by firing squad at Beggarsbush Barracks on Friday 24 November.

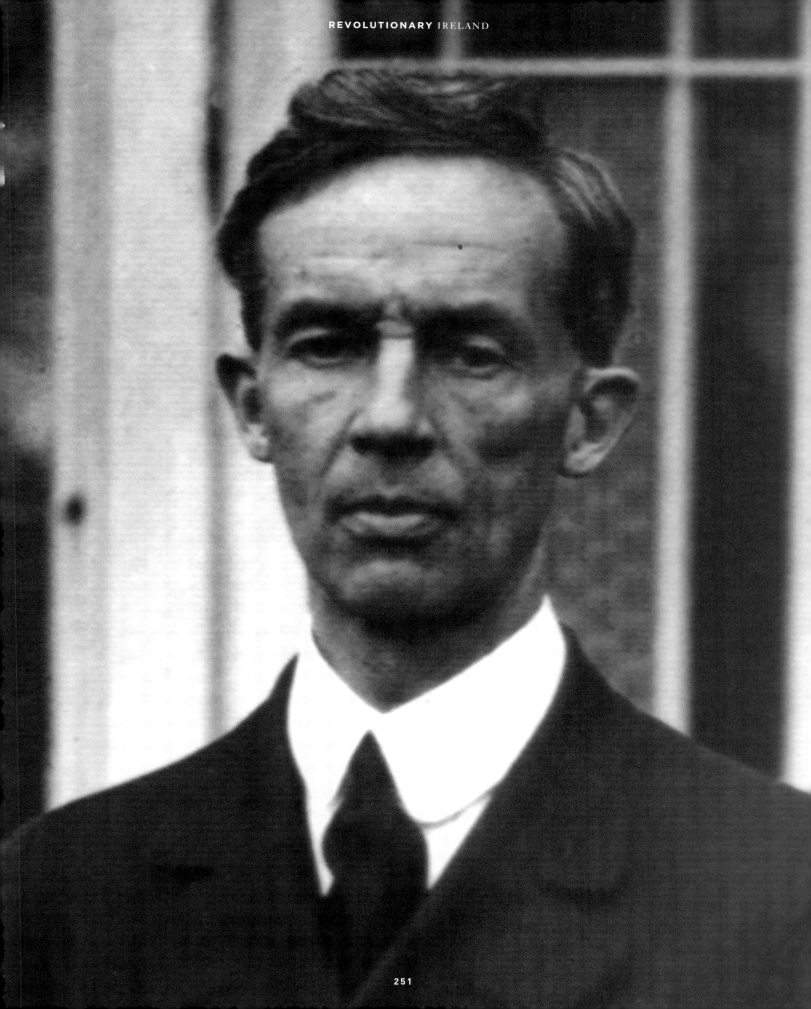

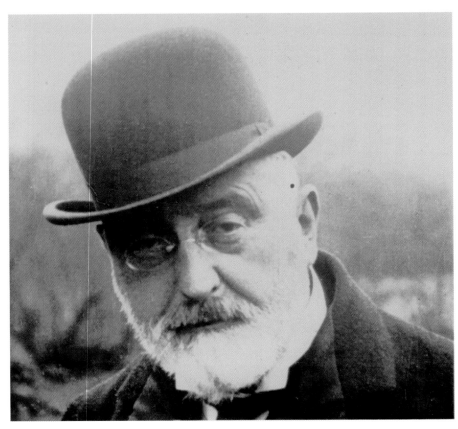

Timothy Healy, Governor-General of the Irish Free State
On 6 December, a year after the Articles of Agreement had been signed in London, the Irish Free State came into being. Timothy Healy KC was appointed Governor-General and took up residence, as the representative of King George V, in the Viceregal Lodge in the Phoenix Park. On 7 December the Government of Northern Ireland exercised its right of secession.

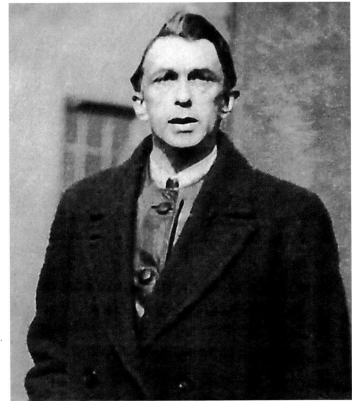

Rory O'Connor
Rory O'Connor (1883–1922). The reaction by the Government of the Irish Free State (as Southern Ireland was officially called from 6 December) was as unequivocal as it was illegal. Aroused during the night, four leading members of the IRA were informed that they were to be shot the following morning, 8 December: Rory O'Connor, Liam Mellows, Richard Barrett and Joseph McKelvey. They were shot at dawn in the prison yard of Mountjoy.

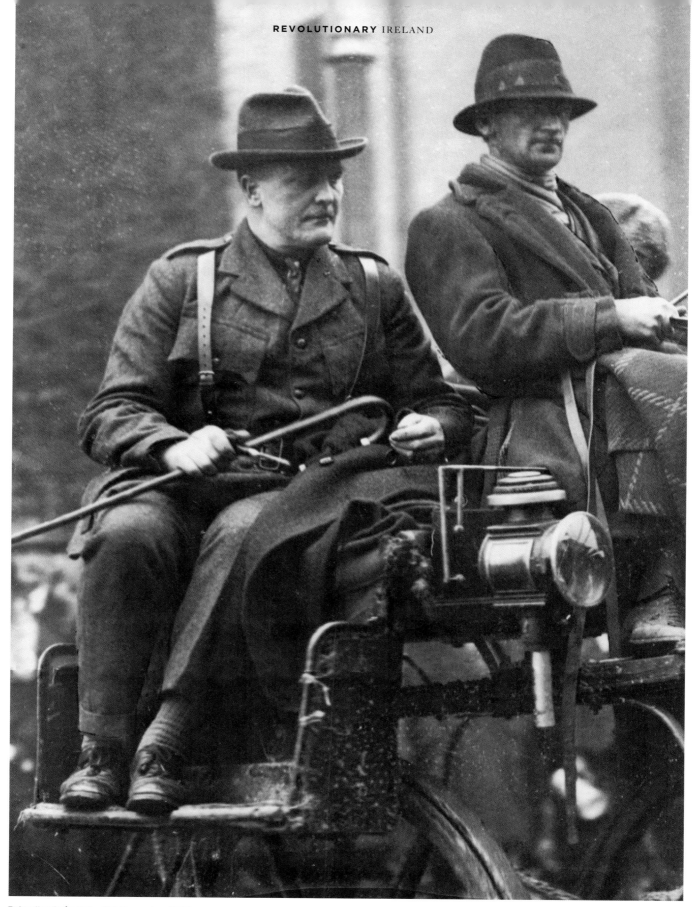

Brigadier Seán Hales TD, December 1922
Also on 7 December there occurred in Dublin one of those pivotal events that bring about the escalation of violence to new levels. In an attempt to halt the Provisional Government's campaign of executions, on 27 November the IRA had sent a letter to the Speaker of the Provisional Parliament warning him that drastic measures would be taken against all deputies who had voted for the resolution authorising executions. On 7 December, Brigadier Seán Hales TD was shot.

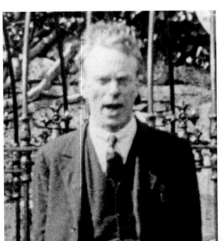

Liam Mellows
Liam Mellows (1895–1922).

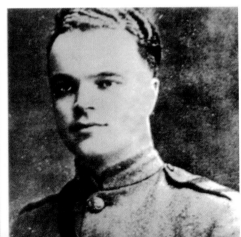

Richard Barrett
Richard Barrett (1889–1922).

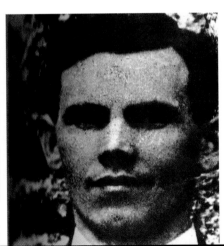

Joseph McKelvey
With the death of these men there was introduced a regime of frightfulness that deepened the bitterness on both sides of the divide. The official account given by the Free State government for this action was that it was done 'as a reprisal for the assassination of Brig. Hales TD.' An exceedingly dangerous precedent had been established, one that only had the effect of hardening attitudes in the IRA.

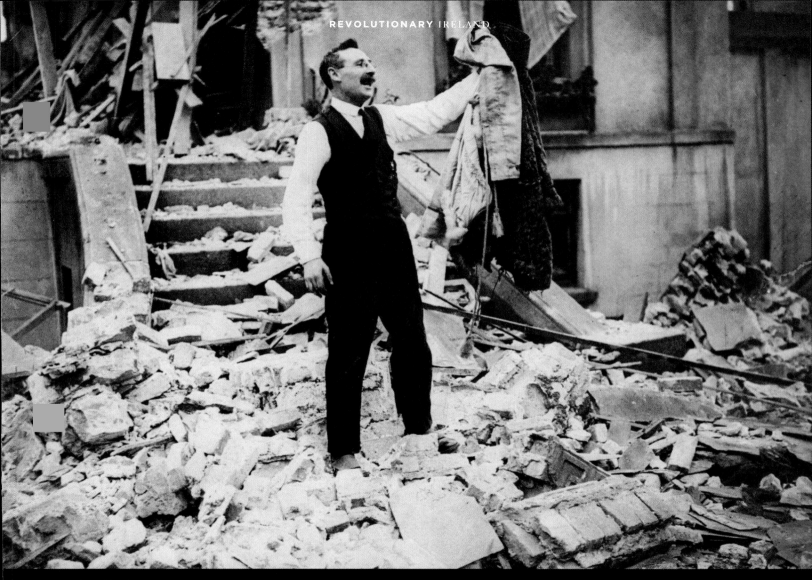

Michael Corrigan

In 1923 our unhappy country entered an era of reprisal and counter-reprisal. This is the home of the Chief State Solicitor, Michael Corrigan, mined by Republicans. But it must be realised that many much finer houses than this were also destroyed, notably that owned by the Earl of Meath, where in the eighteenth century the blind Carolan had first performed his exquisite composition 'Lord Mayo'.

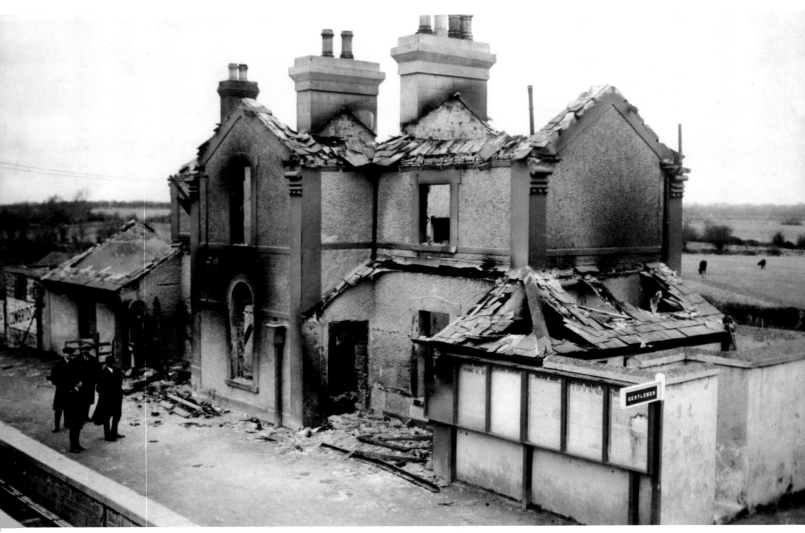

Kilmessan railway station, 1923
The reprisal executions were far from having the effect expected of them by the Free State. The IRA under Tom Barry reoccupied Carrick-on-Suir on 9 December and extended its gains further a few days later by capturing the towns of Callan, Mullinavat and Thomastown. In all these places it succeeded also in capturing much-needed supplies of rifles and ammunition.

But this was to be its last widespread success. From January 1923 on it was to be confined more and more to 'hit-and-run' techniques: attacks on communications, railways and the like. Shown here is Kilmessan, Co. Meath, after a visit from a flying column in January 1923.

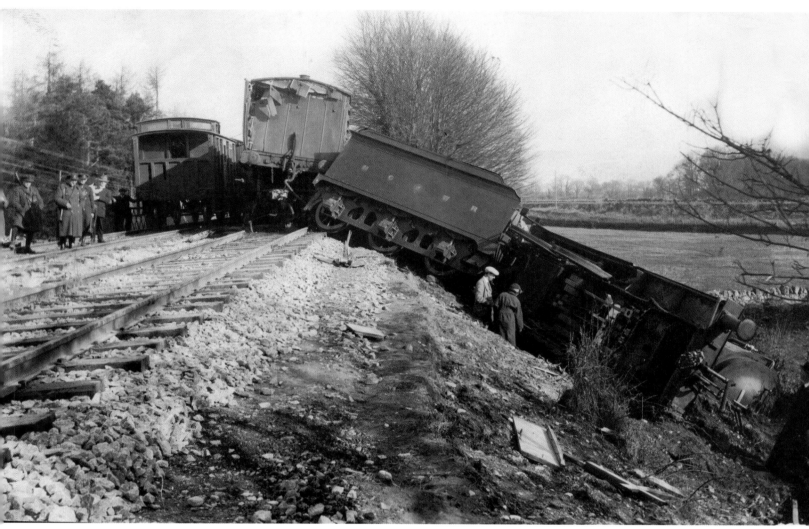

Train derailed, Co. Meath, 1923
The derailment of the Midland Great Western Railway's Galway express is
a typical example of this kind of attack. It took place just beyond Edenderry
Junction in Co. Meath. At the extreme left are a few of the Free State soldiers
brought by a special train from Athlone, the brake-van of which can also be
seen.

As February and March wore on, many thoughtful people came to realise
that this kind of futile activity was ineffective and that sooner or later the IRA
would have to cease resistance. De Valera had been convinced of this from as
early as the previous autumn and had been seeking to persuade the leaders of
the IRA still in the field of this but found them unresponsive.

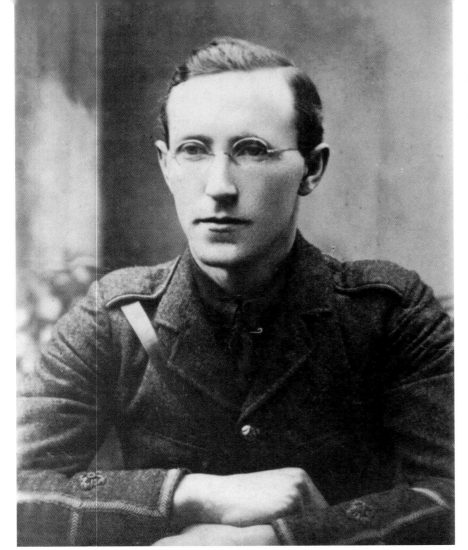

Commandant Liam Lynch, chief of staff of the IRA

On 10 April 1923 Commandant-General Liam Lynch, Chief of Staff of the Irish Republican Army, was fatally wounded while, with other important members of the Army Executive, he was trying to evade a massive encircling movement mounted by General Prout in the Goatenbridge area of Co. Tipperary. General Prout's plan miscarried and most of the Army Executive escaped across the mountains, leaving Lynch behind, at his own request, with a mortal wound from a rifle-shot at long range. In great pain, he was brought down the mountainside on an improvised stretcher of jackets and rifles.

General Prout came, accompanied by a doctor and an ambulance, to meet his gallant enemy at Newcastle and take him to Clonmel, where he died that night.

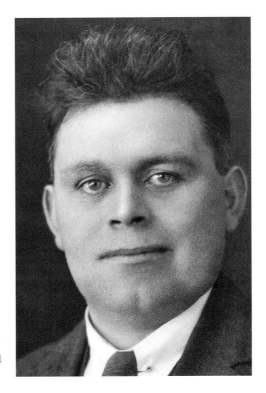

Dan Breen

Dan Breen was one of those members of the Army Executive who had assembled at Goatenbridge to meet Liam Lynch and hold what was to have been a meeting of the utmost importance. Had it been allowed to take place it might have heralded the end of the Civil War. Breen escaped across the mountains, going to ground in a dug-out in the Glen of Aherlow, where he was arrested three days later. His sympathies had always been with the political left, and he tended to reject impractical idealism. He was an outspoken man who said to Liam Lynch: 'In order to win this war you'll need to kill three out of every five people in the country—and it isn't worth it.' In later years he said of the Civil War: 'It was bad but it saved us this much: it saved us from the government of Maynooth.'

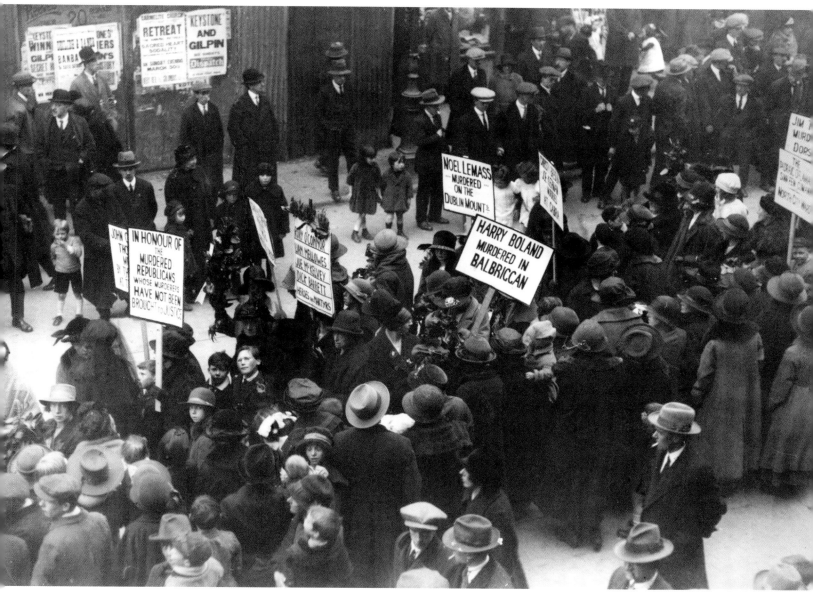

Sinn Féin women demonstrate in Dublin, 1923
Many were the demonstrations, composed mainly of women, that were held in
the streets of cities and towns protesting at the arbitrary shootings, executions,
imprisonments and internments inflicted by the Free State authorities during
the months of February, March and April. This is one taking place in Dublin.

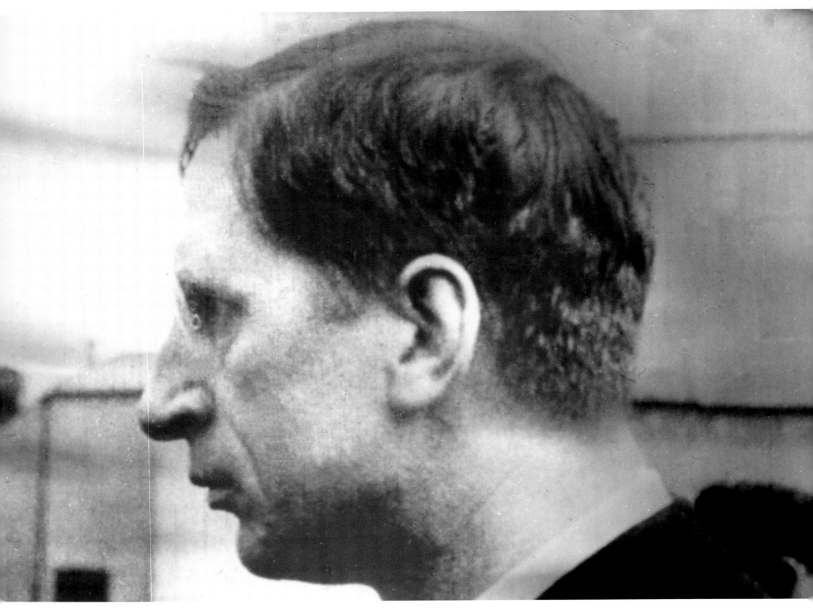

De Valera at Ennis, 1923
On 27 April 1923 de Valera, on behalf of the republican Government, issued a proclamation suspending all aggressive action by the IRA from noon on 30 April. Frank Aiken, Chief of Staff of the IRA, signed a similar one on behalf of the Republican Army. This was followed by an order to 'dump arms' on 24 May. Thus the Civil War came to an end, and all attention was concentrated upon the forthcoming general election.

President Cosgrave toured the country widely, making use of the Bristol two-seater fighter purchased by Michael Collins. De Valera went openly to Ennis, Co. Clare, where we see him here. He began to speak, but before he had time to complete a sentence shots were fired by Free State soldiers among the crowd, and he was immediately arrested, slightly wounded. After being brought to Dublin in custody he was imprisoned, first at Arbour Hill, later at Kilmainham Jail, without any charge being brought against him.

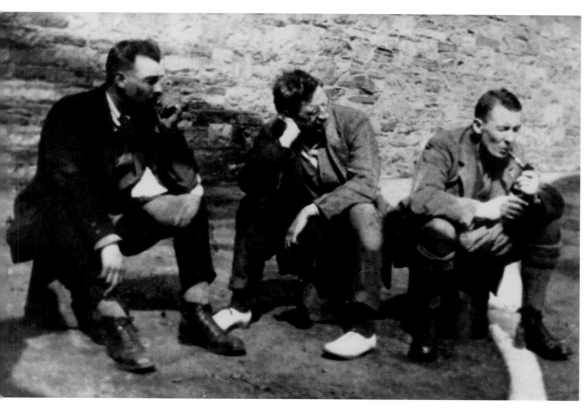

De Valera and Austin Stack in Kilmainham Jail
De Valera and the redoubtable fighter Austin Stack in an exercise yard at Kilmainham Jail, Dublin. The figure on the right is thought to be a 'stool-pigeon' imprisoned with them to gain their confidence. Stack and de Valera suffered imprisonment for more than a year without any charges being brought against them before being released.

Mountjoy hunger strike, Dublin, 1923
Throughout the jails of Ireland many untried republican prisoners remained, and it was not long before the old question that had caused so much trouble under the British administration was again raised, this time against the Free State: that of their right to be treated as political prisoners. The government began a campaign of denying the republican prisoners their rights in this respect, and in October this resulted in the calling of a hunger strike in Mountjoy, which rapidly spread to Kilmainham and other prisons and even to the internment camps. Miss Mary MacSwiney, in sympathy with the hunger-striking prisoners, went on hunger strike herself outside Mountjoy. Here we see her, a blanket over her knees, supported by Maud Gonne MacBride on her right hand and Charlotte Despard on her left. Like most hunger strikes, this one too left a legacy of fatalities and permanently damaged health.

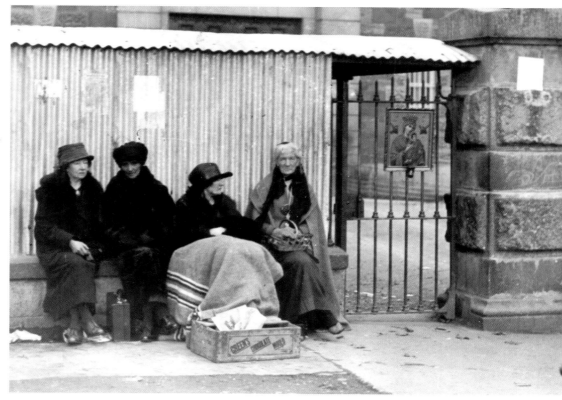

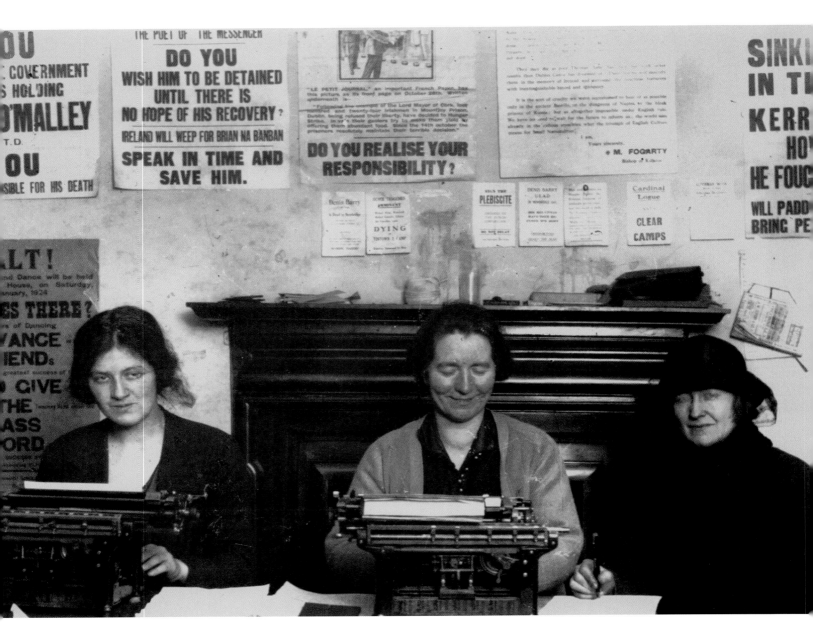

Sinn Féin head office, Suffolk Street, Dublin, 1923

Without the support of these tireless women, seen here at work in the Sinn Féin offices in Suffolk Street, Dublin, the fate of the prisoners might have been far worse. In spite of suffering numerous raids and confiscations, these women kept the prisoners to the forefront of all imaginative people's minds as long as they were able to do so. The woman at the extreme left is Miss Molly Hyland.

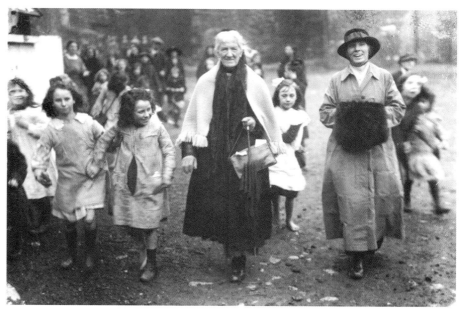

Mrs Despard
Charlotte Despard was as unlike her brother, Field-Marshal French, Earl of Ypres, His Majesty's Lord Lieutenant and General Governor of Ireland, as could be imagined. She was completely oriented towards humanitarian ends. After many years of work seeking to ameliorate the lot of the London poor she turned her attention to Ireland and with enormous success worked for the poor there for the rest of her life.

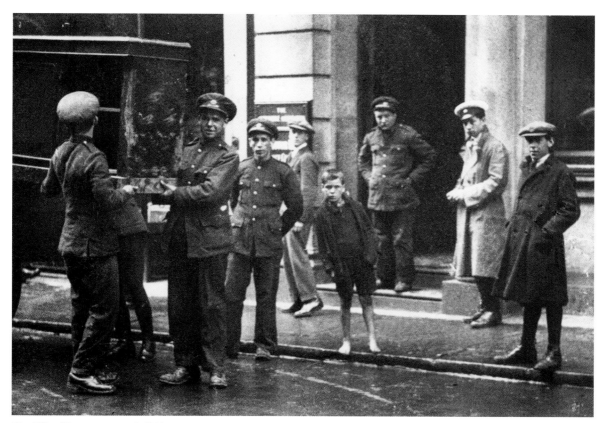

Sinn Féin offices suppressed, 1923
But the time came when the Free State decided that opposition needed to be eliminated. Soldiers of the Free State army were sent in, and the Sinn Féin offices in Suffolk Street were suppressed.

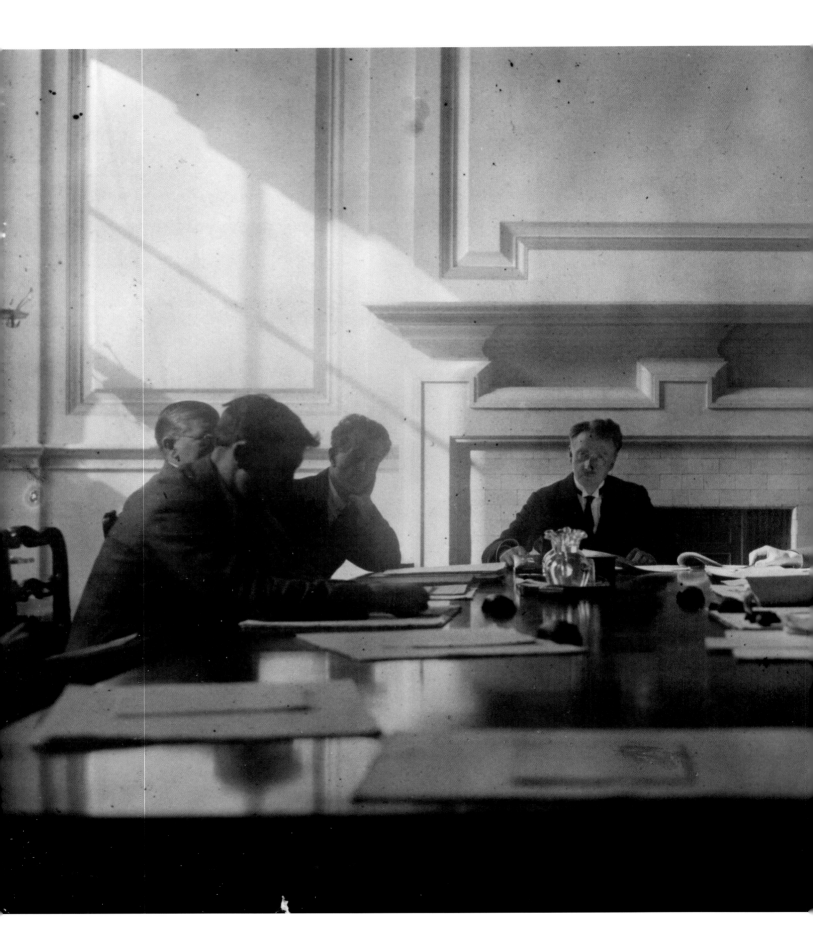

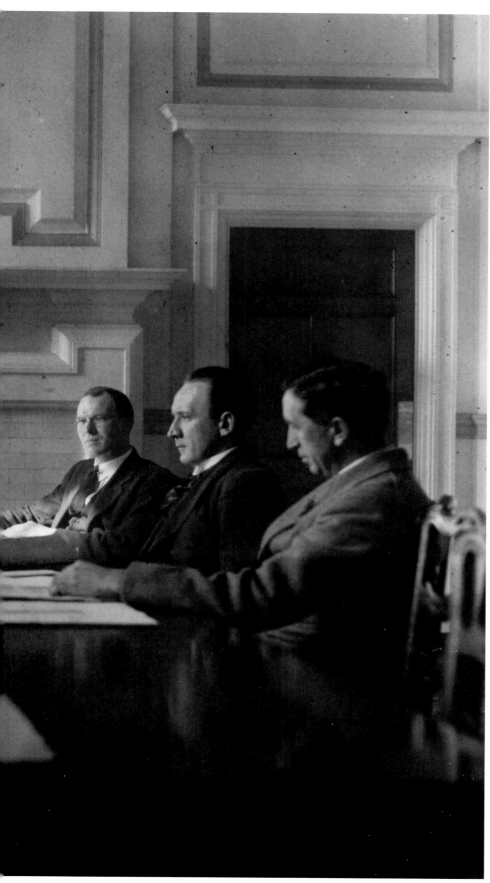

The Cosgrave cabinet

So what of the Irish Free State under William T. Cosgrave? The best thing that can be said of him is that he was active in promoting the Shannon Hydro-Electric Scheme, the harnessing of Ireland's greatest river for the production of electricity. It is the best memorial to his name. With the passing of the years Cosgrave tended more and more to recede into the background, ultimately, on an unwise impulse, making moves towards handing over power to General Eoin O'Duffy and the Blueshirts, a fate from which the 26 Counties was very lucky indeed to escape.

What did the future hold for Kevin O'Higgins? Assassination at the hands of a faction of the IRA.

What did it hold for Ernest Blythe, Minister for Finance? In 1925 and 1926 he signed agreements with the British government that left the Irish Free State severely crippled financially. He then retired from active politics by turning to the arts. He possessed himself of a majority of the shares in Ireland's national theatre, the Abbey Theatre, thus making the Abbey unique in being a national theatre in receipt of a subvention from the state that was at the same time privately owned. He was a survivor!

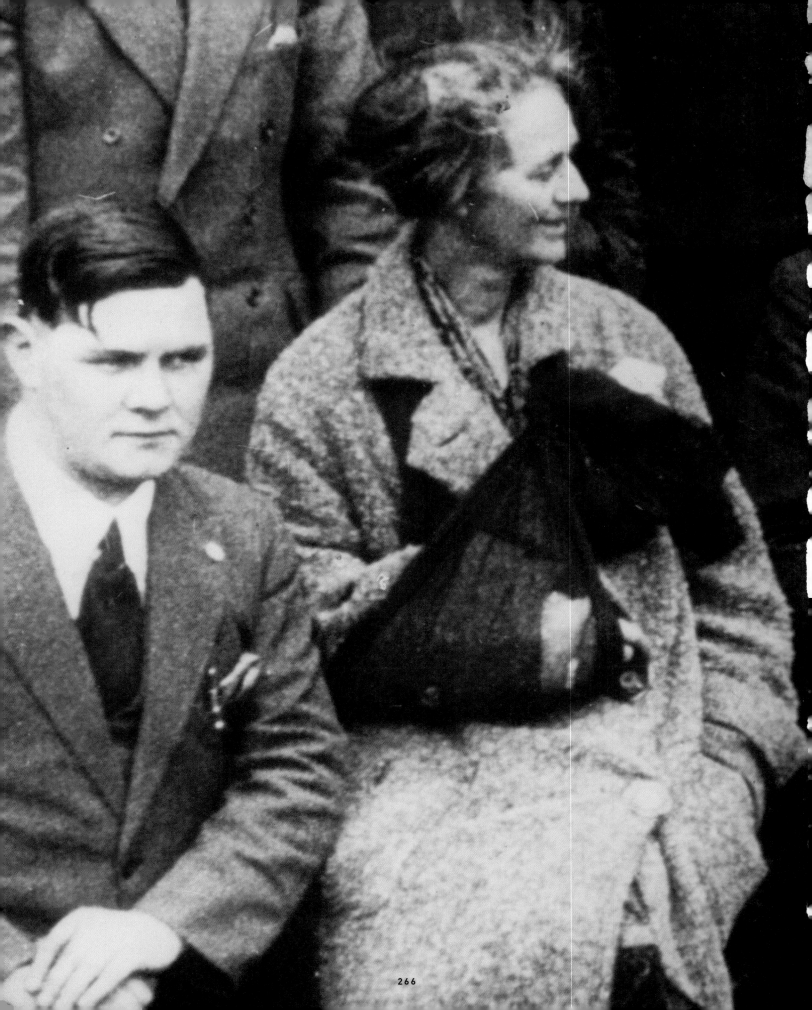

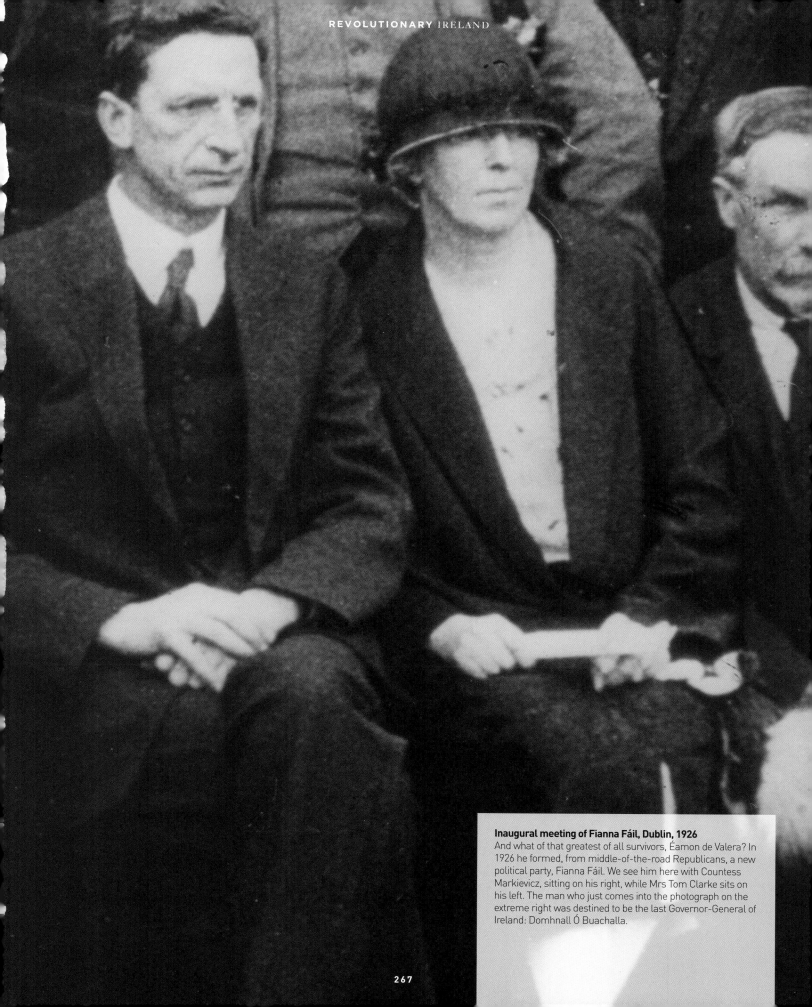

Inaugural meeting of Fianna Fáil, Dublin, 1926
And what of that greatest of all survivors, Éamon de Valera? In 1926 he formed, from middle-of-the-road Republicans, a new political party, Fianna Fáil. We see him here with Countess Markievicz, sitting on his right, while Mrs Tom Clarke sits on his left. The man who just comes into the photograph on the extreme right was destined to be the last Governor-General of Ireland: Domhnall Ó Buachalla.

POSTLUDE

Everyone has a right to express their own views on the vicissitudes of history; but learning what history has to teach us is essential. One thing, above all others, should be constantly kept in mind: 'All flows,' not least time itself. Wise minds may forgive, but only fools forget.

INDEX TO PHOTOGRAPHS